# Baroque
## and Rococo

Editor: Rolf Toman
Text: Barbara Borngässer
Photographs: Achim Bednorz

Feierabend

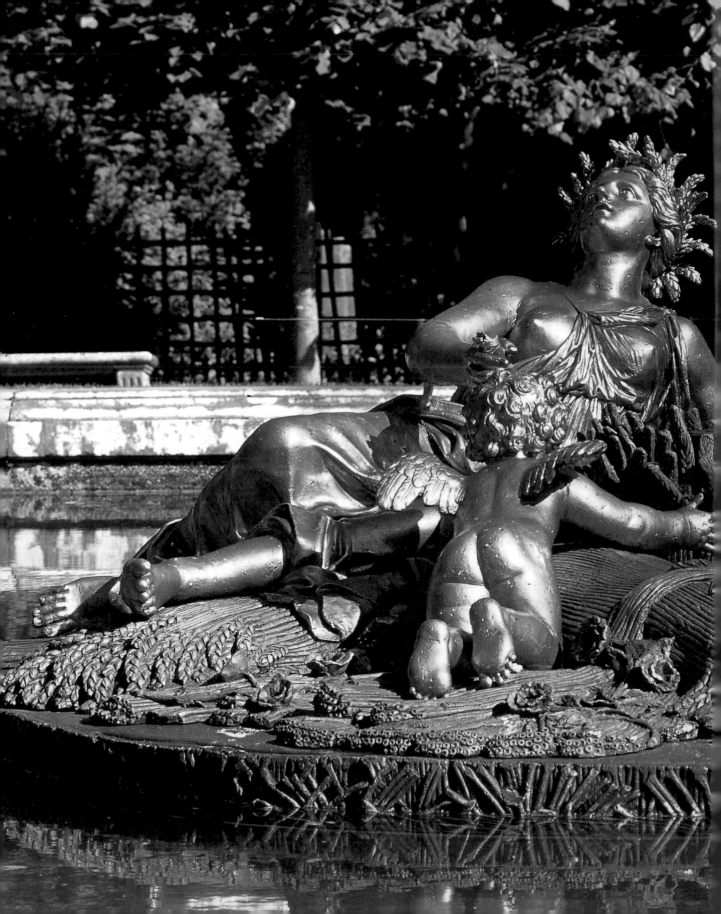

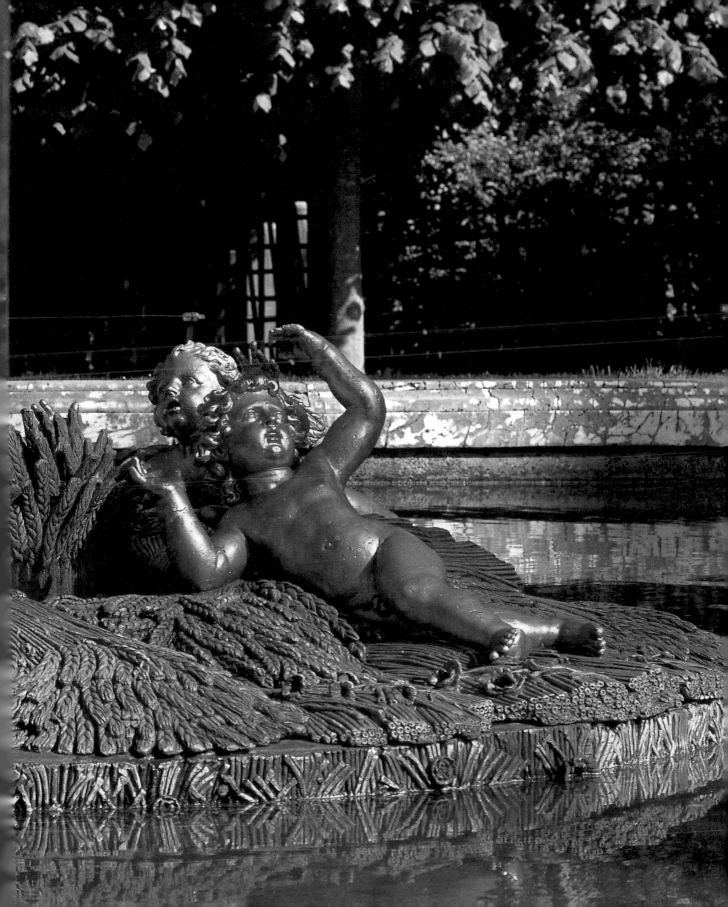

# Contents

Preceding spread:
**Régnaudin,** Ceres or summer fountain in the park of the Palace of Versailles, 1672–1679

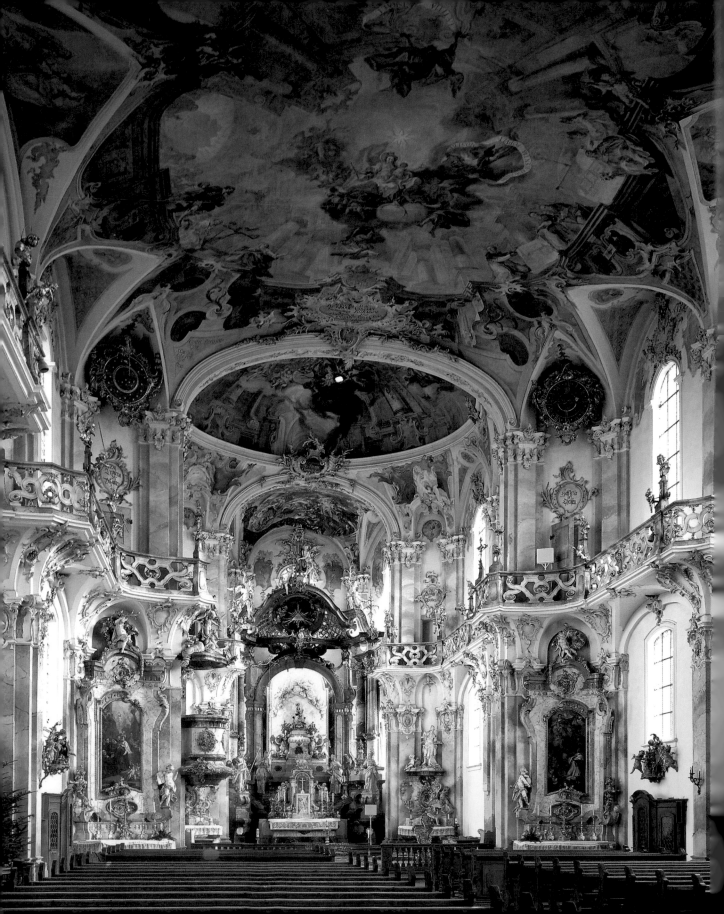

# Introduction by Rolf Toman

### *Theatrum mundi*

No one has more aptly characterized the Baroque spirit than the Spanish dramatist Calderón de la Barca. In his allegorical play *El Gran Teatro del Mundo* ("The Great Theater of the World"), first performed in 1645, he applied the ancient topos of "life as a play" to his own times: Human beings perform as actors in front of God the Father and his heavenly entourage; the play they act in is their own life, their stage is the world.

The metaphor of "world theater" permeates the entire Baroque era, the epoch between the end of the sixteenth and the late eighteenth centuries. This period is marked by stark contradictions both in front of and behind the curtain. Reality and appearance, pomp and asceticism, power and powerlessness are the antagonistic constants of the time. In a world convulsed by social conflict, war and religious controversies, the gigantic spectacle gave people some sort of security. The splendor surrounding the Baroque ruler, whether pope or king, was also part of a political agenda. Ceremony—the stage direction in this "world theater"—became the reflection of a higher, supposedly God-given order.

The arts—both the fine arts and performing arts—played a double role, serving to impress or even dazzle the subjects, while at the same time conveying ideological principles. They provided the theater's backdrop, creating the illusion of a perfectly ordered world. There is no better illustration of this than the illusionistic ceiling frescos in churches and palaces. In them, an illusory space opens up above real space, permitting a glimpse of the heavenly spheres (see illus. pp. 6 and 12).

It was not always possible, however, to distract from the trials and tribulations of everyday life. For this reason, art of the Baroque era often takes on a confusing array of forms. Extravagant displays of material splendor and an uninhibited enjoyment of life's pleasures contrast with deep religious beliefs and an awareness of the inevitability of death. In the Baroque, the motto memento mori, "remember that you must die," became the leitmotif of a turbulent society oppressed by existential fears (see p. 202/203). It is no coincidence that the opulent still lifes of the time often conceal references to the transitory nature of life, such as a worm, a rotten berry, or a partly eaten piece of bread.

Baroque art always appeals first of all to the viewer's senses. Its theatrical pomp, its illusionism, and its dynamic forms are meant to impress, to persuade, to awaken inner emotions. This explains why it is often considered effusive, showy, even bombastic. As early as the late eighteenth century, the Italian author Francesco Milizia saw in Baroque architecture—for example, the works of Borromini—

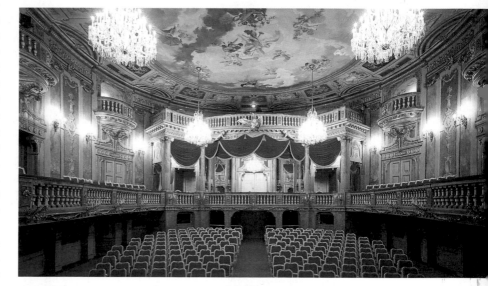

P. 6: **Peter Thumb (architect), Johann Anton Feuchtmayer (stucco),** Birnau, Our Blessed Lady, 1745–1751, interior

**Nikolaus von Pacassi,** Court Theater in Schloss Schönbrunn in Vienna, 1741–1749

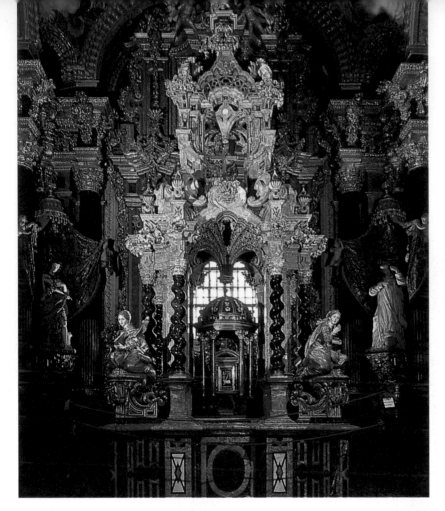

**Francisco de Hurtado Izquierdo,** Sagrario, Granada Charterhouse, 1702–1720

P. 9: **Vieux-Laque room in Schloss Schönbrunn in Vienna,** c. 1770

the "superlative of the bizarre, the excess of the ridiculous." In the twentieth century, too, there was a generally critical attitude toward works from the Baroque era. In the '20s, for example, the Italian philosopher Benedetto Croce disparaged them for their lack of "substance," and claimed that the Baroque "was a game ... a hunt for the means to produce amazement. Because of its character, ... when all is said and done, the Baroque seems cold despite its veneer of emotion and warmth; despite its wealth of pictures and their combination, it leaves behind a feeling of emptiness." These reservations about the Baroque can also be seen in the development of the term itself. Before it entered general usage as a stylistic designation in the late nineteenth century, it was often used as an adjective in the derogatory sense of "quaint," "bizarre," "over-ornate," "indefinite," "confused," "artificial," or "contrived." Many of these reservations can still be detected today. Our age, however, which is once again receptive to "superficial" allurements, may well find a new way of approaching this extremely multi-faceted epoch.

## Pomp and circumstance

In his book *Dutch Civilization in the Seventeenth Century*, the Dutch historian Johan Huizinga gives a succinct outline of Baroque culture: "Splendor and dignity, the theatrical gesture, strict rules, and a closed doctrinal system are dominant features; obedient reverence toward the Church and the State is the ideal. The monarchy as a type of state is given divine status; at the same time, each individual state subscribes to the fundamental concept of unlimited national egoism and autonomy. Public life occurs entirely within the dictates of an overblown eloquence that is meant to be taken completely seriously. Splendor and display celebrate their golden age with pompous formality. A renewed religious faith is vividly expressed in resounding, triumphant representations: Rubens, the Spanish painters, Bernini." Huizinga uses this outline as a background with which to contrast the only "partly similar" characteristics of Dutch culture: "Neither the strict style, nor grand gestures and majestic dignity are typical of this country." Holland completely lacked the theatrical element, a fundamental characteristic of the Baroque period and a central concept that is the sole explanation for many manifestations of Baroque art.

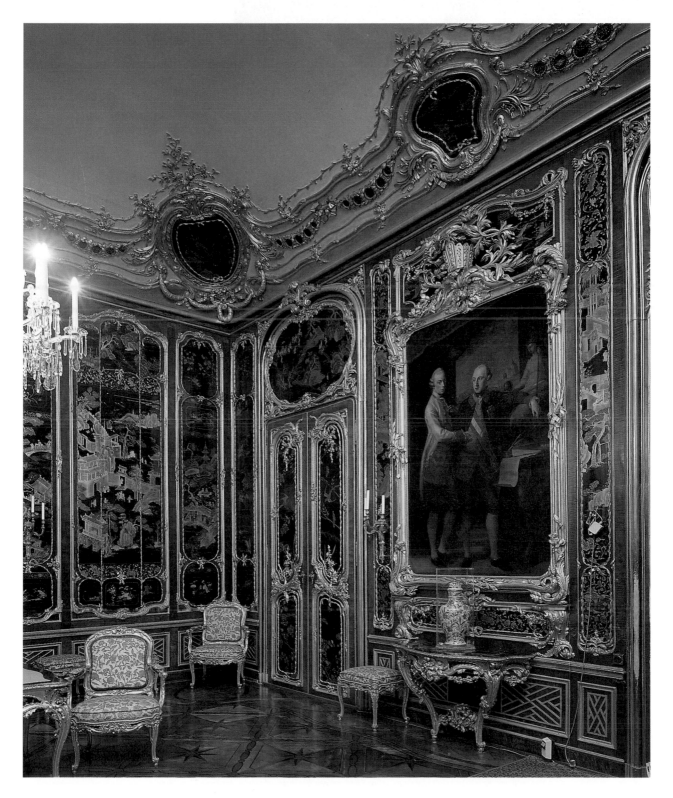

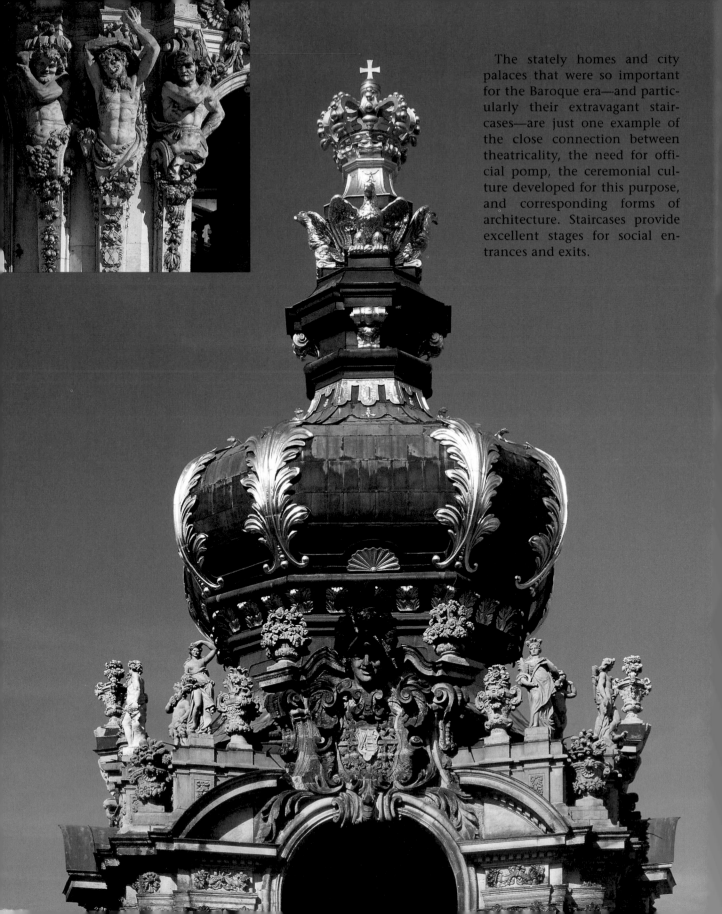

The stately homes and city palaces that were so important for the Baroque era—and particularly their extravagant staircases—are just one example of the close connection between theatricality, the need for official pomp, the ceremonial culture developed for this purpose, and corresponding forms of architecture. Staircases provide excellent stages for social entrances and exits.

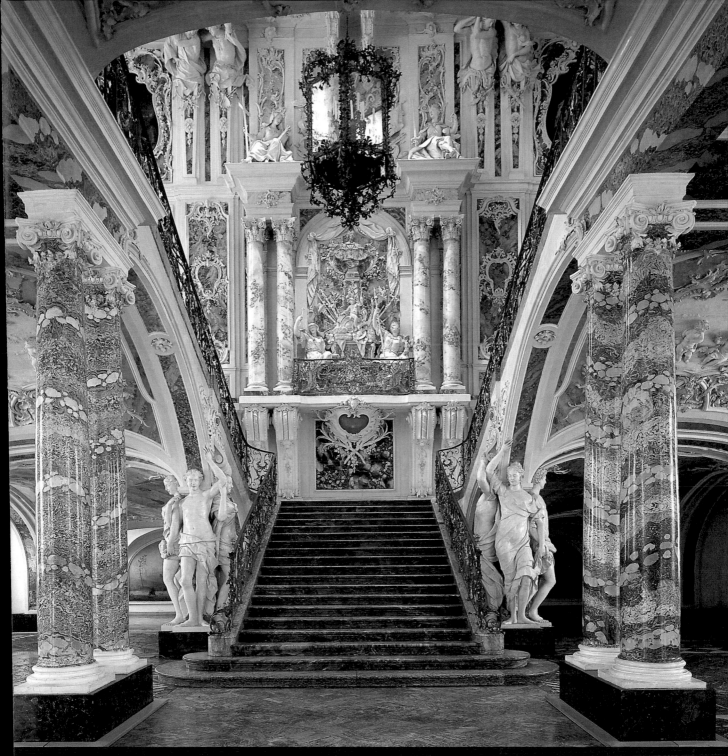

P. 10 top left: **Balthasar Permoser,** supporting pillars on the Wall Pavilion of the Zwinger in Dresden, 1716

P. 10: **Matthäus Daniel Pöppelmann and Balthasar Permoser,** Dresden, Zwinger, detail of the Kronentor (crown gate), 1713

Above: **Balthasar Neumann,** Brühl, Schloss Augustusburg, staircase, 1741–1744

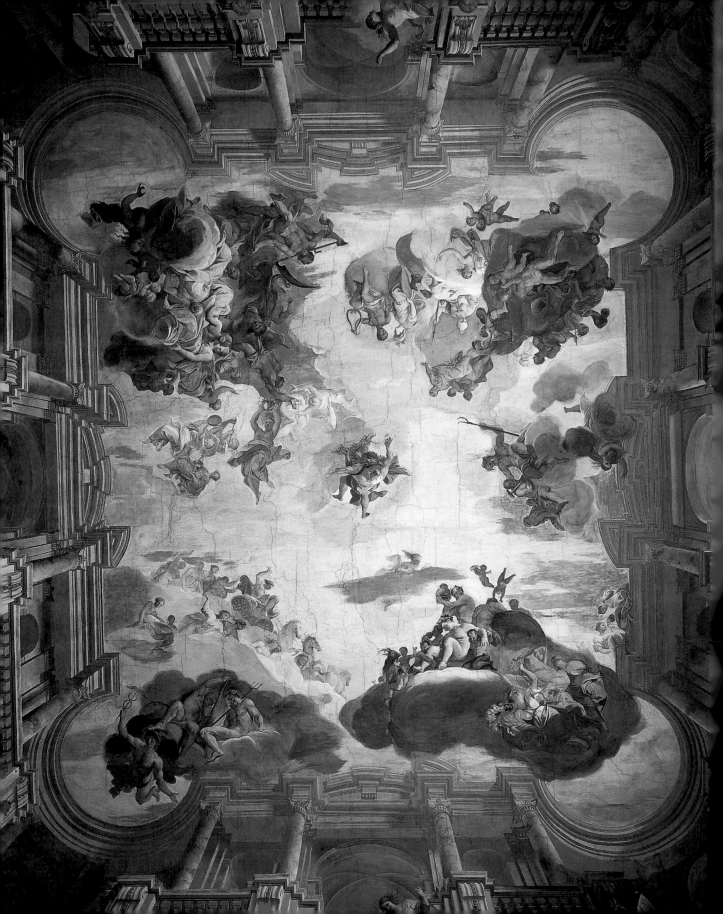

While life at court was regulated by strict ceremony, this provided an outlet for more boisterous forms of celebration, which nonethless adhered to a fixed choreography as well. No era has celebrated more glittering parties than the Baroque. Versailles led the way, and all the courts of Europe followed its example. Celebrations went on for whole days and nights, in which all the arts blended to form a *Gesamtkunstwerk*, a gigantic synthesis. Opera, ballet, and fireworks had their dazzling heyday. The banquet halls decorated with mythological pictures as well as the gardens and water features provided an ideal backdrop; illusionistic and mechanical tricks were employed to transform them into an ever-changing variety of different scenes. For several days, the entire court slipped into the world of the gods and heroes. The fact that these spectacles— and, indeed, the entire courtly culture—caused the state's financial ruin is another story.

But people on the streets also celebrated. At every opportunity, the otherwise dreary cities decked themselves out with temporary wooden buildings and lavish decorations for public state occasions, saints' days, processions and fairs. Here, too, there were theatrical productions: The players performed their crude jests, shedding light on the vastly different world outside of courtly society.

**Andrea Pozzo,** *Apotheosis of Hercules,* 1704–1707, ceiling fresco in the Liechtenstein Garden Palace, Vienna

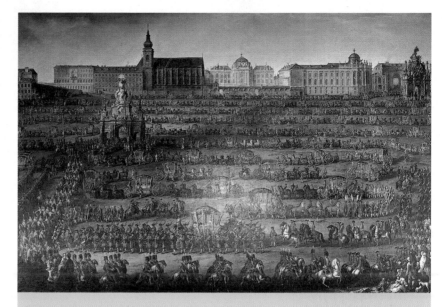

**Martin van Meytens,** *Entrance of Princess Isabella of Parma in Vienna,* 1760, Vienna, Schloss Schönbrunn

**Carlo Carlone (architect) and Antonio Beduzzi (quadrature painting),** ballroom in Schloss Hetzendorf in Vienna, mid-eighteenth century

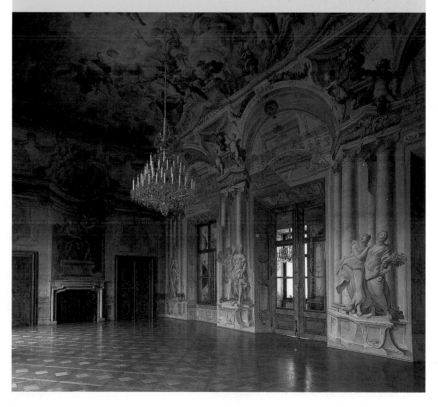

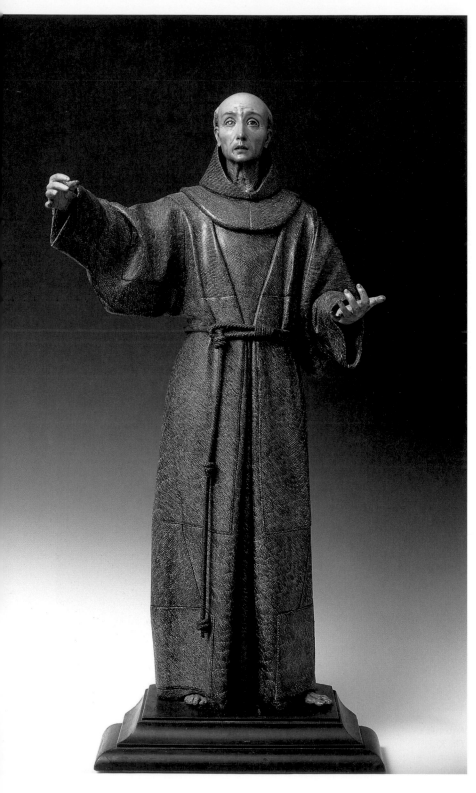

## Rhetoric and *concettismo*

The supposed unrestraint of Baroque art mentioned above should not blind us to the fact that it was, in reality, subject to extremely strict rules. Just as ceremony governed the behavior of people toward each other, rhetoric determined the structure of a speech or a work of art. The term *rhetoric*, used since ancient times, means the "art of using language appropriately." This technique was a part of general education from ancient times up to the end of the eighteenth century. Rhetoric provided a kind of guideline for communication between speaker and listener, and influenced the reception and interpretation of what had been said.

Architecture, too, was governed by rhetorical rules. For example, it was precisely laid down what order was suitable for what purpose, or what architectural *pathos formulae* could be used to decorate a church, a palace facade, or a square. The heavy, squat Doric order, for instance, was assigned to churches dedicated to male saints, as well as to palaces of war heroes. Houses belonging to academics, on the other hand, had Ionic decoration. The colossal order, columns extending over several stories, had since Michelangelo's times been considered a highly noble feature (see illus. right). With

**Pedro de Mena,** *S Pedro de Alcántara*, 1633, painted wood, height 78 cm/31 in, Valladolid, Spain, Museo Nacional de Escultura

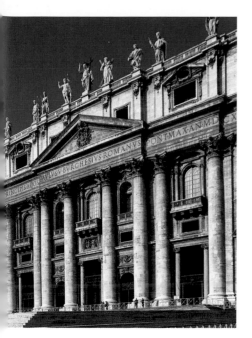

**Carlo Maderno,** Rome, St Peter, 1607–1612, part of the facade with colossal order: The columns rise several stories high.

well thought-out concept that only scholars could devise. For this reason, princes and prince-bishops, and sometimes even artists themselves, called in poets, courtiers, and often clergy to come up with the "invention," the ideas and content that were to underlie a particular subject. This intellectual work was seen as an essential part of a work of art. Only in ideal cases was the artist himself in a position to devise his own *concetti*. When he did have the ability to do so, however, he rose even higher above the status of a mere craftsman. Hermann Bauer describes the *concettismo* as the "transformations of an idea through different fields," as the "path from an object to its (metaphorical) meaning," a "constitutive" element of a Baroque work of art.

palaces, the scenographic arrangement plays an important role. Like an entrance on a ceremonial staircase, the building reveals itself gradually as one approaches and walks through it. Here again, the architecture gives the stage directions, for example, in the sequence of rooms and courtyards in Versailles; as in a well crafted speech, the recipient is led from one experience to the next. In the same way that the arrangement of the rooms serves to underline the hierarchical structure of court life, the exterior is intended for the general public, either to impress or intimidate it.

The deliberate presentation of art described here required a

## The "last things"

Let us return to Calderón's "world theater." In the course of the play, "the world" gives every actor, whether king or beggar, the props appropriate to his station. The actor enters the stage through one door, "the cradle," and leaves it through another, "the grave." This is the moment in which the actors have their "insignia" taken from them once more and recognize whether or not they have fulfilled their role.

When the curtain goes down, only the "four last things" remain: Death, Judgment, Heaven, and Hell. Their allegorical interpretation was a major concern throughout the Baroque era, and provided the *concetto* for extremely moving art works; Pereda's painting of a dream is a good example (illus. below).

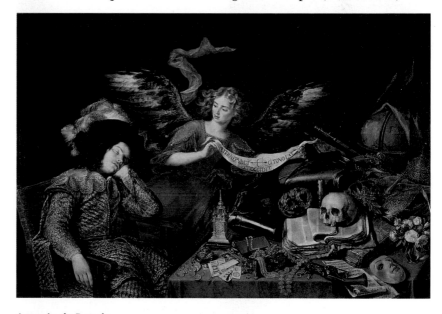

**Antonio de Pereda,**
*The Knight's Dream*, c. 1650,
oil on canvas, 152 x 217 cm/60 x 85.5 in, Madrid,
Museo de la Real Academia de San Fernando

15

# The Architecture of the Baroque

The architecture of the Baroque era served the purposes of ecclesiastical and secular power. Sensuous yet intellectual, it—along with the other arts—was used to awe and move people, and to convince them of the inherent order of things.

The requirements of courtly ceremony, the need for pomp and splendor, the predilection for theatricality, and the sheer desire for monumentality meant that traditional architectural forms had to meet extremely high demands. The palace, for example, with its ordered sequence of rooms, stately staircase, theater, and chapel, underwent radical concepual changes. As it lost its fortress character, it became more open to nature. Palaces were often laid out in a horseshoe shape, entre cour et jardin, between court and garden, creating a new type of building that reached out into its surroundings (see illus. right). The axial arrangement of the park paths gave new impetus to town planners, who followed feudalistic guidelines into the nineteenth century.

As was initially the case with secular architecture, established models were used for sacred architecture as well. The Greek-cross plan churches favored during the Baroque were based on ideas arising from the Counter-Reformation and the Council of Trent (1545–1563), which called for an undivided preaching space with a clear view of the high altar. These concepts were embodied in the pilastered church of Il Gesù in Rome (begun 1568). This church, the mother church of the Jesuit order, was copied and varied hundreds of times, and retained its typological influence into the eighteenth century. Monasteries and convents became increasingly grandiose, with examples from the late Baroque resembling secular palatial residences (illus. left). Here, too, the art of architecture was combined with the "art of ruling" (Pierre Lemoyne, 1665).

**Caspar Moosbrugger,** Weingarten, interior of the abbey church, 1715–1720

P. 17: **Jules Hardouin-Mansart,** Versailles, columned hall of the Grand Trianon, 1687/1688

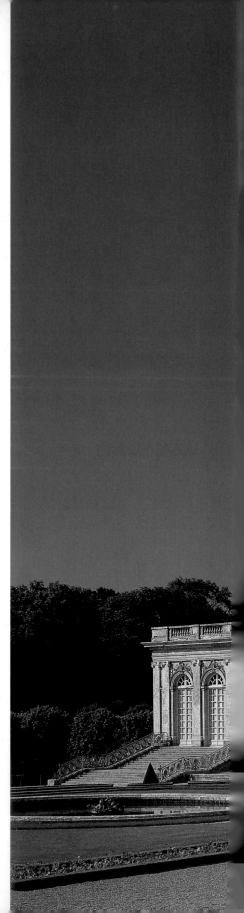

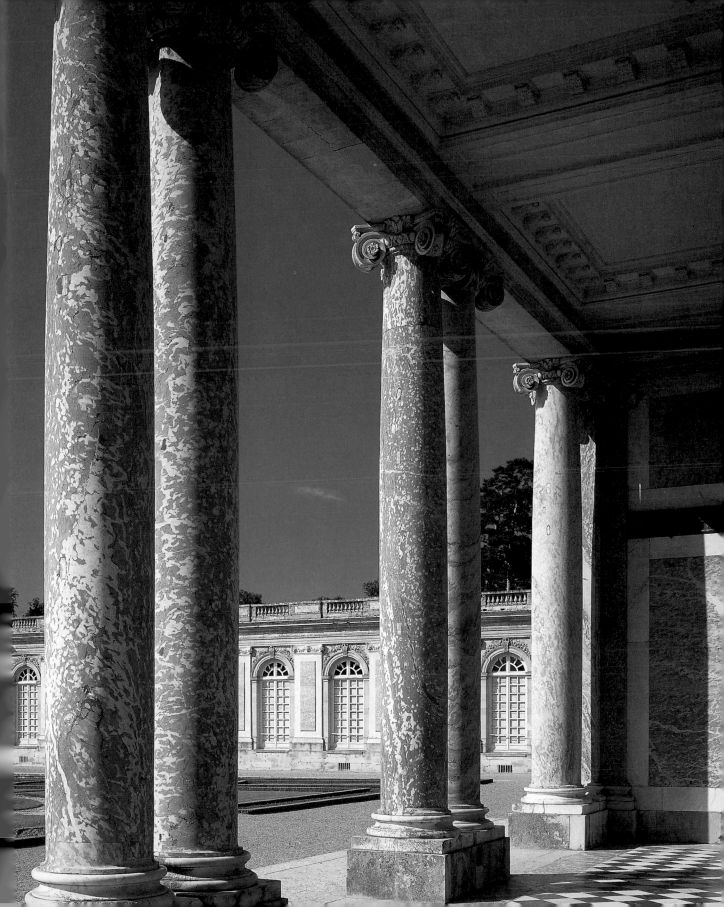

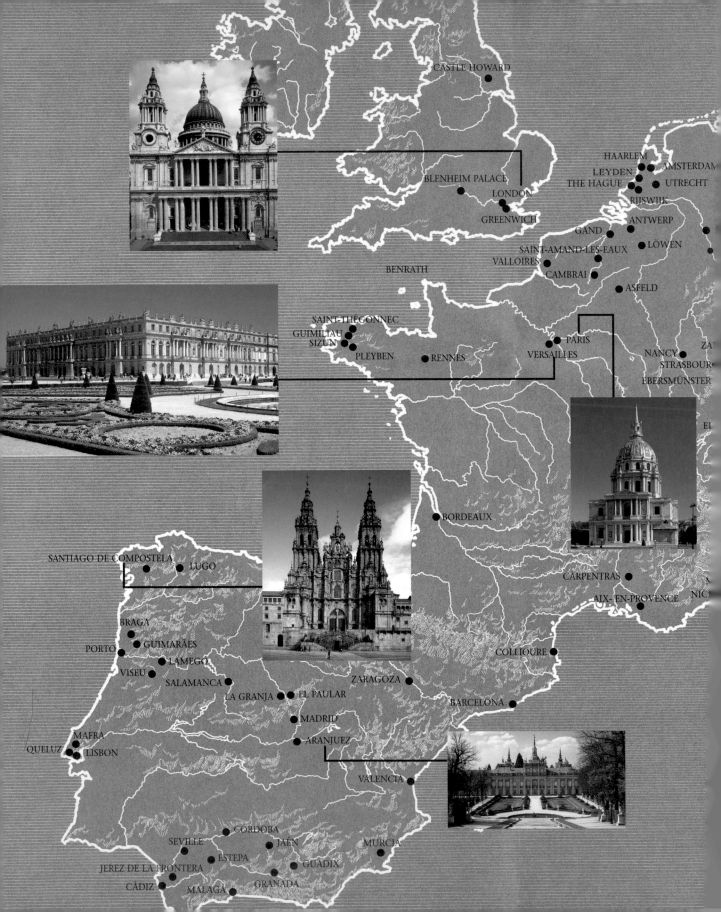

CASTLE HOWARD

HAARLEM
LEYDEN AMSTERDAM
THE HAGUE UTRECHT
RIJSWIJK
ANTWERP
GAND LÖWEN
SAINT-AMAND-LES-EAUX
VALLOIRES
CAMBRAI
ASFELD

BLENHEIM PALACE
LONDON
GREENWICH

BENRATH

SAINT-THÉGONNEC
GUIMILIAU
SIZUN
PLEYBEN
RENNES

PARIS
VERSAILLES

NANCY
STRASBOUR
EBERSMÜNSTER

EI

BORDEAUX

SANTIAGO DE COMPOSTELA
LUGO

CARPENTRAS
AIX-EN-PROVENCE NICE

COLLIOURE

BRAGA

PORTO
GUIMARÃES
LAMEGO
VISEU
SALAMANCA
LA GRANJA EL PAULAR
MADRID
ARANJUEZ

ZARAGOZA

BARCELONA

MAFRA
QUELUZ
LISBON

VALENCIA

CORDOBA
SEVILLE JAÉN
ESTEPA
JEREZ DE LA FRONTERA GUADIX
CÁDIZ GRANADA
MALAGA MURCIA

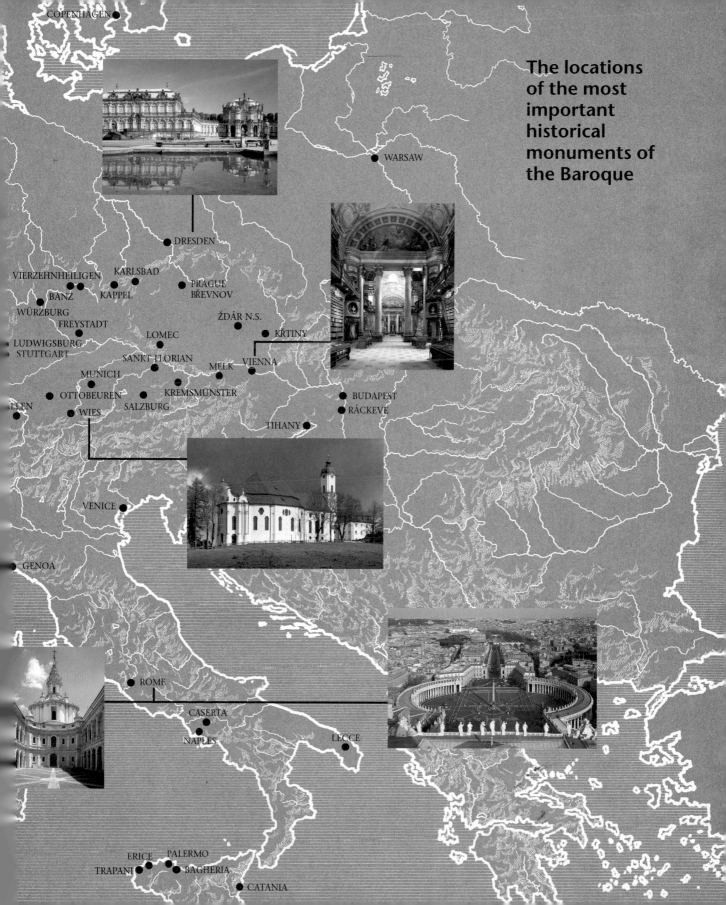

**The locations of the most important historical monuments of the Baroque**

COPENHAGEN

WARSAW

DRESDEN

VIERZEHNHEILIGEN

KARLSBAD

BANZ

KAPPEL

PRAGUE

BŘEVNOV

WÜRZBURG

FREYSTADT

ŽĎÁR N.S.

LOMEC

KRTINY

LUDWIGSBURG

STUTTGART

SANKT FLORIAN

MELK

VIENNA

MUNICH

OTTOBEUREN

KREMSMÜNSTER

BUDAPEST

LLEN

WIES

SALZBURG

RÁCKEVE

TIHANY

VENICE

GENOA

ROME

CASERTA

NAPLES

LECCE

ERICE

PALERMO

TRAPANI

BAGHERIA

CATANIA

## The Art of Town Planning

The idea of controlling and regulating the growth of a settlement originated in ancient times. Whether the search for a rational plan or an ideal city was motivated by topographical, strategical, ritualistic, or ideological considerations, many cultures decided to build regular road networks. The grid layout devised by Hippodamus of Miletus is seen as a milestone in urban planning. In 479 B. C. he rebuilt his home town, which had been destroyed by the Persians, according to an orthogonal design. This plan spread via the Greek colonies to southern Italy and the Roman world. It was Vitruvius who finally passed on the concepts of town planning to posterity. Whereas in the Middle Ages there was a tendency toward practical, variable solutions, ancient forms of town planning experienced a mighty comeback in the Renaissance. The writings of Leon Battista Alberti, above all his *De re aedi-*

*ficatoria*, pointed the way for modern town planners. However, the humanist Alberti, like his spiritual father Vitruvius, was not merely concerned with *urban planning*; rather, he went deeply into the subject of *urban development*, with all its aesthetic, functional, and social components.

The social utopias of the early modern age and the desire for clear structures gave rise to a number of ideal city designs: The star-shaped Palmanova fortress near Udine (1593) is the best known of these. The role played by the founding of cities in the New World in this regard has not yet been adequately examined. The fortresses, missions, and towns in the colonies at any rate provided an ideal field for experimentation, as it was possible to build there without regard to historical structures: *ex nihilo*, so to speak.

The *renovatio Romae*, the restoration of medieval

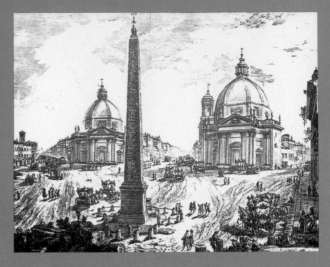

**Rome,** Piazza del Popolo with the obelisk and the churches S Maria in Monsanto and S Maria dei Miracoli in the mid-eighteenth century. Engraving by Giovanni Battista Piranesi

Rome, the "head of the world," was, however, the focus of all urbanistic endeavor, at least since the time of Julius II and Leo X. This renewal project was radically carried out in Baroque style

under Sixtus V. In 1585, the pope commissioned his architect, Domenico Fontana, with a project aimed at giving the city an appearance reflecting its religious role. His elaborate, novel concept connected the city's most important religious locations, the seven early Christian basilicas, by means of wide, straight processional roads that also radiated out into the surrounding area (illus. left). Open spaces, streets, and rows of facades, as well as monuments such as obelisks and fountains, served to create visual axes and give optical coherence to the heterogeneous architectural elements. A striking example is the Piazza del Popolo, the main gate of the city and the starting point for the "tri-radiate" avenues Via di Ripetta, Via del Corso, and Via del Babuino. Sixtus V accentuated this focal point by moving an Egyptian obelisk there. In the seventeenth century, the optical effect

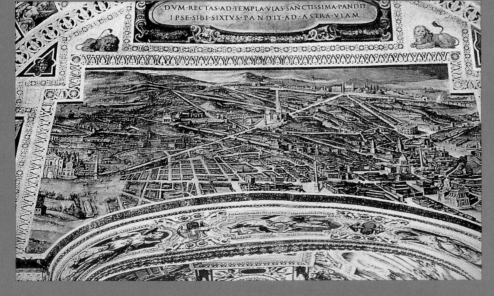

**Rome in the sixteenth century** with Pope Sixtus V's layout of the city, fresco, Rome, Vatican Museums

**Rome**, view of St Peter's Square with St Peter's Dome and the Vatican Palace

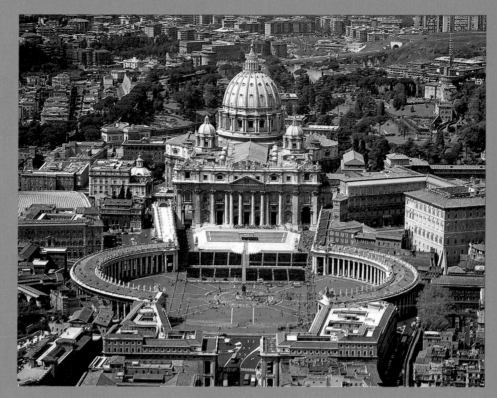

was further heightened by building the two domed churches of S Maria in Monsanto and S Maria dei Miracoli, which stand at the head of the avenues (illus. p. 20).

St Peter's Square is doubtless the highest achievement of Baroque architecture in Rome. Despite all the constraints, Bernini succeeded in creating an urban space that exceeded all expectations. The final design of 1637 was based on a double plaza that rises upward with theatrical effect, while behind it, the façade of St Peter's, with its balcony for papal benedictions, towers up like a scenic backdrop (illus. right; also see p. 26/27). The first, oval-shaped *piazza obliqua* with its Doric colonnades receives the crowds of pilgrims just as the Church receives the faithful with open arms. Toward St Peter's, the space narrows into the trapezoidal *piazza retta*, which inclines gently upward, furnishing Maderno's façade with a suitable "pedestal." The hub of the complex is the obelisk, moved here in 1586, which is aligned with the nave of St Peter's. The cross axis is accentuated by fountains and projections of the colonnades. Finally, of the numerous other Baroque squares in Rome, the Piazza Navona (altered 1644–1650) and Piazza S Ignazio (1726–1728) should be mentioned; these have lost none of their suggestive effect even today. The Spanish Steps and the Trevi Fountain are also complex art works in an urban setting. In Turin, the capital of Savoy, the idea of using the right-angled system of the Roman castrum as the basis for a modern extension of the city was already contemplated in the late sixteenth century. Following first plans by Ascanio Vitozzi, the project was carried out in the seventeenth century by Carlo and Amedeo di

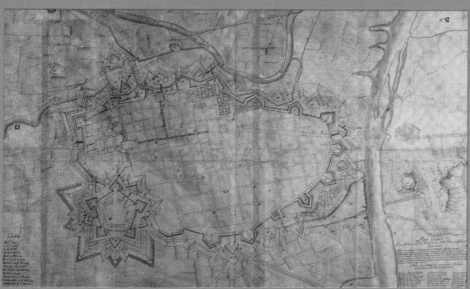

**Turin**, map of the city from the early eighteenth century, Turin, Archivio di Stato

Castellamonte. A systematic road network, the geometrical layout of squares and axes, and finally, farsighted legislation aimed at creating uniform street frontages turned Turin into the most modern city in Europe (illus. p. 21 below; also see p. 44). The new ideas springing from the renovation of Rome were taken up everywhere, although they were realized in different ways. In the Paris of Henry IV, the *place royale* became the epitome of

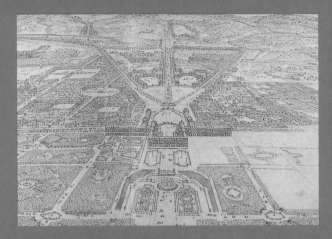

**Versailles,** palace and park, engraving after Israel Silvestre, end seventeenth century

Baroque urban planning. In contrast to Rome, it did not serve the purposes of the Church, but clearly those of absolutism. No matter what the playa's actual shape— whether triangular like the Place Dauphine, quadrangular like the Place des Vosges, or round like the Place des Victoires, built under Louis XIV—

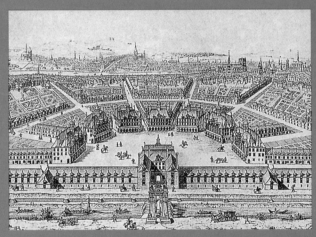

Above: **Paris, Place de France,** designed by Claude Chastillon(?), early seventeenth century

Below: **Karlsruhe, Schloss and city,** engraving of 1739

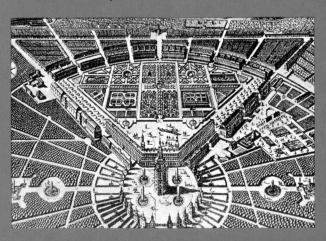

at the center of the uniform facades was always the king's statue, which also dominated the city's entire system of axes (see also p. 70/71). The monarch, who had formerly ruled over fortresses, castles, and estates, now seized hold of the whole city organism to an extent never seen before. The *place royale*, however, is much more than just a monumental testimony to royal power. Rather, it embodied the sovereign's concern for the welfare of his city and subjects, and his intention to help regulate the development of a community. The concept was taken up all over Europe: between Madrid, London, and Copenhagen, the "royal square" occurred in many different forms.

The Place de France in Marais, on the other hand, on the northern edge of early Baroque Paris, is to be seen in a symbolic light. The plan for its construction, which has come down to us in an engraving, was probably devised by Claude Chastillon in the early seventeenth century (illus. left). However, the assassination of Henry IV in 1610 prevented its ever being realized. Despite this, the design

marks an important step forward in modern town planning. The star-shaped arrangement, envisaged here for the first time on a large scale, contains clear references to the structure of the kingdom. Behind a newly opened city gate—usually the ancient or medieval entrances were used—the polygonal Place de France opens up in an expansive gesture. Eight streets bearing the name of French provinces radiate from it, giving access to the inner city right down to the banks of the Seine. The relationship between the capital and the kingdom could hardly have been outlined more vividly.

Relations between the French court and the city were to undergo fundamental changes in the second half of the seventeenth century. At the moment when, in 1677/1678, Louis XIV turned his back on Paris and ordered his residence moved to the "suburb" of Versailles, the perspective of town planning also changed. Whereas kings had formerly influenced their capital from within and "occupied" central points in the city, the planned city of Versailles grew up under the

**Lisbon,** Praça do Cómercio, after 1759

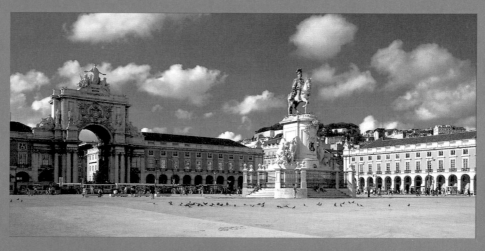

eyes of Louis XIV alone (see illus. opposite). The view from the royal bedroom determined the radial arrangement of the avenues, and indeed the entire layout of the royal town, including the extensive gardens. The close connection created between palace, park, and town—in this order, naturally—influenced many late Baroque royal seats, including Mannheim, Stuttgart, and Karlsruhe (see illus. p. 22 below).

With the emergence of mercantilism, the absolutist urban structure underwent reinterpretation. In Lisbon, which was given a new *Cidade Baixa* (lower city) following the devastating earthquake of 1755, the well established grid layout was maintained. However, the area formerly taken up by the destroyed royal palace was now used for the Praça do Cómercio, the imposing commercial square with adjoining administration buildings (illus. above).

In contrast, the English spa resort of Bath, famous since ancient times, is a prime example of the way various models can overlap one another. In the town's three monumental squares—the quadratic Queen's Square, the round Circus, and the semi-circular Royal Crescent (see illus. p. 103)—the basic layout of the royal plazas in Paris is combined with references to Rome and the inclusion of natural features.

Finally, let us take a look at the Baroque style of fortress, which was heavily influenced by the Frenchman Sébastien le Prestre Marquis de Vauban (1634–1707). As an army commander, engineer, town planner, and theoretician, he had an unparalleled impact on the defensive architecture of his time. His theory of the three types of fortification was a basic part of military know-how. He himself constructed 33 fortresses and planned towns, including Neuf-Brisach in 1699, as a grid within a triple, star-shaped system of bastions (illus. left). There are 411 other projects of his recorded in archives all over Europe.

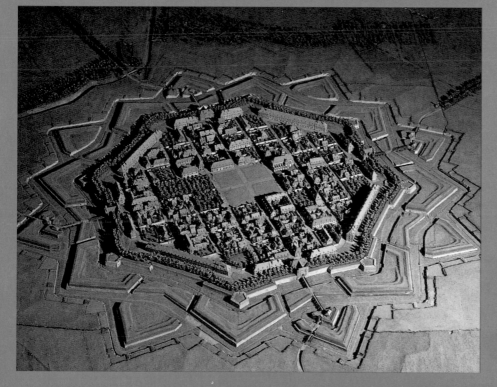

**Neuf-Brisach**, relief map, Paris, Musée des Plans-Reliefs, 1706. Neuf-Brisach was conceived by the famous architect of fortresses, Sébastien le Prestre Marquis de Vauban, incorporating the most modern military ideas.

23

# Italy

The transition from Mannerism to Baroque took place in Rome, and for decades it was Roman artists who introduced the new, sensual style of architecture to the rest of the world. Only in the later seventeenth century did regional variants evolve—in Piedmont, in Venice, and in the then Spanish-ruled southern part of Italy.

The driving force behind this artistic renewal was—as had already been the case in the time of Raphael, Bramante, and Michelangelo—the Vatican and the court surrounding it. But not until the Counter-Reformation were the conditions created for a radical change of direction. For example, the Jesuits used the rhetorical power of Baroque art to get across religious messages. Their first church, Il Gesù in Rome, with its open preaching space and commanding facade, became the incunabulum of Baroque architecture (illus. p. 25 below).

# Rome

Rome owes its singular urban appearance to the Church's desire to promote itself as well as to the personal ambitions of the popes Sixtus V, Paul V and Urban VIII, sometimes drawing on the plans of their predecessors, determined the important axes in the city, broke through medieval buildings, and adorned the new, magnificent avenues with fountains and obelisks. In the splendidly designed plazas, architecture and

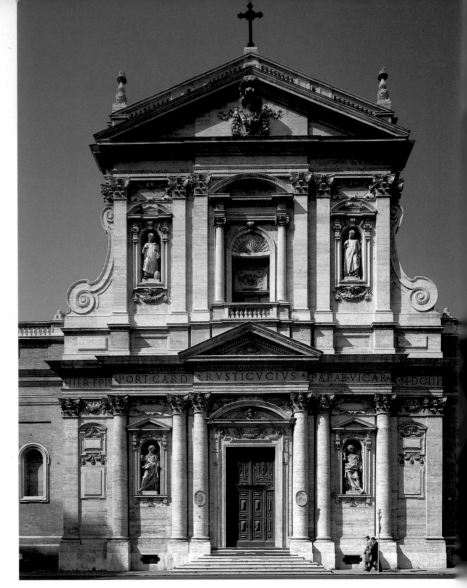

**Carlo Maderno,** Rome, S Susanna, facade, 1597–1603

sculpture joined in synthesis to create complex Baroque art works. Between the sixteenth and the eighteenth centuries, countless churches were started or radically altered. All artistic, sensuous means were used to make the unique nature of the *urbs* apparent to the faithful. But even palace architecture was given new momentum because

of the need of the popes and the aristocracy for splendor and luxury.

Only the best artists were engaged to work on restoring the city: Carlo Maderno, Gianlorenzo Bernini, Pietro da Cortona, Carlo Rainaldi, Carlo Fontana, and others turned the Eternal City once more into a focal point for architecture.

24

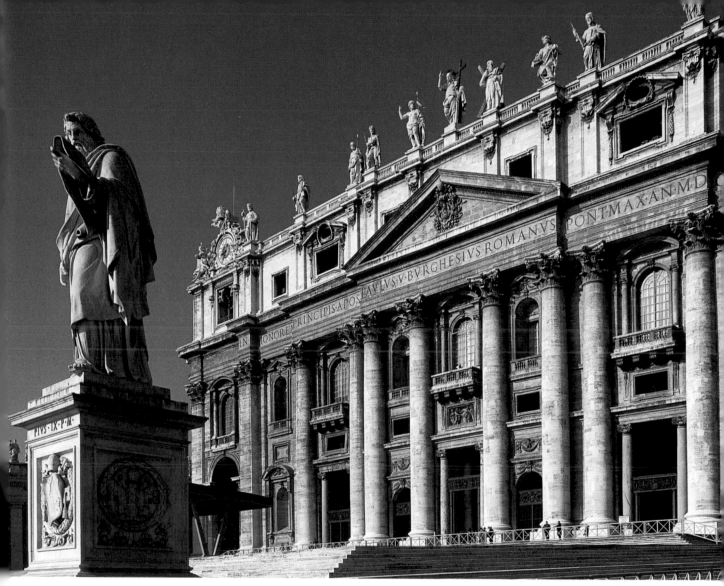

Above: **Carlo Maderno,** Rome,
St Peter, facade, 1607–1612

Right: **Giacomo Barozzi da Vignola
and Giacomo della Porta,** Rome,
Il Gesù, 1568–1584

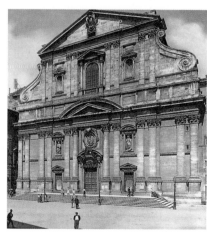

## Carlo Maderno

This architect and engineer, born
in 1556 at Lake Lugano, is con-
sidered the founder of early Ro-
man Baroque. With the facade of
S Susanna (1603; illus. p. 24), he
perfected the new sculptural and
dynamic architectural language
that had its roots in Il Gesù. In
1603 Maderno was appointed
chief architect of St Peter's and

tasked to place a nave, portico,
and facade in front of the
central edifice of St Peter's
Basilica, which had already been
started. This meant he was in
competition with Michelange-
lo's plans. The facade was built
between 1607 and 1612, power-
fully structured through a colos-
sal order, with the balcony for
papal benedictions at its center.

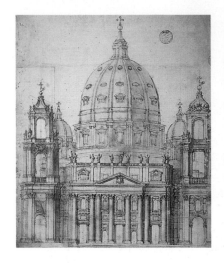

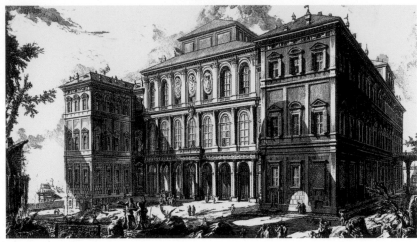

## Gianlorenzo Bernini

"You are made for Rome, and Rome is made for you"—Maffeo Barberini, later Pope Urban VIII, is said to have spoken these prophetic words to the young Bernini. Indeed, this artist, born in 1598 in Naples, spent almost his entire life in Rome, where he created his strongly molded architectural masterworks, most of them commissioned by popes. The son of a sculptor, he came to the Tiber in 1605/1606 and first entered service with the Borghese family. Only once did he leave the city for any length of time: to devise plans for Louis XIV for the rebuilding of the Louvre (see p. 78).

Bernini's career as an architect began with the pontificate of Urban VIII, who entrusted the artist, still inexperienced in the architectural field, with alterations to S Bibiana. In 1629, after Maderno's death, Bernini took over as chief architect of St Peter's Basilica, newly consecrated in 1626, as well as continuing the Palazzo Barberini with its unusual H-shaped de-

sign (illus. above). He was aided by Francesco Borromini, Maderno's pupil, in both projects.

His tasks at St Peter's included the interior decoration of the building, the ciborium over the high altar, the associated re-designing of the crossing, and finally, the design of the Cathedra Petri and the tombs of Urban VIII and Alexander VII. The biggest architectural challenge for Bernini, however, was the creation of a suitably dignified forecourt and the integration of St Peter's into the Borgo (district). The discrepancy in proportion between the width of Maderno's facade and the height of Michelangelo's dome presented an almost insoluble problem. At first, Bernini ordered work to continue on the side towers, begun by Maderno, but following his own plans. When the southern tower threatened to collapse, the work was stopped and Bernini fell out of favor. The design shown here (illus. above left) shows a new plan from 1645/1646 that was never realized.

It was not until 1656, under Alexander VII, that Bernini was able to begin with the design of St Peter's Square. Despite the constraints imposed on him— the obelisk moved there by Domenico Fontana was to remain, the view of the church and the papal balcony was to remain unobscured—Bernini found a brilliant solution. After several preliminary plans (illus. p. 27 below), he devised a double open area that rises up theatrically. It encourages people to linger while channeling their gaze toward St Peter's itself. The lower, oval-shaped *piazza obliqua*, which is open to the Borgo, receives the crowds of the faithful; a quadrangle colonnade of Doric columns encircles the space in an expansive gesture that represents the open arms of the Church (illus. p. 27). Toward St Peter's, the terrain inclines upward; here, the plaza narrows to form the trapezoidal *piazza retta*, behind which Maderno's facade towers up like scenery on a stage. The effect culminates in

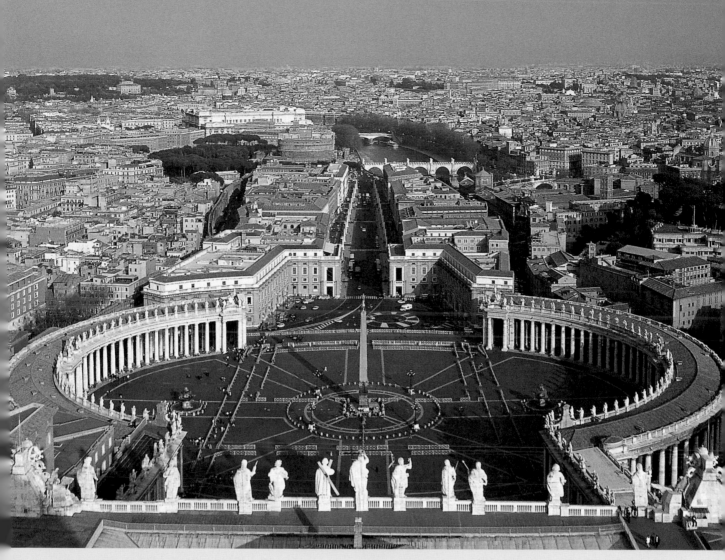

Gianlorenzo Bernini, Rome, St Peter's
Square, 1656–1671 (above); design of
the third wing, engraving by
Giovanni Battista Falda, 1667 (right)

P. 26 left: Gianlorenzo Bernini, design
of the facade of St Peter's Basilica
with flanking turrets, 1645/ 1646,
graphite, quill and black chalk, 57.5 x
43.4 cm/22.5 x 17 in, Rome, Biblioteca
Apostolica Vaticana, vat. lat. 13442, f.4

P. 26 right: Carlo Maderno (design),
Gianlorenzo Bernini and Francesco
Borromini (execution), Rome, Palazzo
Barberini, 1626–1629; engraving by
Giovanni Battista Piranesi

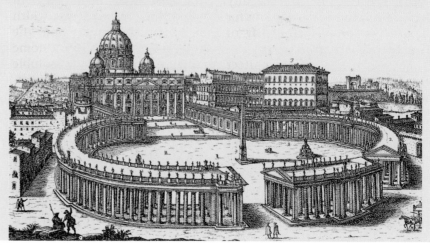

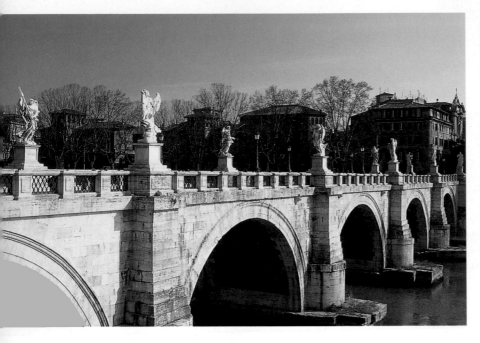

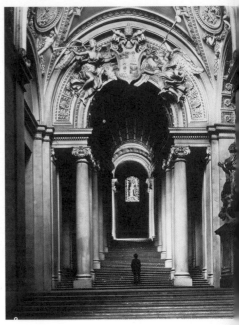

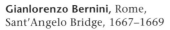

**Gianlorenzo Bernini,** Rome,
Sant'Angelo Bridge, 1667–1669

**Gianlorenzo Bernini,** Rome, Vatican
Palace, Scala Regia, 1663–1666

the balcony, from which the pope gives his benediction to both the city and the world, *urbi et orbi.*

The Scala Regia (1663–1666), the ceremonial steps down which the pope was carried from the Vatican Palace into St Peter's Basilica, forms a special "backdrop" (illus. above right). Here, too, Bernini had to struggle against difficult restrictions, and again he hit upon an impressive solution. He placed a vaulted colonnade in the shaft-like passageway. It provides a magnificent background for the pope's procession, while at the same time concealing the converging walls behind. The nobility of the architecture combines with the effect of the lighting to give the space its solemn splendor.

In the years around 1660, Bernini was commissioned to build three churches. The most important of these was the noviatiate church of the Jesuits in Rome, S Andrea al Quirinale (started in 1658). Again, he used an oval as the chief element of the ground plan. The eye-catcher is the theatrically designed chancel at the end of the short nave, enclosed in an aedicule through whose broken pediment the patron saint seems to ascend toward heaven (illus. p. 29). The sculpture corresponds to the altarpiece showing scenes of martyrdom, and to the dramatically lighted dome, which suggests the heavenly sphere of salvation. The facade facing the street is also designed on a spacious scale: A baldachin on two Ionic col-

umns protrudes well beyond the front of the church, while two concave walls form an imaginary forecourt (illus. p. 29 top right).

Bernini's most important secular building, the Palazzo Chigi-Odescalchi, dates from 1664/1665: The harmonious structuring of its facade broke new ground in Baroque palace architecture. The conversion of the Roman Pons Aelius into the Baroque Sant'Angelo Bridge occurred during the pontificate of Clement IX (1667–1669); the bridge was redesigned as a Way of the Cross to St Peter's (illus. above left). Ten angels sculpted by Bernini and his workers present the instruments of Christ's Passion; their facial expressions are marked by compassion with His suffering.

**Gianlorenzo Bernini,**
Rome, S Andrea al Quirinale,
1658–1661, church front
with semicircular porticus,
above which the coat-of-
arms of the patron Camillo
Pamphili is shown (above);
view of the facade of the
altar area (below)

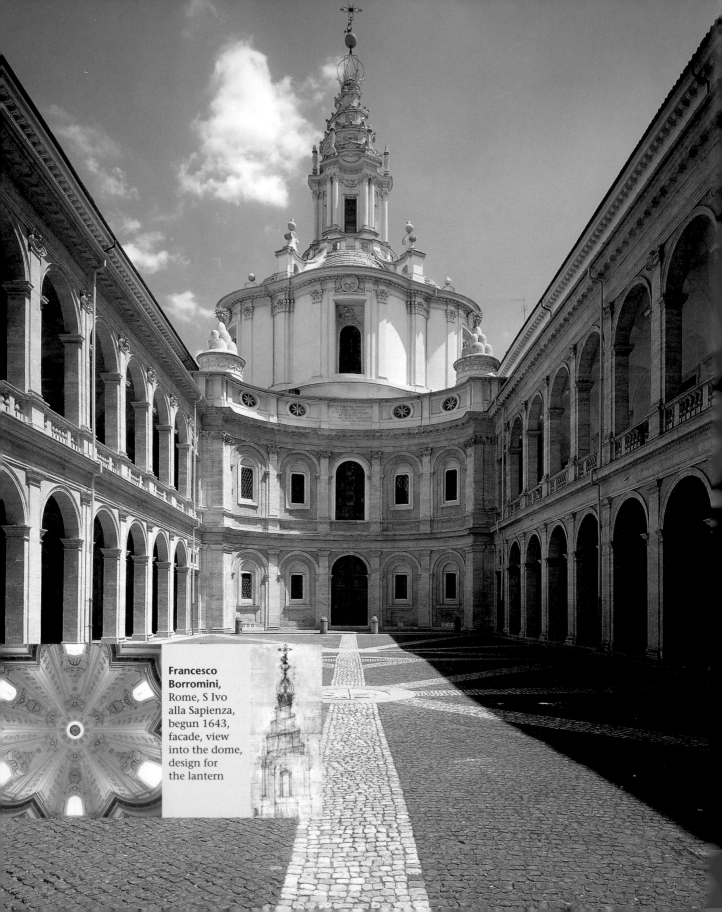

**Francesco
Borromini,**
Rome, S Ivo
alla Sapienza,
begun 1643,
facade, view
into the dome,
design for
the lantern

# Francesco Borromini

Eccentric or visionary, the destroyer of architecture or its salvation—opinion is divided on Francesco Castelli, known as Francesco Borromini. It is certainly true that this architect, born in 1599 into a family of stonemasons in Bissone on Lake Lugano, broke with many conventions. The dynamic energy of his ingenious constructions, his inclusion of Gothic and Mannerist elements, and, above all, his rejection of classical rules made him somewhat of an outsider in the world of art. He died in Rome in 1667, probably by his own hand.

Borromini came to Rome at the age of 20, where he worked as a stonemason at St Peter's. His unusual talent as a draftsman caught the eye of Maderno, who asked him to help with his commissions. Borromini is on record as having assisted with the altar in the crossing of St Peter's in 1623 and the planning of the Palazzo Barberini from 1625. He appears to have made a considerable contribution to both of these works. When, after Maderno's death, Bernini took over the supervision of the papal projects in 1629, a life-long rivalry arose between him and Borromini. This conflict between creative craftsmanship and courtly invention became the embodiment of the divergent artistic trends in Baroque Rome.

Borromini ceased his collaboration with Bernini in 1632. However, he immediately found new patrons who allowed him to realize his own conceptions.

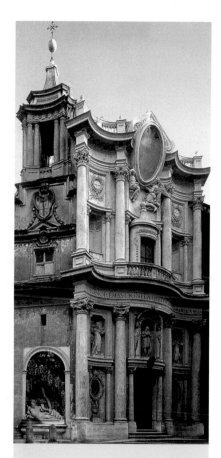

**Francesco Borromini**, Rome, S Carlo alle Quattro Fontane, 1638–1641, detail of the facade, 1665–1667 (above); view into the dome (below)

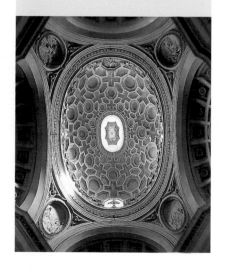

In the same year, he was appointed architect of the Roman University, for which he designed the spectacular church of S Ivo alla Sapienza. Before this, however, he created his first masterwork: the church of S Carlo (S Carlino) alle Quattro Fontane (started 1638), for the Discalced Trinitarians. This admittedly "modest" building, situated within the confined space of a monastery, was a unique artistic challenge, to which Borromini responded with a high degree of creativity. He conceived a space that was both ingenious and confusing, one that "moved" architecture in the truest sense of the word. Built on an ellipsoidal ground plan, its elevation is dominated by the axes of two isosceles triangles, which are emphasized by monumental columns. The complicated spatial structure is surmounted by an oval dome (illus. left). In S Carlo, illusion, the imaginary, begins to overcome the visible construction. Borromini was not able to build the facade until 1665–1667. With its curved form (concave – convex – concave), it represents another pivotal work of Baroque architecture (illus. above).

In the university church of S Ivo alla Sapienza (begun 1643), Borromini was able to heighten still further the plasticity and emotional effect of his architecture. Its facade, set in the narrow courtyard designed by Giacomo della Porta, is built in the shape of an exedra. The actual domed building rises up behind it in an opposite curve, crowned by a spiral-shaped lan-

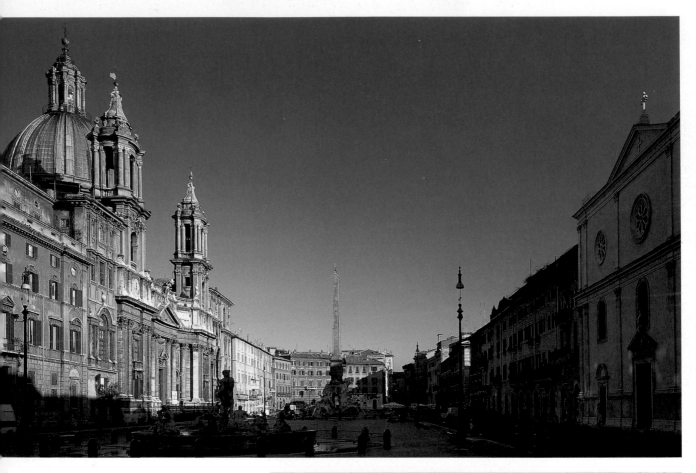

**Rome, Piazza Navona**

Right: **Francesco Borromini**, Rome,
S Giovanni in Laterano, interior,
1646–1649

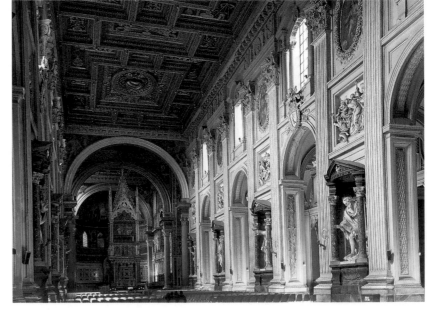

tern (illus. p. 30). Inside, the
central space opens up into ap-
ses, niches, and balconies, leav-
ing relatively few wall surfaces.
Its contours seem to breathe,
expand, and contract. The clever
geometric system underlying
this oscillatory effect is barely
noticeable. Even Borromini's
contemporaries had difficulties
with the "readability" of this
building; they kept looking for
new iconographic and heraldic
interpretations of the ground

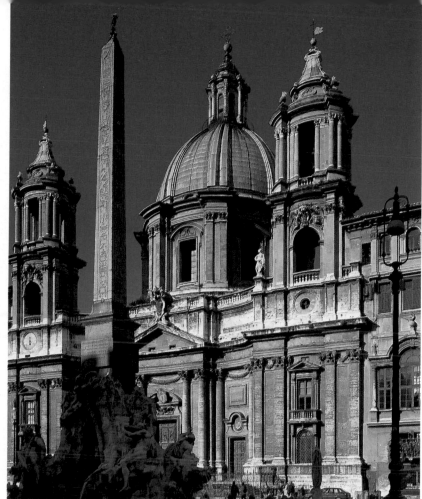

**Francesco Borromini,** Rome, S Andrea delle Fratte, bell tower, 1653–1656

**Francesco Borromini and Carlo Rainaldi,** Rome, S Agnese, facade, 1653–1657 (completed in 1666)

plan or the unconventional lantern, for example, which was seen as symbolizing the Tower of Babel.

It thus seems almost surprising that Pope Innocent X preferred Borromini to Bernini, and entrusted him with the most important commissions awarded during his pontificate. These included first and foremost the reconstruction of the nave in the Constantinian Lateran Basilica for the jubilee year 1650. Borromini solved the difficult task of preserving the Early Christian structure, while at the same time radically modernizing the interior by reducing the number of arcades from the original 14 to five, framing them with colossal pilasters. He broke up and structured the wall surfaces in between by means of niches, reliefs, and large windows (1646–1649; illus. p. 32 below). The barrel vaulting that was intended to cover the flat wooden ceiling was never installed.

From 1653, Borromini supervised work on S Agnese in Piazza Navona, the church belonging to the pope's family palace (illus. above). There were violent quarrels about the design, and Borromini was forced to leave his post after four years. Nonetheless, he was largely able to complete the interior and the generously curved facade with two towers that provides the plaza with such a picturesque backdrop. Among his later works, the dome and bell tower of S Andrea delle Fratte (1653–1656) are worthy of mention; in these, too, Borromini's unorthodox style is clearly visible (illus. above left).

## Pietro da Cortona

Pietro da Cortona, an outstanding painter, draftsman, and stage designer, was born in 1597 as Pietro Berrettini. He saw architecture as a hobby, and completed only a few buildings; however, these came to be considered among the epitomes of Baroque design.

Even his first architectural work, the Villa del Pigneto for Cardinal Giulio Sacchetti (begun 1626), is seen as a milestone in villa architecture because of its structural plasticity. Cortona's architecture came to be characterized by dynamism and an effective balance of mass and space, features that are convincingly demonstrated in his sacred buildings. In 1635, the master, who had now risen to become the *principe* of the Accademia di S Luca, took over the alterations to the church belonging to that renowned art academy. When the mortal remains of St Martina were found during the work, it was decided to erect a splendid new building. Cortona designed a central-plan building on a Greek cross with a heavily molded, animated interior. The wall is broken up by the interplay of columns and pilasters; white-and-gray reliefs articulate the remaining wall surfaces and vaulting (illus. p. 35). The facade is built in a convex curve—the first of its kind—between the double pilasters on each side.

The front of S Maria della Pace (1656–1657) projects far out into its urban setting. Its ground floor is designed as a semi-circular portico whose flow

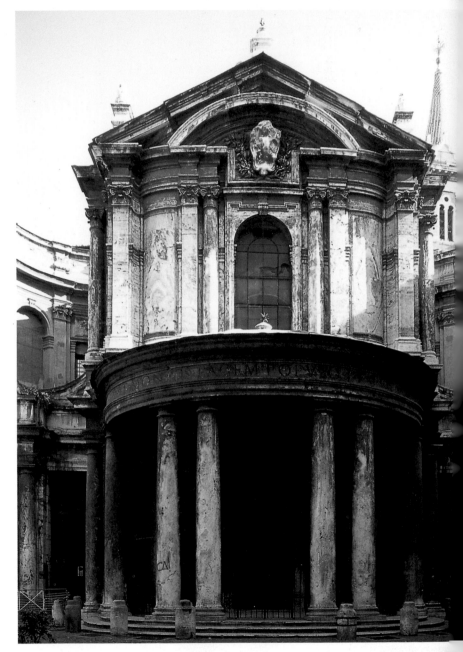

**Pietro da Cortona,** Rome, S Maria della Pace, facade, 1656–1657

is taken up by two concave wing elements. The church and its surroundings are shaped according to a compelling concept; they form an urbanistic gem (illus. above). The classical, elegant dome of S Carlo al Corso (begun 1668), which dominates the silhouette of Rome, is one of Cortona's last masterpieces.

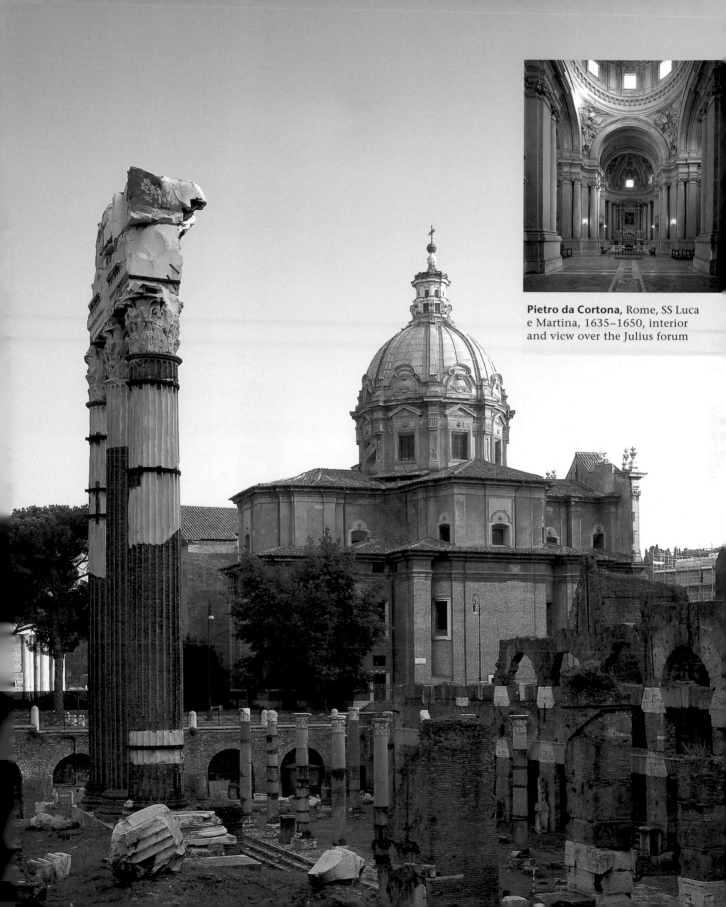

**Pietro da Cortona,** Rome, SS Luca e Martina, 1635–1650, interior and view over the Julius forum

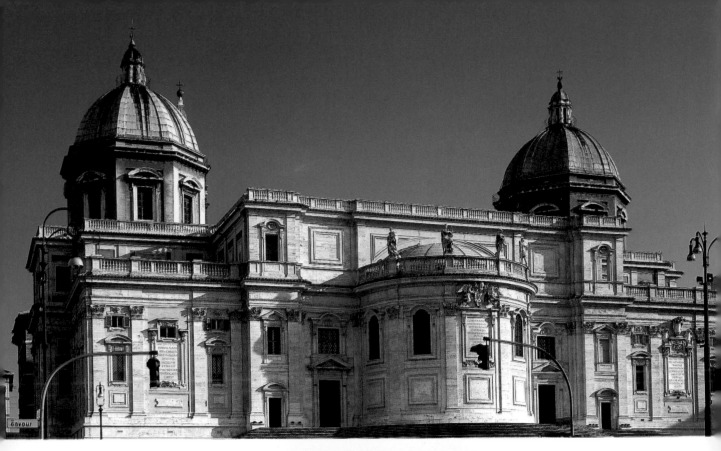

Carlo Rainaldi, Rome, S Maria
Maggiore, apse, 1673

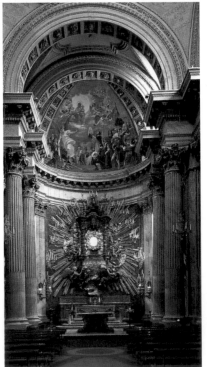

Carlo Rainaldi, Rome, S Maria in
Campitelli, interior, 1663–1667

## Carlo Rainaldi

Alongside Bernini, Borromini
and da Cortona, Carlo Rainaldi
(1611–1691) deserves recognition
for his decisive influence on the
appearance of Baroque Rome.
He started off as an architect in
S Agnese on Piazza Navona as a
pupil of his father, until Borro-
mini took over in 1653. In the
years that followed, Pope Alex-
ander VII entrusted Rainaldi
with three important commis-
sions: the design and construc-
tion of the church of S Maria in
Campitelli (1655–1667), the fa-
cade of the Theatine church of
S Andrea della Valle (1661–1665),
and the twin churches on the
Piazza del Popolo (begun 1661).

For S Maria in Campitelli, Rai-
naldi, after first considering an
oval ground plan, decided to use
one based on two staggered
Greek crosses. His design for the
interior is even bolder. The space
is dominated by the longitudi-
nal axis, while freestanding col-
umns lead the gaze toward the
spectacular chancel (illus. left).
The Piazza del Popolo, a point
of convergence for three main
traffic axes, also became a scen-
ographic masterpiece. The two
domed churches flank the square
like scenic backdrops. In 1673,
Rainaldi completed the apse of
S Maria Maggiore (illus. above;
begun under Clement IX, fin-
ished under Clement X).

## Carlo Fontana

Unlike the generation preceding him, Carlo Fontana (1635–1714) did not produce any strokes of artistic genius. As the head of the Academy of St Luke and forerunner of neoclassicism, he set an example of a versatile type of high-quality architecture. He had great influence on the architecture of the eighteenth century through his pupils, as well as his writings and designs, which circulated throughout Europe.

Fontana made a name for himself as a pupil and assistant of Cortona, Rainaldi, and Bernini. In 1666 he was appointed architect of the Camera Apostolica and soon gained an excellent reputation. The facade of S Marcello al Corso (1682–1683) is an outstanding example of his early commissioned works; it blends Borrominesque energy with classical balance and architectural logic (illus. above). He lined the Cappella Cibo in S Maria del Popolo (1683–1687) with polychrome marble in a revival of Mannerist traditions. From 1686 he was *principe* of the Academy of St Luke.

Pope Innocent XII commissioned Fontana to continue work on the Palazzo Montecitorio, which Bernini had begun. Many other commissions followed, both in Italy and abroad. His book *Templum Vaticanum et ipsius origo* was published in 1694, a complex architectural history of St Peter's to which he added his own projects. These include the design for a *via triumphalis* to Sant'Angelo Bridge and for a Christian church into the Colosseum (illus. right).

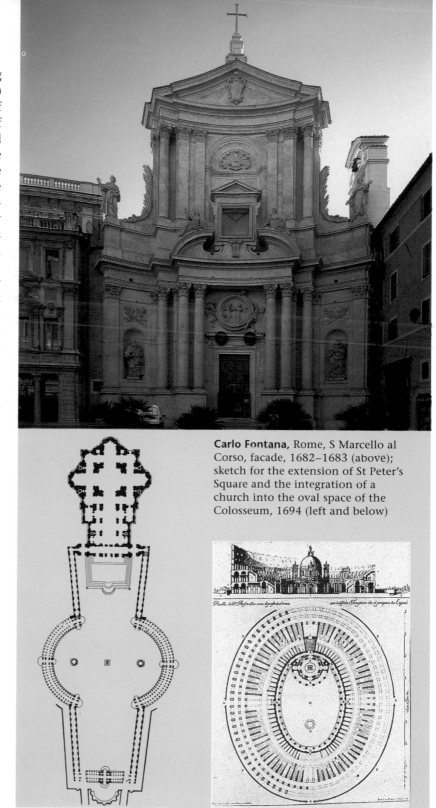

**Carlo Fontana**, Rome, S Marcello al Corso, facade, 1682–1683 (above); sketch for the extension of St Peter's Square and the integration of a church into the oval space of the Colosseum, 1694 (left and below)

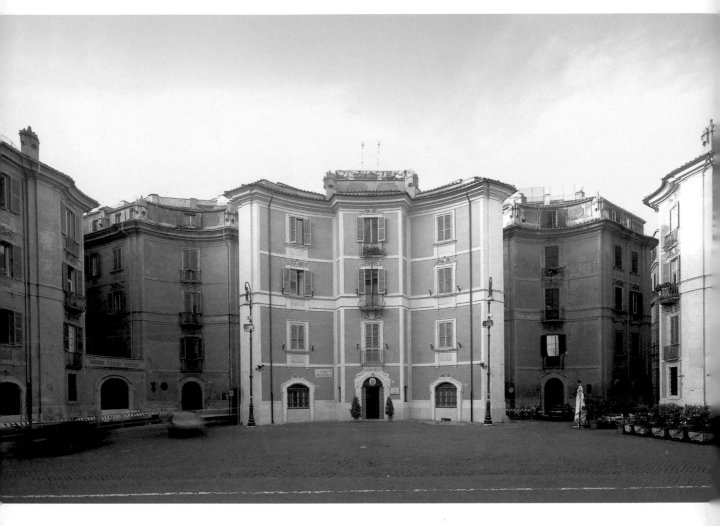

**Filippo Raguzzini,** Rome, Piazza S Ignazio, 1726–1728

P. 39: **Alessandro Specchi and Francesco de Sanctis,** Rome, the Spanish Steps, 1723–1726, in the foreground the Fontana della Barcaccia by Gianlorenzo Bernini

## The City as Stage

In an epoch in which life was seen as a play, town planning also followed the rules of theatrical presentation. Although Rome had already been given a dignified appearance in the sixteenth and early seventeenth centuries with sweeping avenues, fountains, and obelisks, the magnificent ensembles of the Piazza Navona (illus. p. 32), St Peter's Square (illus. p. 21), and the Piazza del Popolo (see p. 20) were only finalized in the mid-seventeenth century. Late Baroque and *barocchetto*, the Roman version of Rococo, tended toward more intimate, serene scenarios. Examples of this are the Porto de Ripetta, the harbor on the Tiber that was destroyed in the nineteenth century, and above all, the Spanish Steps (1723–1726), realized according to Francesco de Sanctis' graceful plan (illus. p. 39 top). From below, three sections sweep upward toward the backdrop formed by the facade of the Trinità dei Monti (illus. p. 39). Filippo Raguzzini's Piazza S Ignazio, with its scenographically staggered facades, is less spectacular, but of equal architectural significance (1726–1728; illus. above).

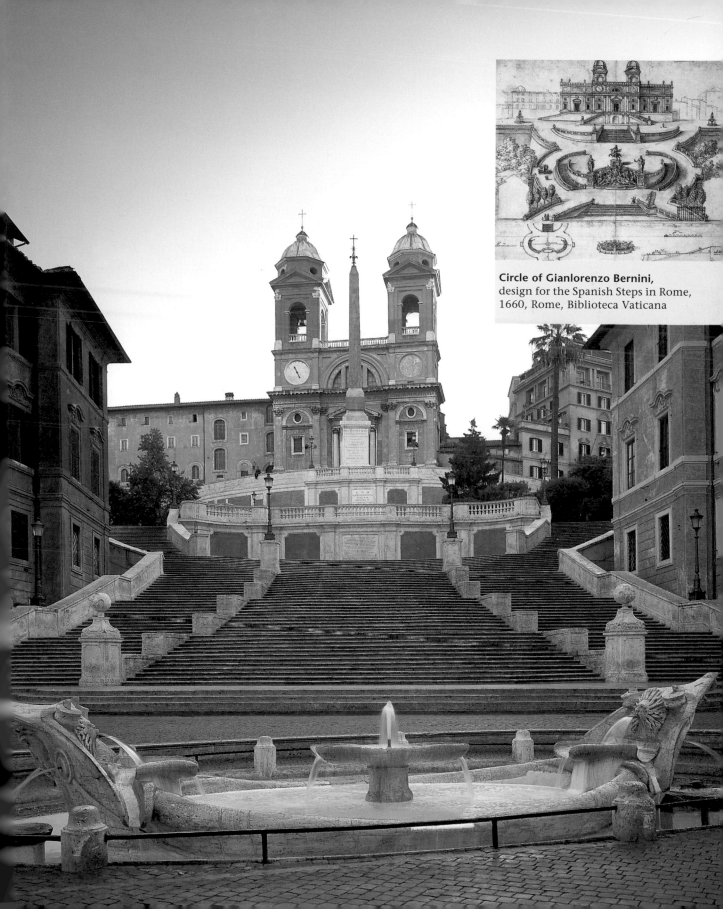

**Circle of Gianlorenzo Bernini,** design for the Spanish Steps in Rome, 1660, Rome, Biblioteca Vaticana

**Nicola Salvi,** Rome, Trevi Fountain with the facade of the Palazzo Poli, 1732–1762, full view and details

P. 41: **Alessandro Galilei,** Rome, S Giovanni in Laterano, facade, 1732–1735

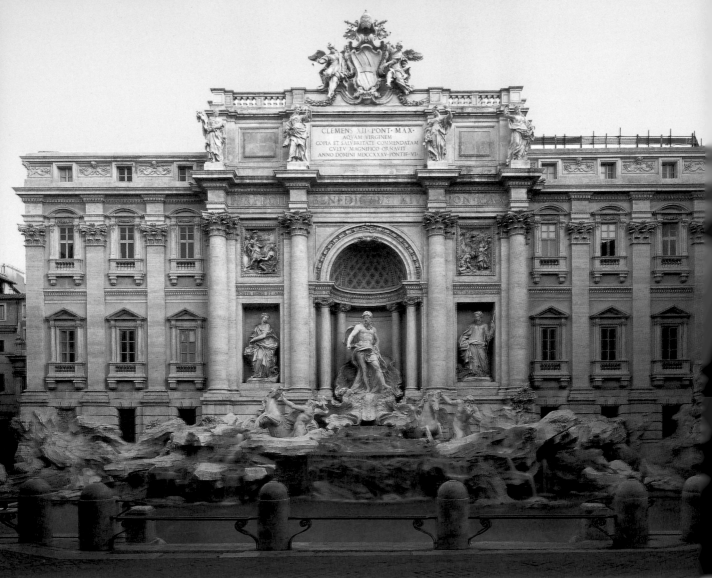

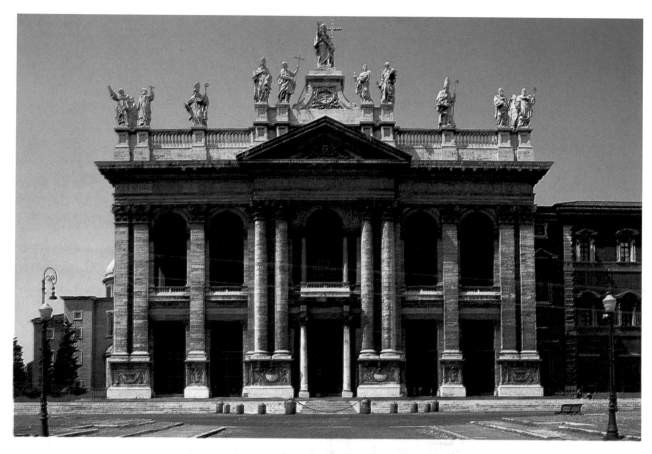

## Rome in the Eighteenth Century

At the start of the eighteenth century, Roman architecture went through a paradigmatic change. Patrons and artists were no longer drawn to the elevated Baroque of a Bernini or Borromini, but to a sober classicism that had long been dominant in England and France. Carlo Fontana was the first to take up the new ideas, mainly influencing villa architecture. The backdrop of the Trevi Fountain, designed in the style of a triumphal arch, demonstrates the new rationality and clarity, despite all its Rococo-like detail. It is the work of Nicola Salvi. This Roman architect pro-duced the sensational design combining the fountain and palace facade (Palazzo Poli) in 1732 (illus. p. 40). The decisive turn to classicism only occurred, however, when two important church projects propagated the new/old style. The competition for the design of the facade for St John Lateran (1730–1732) has gone down in the annals of architectural history not only because of the intrigues it engendered, but because the decision in favor of the classically influenced design by Alessandro Galilei represented the official rejection of High Baroque and *barocchetto*. Colossal columns and pilasters give structure to the serene, two-storied facade and frame the deep, shaded, arched openings (illus. above). Double columns and a triangular pediment mark the central axis with its balcony for benedictions.

Ferdinando Fuga built the facade of S Maria Maggiore from 1741 to 1743. Like St John, this church is one of Rome's four patriarchal basilicas. It is instructive to see how differently he approached the same task with the same stylistic means. Fuga does without the colossal order, instead emphasizing the independence of the stories, which are structured using different pediments or varied openings in the wall.

41

# Naples and Southern Italy

Until 1713, the twin kingdoms of Naples and Sicily were under the control of the Spanish crown; after that, the Austrians, Savoys, and finally the Spanish Bourbons ruled the fate of Southern Italy.

Naples, which for centuries was the seat of the viceroys, prided itself on its big-city character. Even today, Baroque and Rococo strongly influence its appearance, and the facades of its churches and palaces are adorned with stucco, marble, and colorful majolica. In the seventeenth cen-tury, the Berniniesque architec-ture of Cosimo Fanzago domin-ated the face of the city (illus. below), while in the first half of the eighteenth century the picturesque flights of stairs built by Ferdinando Sanfelice cre-ated theatrical scenarios. Finally, around 1750, the strictly classi-cizing architects Luigi Vanvitelli and Ferdinando Fuga, both trained in Rome, gained the ascendancy. The buildings that gave Naples the reputation of being an enlightened city are mainly the work of Fuga. Other centers of Baroque architecture include Lecce in Apulia, with its extravagant facades, and espe-cially southeastern Sicily, where unique architectural ensembles have been preserved in Noto, Modica, and Ragusa Ibla.

## Luigi Vanvitelli

Vanvitelli was born in Naples in 1700, the son of the Dutch veduta painter Gaspar van Wit-tel. After studying with his father, he went to Rome where, in 1725, he turned to archi-tecture. After numerous com-missions throughout Italy, he returned to Naples in 1751, where he took over the task of building the Reggia in Caserta, the residence of the Bourbon kings of Naples. With its 1,200 rooms and an area of 208 x 165 meters (641 x 508 ft), the palace was intended to rival or even surpass Versailles.

Vanvitelli fulfilled Charles of Bourbon's high expectations. He devised a structure whose ground plan is related to that of the Escorial in Spain: four wings form a cross within a rectangle, enclosing four courtyards around which are grouped the suites of rooms. The intersections are splendidly designed pieces of architecture, such as the oct-agonal vestibule in the center of the complex, which opens into a staircase with three ramps (illus. p. 43 below). The outer facades have a rather functional appearance in com-parison; their projections indi-cate the structure of the build-ing (illus. p. 43 above). Behind the palace, a two-mile-long avenue slopes upward to the large waterfall that serves as a distant backdrop.

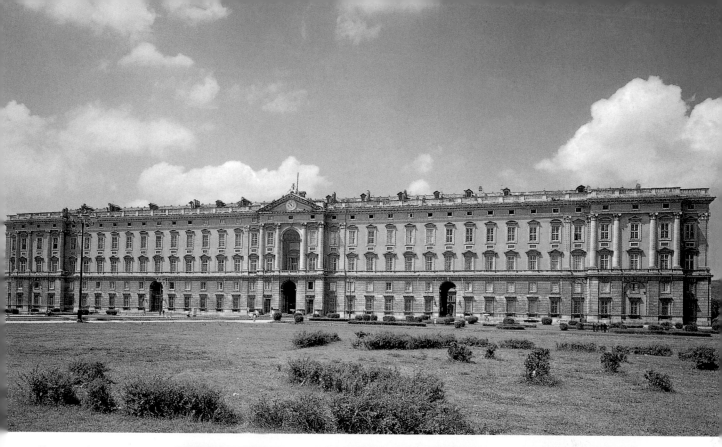

Above and right:
**Luigi Vanvitelli,**
Caserta, La
Reggia, begun
1751, facade and
staircase (right)

P. 42:
**Cosimo Fanzago,**
Naples, S Maria
Egiziaca, begun
1651, facade

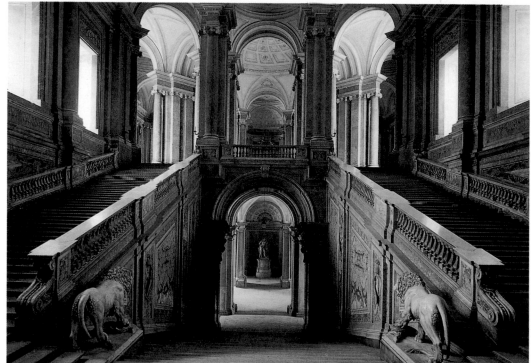

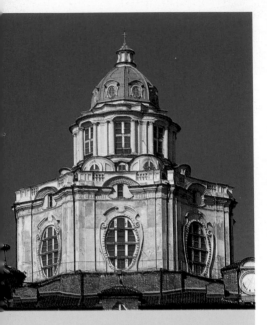

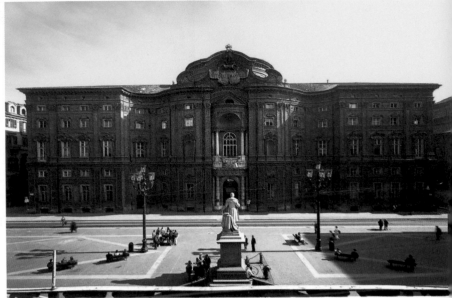

Guarino Guarini, Turin, S Lorenzo, 1668–1687, dome (above), interior view (below)

Above right:
Guarino Guarini, Turin, Palazzo Carignano, 1679–1681

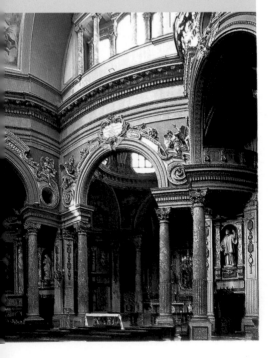

# Turin and Piedmont

Turin, the capital of the Duchy of Savoy, and the residence of the kings of Sardinia-Piedmont from 1720, was one of the few centers besides Rome able to contribute significantly to the architecture of the Baroque era.

In the late sixteenth century, the regularity of the city expansion carried out by Ascanio Vitozzi had already become a talking point. It was continued in the seventeenth century by his successors Carlo and Amadeo di Castellamonte. These created a homogeneous city structure that united palatial, sacred, and secular architecture. Turin became one of the most modern cities in Europe.

## Guarino Guarini

The Theatine monk Guarino Guarini from Modena (1624–1683) was famous as a philosopher and mathematician before he turned his attention to architecture. His buildings, and above all his dome constructions, can barely be explained without this background. Nonetheless, Guarini was anything but a cold rationalist. His pulsating and dynamic spatial conceptions made him a worthy heir to Borromini.

Before Guarini came to live in Turin in 1666, his extensive travels had taken him to Rome, Messina, and Paris; his designs circulated throughout Europe and influenced architecture from Lisbon to Prague. However, his masterworks have been preserved almost solely in Piedmont. As court architect to the Duke of Savoy, he worked on completing the Chapel of the Holy Shroud (S Sindone) next to Turin cathedral from 1668, creating one of the "most mysterious and profoundly stirring spaces" of all time (illus. p. 45 top and right). The irrational character of this reliquary

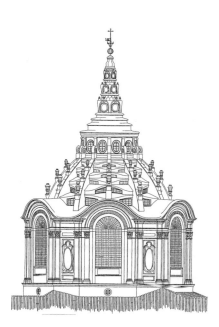

**Guarino Guarini,** Turin, Chapel of the Holy Shroud (Cappella della Santissima Sindone), 1668–1694; sketch of the exterior of the dome (above); view into the dome (right)

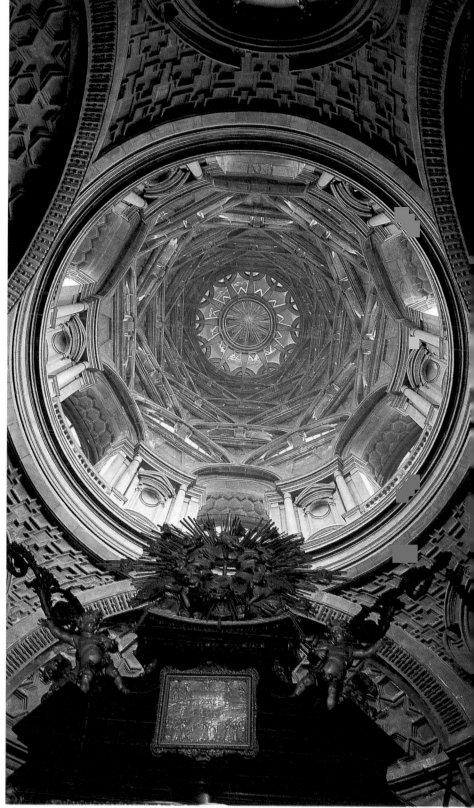

chapel is produced by more than the black marble lining of the walls. The extraordinary interior of the dome, consisting of 36 interwoven segment arches, also has an extremely evocative effect. More or less at the same time (1668–1687), Guarini was also working on the church of S Lorenzo (illus. p. 44 left), a central-plan building with a dome of soaring arches. The artist possibly borrowed the principle of the picturesquely intersecting ribs from Moorish architecture. Among Guarini's secular buildings, the Palazzo Carignano, is also worthy of mention, with its center dominated by an oval salon (1679–1681; illus. p. 44 top right).

## Filippo Juvarra

Filippo Juvarra (1678–1736), a gifted artist and draftsman, entered the service of Victor Amadeus II of Savoy in 1714. In the 21 years during which he worked for the Piedmontese court, he was to give the region and its capital a new profile—and relegate Rome to the role of a spectator.

Juvarra was born in Messina. As a young artist, he studied with Carlo Fontana, winning the first prize of the Academy with a "palace for three people" as early as 1705. As a stage designer he achieved considerable fame, something which may have prompted Victor Amadeus II to appoint him royal architect. In this position, Juvarra built a large number of churches, palaces, and villas, decorated interiors, and even planned whole districts. His elegant, decorative style made him the most popular architect of the Late Baroque period, sought after by sovereigns throughout Europe. Juvarra died in Madrid in 1736 while working on the new royal palace (illus. p. 61 top).

One of his early works in Turin was also to become his most important. The votive church of La Superga, picturesquely situated on a 700-meter (2,156-ft)-high mountain top to the east of Turin (1717–1731; illus. opposite). This towering central-plan building, founded on the occasion of the lifting of the French siege in 1706, serves as the mausoleum of the Savoy family. Its cylindrical center is flanked by low wings with bell towers, and a classical portico projects far out in front. The elegant dome rises above the whole upon a high drum. Behind the picturesque facade, which is designed to be visible for a long distance, the adjoining buildings of the monastery play a clearly subordinate role. With the Superga, Juvarra took ideas from the Roman Baroque and moved them to a new setting—the natural landscape.

The Palazzo Madama, named after the person who commissioned it, the mother of Victor Amadeus II, is situated in the historic center of Turin. It was never completed, and still adjoins the late medieval fort. From 1718, Juvarra worked on plans for a large-scale restoration of the complex. The parts of this project that were realized are unusual despite, or perhaps because of, its fragmentary state. Behind the palace facade, whose giant order recalls Bernini's palace architecture, the visitor encounters only a magnificent, crosswise staircase covered by a massive barrel vault. This double staircase converges in the upper story, the architec-

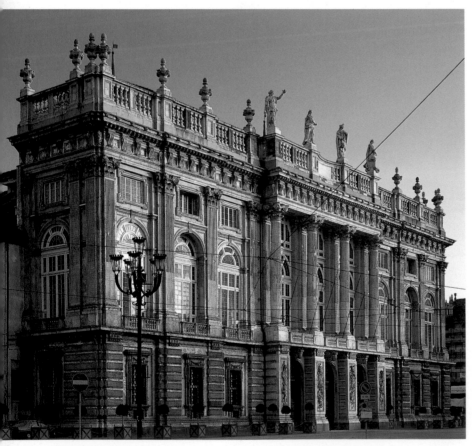

**Filippo Juvarra,** Turin, Palazzo Madama, 1718–1721

P. 47: **Filippo Juvarra,** Turin, La Superga, 1717–1731

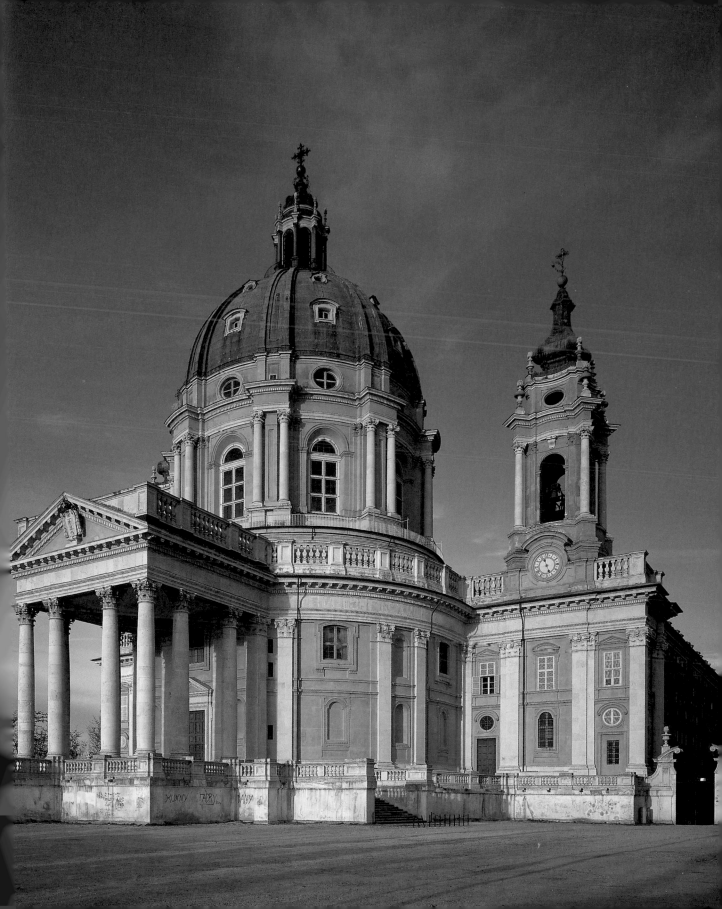

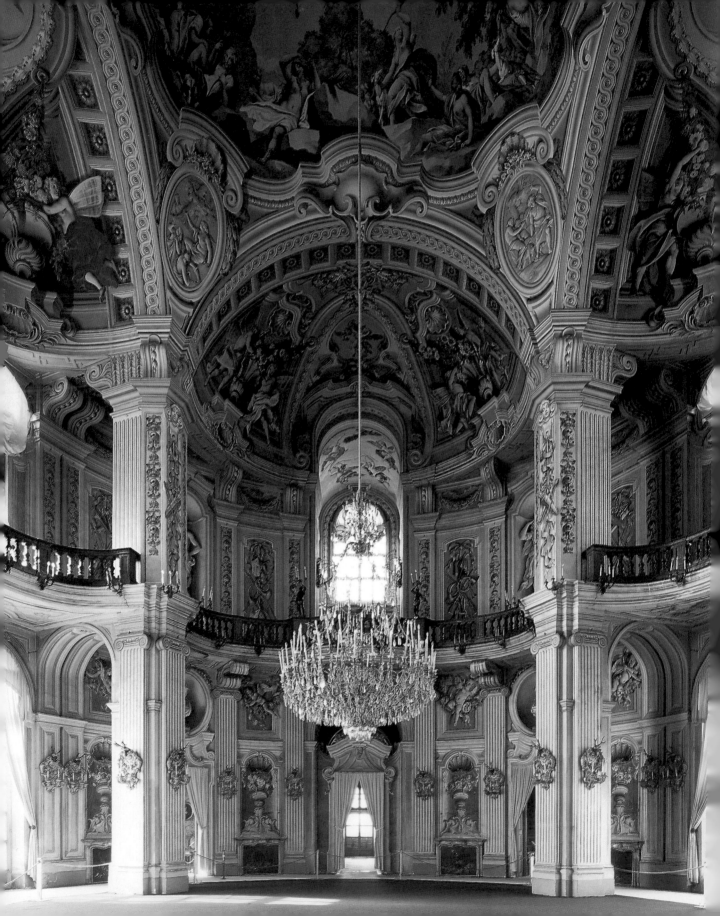

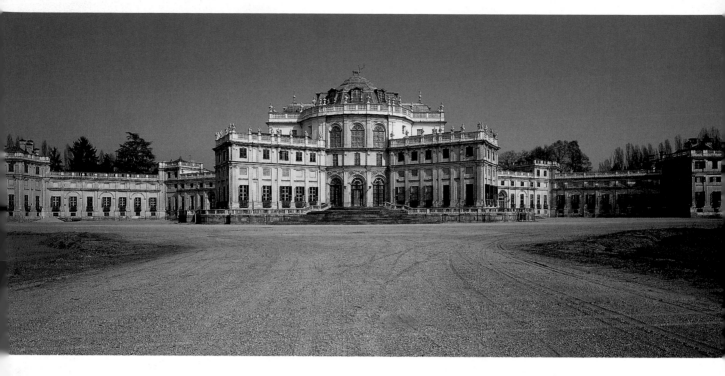

ture providing a theatrical backdrop for the ascent.

For the hunting lodges Venaria Reale (1714–1726) and Stupinigi (begun 1729), as well as for the summer residence of Rivoli (1718–1721), Juvarra came up with new conceptions that integrate elements of the landscape around. Even the ground plan of Stupinigi reaches far into its surroundings. The royal chambers are housed in wings that take the shape of a sprawling X. They culminate in a high, oval-shaped banquet hall, which is lavishly decorated with hunting scenes (illus. p. 48). An octagonal main courtyard fronts the scenic backdrop provided by the ensemble. The influence of the stage designer Juvarra is unmistakable, yet the complex is as practical as it is decorative: Stables and working quarters

are situated in the spandrels and at the edges of the main wing, emphasizing the residence's function as a hunting lodge. In addition to his architectural works, Juvarra left a large number of drawings, sketches, and designs.

P. 48 and above: **Filippo Juvarra,** Stupinigi Hunting Lodge, 1729–1733, exterior view (above), Great Hall (p. 48)

**Bernardo Vittone** (1705–1770) was overshadowed for a long time by his more famous colleagues Guarini and Juvarra; it is only during recent decades that the artistic quality of his œuvre has been adequately recognized. Vittone studied in Rome, but worked almost exclusively in the Piedmont, where he created many a vividly painted church interior. He dealt with theoretical issues and posthumously published Guarini's *Architettura civile*.

**Bernardo Vittone,** Bra, S Chiara, 1742, view of the dome

# Venice and the Veneto

The work of Andrea Palladio continued to dominate the architecture of Venice and the Veneto in the Baroque era. Palladio's classical, rational style of spatial composition and his setting-related designs were taken as models until well into the eighteenth century, and paved the way for the very quick acceptance of neoclassicism in Venice.

The Venice of the seventeenth and eighteenth centuries, shaken by crises, produced nothing in the way of important urban innovations—the plazas and the main axes were built mainly during the Renaissance—but there are some occasional features that give Venice a hint of Baroque. Some examples of this are the Palazzo Belloni-Battagia (c. 1650), Ca' Pesaro (1652–1710), and the Palazzo Bon-Rezzonico (begun 1666, illus. p. 52). Each of these buildings is connected with the name Baldassare Longhena, the single great Baroque architect of the city of Venice.

## Baldassare Longhena

Baldassare Longhena, who descended from a family of stonemasons, was born in Venice in 1598. His teacher was Vincenzo Scamozzi, a theoretician and pupil of Palladio. Scamozzi taught Longhena his master's principles. In 1630, Longhena won the competition for the design of the votive church of S Maria della Salute, to be built as the result of a vow made during a plague epidemic (illus. p. 51). His design combines a central octagon with an exedra-like sanctuary; both elements are crowned by massive domes. Outside, Longhena exploited the natural backdrop at the entrance to the Canal Grande, against which the various elements are thrown into dramatic relief by the sunlight. The facades of the octagon are vividly structured, while large, projecting volutes mediate between the octagon and the drum. The whole building is radiantly white. The staircase of S Giorgio Maggiore (1643–1645; illus. left), with its lavish marble inlaid work, is another important masterpiece of Baroque scenographic design.

Longhena made an important contribution to palace architecture, although he did not live to see the completion of his main works in this field. Ca' Pesaro, one of the largest and most extravagant private palaces in Venice, shows the same virtuosic treatment of mass and volume, the same ingenious play of light and shade, as S Maria della Salute (1652–1710; illus. p. 52 left). The columns of the upper stories surround the cubic building like a second spatial layer. The Palazzo Bon-Rezzonico, which Longhena began in 1666, also features the same highly effective facade design.

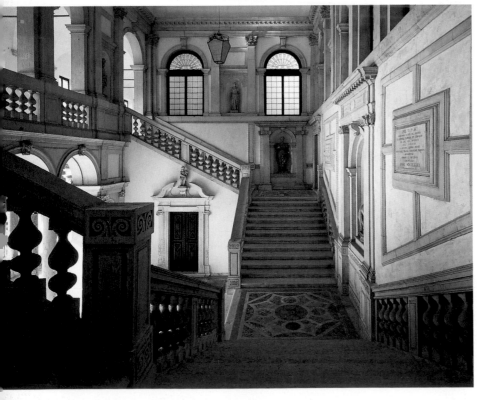

**Baldassare Longhena,** Venice, S Giorgio Maggiore; staircase, 1643–1645

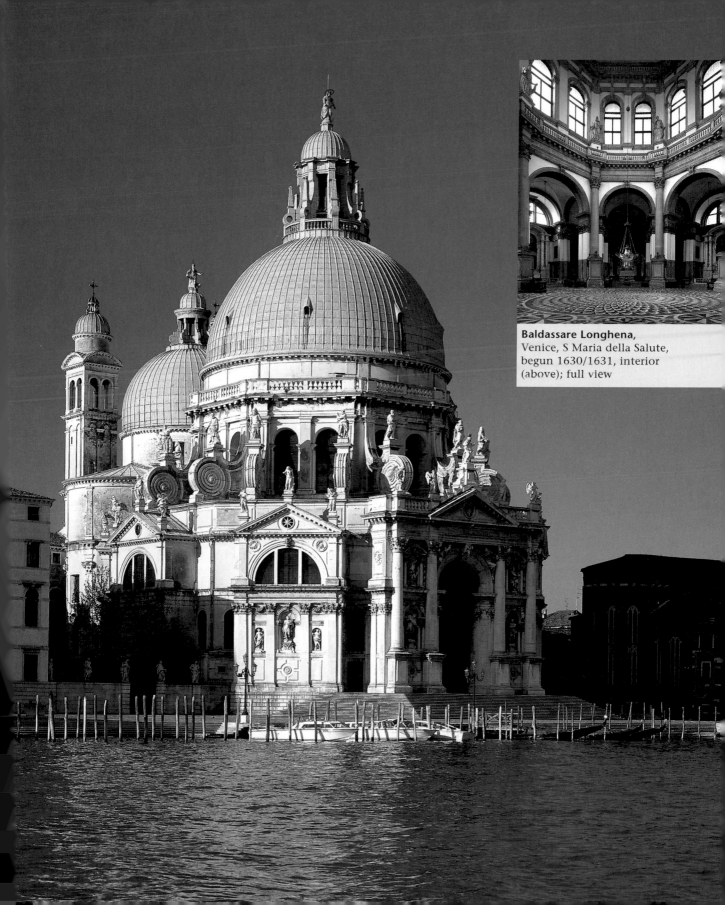

**Baldassare Longhena,**
Venice, S Maria della Salute,
begun 1630/1631, interior
(above); full view

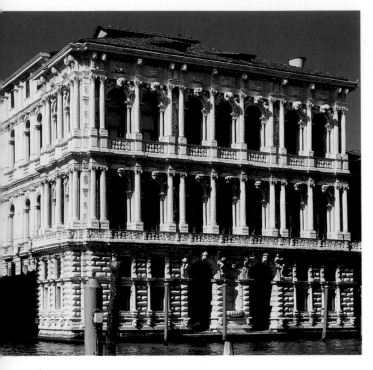

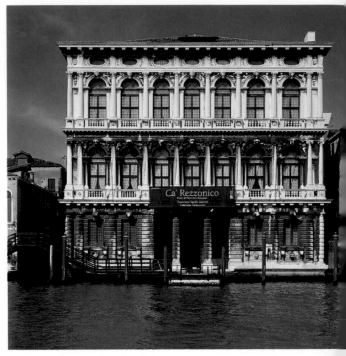

**Baldassare Longhena,** Venice,
Ca' Pesaro, 1652/1659–1710

**Baldassare Longhena and Giorgio
Massari,** Venice, Ca' Rezzonico,
begun 1666, expanded after 1745

P. 53: **Giorgio Massari,** Venice,
Ca' Rezzonico, ballroom, after 1745

## Giorgio Massari

Like Baldassare Longhena in the seventeenth century, Giorgio Massari (1687–1766) heavily influenced Venetian architecture in the eighteenth century. He built countless churches and palaces, and made important contributions to an equal number of projects, both in Venice and throughout the Veneto. His harmonious, classical style follows the tradition of Palladio and Longhena though he did not develop their powerful plasticity.

Little is known about Massari, who was the son of a furniture-maker. It is probable that he only turned to architecture late in life. He found his first patron in the rich merchant Paolo Tamagnin, who commissioned him to rebuild the church of S Giovanni in Bragora. From 1726 to 1736 he supervised the building of the new church of the "Gesuati," whose facade, with its massive Corinthian order, dominates the Canale di Giudecca. His works also include the unfinished hall church S Marcuola and the oval-shaped SS Pietà.

The most important of the palaces built or completed by Massari—it is a characteristic of Venice that its buildings develop over centuries—is the Palazzo Grassi. Before this, however, he made a name for himself with his alterations to Ca' Rezzonico (illus. above right). Begun by Longhena, the building attained its present-day appearance under his supervision. The interior was altered to meet the social needs of the eighteenth century: for example, Massari opened up the upper story to become a well-lit ballroom (illus. p. 53).

The Palazzo Grassi is the largest, and historically seen, the most recent aristocratic palace on the Canal Grande. With its strongly structured facade, it deliberately follows the Venetian tradition. But a change seems to be in the air: the cool, elegant appearance of the building anticipates neoclassicism. Massari's patrons, the Bolognese Grassi family, did not enter the Venetian patriciate until 1718.

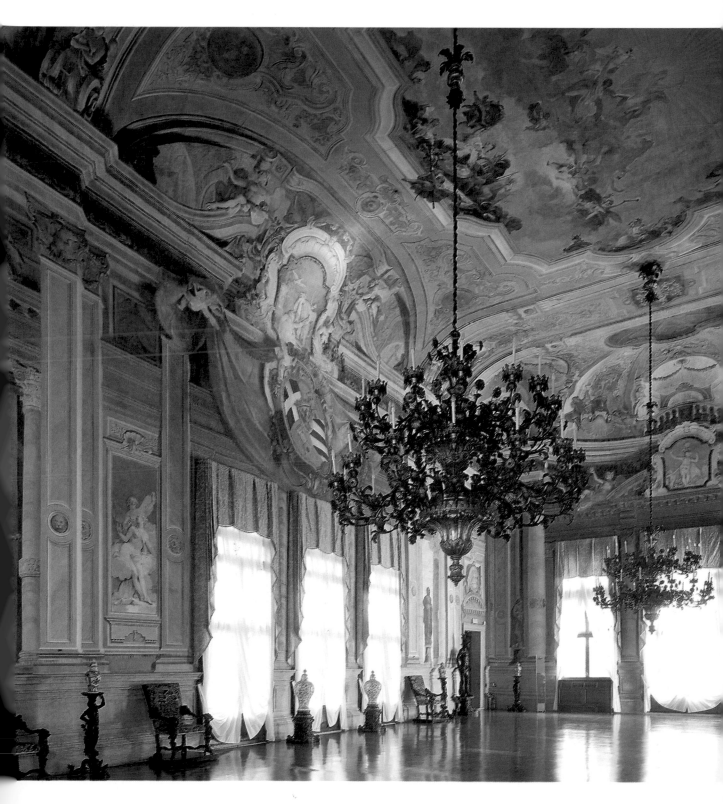

# Italian Baroque Villas

Even in Roman Antiquity, wealthy patricians were drawn from the city to the countryside. Starting in the 2nd century B.C., luxurious country residences began to spring up around the Bay of Naples, and from the Campagna to the slopes of the Rhine and Moselle rivers. These houses combined the pleasures of country life with an elevated lifestyle. At the time of the Roman Empire, the villa, a freestanding manor house in a garden or park setting, thus became a specialized and prestigious assignment for architects. The rediscovery of the classical world of Greece and Rome and of Vitruvius' writings led to a renaissance in villa architecture as well. Leon Battista Alberti and

Vincenzo Scamozzi provided the theoretical background, while Raphael, with the Villa Madama, and Andrea Palladio, with his villas in the Veneto, demonstrated the fusion of classical architecture and landscape. The Baroque era saw the villa become monumental, palatial. However, in contrast to the palace, which had to be constructed to meet the demands of strict courtly ceremony, the villa allowed a certain freedom of design.

One of the first buildings to follow this trend was the Villa Medici on the Pincio in Rome, begun in 1544 by Annibale Lippi. The central block, which opens out into porticoes, is accompanied by two high, protruding, tower-like wings. Villa Lante in Ba-

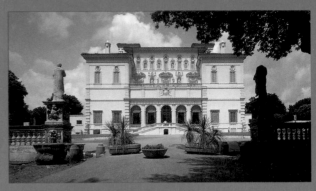

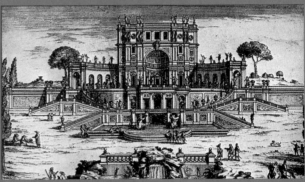

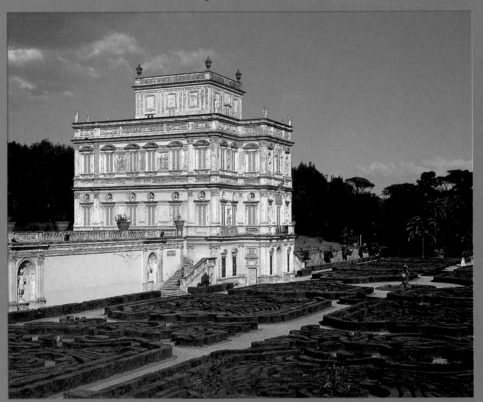

Top: **Giovanni Vasanzio,** Rome, Villa Borghese, 1613–1616

Above: **Pietro da Cortona,** Rome, Villa Sacchetti al Pigneto, 1625–1630, engraving by Ghezzi

Left: **Alessandro Algardi,** Rome, Villa Doria Pamphili, c. 1650

gnaia and Villa d'Este in Tivoli, both set in extensive gardens, also influenced the development of the Baroque villa style.

The Villa Borghese, built between 1613 and 1616 for the nephew of Pope Paul V, Cardinal Scipione Caffarelli Borghese, was based on the model of the Villa Medici. Situated in an expansive park crisscrossed by avenues, the "Casino" has the same block-like appearance, and, like the Villa Medici, is open to the

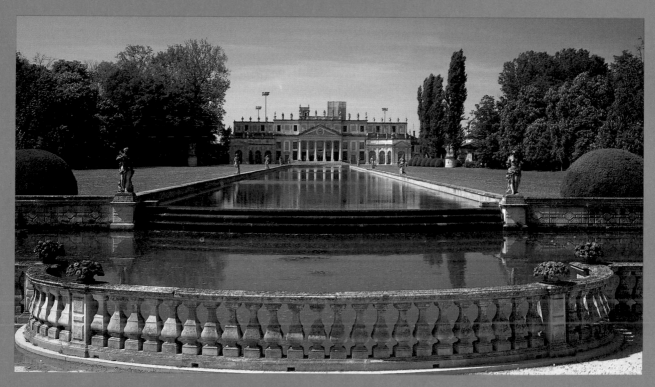

garden and flanked by massive, projecting wings (illus. p. 54 top). There are archaeological finds (some restored) set into the main facade, which rises up behind the wide terrace in the upper story. Scipio Borghese originally intended the building as a place to store his large collection of paintings and sculptures.

One of the most magnificent projects in Roman villa architecture, the Villa Sacchetti del Pigneto—the first important architectural work carried out by Pietro da Cortona (1625; illus. p. 54 center)—was soon let go to ruin. The dominant feature of the triumphal garden facade, framed by concave wings, was a massive belvedere niche. This spot provided an ideal view of the gardens below, which could be reached via terraces and steps.

After finding designs by Borromini unsatisfactory, Prince Camillo Pamphili commissioned the sculptor and architect Alessandro Algardi to build his Villa Doria Pamphili near the Via Aurelia Antica in 1650. Algardi was also given the task of planning the extensive park—then the largest in Rome—with lakes. The influence of the Villa Medici is noticeable in this cube-shaped garden palace

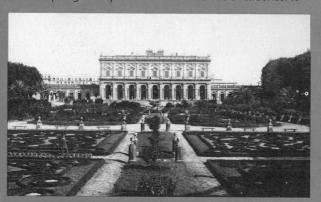

as well, and, as in the Villa Borghese, there are fragments of ancient artifacts set into the facade (illus. p. 54 bottom). The museum function of the Roman villas was even more apparent in the Villa Albani, which Cardinal Alessandro Albani had built by Carlo Marchionni from 1743 to 1763. From the start, this villa was intended more as a place to house his art collection than as a residence. It

**Francesco Maria Preti,** Strà, Villa Pisani, 1735–1756, garden facade

Below: **Carlo Marchionni,** Rome, Villa Albani, 1743–1763, garden facade

was here that the great scholar Johann Joachim Winckelmann wrote his *History of the Art of Antiquity.* Marchionni's facade design broke new ground: The ambitious garden facade takes features from Michelangelo's Palazzo dei Conservatori and absorbs them into eighteenth century architecture (illus. left). In the Veneto, too, villas emulated former times of glory. The Villa Pisani in Strà (1735–1756) takes up Palladio's classical concepts, but employs them on an unusually large and splendid scale. Here, the villa can barely be distinguished from a summer palace.

55

# Spain

The construction of the palace-monastery S Lorenzo del Escorial (1563–1584; illus. below) marked a new era in Spanish architecture. The choice of a "Roman" design following the principles of Vitruvius was an explicit rejection of the so-called Plateresque style and of the Late Gothic style that had dominated up into the sixteenth century. From then on, the austerely classical style represented by court architect Juan de Herrera remained a model until well into the seventeenth century.

El Escorial was not just a new start in the stylistic sense. This monastery, begun (not by chance) in the year in which the Council of Trent ended, embodies the start of absolutism: the complete authority of the state based on divine right. By deciding to combine the royal palace and the burial place of the Habsburgs with the church, monastery, and college of the Hieronymites, Philip II gave material expression to the perfect union of secular and ecclesiastical power.

The grid-like complex, measuring 208 x 162 meters (641 x 499 ft), is based on two Spanish architectural models: the *alcázar*, a Moorish fortified castle with defensive towers, and the hospital with its system of courtyards. The symbolic structure of the ground plan gave rise to far-fetched interpretations. Some saw El Escorial as a likeness of Solomon's Temple; others saw in it a reference to the martyrdom of its patron saint, St Lawrence, said to have been roasted to death on a gridiron. In a complex regard, El Escorial and the patronage of Philip II provided the model for the architectural culture of the Spanish kingdom. The close connection of the aristocracy with the royal court and the intellectual climate of the Counter-Reformation, coupled with the centralization measures undertaken by the Spanish crown, made the strict classicism of the Escorial a dominant aesthetic model. The direction taken by courtly art had an even more lasting influence. Like the king, the aristocracy devoted its full attention to matters of spiritual salvation. Its entire fortune was poured into religious foundations, churches, chapels, monasteries, and convents. Secular buildings, which had given new momentum to architecture in Italy and France, were almost without significance in Spain. Even Madrid, which was the capital of an empire from 1561, had monasteries as its almost sole adornment. Only in the field of urban architecture was an individual type of secular construction created: the plaza mayor, of which the most beautiful example is found in Salamanca (illus. p. 57).

Juan de Herrera (1530–1597), scholar and confidant of the king, and the completer of the Escorial, supervised all important building projects. His pupils carried the "Herreran style" or *estilo desornamentado* (unadorned style) into every corner of the kingdom, even into annexed Portugal. But Herrera found lasting solutions not only in the area of facade design, but also that of

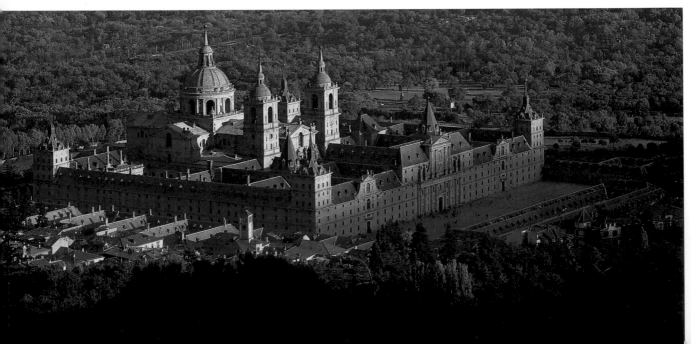

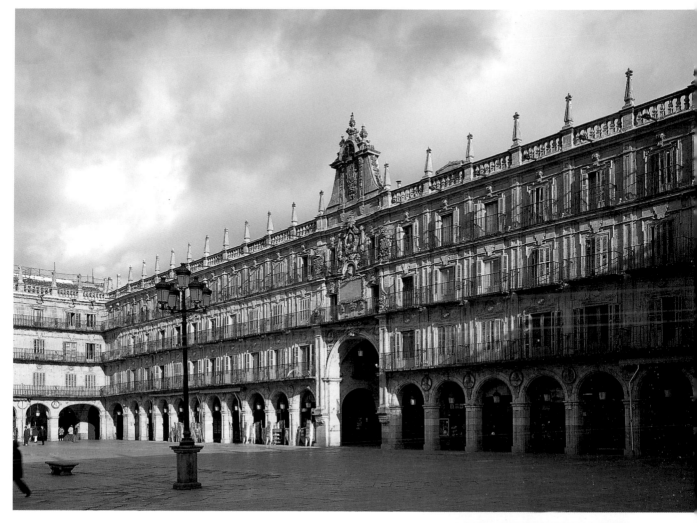

P. 56: **Juan Bautista de Toledo and Juan de Herrera,** S Lorenzo de El Escorial, 1563–1584, full view

**Alberto de Churriguera and Andrés García de Quiñones,** Salamanca, Plaza Mayor with Pabellón Real, 1728–1755

Right: **Fray Alberto de la Madre de Dios,** Madrid, La Encarnación, begun 1611

spatial organization. With its rectangular ground plan and broad preaching space in the nave, the cathedral of Valladolid, where Herrera carried out alterations from 1580, was to become a prototype, in particular for colonial church architecture.

Only very hesitantly did Spanish architecture of the early seventeenth century become open to new trends. One example of this is the Encarnación church in Madrid (illus. right), sponsored by Doña Margarita de Austria and Philip III, and begun in 1611 by Fray Alberto de la Madre de Dios. The oppressiveness of many buildings of the post-Herrera era slowly gave way to more elegance.

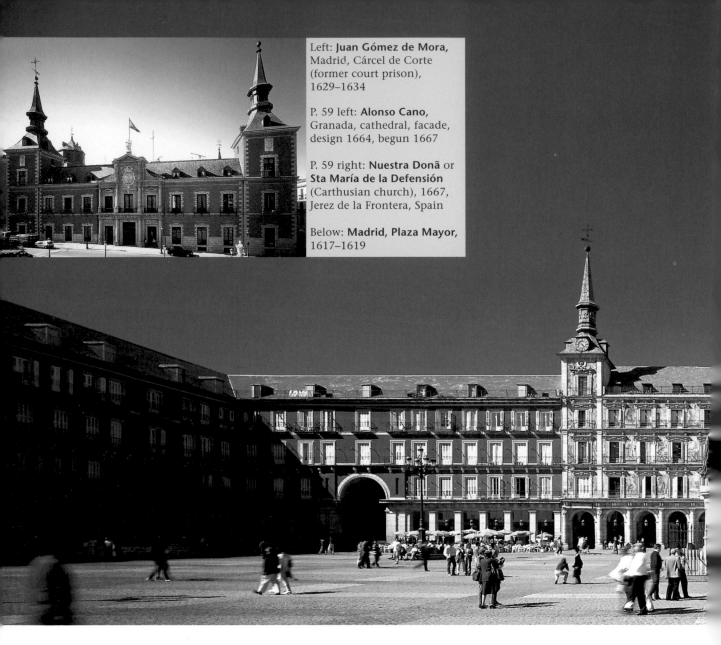

Left: **Juan Gómez de Mora,**
Madrid, Cárcel de Corte
(former court prison),
1629–1634

P. 59 left: **Alonso Cano,**
Granada, cathedral, facade,
design 1664, begun 1667

P. 59 right: **Nuestra Donã** or
**Sta María de la Defensión**
(Carthusian church), 1667,
Jerez de la Frontera, Spain

Below: **Madrid, Plaza Mayor,**
1617–1619

## Madrid's Rise to Become a Royal Seat

Although Madrid had been declared the permanent royal seat in 1561, until the seventeenth century it lacked the splendor associated with a capital. Not until 1606, when Philip III finally ordered the court to settle there permanently, did a period of busy building activity set in, turning the capital into an appropriate setting. Juan Gómez de Mora (1586–1648) became the architect of this upswing. In 1617 he produced the first projects for the Plaza Mayor (illus. above). Between 1619 and 1627 he transformed the old, rambling *alcázar* into a modern palace. The splendid four-winged building with a uniformly structured facade was lost to fire; it was replaced by a new building created by Juvarra and Sacchetti (p. 60/61). The Cárcel de Corte (court prison, 1629–1634; illus. above) and the Ayuntamiento (city hall, begun 1640) gave Madrid some public buildings in keeping with the times. However, a cathedral that was intended to compete with St Peter's was never built.

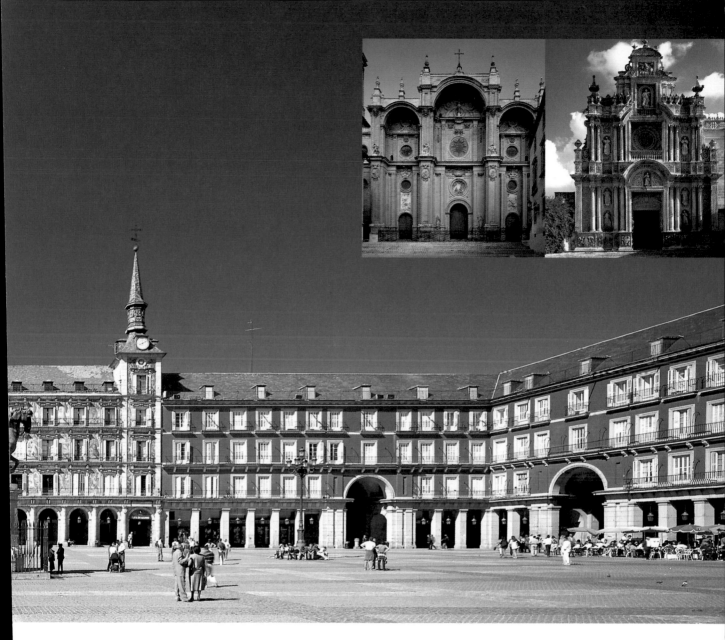

## Regional Architecture in Spain

In about the middle of the seventeenth century, some regions in Spain began to emerge from the shadow of the crown. Their architecture signaled the final rejection of Herreranism and a completely new start in Iberian Baroque architecture. In Andalusia, Alonso Cano (1601–1667) came onto the scene, a personality whose creativity and charisma were surpassed only by that of Diego Velàzquez. Cano is the only important "all-round" artist that Spain has produced. Although the main focus of his work was painting, the plan he presented in 1664 for the facade of the cathedral of Granada (illus. top left) shows an equal wealth of invention. Although Cano had to take into account the structure of the nave, which had been built by Diego de Siloe, he created a design that sets itself apart from all other contemporary facades: a frame-like structure in the style of a triumphal arch, with portals and walls that are set well back.

59

# Bourbon Court Architecture

When Philip V, the first Bourbon king, ascended the Spanish throne, there were at first no direct artistic consequences—the kingdom was still too shaken by the turmoil caused by the War of the Spanish Succession. It was not until 1720 that things began to change. Bourbon court art, a style influenced by the classicistic Baroque of Italy and France, now began to compete with the Habsburg legacy and the many forms of regional architecture. The building of palaces, which had been neglected under the Spanish Habsburgs, became the most important task, one that was to be carried out almost solely by foreign artists.

The first project of any note undertaken by the Bourbon kings was the enlargement of

**Santiago Bonavia and Francisco Sabatini,**
Aranjuez, main facade with wings, 1748 and 1771

the hunting lodge of La Granja near Segovia. Philip V acquired the property, which had been used by the Hieronymite order, in 1720. He commissioned his court architect Teodoro Ardemans (1664–1726) to draw up the plans. At first, Ardemans came up with a traditional *alcázar*-like design that was interrupted in the NW by a cross-shaped chapel. It was only in the second building phase, when Roman architects Andrea Procaccini and Sempronio Subisati extended the core of the building with a pair of three-winged additions in around 1730, that Italian and French influences began to prevail. The Patio de la Herradura in the SW and the Patio de los Coches in the NE provided the archaic *alcázar* with two splendid cours d'honneur.

The trend toward an internationalization of architecture can be seen even more clearly in the garden facade, which is entirely influenced by

Roman Baroque. It was completed in 1736 by Giovanni Battista Sacchetti according to plans drawn up by the court architect in Turin, Filippo Juvarra. Four colossal columns in the central projecting section, and a subtly graded arrangement of colossal pilasters beside it, gave the facade an expressive power that had not been seen before in Spanish palace architecture (illus. p. 61 bottom).

When a devastating fire completely destroyed the *alcázar* in Madrid together with most of its furnishings, Philip V commissioned Filippo Juvarra to draw up plans for a new building. Juvarra designed a monumental complex, surpassing Versailles in size (with sides 474 meters/1,460 ft long and 23 meters/71 ft high), for a location outside the city. The plan was never executed because the king objected to moving the royal seat, and because of Juvarra's death. His successor, Sachetti, altered Juvarra's plans and built the

present palace at the edge of the old town (illus. p. 61 top). The closed complex with its four wings, inner courtyard, and lateral projections follows the tradition of the Spanish *alcázar*. The design of the facades combines elements of both French and Italian court architecture. The main three-story section, with its colossal columns and pilasters, is situated above a high ashlar base uniting the ground floor and mezzanine. A projecting entablature containing two more stories finishes off the massive building, which is designed to be widely visible. Originally, as in Bernini's design for the Louvre, it was planned to have statues crowning the balustrade, which would have reduced the palace's cubic severity. Inside, the appartement double (see p. 73) followed contemporary French fashion.

Philip II had already chosen Aranjuez, a monastery in a well-watered hunting area, as a summer residence. However, the plans of his architects,

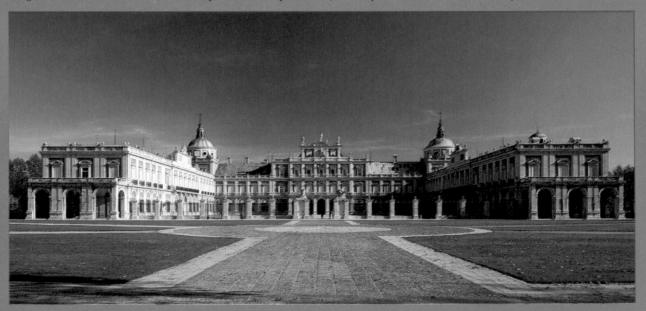

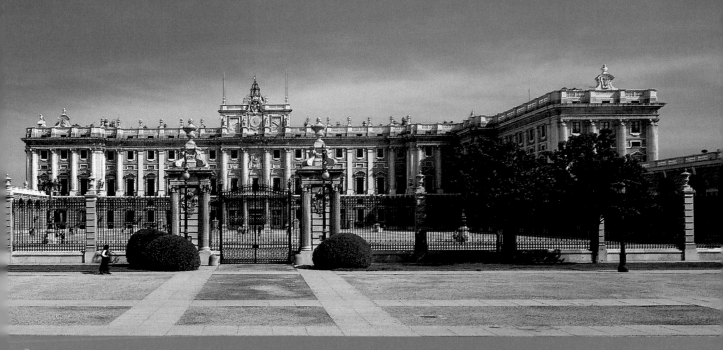

including Herrera and Gómez de Mora, were not completed. Now, Philip V and Isabella Farnese had it turned into a magnificent palace with extensive gardens. In 1731, Santiago Bonavia took over the supervision of the alterations, which were set back by a fire in 1748. The reconstruction carried out under Ferdinand VI kept for the most part to Herrera's conception, which called for a two-story building with four wings, a striking west facade, and corner towers; the side wings were built in 1771 by Francisco Sabatini (illus. p. 60 bottom). Bonavia's reversion to the architecture of the sixteenth century was certainly no coincidence; it was due to a change in the strategy of legitimation employed by the second Bourbon on the throne, who invoked the Hispanic tradition more than his predecessor.

The palace complex was enlarged in the middle of the century to become the present royal town with its geometrically arranged road system, as well the venue for court festivities. In the extensive gardens, a landing stage was built especially for water performances. The complex also included the church of S Antonio, a rotunda with a rounded portico, and the Casita del Labrador, a former farmhouse built under Charles IV that was extended to become a small, three-winged palace in the neoclassical style; it housed the king's collection of antiques.

**Filippo Juvarra and Giovanni Battista Sacchetti,** Madrid, Palacio Real, 1735–1764, main facade facing the Plaza de las Armas (above); La Granja, garden facade 1734–1736 (below)

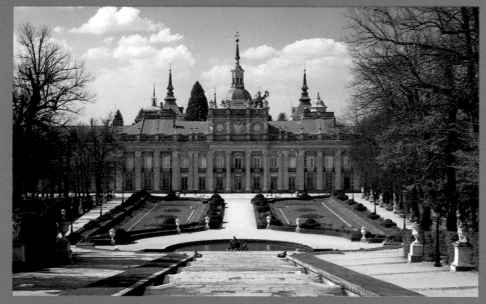

P. 62: **Fernando de Casas y Novoa,** Santiago de Compostela, cathedral, facade, 1738

**Jaime Bort,** Murcia, cathedral, 1742–1754

The city of Jaén also made an important contribution to Andalusian Baroque architecture. From 1667, a facade plan that had been designed for the cathedral by Eufrasio López de Rojas (died 1684) was carried out. The massive front with its five bays and colossal Corinthian order takes its bearings from Maderno's St Peter's. On the other hand, the Carthusian church of Nuestra Señora de la Defensión that was built at the same time near Cadiz has the appearance of the Baroque realization of a Gothic shrine. The main feature of its architectural concept is the decorative disintegration of the wall (illus. p. 59 top right), a technique which reached its zenith in the eighteenth cen-

tury in the works of Francisco de Hurtado Izquierdo (see p. 64/65) and the Churriguera brothers. As in Andalusia, Galicia also developed its own creative form of architecture in the seventeenth century. Central to this was Santiago de Compostela and its cathedral. An ambitious building project was begun in 1649 under the humanistically oriented canon José de Vega y Verdugo. This culminated in the construction of a new cathedral facade by Fernando de Casas y Novoa in the eighteenth century (begun 1738; illus. opposite). The task was extremely challenging, both esthetically and architecturally. The new facade was to both conceal and protect the Romanesque Portico de la Glo-

ria, so it had to admit as much light as possible; and it also had to integrate the Baroque perron that had already been started. Casas y Novoa solved this difficult problem in masterly fashion: He hid the Romanesque portal behind the tripartite front flanked by two towers, opening it up with huge windows. The lively vertical structuring provided by rows of columns superimposed one upon another, the staggered effect of the towers and pediments, and the filigree appearance of the walls all reminded contemporaries of gold work, so they gave the facade the name *fachada del obradoiro.*

In central Spain, the Churriguera family of artists gave Baroque architecture a new impetus. Typically enough, it was one of their works combining architectural and sculptural elements—the retable of S Esteban in Salamanca, built by the oldest of the five brothers, José Benito de Churriguera—that became a groundbreaking model because of its bold use of "Solomonic" columns, its large-scale conception, and its lavish ornamentation (see p. 170). The elegant Plaza Mayor in Salamanca (see p. 57), the work of Alberto, the youngest brother, marks the transition to the Rococo.

The cathedral of Murcia can be cited as an example for architectural activity in eastern Spain (illus. above). Its extensive facade, which is "broken down" by a variety of dividing elements, makes an impression both of monumentality and of delicacy.

## Carthusian Monasteries: El Paular and Granada

The most original and splendid achievement of the Spanish Late Baroque is manifested in the extravagantly decorated interiors of two Carthusian monasteries. They were created by Francisco de Hurtado Izquierdo (1669–1725), an architect, sculptor, and interior designer from the province of Córdoba. His decorations, derived from classical elements, yet prismatically refracted and duplicated, influenced Andalusian and colonial Baroque architecture for decades.

Hurtado's first groundbreaking work was alterations to the Sagrario, the inner sanctum, of the Carthusian monastery in Granada (1702–1720). He designed the tabernacle as a huge shrine, "curtained off" by a square room with a dome. In 1718, he designed another *sagrario*, modeled on that in Granada, for the Carthusian community of El Paular, near Segovia (illus. opposite). Here, the inner sanctuary consists of two rooms. The center of the first one is occupied by the tabernacle of marble and jasper. This is an architectural capriccio consisting of several stories above four exterior pillars and an inner ring of supports. The space behind it is lit by round windows above the cornice; the lighting, together with the gilding on the retable, produces a dramatic contrast to the darker inner sanctum. The most artistically mature, but at the same time least documented, work of the Andalusian Baroque is the sacristy of the Cartuja in Granada. This compact, single-aisle room gains its vitality from the extravagant, molded decoration of its structural elements, the pilasters, which remain clearly visible despite the lavish stucco ornamentation (illus. left).

Hurtado's art was seen by the following generations as the epitome of decadence. Only in recent decades has his work come under more objective scrutiny.

**Francisco de Hurtado Izquierdo(?),** Granada, sacristy of the Carthusian monastery, begun 1732

p. 65: **Francisco de Hurtado Izquierdo and Teodosio Sánchez de Rueda,** El Paular, Sagrario of the Carthusian monastery Nuestra Señora del Paular, begun 1718

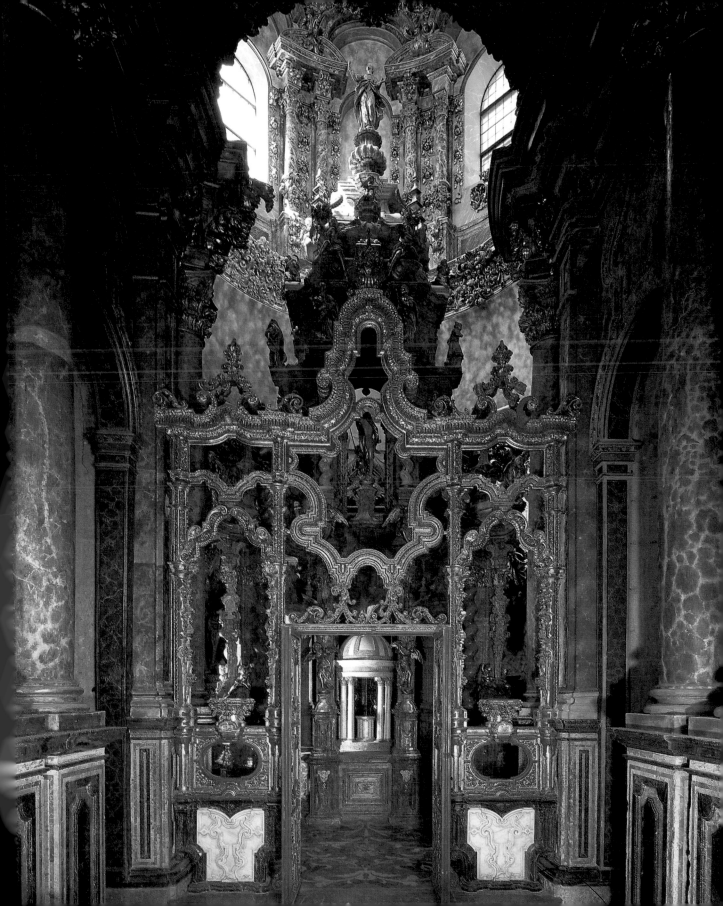

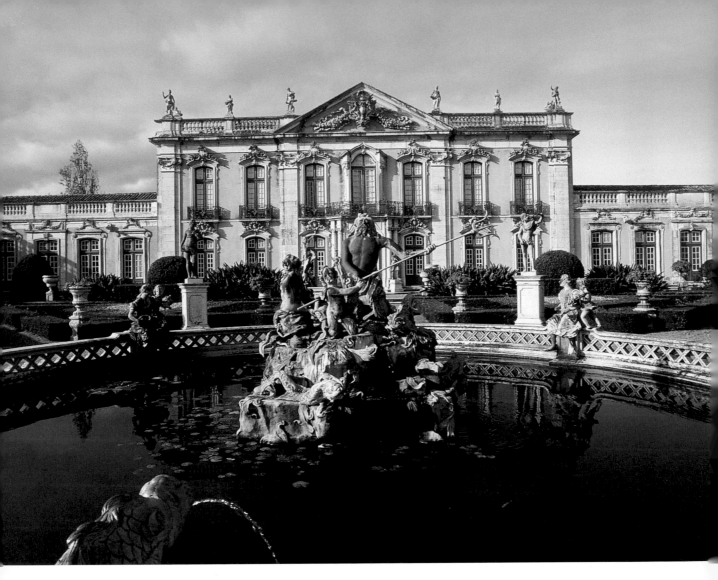

# Portugal

It was only toward the end of the seventeenth century, when this colonial power experienced an unbelievable economic upswing as a result of the discovery of gold and diamond mines in far-off Brazil, that Baroque architecture of any note arose in Portugal. Almost overnight, the country became the richest in the world, and its king, João V (1706–1750), a much sought-after patron. The Portuguese court tried to emulate the example of Louis XIV, attempting to make up for a lack of tradition with material splendor and purchasable privileges. João V squandered money and gold on spectacular projects, and drove Portugal to ruin by the end of his reign. The country was dealt a further blow in 1755 by a huge earthquake that leveled large parts of Lisbon to the ground. However, this turned out to be the chance for a radical new start: Under the leadership of the minister Pombal, Portugal became part of the vanguard of the Enlightenment.

João V wanted to build a second Rome and a second Vatican on the Tagus River. His envoys at the papal court provided him with detailed plans. The ambitions of this only superficially pious ruler reached their climax in the building of the Mafra palace-monastery (foundation stone laid in 1717), which surpasses El Escorial in size. Architectural "quotations" of the most important Roman institutions—St

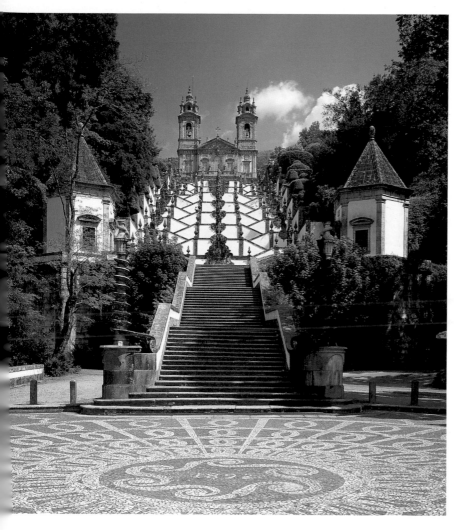

dence and church of the patriarch. Filippo Juvarra was called to Lisbon for the task. This project also remained uncompleted, as Juvarra left Portugal again. In João V's final years, work began on the summer residence of Queluz, which Mateus Vicente and the garden architect Jean-Baptiste Robillon made into one of the jewels of the Rococo (illus. opposite).

In the north, away from the court, a separate school of architecture arose from 1725. Its founder is almost certainly Nicola Nasoni, a Sienese painter who realized his true vocation in the Igreja dos Clérigos in Porto. Braga was another center of Late Baroque architecture. Archbishop D. Rodrigo de Moura Teles had surrounded the city with a ring of monasteries and convents. The most interesting monument is the Santuàrio do Bom Jesus do Monte (1784–1811), whose picturesque processional path is lined by a series of sculptures dealing with both Christian and ancient, pagan allegories (illus. left).

Above: **Braga, Bom Jesus do Monte,** 1784–1811, way of the Cross and church facade

Right: **Johann Friedrich Ludwig,** Mafra, abbatial residence, begun 1717, view into the narthex of the church

p. 66: **Mateus Vicente and Jean-Baptiste Robillon,** Queluz near Lisbon, Queluz Palace, completed after 1747, Fachada de Cerimónia

Peter's, S Ignazio, and Bernini's Palazzo Montecitorio—indicate the king's pretensions. The project supervisor was Johann Friedrich Ludwig (1670–1752) from southern Germany. In his work, he followed Roman models. The monastery church, lined with precious marble, was consecrated in 1730 (illus. right). Work on the palace continued into the 1740s—it was never lived in. Parallel to the work on Mafra, plans were being made for the patriarchate, the resi-

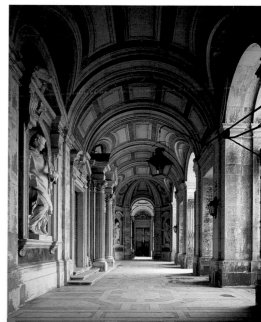

# Architectural Theory

The systematic study of the fundamental principles of architecture began in the Early Renaissance; it was part of the process through which the arts strove for autonomy. Leon Battista Alberti's treatise *De Re Aedificatoria* was the first in a series of theoretical writings that attempted to explain the forms and functions of architecture. What they all have in common is their dependence on Vitruvius's *Ten Books on Architecture*, a work that circulated widely in numerous—unillustrated—medieval copies and translations. From Serlio, Vignola, and Palladio, the

**François Blondel**, Cours d'architecture, 1675–1683, frontispiece with the Porte Saint-Denis in Paris

development then leads, at the dawn of the Baroque, to Vincenzo Scamozzi (1548–1616). In his fragmentary treatise *L'idea della architettura universale* (1615), this widely traveled architect and scholar tried to summarize architectural theory and practice at the end of the Renaissance (illus. above). His extensive knowledge of Italian and foreign authors allowed him to treat mathematical and geometrical methods, geographical requirements (which clearly favor Italy), and basic issues of typology and urban design in an exact and scientific fashion. Scamozzi's views on the five orders of columns were widely endorsed. Unlike previous authors, he represents this number as being God-given (illus. right).

Guarino Guarini (1624–1683) also saw architecture as being based first and foremost on science. This learned Theatine priest, who became famous as a philosopher and as an architect, published various treatises; the most important of these is *Architettura civile*, which appeared posthumously in 1737 (illus. below). The engravings contained in it were in circulation throughout Europe even before the book was published. In contrast to Scamozzi, Guarini grants architecture, and thus also the orders, some room for change; he no longer sees Antiquity as the only authority. This allows him to find the Gothic style, long the object of scorn, worthy of being assigned an order.

Even the mathematician François Blondel (1617–1686),

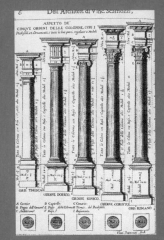

**Vincenzo Scamozzi**, *L'idea della architettura universale*, 1615. The five orders (left); Vitruvian figure (right)

who rose to become the leading architectural theoretician of absolutist France, called for a change in Vitruvius's canon of orders. His writings are informed by the idea of the natural laws and *bon goût*, good taste, which, according to him, is possessed by all intelligent people. Michelangelo seems to him unworthy of imitation, and works by Borromini and Guarini fill him with repugnance. With this view, Blondel became the advocate of a strict academic classicism and influenced many French authors. In 1671, he was appointed director of the Académie Royale d'Architecture. Between 1675 and 1683, he published the material from his lectures in the five-part *Cours d'architecture*, which he dedicated to Louis XIV. Blondel left few buildings of his own. The Porte St-Denis in Paris, considered his main work, combines the ancient architectural features that he found most beautiful in a triumphal gate.

The German book on architecture to receive the most attention was probably the *Fürstlicher Baumeister* (1711–1713) by Paul Decker (1677–1713). Strictly speaking, this is not a treatise or a theoretical exposition, but a book of engravings with a little commentary that gathers together examples of palatial building types (illus. p. 69 top). Johann Bernhard Fischer von Erlach's *Entwurff einer Historischen Architektur* (A Plan of Civil and Historical Architecture), begun in 1705 and published in

**Guarino Guarini**, *Architettura civile* (late seventeenth century), 1737 (ed. Bernardo Vittone), cut through S Filippo Neri in Turin

**Paul Decker,** *Fürstlicher Baumeister*, 1711, part two, 1716, Royal Palace

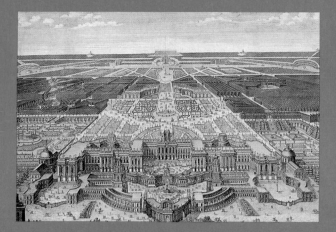

Vienna in 1721, was no less successful. This work, too, is not a treatise, but "the first comparative world history of architecture" (Kunoth), apart from Scamozzi's attempts. In only five books, Fischer runs through the most famous monuments of the Orient and Eastern Asia, Egypt, Greece, and Rome, including the seven wonders of the world and Solomon's temple. He added his own designs and some ancient vases. It is significant that Fischer von

Above: **Johann Bernhard Fischer von Erlach,** *Entwurff einer Historischen Architektur,* 1721, Mount Athos

Erlach studied the sources himself in orde to depict far-away buildings or to recon-struct those that had been

Below: **Colen Campbell,** *Vitruvius Britannicus,* 1715–1725, Wanstead House I, London

destroyed. His own work, which is presented in the fourth volume, takes its place among the worldwide "his-torical architecture" and lays claim to being a continuation of Roman Habsburg architec-ture. The illustration chosen here (left) shows Mount Athos, from which Deinocra-tes, the architect of Alexander the Great, wanted to chisel out the figure of a giant.

*Architectura civil, recta y obliqua …*, an unconventional treatise that puts the classical theories of architecture in a relative light, was the work of the Spanish Cistercian monk and diplomat Juan Caramuel de Lobkowitz (1606–1682). In it, Lobkowitz, an all-round scholar, proposes a complex theory of construction based on laws of mathematics and perspective. Without a trace

of self-doubt, he criticizes the most important architects, including Michelangelo and Gianlorenzo Bernini, whom he advises to alter the col-umns in St Peter's Square in Rome (illus. below). Although the treatise was criticized for its rigorously speculative, sometimes uto-pian style, it nonetheless her-alded a new liberty within the discourse of architectural theory.

In England, it was the *Vitruvius Britannicus* by Colen Campbell (1676–1729) that had the greatest influence on its time. In its three volumes, published between 1715 and 1725, Palladio's work is acknowledged as being the

**Juan Caramuel de Lobkowitz,** *Architectura civil recta, y obliqua,* 1678, correction of the colon-nades of St. Peter's Square

acme of architecture. At the same time, Campbell attempts to improve Palla-dio's models in some points and adapt them to British needs. The designs for Palla-dian country residences were a major factor in guarantee-ing the success of the publication (illus. left).

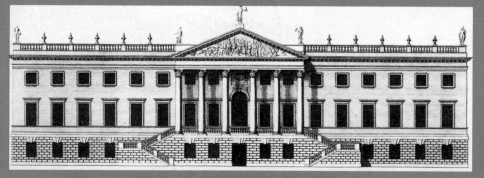

# France

"The splendor and glory surrounding kings is part of their power." This theory, proposed by the social theoretician Montesquieu, provides the key to understanding French state culture. It explains its success and its function as a model throughout the entire Baroque era.

For 200 years, from the rule of Henry IV through the time of the Sun King to the French Revolution in 1789, science and the arts embodied the achievements of the Bourbon monarchy. As had last been the case in antiquity, town planning and architecture became the expressive instrument, or even the symbol, of absolutist rule. In keeping with the centralist concept of state power, Paris and the court were the center of the development. Here, architecture became the reflection of a hierarchically structured society. Two other constants proved to be just as fundamental for French statecraft: the orientation toward classical Antiquity, and the adherence to classicism—in the face of opposing contemporary fashions—as the style best suited for tasks of state display. Classicism became the accepted manner of representing absolutist power even beyond the confines of France and the epoch. The Rococo style, despite its having evolved in France, was left to fulfill almost solely decorative tasks.

The cities of Henry IV were the start of the golden age of French architecture. The intention was to build a "new" city as the reflection of absolute rule, modeling it on the measures taken by Pope Sixtus V to beautify Rome. Even the first project, the Place Dauphine between Pont Neuf and Île de la Cité, shows a high degree of theoretical and practical planning: The triangular complex became the starting point for a system of axes running through the entire city. At its center stands the statue of Henry IV, the first modern royal monument.

The Place des Vosges, the second project carried out by the king, became the prototype of the *place royale* (begun 1605; illus. opposite top). Situated in the Marais district, this rectangular square is completely surrounded by uniform three-story brick buildings with porticoes. Only the two pavilions—the Pavillon du Roi and the Pavillon de la Reine—on the narrow ends of the square receive distinctive treatment.

**Vaux-le-Vicomte,** château grounds, fountain with crown sculpture

P. 71 top: **Paris,** Place des Vosges, begun 1605

P. 71 bottom: **François Mansart,** Château Maisons (Maisons-Lafitte), 1642–1650

Below: **Salomon de Brosse,** Paris, Palais du Luxembourg, 1615–1624, garden facade of the nineteenth century following the model of the seventeenth century

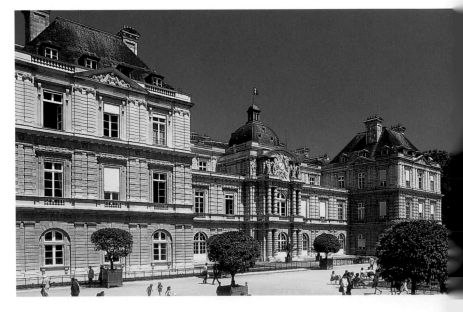

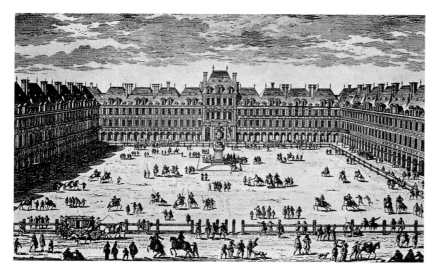

When Louis XIII took the throne, an intensive search began for new solutions to traditional architectural tasks. For example, in the second decade of the seventeenth century, Salomon de Brosse (1571–1626), court architect and scion of a famous family of architects, built three large palaces that revolutionized this type of building. One of them was the Palais du Luxembourg in Paris (1615–1624). The original conception for this palace, built for Marie de Médicis and altered several times, provides for a corps de logis with corner pavilions, side wings, and a low entrance wing whose center is emphasized by a domed pavilion. The rustication of the facades is a reference to the Palazzo Pitti, the city palace of the Medici in Florence.

All the elements are strictly and clearly divided; the roof zone unites the different cubes of which the building is composed. Between 1836 and 1841, the Palais du Luxembourg was considerably extended by Alphonse de Grisors (illus. p. 70 bottom). The interior was also innovative; the corner pavilions contained complete suites made up of a variety of rooms, a solution that anticipated later interior arrangements.

François Mansart (1598–1666), probably a pupil or assistant of de Brosse, was more interested in the strong modeling of the facade itself. His masterpiece is the Gaston d'Orléans wing of the Blois château, which he built from 1635 to 1638. The design of the dominant, projecting middle section is repeated with even greater plasticity in Maisons Château—later Maisons-Lafitte Château—built for the rich president René de Longueil (begun 1642; illus. below).

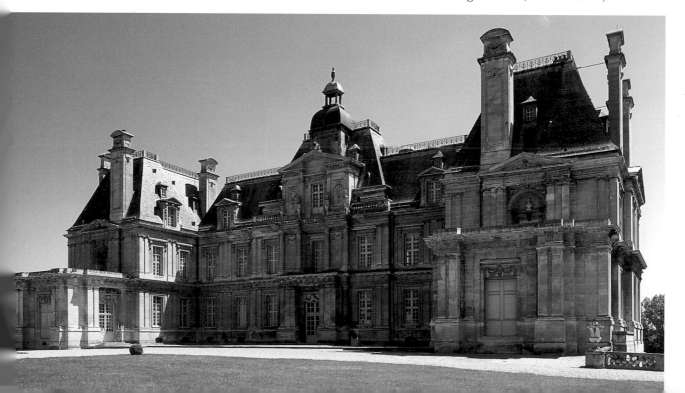

**Louis Le Vau,** Paris, Hôtel Lambert, 1640–1644, Galerie d'Hercule (above); court facade

## Louis Le Vau

Louis Le Vau (1612–1670) is considered the most important architect of the Louis XIV era. The son of a Paris architect, he studied in Genoa and Rome before returning to France, where he developed an original formal vocabulary that had a great influence on French Baroque architecture.

Le Vau began a new era in palace architecture with Vaux-le-Vicomte (see p. 74/75). However, he also shone in other areas, such as the building of *hôtels*. The *hôtel*, or city palace, was the most favored architectural project in seventeenth-century France: The aristocracy and upper classes tried to outdo one another in the building of magnificent residences which always had a public character despite their private purpose. Integrating the building into the often irregular urban site and the "convenience" of the room arrangement posed challenges to the architect, as did the problem of furnishing as well as decorating them in an appropriately splendid manner.

An innovative example of this genre is the Hôtel Lambert (1640–1644) on the Île St Louis. Here, Le Vau devised a completely new plan that took into account the site's lack of depth. Instead of placing the garden along the axis of the portal, courtyard, and residential wing, as was usual, he moved it to the right, next to the main courtyard. The latter, with its rounded corners, leads to a monumental staircase flanked by oval vestibules, which in turn leads into the side gallery be-

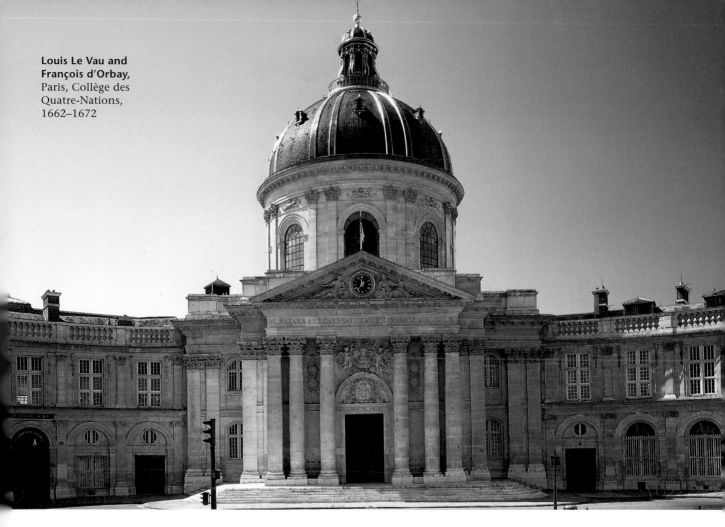

tween the garden and the open landscape. The decoration of the facade combines French elegance with Roman monumentality. The front facing the courtyard is dominated by Doric and Ionic columns placed above each other; a continuous entablature unites the various wings. The main feature is the pedimented staircase with freestanding Doric columns on the ground floor (illus. p. 72 bottom). The facades facing the garden are structured by means of colossal Ionic pilasters, between which are placed French windows—an invention by Le Vau that was to become the hallmark of French palace architecture.

The decoration becomes even more lavish in the interior with the Galerie d'Hercule. This was completed in 1654 with the addition of paintings by Charles Le Brun and reliefs by Van Obstal. Its furnishings, which have been preserved, evoke the ancient world and the heroic deeds of Hercules—an indication of the way the Parisian aristocracy thought of itself (illus. p. 72 top).

Of Le Vau's sacred buildings, the domed church of the Collège des Quatre Nations (1662–1672; now the Institut de France) de-

serves particular mention. This was the last building founded by Cardinal Mazarin, who, until his death in 1671, managed matters of state on behalf of Louis XIV, who was still a minor. The church also served as the burial place for this influential statesman. Le Vau designed the main facade facing the Seine entirely in Roman Baroque style; concavely curved wings frame the central church building with its oval interior. The imposing front of the building has a classical portico and is majestically crowned with a high drum and dome (illus. above).

## Vaux-le-Vicomte

The château of Vaux-le-Vicomte near Melun caused an unparal-leled scandal. Begun in 1656 by the court architect Louis Le Vau for the *surintendant des finances*, Nicolas Fouquet, this building surpassed everything that had been done in this field up to then. This was an unforgivable affront to the king, and Fouquet ended up paying for it with his life. In fact, Vaux-le-Vicomte did indeed anticipate develop-ments that Louis XIV wanted to reserve for himself alone in Versailles.

The château, picturesquely sur-rounded by moats, is situated amid extensive parks designed by André le Nôtre, then an un-known garden architect. The style *entre cour et jardin*, between courtyard and garden, represent-ed an important innovation. The integration into the landscape setting, the way the château re-veals itself in a gradual pro-gression from the working quar-ters via the main courtyard and vestibule to the large salon, and finally, the manner in which the complex is opened up to nature were to become mandatory for all prestigious buildings.

Significant innovations were introduced in the interior, too. The *appartement double* (as op-

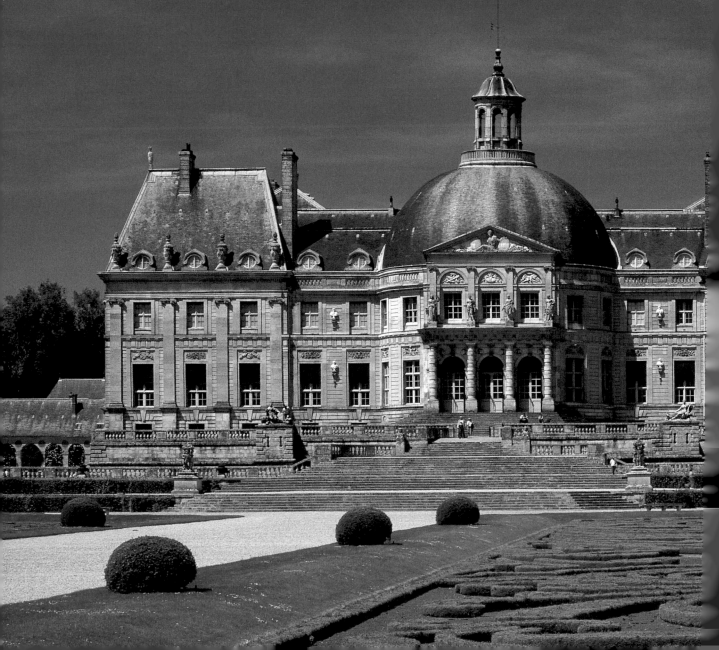

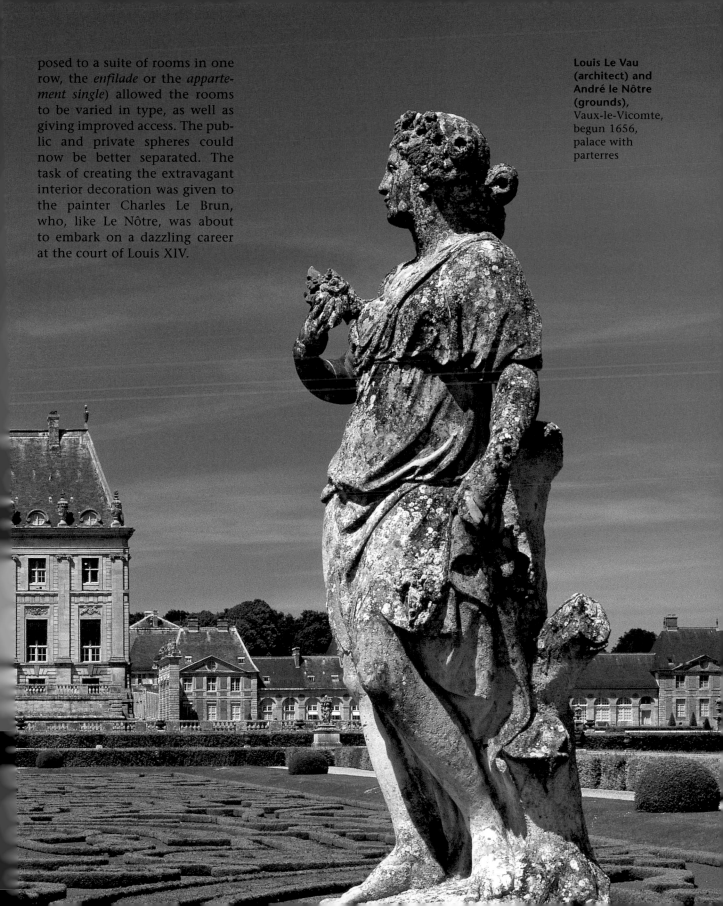

posed to a suite of rooms in one row, the *enfilade* or the *appartement single*) allowed the rooms to be varied in type, as well as giving improved access. The public and private spheres could now be better separated. The task of creating the extravagant interior decoration was given to the painter Charles Le Brun, who, like Le Nôtre, was about to embark on a dazzling career at the court of Louis XIV.

**Louis Le Vau (architect) and André le Nôtre (grounds),** Vaux-le-Vicomte, begun 1656, palace with parterres

## Sacred Buildings in Paris

The development of French sacred architecture ran parallel to that of secular architecture. At first, however, it received no comparable innovative impetus. Only gradually did a characteristic form of Baroque church architecture evolve in France; it reached its highest expression particularly in the dominating dome constructions.

The first important sacred building of the Baroque era in France was the facade of St Gervais in Paris (1616–1621; illus. below), probably built by Salomon de Brosse. It is still entirely rooted in the tradition of the sixteenth century, and combines elements of the French palace with the solemnity of early Roman Baroque as embodied in Vignola's Gesù. The towering three-story front contrasts with the gravity and high relief derived from the Roman model.

Left: **Salomon de Brosse or Clément Métezau(?),** Paris, St Gervais, 1616–1621

**Jacques Lemercier,** Paris, church of the Sorbonne, begun 1626, courtyard (east) facade

The striking staggered arrangement of different elements was to become characteristic of French church architecture.

With Jacques Lemercier, the Italian influence on sacred architecture grew. This architect, born in 1585, lived in Rome from 1607 to 1614, where he studied the works of Giacomo della Porta. He built the Pavillon de l'Horloge at the Louvre for Louis XIII (after 1624). As well as numerous *hôtels* and churches, for Cardinal de Richelieu he designed the château and planned town of Richelieu (begun 1631), and built the Palais Cardinal (now Palais Royal, begun 1633) in Paris.

Another of Richelieu's commissions became a milestone in the development of Baroque classicism in France: the church of the Sorbonne (begun 1626). The ground plan of this domed central-plan building recalls the church of S Carlo ai Catinari in Rome, while the west facade takes up the structure of Roman Jesuit churches. A different approach can be seen in the fa-

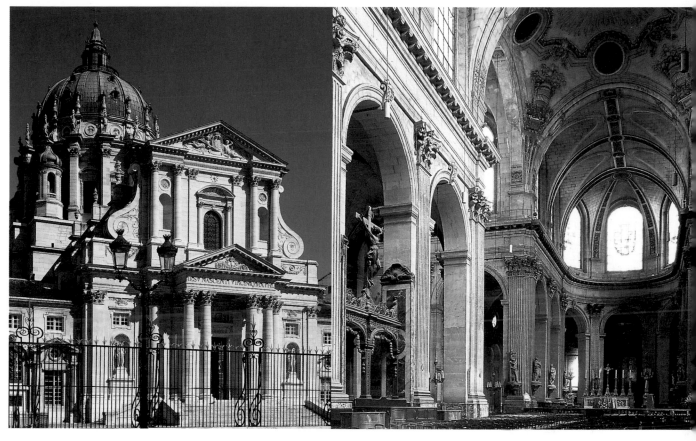

**François Mansart and Jacques Lemercier,** Paris, Val-de-Grâce, begun 1645, completed by Pierre Le Muet and Gabriel Le Duc 1710

**Ch. Gamard, Daniel Gittard,** Paris, St Sulpice, begun 1646, interior

cade facing the courtyard (illus. p. 76 top). The staggered arrangement of temple front, triumphal arch, hipped roof, and the dome on its drum makes a picturesque impression, rather like a theater backdrop, in its unconventional combination of classical and Baroque elements.

Another domed building was erected as a votive church on the birth of the heir to the throne: Val-de-Grâce, begun in 1645 by François Mansart, continued by Lemercier, and completed in 1710 by Pierre Le Muet and Gabriel Le Duc (illus. above). Here, too, Roman architecture provided the major stimulus. However, Mansart, upon whose plans the ground plan and elevation up to the entablature were based, managed to achieve an even more monumental effect. The high dome on a drum that crowns the building like a tower is supported on massive piers. The Roman model is also significantly modified in the facade: A freestanding portico with Corinthian columns is placed before the front of the building, which is reminiscent of Carlo Maderno's S Susanna.

The centralizing domed churches gave French sacred architecture its own Baroque form of expression. However, other styles managed to survive as well. One example is the parish church of St Sulpice, built by Daniel Gittard (1625–1686) from 1646 according to plans by Ch. Gamard (illus. above). Here, a basilical construction rooted in the medieval tradition, with side aisles, transept and choir, is given a classical veneer.

## The Louvre and the Church of the Invalides

In 1661, Louis XIV took over the running of state affairs himself. Within a few years, his government became an example of unlimited royal rule, and the court of the Sun King a magnificent symbol of the absolutist philosophy. The driving force behind this statecraft was the *contrôleur des Finances*, Jean Baptist Colbert. As director of the Royal Academy for Painting and Sculpture (*directeur de l'Académie Royale de Peinture et de Sculpture*) and *surintendant des Bâtiments* (supervisor of building projects) he had control over all the arts.

Colbert's major concern was the enlargement of the Louvre, whose fortress-like four-wing complex had often been extended and modernized, but did not possess a suitably imposing facade facing the city. The most famous Italian architects drew up plans, and two designs by Bernini were on the short list. (illus. below). In 1665 Bernini himself traveled to Paris to modify them. His third proposal was also rejected on the grounds that it did not adequately reflect the aloof nature of absolutist power. The east facade was finally built in 1667/1668 according to plans by the doctor and mathematician Claude Perrault. Its main feature is the long colonnade of paired Corinthian columns that gives the front its imposing gravity (illus. left). The decision in favor of Perrault's classical, academic design determined the future orientation of French Baroque architecture.

The most mature building of the French Baroque was designed by Jules Hardouin-Mansart. The church of the Invalides, inaugurated in 1706, is actually the nave of a hospital-church connected to a central-plan building. It represents a splendid synthesis of two architectural elements: the block-like base with its portal front, and the towering dome on top of a drum, reminiscent of St Peter's (illus. p. 79).

Hardouin-Mansart's virtuosity and organizational abilities also virtually predestined him for tasks of town planning. He designed two new urban focal points in Paris, the circular Place des Victoires and the Place Vendôme. His style remained the accepted standard until well into the eighteenth century.

Above: **Claude Perrault,** Paris, Louvre, eastern facade, 1667/1668

Left: **Gianlorenzo Bernini,** 1st and 3rd design of the Louvre in Paris, 1664 and 1665

P. 79: **Libéral Bruant and Jules Hardouin-Mansart,** Paris, church of the Invalides, 1677–1706

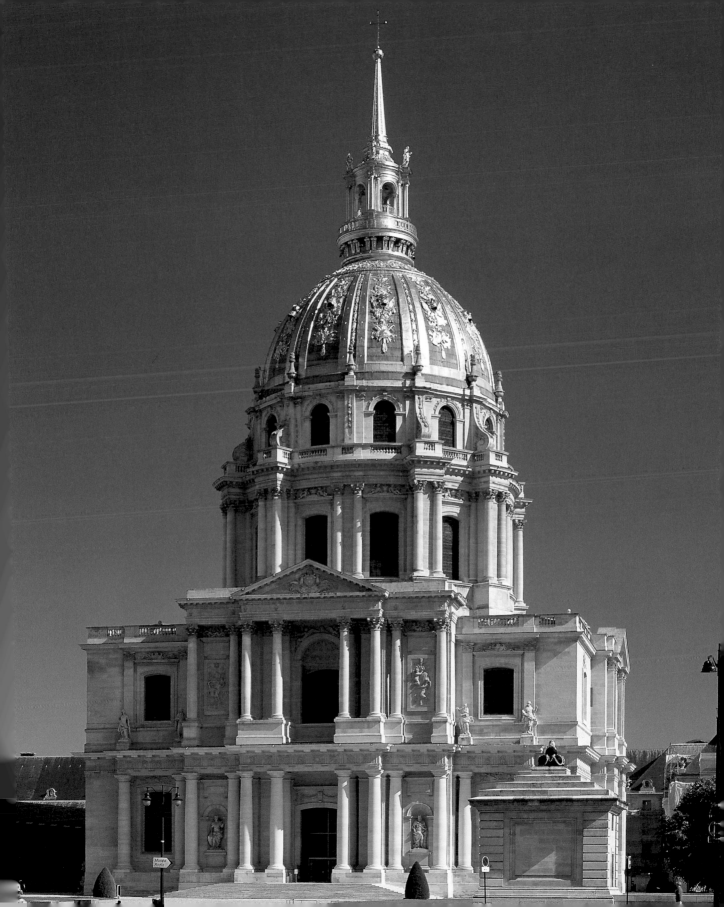

## Versailles

The Versailles of Louis XIV is considered the epitome of Baroque magnificence. This palace with its extensive parks was much more than that, however: It was intended as the perfect embodiment of absolutist rule, as the residence of a Sun King whose life and deeds possessed an exemplary character.

The enlargement of Louis XIII's former hunting lodge began in 1668. The king called on artists who had already developed innovative, landscape-related concepts at Vaux-le-Vicomte: Le Vau, Le Brun, and Le Nôtre. The most urgent measures to be undertaken were the extension of the core building (which now had a broad terrace open to the garden), the layout of the axial system, and finally, the construction of the extensive park itself (illus. below and p. 81).

In 1677/1678, on the occasion of the signing of the Treaties of Nijmegen, Louis XIV decided to move his seat to Versailles. This meant a huge amount of re-planning, as the entire royal household was also forced to move. The 31-year-old Jules Hardouin-Mansart was entrusted with the execution of this task. For the next 30 years, he was in charge of the enlarging of Versailles, a project that involved up to 30,000 workers.

Hardouin-Mansart's first step was to close the garden front by building a mirror gallery to replace the terrace (completed 1687). This type of room, introduced by Francis I at Fontainebleau, here took on monumental proportions. Le Brun designed

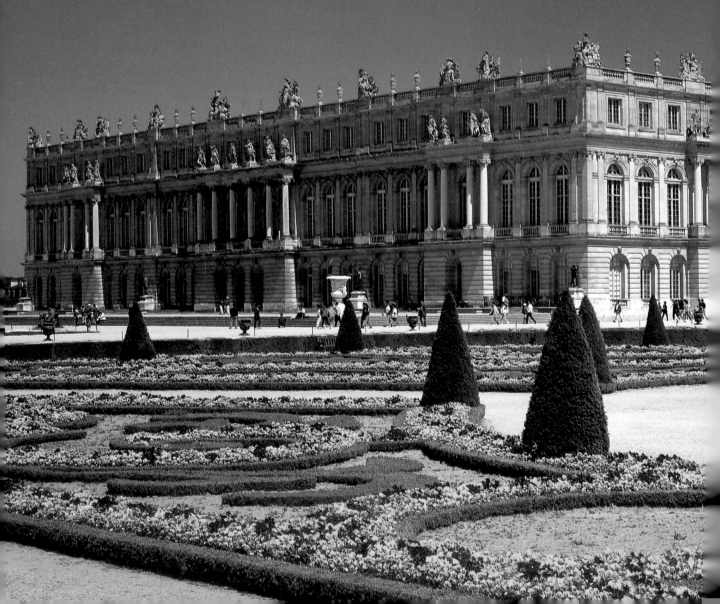

the interior decoration with its allegorical painting cycles illustrating the history of France up to the Treaties of Nijmegen. But the gallery is most famous for its 17 great mirrors, which reflect the sunlight and suggest a symbolic interpretation (illus. p. 85). The Salon of Peace and the Salon of War, in which the military successes of the king are celebrated, are situated at the ends of the gallery. The apartments of Louis XIV were housed in the old core building.

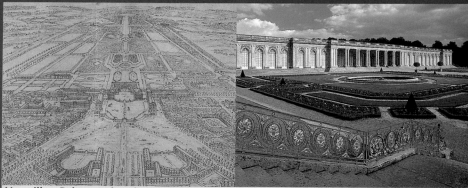

**Versailles, Palace and park,** engraving after Israel Silvestre, end seventeenth century (left); portico of the Grand Trianon, 1687/1688 (Jules Hardouin-Mansart; right)

**Louis Le Vau and Jules Hardouin-Mansart,** Palace of Versailles, park facade, 1668/1678

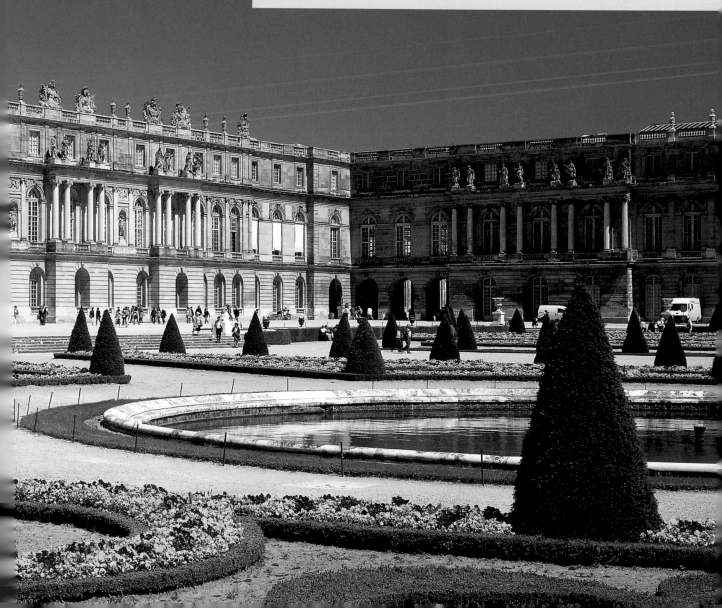

# The Staging of the Sun King

The Baroque era loved theater; its stage was the world. The whole of life became a "history" or a myth, every public act became a ceremony. The king himself was the "living image" of his God-given majesty.

No one embodied this principle more than Louis XIV. His court saw itself as the mirror image of the cosmos; the king ruled as Jupiter, Apollo, or the sun that outshone everything else, as a

under the rule of the Sun God in the *Bucolica*. A complex system of propaganda served to convey metaphorical concept. In the visual arts, this was done through historical paintings, portraits, monuments, and medallions, and in the literary field with panegyrics. But it was the representation of the king that became the most important instrument. His day was compared with the sun's daily course. Every action—meals, receptions, a walk through the gardens—became a symbolic act, a metaphor of his divine epiphany.

The most important act was the *lever*, the king's rising and dressing. There are comprehensive instructions describing every step, every act of assistance given by the servants; there were rules of protocol to cover every eventuality. Hours went by before the king left his bed and was completely dressed. The royal household was in attendance at every act: Proximity to the king meant

**Versailles, palace,** bedroom of Louis XIV, after 1701

a share in the glory of the firmament. The palace and its entire furnishings were set up according to this concept. In Versailles, the residence of the Sun King, every room could be interpreted symbolically; there was no private sphere. The king's bedroom was at the heart of the complex, exactly above the middle of the Cour de Marbre (marble courtyard),

right on the east-west axis; it was both a place of reverence and a hub of power. Directly next door, in the Great Gallery, paintings portrayed a glorified account of "the history of the king," while large mirrors reflected the sunlight. The order of the rooms and thus the degree of accessibility were part of the ceremonial; the higher a courtier stood in the favor of the king, the further he was allowed to penetrate into the interior of the palace. The Ambassadors' Staircase was

**Louis XIV posing as Apollo,** from Henri Gissey, *Le Ballet de la nuit*, 1653, Paris, Bibliothèque Nationale

Right: **Henri Testelin,** *Colbert presents the members of the Royal Academy of Sciences to Louis XIV,* 1667, oil on canvas, 348 x 590 cm/ 137 x 232 in, Versailles, palace

patron of the arts and of peace. Ancient literature provided the topos: Virgil had already described the dawn of a new "Golden Age"

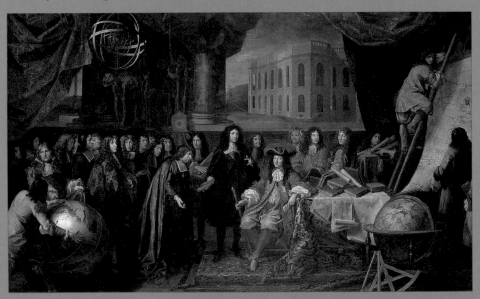

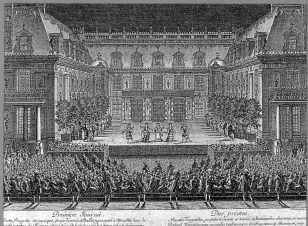

**Israel Silvestre,** nightly play in the Cour de Marbre, from a sequence of engravings of the *Plaisirs de l'Île enchantée, Première Journée,* 1664

**Ephemeral triumphal arch** near the fountain of St Gervais, copper engraving from *Entrée Triumphante …,* 1660

ry buildings were built, then dramatically captured and blown up.

Spectacles were central to Baroque culture, whether they were performed to entertain the court or to impress the people, who saw in them a chance to escape from their depressing everyday lives. The *entrées solennelles* (solemn entrances) of the French king, for which extravagant scenery and lavish festive constructions, mostly wooden triumphal arches, were specially designed, were imitated all over Europe. The *trionfo* resembled a government program: In it, transcendent structures of rule, models of an ideal world, were communicated on the level of an amusement. Virtue conquered Vice, Faith conquered Unbelief, and Order conquered Chaos.

the starting point for the circuit through the palace. This was the first and most important ceremonial staircase of the Baroque. It provided the perfect backdrop for the guest's ascent and the gracious approach of the ruler. The king dealt with state affairs in the Grands Appartements or Great Rooms. In later years, they were opened to select members of the public three times a week for games and dancing—a gesture designed to give a "popular touch."

The park, whose dramatic installations, recreational buildings, fountains, summerhouses, and sculptures made it the perfect place to stage magnificent parties, became equally important. The

*plaisirs de l'Île enchantée,* a spectacle lasting several days that was put on in 1664 in honor of the king, became famous. The king himself took part as Knight Roger. The climax was the destruction of Alcina's palace, staged using a gigantic fireworks display. For such events, tempora-

These presentations were put on for both secular and ecclesiastical festivities; splendid pageants and lavish architectural installations (*castra doloris*) formed a part of the celebrations. Religious festivals such as the Easter processions or the Feast of Corpus Christi were celebrated in an equally theatrical fashion. The ephemeral nature of the temporary architectural features and the limited time frame of the whole spectacle were interpreted as expressions of transitoriness. Even the uneducated understood the visual allegories; symbolic acts, verbal and pictorial imagery served to communicate on a broad basis. People in the Baroque era were familiar with rhetorical patterns and emblematic structures; artists and scientists worked together to devise the concepts that informed them. The individual disciplines were integrated to form a synthesis of the arts.

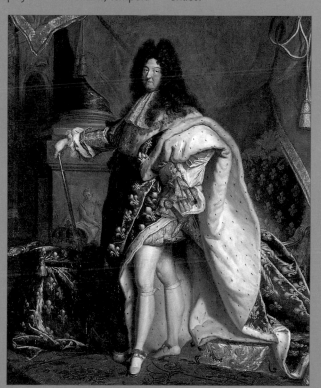

**Hyacinthe Rigaud,** *Portrait of Louis XIV,* 1701, oil on canvas, 279 x 190 cm/ 110 x 75 in, Paris, Musée du Louvre

The king's bedroom was placed in the center, exactly on the axis running from east to west, as his day was meant to resemble that of the sun.

The rooms in the southern part of the surrounding extension built by Le Vau served as the apartments of the queen, Marie-Thérèse, while those in the north were used for official functions. The latter, the Great Rooms, were reached via the Ambassadors' Staircase (which has not been preserved) and the Salon of Hercules.

In front of this three-wing core building, which surrounded the old marble courtyard from the time of Louis XIII, Hardouin-Mansart placed the transverse north and south wings. They enclosed a second courtyard, the Royal Court. The immense breadth of these wings, which extend for more than 670 meters (2,864 ft), is still stunning today.

The palace chapel, which is attached to the north wing, is one of the most striking examples of late French Baroque architecture. This church, begun by Hardouin-Mansart in 1689 and completed by Robert de Cotte in 1710, combines elements of ancient, medieval, and Baroque architecture. Based on the model of the Ste Chapelle of St Louis, it was a manifestation of the deliberately ceremonious presentation of the French kingship (illus. left).

The park formed an integral part of this ceremony. It served as a place of recreation and provided a natural backdrop for the numerous court festivities. Here, too, one finds innovative architecture, such as Hardouin-Mansart's Orangerie and the Grand Trianon (1687/1688), a ceremonial building with an open columned hall (illus. p. 81 top right). Its serene conception reflects Italian models, and its interior furnishings are designed for *commodité*, presaging the advent of a culture based on more refinement and intimacy. Almost 80 years later, Louis XV had its counterpart, the Petit Trianon (1764–1768), built for his favorite, Madame de Pompadour. Jacques Gabriel, a pupil of Hardouin-Mansart, gave this building a classical, Palladian form.

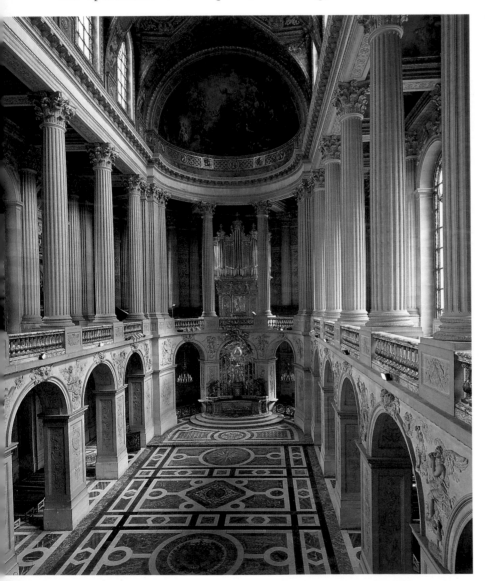

Above: **François Mansart and Robert de Cotte,** Versailles, palace chapel, 1689–1710

P. 85: **Jules Hardouin-Mansart and Charles Le Brun,** Versailles, Palace, Hall of Mirrors, begun 1679

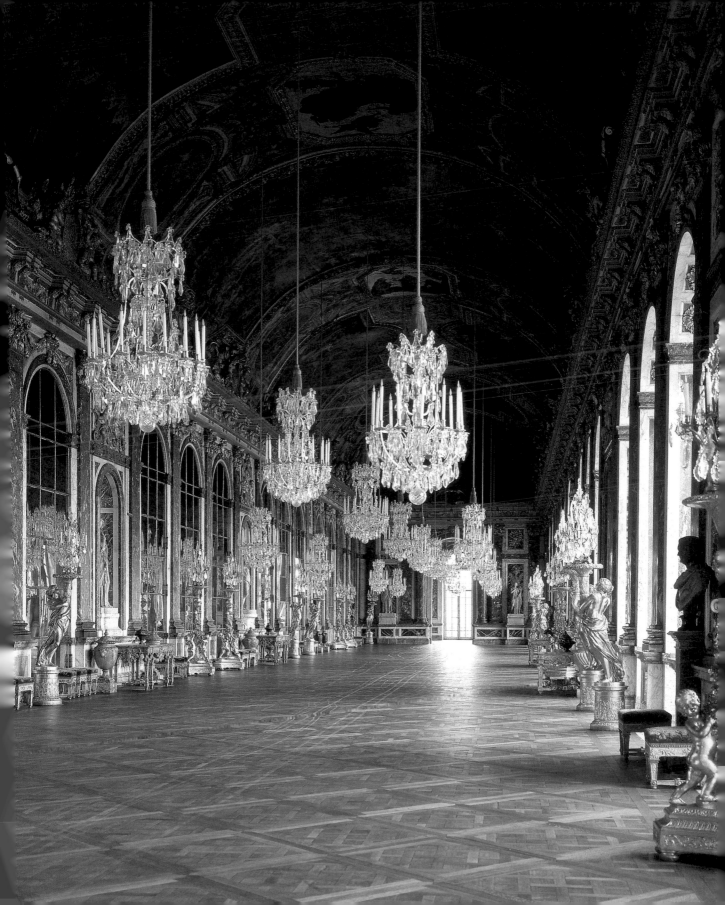

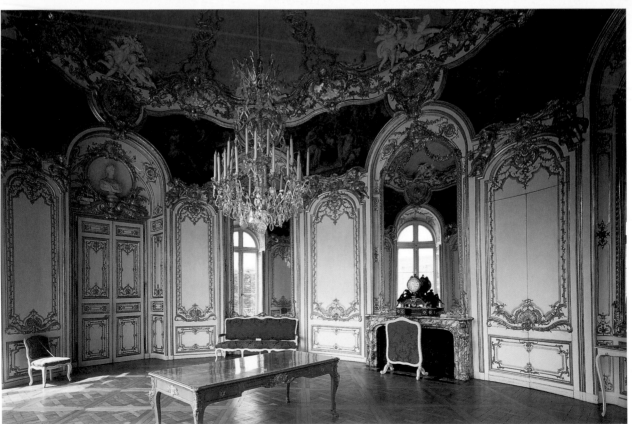

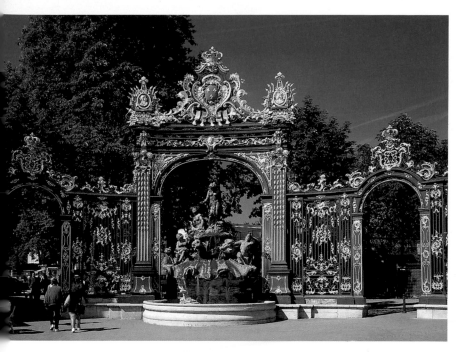

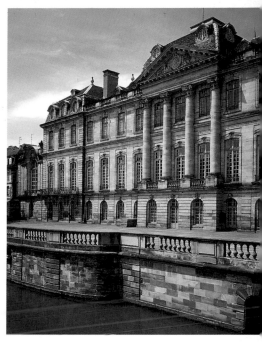

P. 86 top: **Pierre Alexis Delamair,** Hôtel de Soubise, court facade, begun 1704

P. 86 bottom: **Germain Boffrand, Charles Joseph Natoire,** Hôtel de Soubise, Salon de la Princesse de Soubise, 1735

**Emmanuel Héré de Corny,** Nancy, Place Royale (today Place Stanislas), 1752, fountain and wrought-iron fence by Jean Lamour

**Robert de Cotte and Joseph Massol,** Strasbourg, Palais de Rohan, 1731–1742

## Régence and Rococo

The war of succession had consequences for architecture. The royal projects made only slow progress, while the circle of patrons moved from the court to the aristocracy, which returned from Versailles to Paris. However, for the city palaces that sprung up everywhere from then on, stately facade design was less important than "refined" interior decoration and comfort.

The Hôtel de Soubise shows how much the emphasis changed: While the garden front is still clearly based on the model of Versailles (illus. p. 86 top), Germain Boffrand explored new avenues in the design of the living

areas. He designed several suites connected to one another by oval rooms. One of the most beautiful rooms of his time was the Salon de la Princesse de Soubise (illus. p. 86 bottom), which he adorned to perfection with the aid of from stucco artists and the painter Charles Joseph Natoire. Gilded stucco filigree covers the wall and ceiling; panels alternate with high mirrors that optically enlarge the room. The division between wall and ceiling vanishes.

The new style, which was not called "Rococo" until later, rose to prominence in the second decade of the eighteenth century, after first going through a transitional phase, the Régence, named

after the regency of the Duc d'Orléans (see p. 144/145). The academies continued to adhere to the official style of state art influenced by classicism, so that both styles existed alongside one another.

One of the most influential architects of this time was Robert de Cotte. In Strasbourg, he built the Palais de Rohan with its magnificent facade looking onto the Ill River (illus. above right). The provinces increasingly demanded their rights and independence. Nancy, for example, was transformed into an attractive ducal seat under the supervision of Emmanuel Héré de Corny (illus. above left).

87

# Garden Design

The landscaped garden can illustrate the tensions existing in the Baroque era better than any other medium: Its axial system of allées embodied the firmly decreed order of absolutism, while sculptures, fountains, and decorative

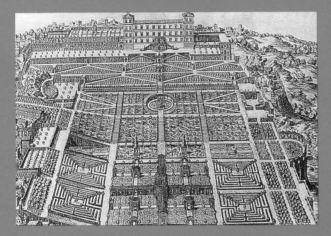

architecture escaped into a world of illusion. The scenario was a calculated one. The Baroque garden served the purposes of official display, an integral component of which is fiction. The "theatrum mundi" used the garden as scenery. As in palace archi-

tecture, nothing was left to chance: Every path, every flower bed, every watercourse obeyed the stage directions; even the viewer's gaze had to yield to the arrangement of vistas. Baroque landscape design reached its unmatched zenith in Versailles; the French garden came to be

seen as the epitome of modernity and culture. Largely responsible for this was André Le Nôtre (1613–1700; illus. above right), who changed the course of European garden design. Before Le Nôtre, the most important impulses had come from

Italy. During the Renaissance, the aristocracy had been drawn to the countryside by its yearning for Arcadia; here, it could indulge in a new lifestyle, the *villeggiatura*. The harmony of nature and culture, the unity of house and garden, and integration into the landscape were among the main characteristics of these new, suburban country seats. The Villa d'Este in Tivoli, which Pirro Ligorio built for Cardinal Ippolito d'Este from 1560 (illus. left), and above all, Villa Borghese in Rome (begun 1613) are seen as milestones in this development. The orthogonal system of pathways, the layout of terraces and stairways, the integration of watercourses, and the regular planting of bosquets as a transition to open nature were all already formulated here.

In France, the new ideas in garden design gained acceptance toward the end of the sixteenth century. Henry IV and his wife Marie de Médicis played an important role here. They had an unusual garden built in St-Germain-en-Laye, spread out over six terraces.

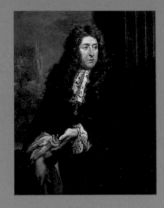

Carlo Maratta, *Portrait of André le Nôtre*, 1678, oil on canvas, 112 x 85 cm/44 x 33.5 in, Versailles, Palace

Left: **Tivoli, Full view of the Villa d'Este**, engraving by Étienne Dupérac, 1573

**Louis Le Vau (architect) and André le Nôtre (park)**, Vaux-le-Vicomte, begun 1656, garden facade with parterres, 1653–1560

Grottos and hydraulic water features delighted visitors. The Jardin du Luxembourg, which Marie had laid out after Henry's death, recalled the Boboli Gardens of the Palazzo Pitti in Florence.

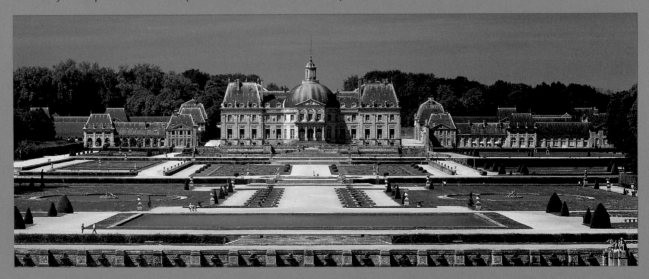

What was completely new was the artistic arrangement of the parterres, which were planted so as to produce an ornamental pattern, like that of embroidery.

European garden design experienced a "quantum leap" when André Le Nôtre was called to Vaux-le-Vicomte, the château of Louis XIV's ambitious finance minister, Nicolas Fouquet. Le Nôtre, the son of a royal garden architect, first studied painting and architecture before turning to landscape design. In 1637 he was involved in the development of the Tuileries Gardens, while in 1653 he was appointed *Dessinateur des jardins de sa Majesté*, and in 1657 *Contrôleur gènerale des bâtiments du Roi*. He remained Louis XIV's chief landscape architect throughout his life. The design of his gardens and his parks was in complete accordance with the taste at court, and embodied the philosophy of the Baroque era.

The park of Vaux-le-Vicomte, near Melun, which Le Nôtre laid out from 1661, became an admired prototype of a new culture of self-promotion and display, like the château itself (illus. p. 88 bottom). Fouquet was well aware of this; he drew the attention of the court to all their attractions during magnificent parties—rather too obviously, for the king felt himself to have been duped and threw his *surintendant* into prison for life. Louis Le Vau, the architect; Le Brun, the painter; and Le Nôtre were commissioned to build the king an even more splendid complex in Versailles.

The elements developed in Vaux-le-Vicomte were to be featured in Versailles on a much larger scale and with

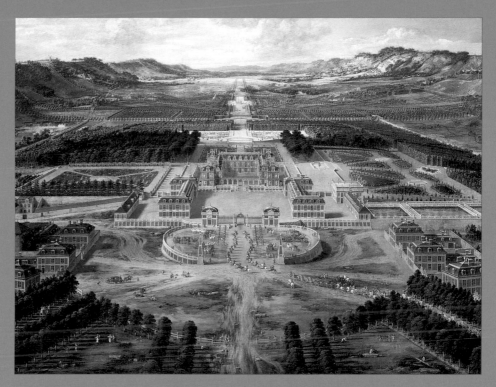

even more compelling logic: the setting of the palace within an orthogonal system of allées and squares that seems to reach out into the open landscape of the countryside, the arrangement of the visual axes, the layout of terraces following the contours

of the terrain (illus. above). *Parterres de broderie*, lined with bosquets, flank the middle axis, which in Versailles has an important additional element, the *parterre d'eau* with its shimmering ponds and fountains, a sort of pendant to the Hall of

**Pierre Patel**, *View of the Palace and Park of Versailles Seen From Above*, 1668, oil on canvas, 115 x 161 cm/ 45 x 63 in, Versailles, palace

Mirrors inside the palace. A canal running crosswise divides this *petit parc* from the *grand parc*, whose paths and woods carry on the axes, but still provide an expansive transition into the open countryside. The visitor's gaze, always carefully guided, thus wanders from the palace over the tamed nature of the park toward the infinite horizon.

Water plays a major role in Baroque gardens. It washes picturesquely around the rocks in the grottoes, canals

**André Le Nôtre and Jules Hardouin-Mansart,** Versailles, palace park, Latona Fountain 1668/1686

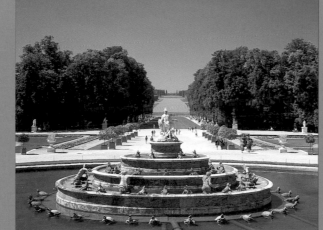

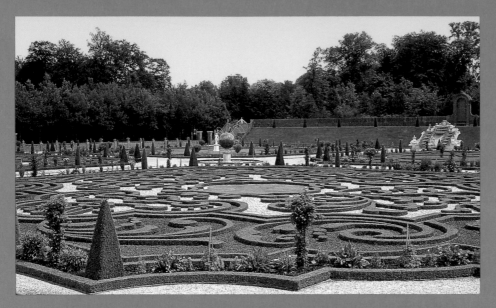

century. The treatise *La Théorie et la Pratique du Jardinage* (A. J. Dézallier d'Argenville, 1709) proclaimed its advantages in every corner of Europe. A few examples of the way the concept spread follow.

The palace gardens at Het Loo, near Apeldoorn, which Prince William of Orange had laid out from 1684, are an eloquent example of the French ideas' quick and lasting influence. This strictly symmetrical park has regained all its original elegance following restoration work carried out from 1970 to 1984 (in the nineteenth century, many Baroque gardens were left to go to ruin or were turned into landscape gardens). Its layout is probably based on plans drawn up by the Paris Academy of Architecture; later, the Huguenot Daniel Marot took over as designer.

structure the spatial layout, and waterfalls form backdrops and curtains. Fountains create splendid *points de vue* (illus. p. 89 bottom). The water supply and a functioning hydraulic system were guaranteed through a brilliant technical achievement: the *machine de Marly*, a system of 257 pumps that brought water from the Seine to Versailles through an aqueduct, was considered a marvel. But the gardens at Versailles were much more than a masterly achievement of design and technology: like the palace, they paid homage to the mythos of the Sun King.

The entire garden complex is arranged according to a rigorous iconographic scheme in which the park is seen symbolically as the realm of light where Apollo, the sun god and leader of the Muses, reigns supreme. Apollo's rays form the axes of the system of paths. All the mythological figures of classical Antiquity join him; gods and goddesses, nymphs and tritons, cupids and fauns enliven parterres, water features, and decorative buildings. The paradisiacal world of Antiquity is put at the service of absolutism: the garden at Versailles is a testimony to Louis XIV's universal claim to power. Never before or since were artistic creativity and an intellectual concept more obviously combined.

The French Baroque garden remained the accepted model for all prestigious gardens until the English landscape garden took over in the second half of the eighteenth

**La Perdrix,** *The Melancholic,* 1680, Versailles, park

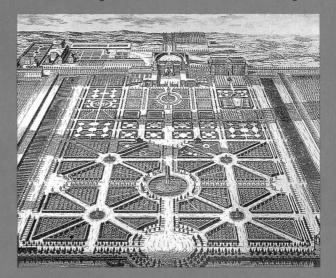

Above and p. 91 bottom: **Perronet, Martin Charbonnier et al.,** Hannover, Herrenhausen Palace and the "Great Garden", 1666–1714, engraving by J. van Sasse, 1720 (above), parterres (p. 91 bottom)

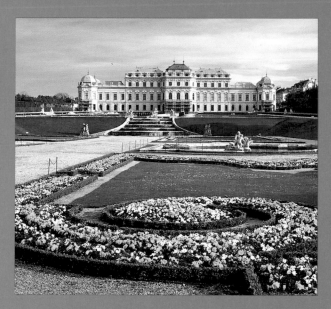

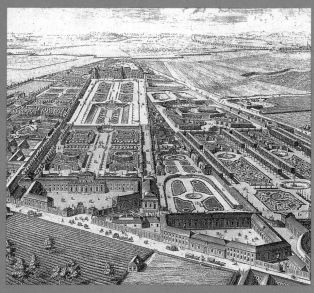

The park, which extends for several miles, is divided into three main segments. At the sides of the palace are the "King's Garden" (with an area for playing ball games) and the "Queen's Garden" (with flowers in the colors of the House of Orange). Here, arbors and pavilions invite the visitor to linger. The "Great Garden" adjoining the palace includes a lower and an upper section; it displays a variety of features such as parterres, terraces, fountains, and bosquets. Its attractive layout is enhanced by a lavish array of sculptures. The *parterres de broderie* at Het Loo are particularly elaborate, with their boxwood borders forming intricate ornamental designs.

In Vienna, the cosmopolitan field marshal Prince Eugene decided to compete with Louis XIV in the area of garden design. In addition to commissioning Johann Lukas

Left and above: **Dominique Gerard**, Vienna, the park of Belvedere Palace, 1716

von Hildebrandt to build the two Belvedere palaces (see p. 113/114), he also appointed Dominique Gerard to finalize the layout of the garden there. Gerard, a pupil of Le Nôtre, succeeded in creating a thoroughly individual work. The sloping site is skillfully exploited so as to allow the open space linking the upper and lower Belvedere palaces to be graded both architecturally and symbolically (illus. above). The visitor walks through intimate hedge thickets with lawn parterres, passes the lower waterfall with its grotto architecture, and then ascends to the second level, which features ponds and groups of statues. The large waterfall with its array of sea gods leads on finally to the high point of the complex, the Upper Belvedere. The garden and the buildings are coordinated with one another in masterly fashion.

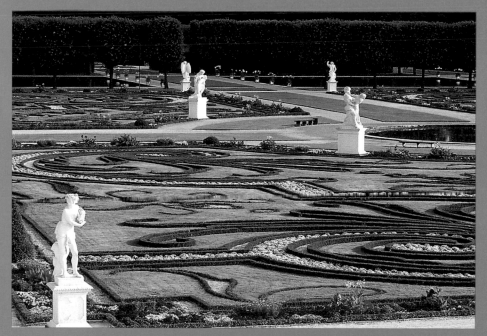

The retaining walls of the terraces are constructed so that anyone approaching will perceive them as a pedestal for the Upper Belvedere—a scenographic device of the most magnificent kind.

The Great Garden in Herren-hausen, near Hanover, represents a type of garden design that was to become standard for Lower Saxony and north-eastern Germany. This garden was laid out at the instigation of Sophia, electress of Han-over, and combines French and Dutch elements (illus. p. 90 bottom right and p. 91 bottom). The park, sur-rounded by a moat, is based on an axial plan, and features several semicircular and cir-cular open spaces. Green-houses, a garden theater, and special gardens (*jardin secret*, orchards of oranges, figs, and other fruits, and melon gar-dens) bring variety to the classical scheme.

La Granja near Segovia has the reputation of being the "Spanish Versailles." This park does indeed owe a great deal to its French model, for instance, the way it merges gradually into the open countryside and its axial layout. And, like the Versailles garden, it has a variety of parterres and is informed by an extravagant mythological and allegorical program (illus. right). La Granja does have one inestimable ad-vantage, however: Because of its vicinity to the Sierra de Guadarrama, it has an almost inexhaustible supply of water. This fact inspired Philip V's court artists (including René Carlier and Étienne Boutelou) to construct luxuriant springs, cascades, and fountains.

**La Granja de S Ildefonso,** Park, 1721–1728, effects in fall

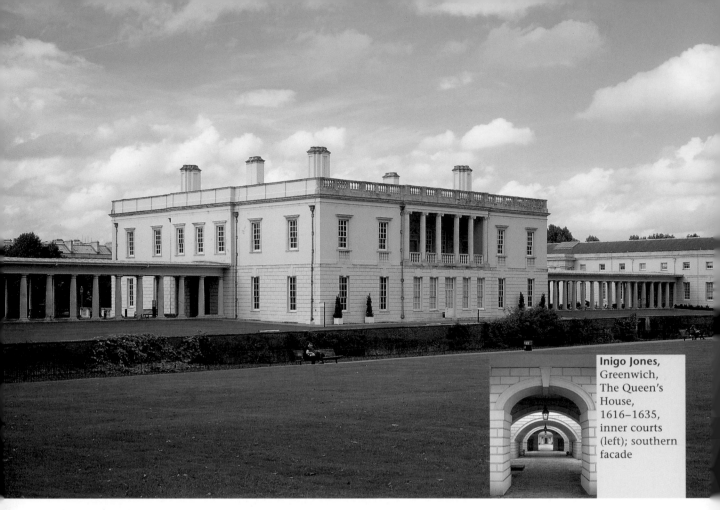

# England

In England, the Baroque era began with the "discovery" of the Renaissance. Inigo Jones, who was actually a "picture maker" (landscape painter) and stage designer, undertook journeys to Italy in around 1600 and 1613/1614 (Venice, Vicenza, and Rome), and returned home an ardent admirer of the architecture of the Vicenzan architect and theorist Andrea Palladio. Jones was fascinated by the simple harmony of Palladio's buildings, inspired by those of Antiquity. At the same time, Palladio's theoretical studies encouraged him to carry out his own research on classical architecture. The passion for this architecture, which Jones shared with the art collector and patron Thomas Howard, earl of Arundel, the first person in England to create a collection of ancient artifacts, not only influenced his own works, but was a guiding principle in English architecture up until the late eighteenth century.

In several important regards, English architecture developed independently from what was happening on the Continent. Its evolution can be roughly divided into three phases: Palladianism, which maintained its influence for more or less the first two-thirds of the seventeenth century, primarily owing to Inigo Jones; "true" Baroque, associated with Christopher Wren, which took over after the Great Fire of London in 1666; and the Neo-Palladianism of the early eighteenth century. The latter is also closely bound up with the name of one person, that of the art lover Lord Burlington. Toward the end of the century, the study of Greek Antiquity led to neoclassicism, as it did on the Continent as well. Rococo was to be no more than a fleeting episode in England.

## Inigo Jones

The experiences gathered by the stage designer Inigo Jones (1573–1652) and the Earl of Arundel on their trips to Italy brought about a fundamental re-orientation of English architecture, which still adhered to medieval or Mannerist forms.

Queen's House, the queen's palace at Greenwich, whose foundation stone was laid in 1616, clearly demonstrates this paradigmatic change. It consists of two rectangular blocks connected by a bridge (illus. opposite). The *piano nobile*, which is situated above the rusticated ground floor, opens into a wide loggia looking over the garden. The models for this palace, which could really be called a *villa suburbana*, a grand country seat, are not difficult to find: the Medici villa by Giuliano da Sangallo in Poggio a Caiano, which has the same block shape, also has a loggia overlooking the park; and the villas built by Vincenzo Scamozzi vary the theme of the garden front in a similar manner.

Further important commissions quickly followed for Jones: in 1619 the rebuilding of the Banquet Hall in Whitehall, in 1623 the Queen's Chapel, Jones's first church, and finally, Covent Garden, where Jones also had success with town planning projects. For Charles I he designed Whitehall Palace, a huge palace complex that was destroyed in the turmoil of the Civil War of 1642–1649 between crown, parliament, and puritans.

There were only a few artists that emerged from Jones's sha-

dow. One of them was Isaac de Caus, who built Wilton House with its elegant, rectangular reception rooms, the "Cube," and the "Double Cube" (illus. above).

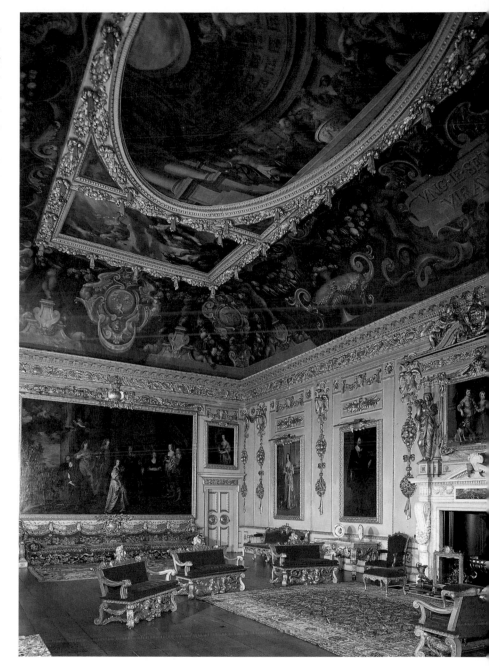

**Inigo Jones (interior) and Isaac de Caus (garden),** Wilton House (Wiltshire), begun 1632, renovated 1647 by John Webb after a fire, view of the interior room the "Double Cube"

Above: **Sir Christopher Wren,**
Hampton Court Palace, 1689–1692

Left: **Sir Christopher Wren,**
Greenwich Hospital, begun 1695

P. 97: **Sir Christopher Wren,**
London, St Paul's Cathedral,
1675–1711, west facade

## Sir Christopher Wren

Not until Christopher Wren (1632–1723) arrived on the scene did Roman-style classicism take over in England. This change was favored by two factors. The first was the political swing toward Catholicism and the second was the devastating fire that swept through London in September 1666 and laid waste to around four-fifths of the city.

King Charles II commissioned Wren and his colleagues Roger Pratt and Hugh May to come up with rebuilding proposals and a concept for the design of a modern city. The latter was never carried out, as Wren's ideas turned out to be impracticable. However the new cathedral of St Paul's, as well as 51 other churches, are for the most part the result of his efforts.

The new version of St Paul's Cathedral was heavily influenced by St Peter's in Rome. The "Great Model" of 1673 is similar in scale to Michelangelo's domed central-plan building; however, what was built in the end was a traditional longitudinal building whose most characteristic feature is the gigantic double dome over the crossing (illus. p. 97).

Hampton Court, the summer residence of the English royal family, was built at the instigation of King William III and his wife Mary between 1689 and 1692 (illus. top). The complex, which was only partially realized, was built in place of a palace that dated from Tudor times.

Wren's last work was Greenwich Hospital in Chelsea (begun 1695; illus. above). Following the model of Versailles, the wings are grouped around several courtyards built behind one another. Long colonnades form a connecting motif. The complex is finished off with picturesque buildings at the front that stand at right angles to the rest of the complex.

## Vanbrugh and Hawksmoor

Sir John Vanbrugh (1664–1726) and Nicholas Hawksmoor (1661–1736) took Wren's style and made it even more monumental, but at the same time, more picturesque. These two men with very different characters and approaches to architecture assisted Wren at Greenwich Hospital.

From 1699 they were commissioned to build Castle Howard (completed in 1712), a country seat in North Yorkshire. Vanbrugh was invited by the Earl of Carlisle to draw up the plans (illus. below). This complex *entre cour et jardin* consists of a corridor-like apartment wing, whose center is emphasized both by the salon opening onto the garden, and the large, square hall facing the courtyard. This hall makes a church-like impression with its suggestion of transept arms and massive elevated

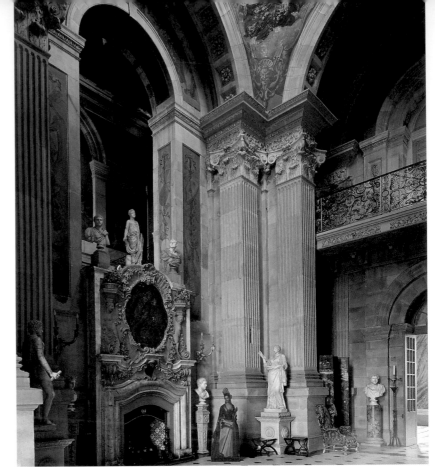

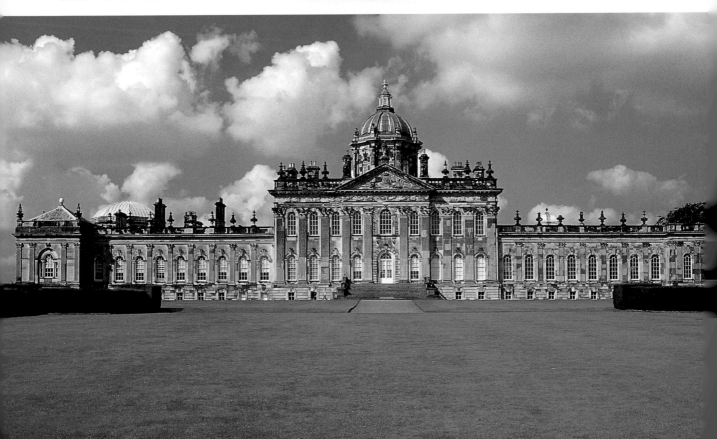

dome (illus. p. 98). Concave arcades lead to the wings containing the working quarters and stables. Its additive conception and picturesque arrangement of the different elements reflect the model of Greenwich Hospital. In the design of the garden buildings, Vanbrugh experimented with "historical" architecture, taking his inspiration from such sources as classical temples, Egyptian obelisks, Turkish kiosks and small Medieval towers. On the other hand, the mausoleum, which Hawksmoor built as a burial place for the Howard family in 1729, served as a model for the Romantic epoch.

Blenheim Palace (Oxfordshire, 1705–1725) is an even more monumental example of English Baroque palace architecture (illus. below). The palace was a present from the queen to the Duke of Malborough after his victory over Louis XIV. It was begun by Vanbrugh, but finished by Hawksmoor because of a squabble with the Duchess of Malborough. The large complex, 275 meters wide and 175 meters deep (900 x 575 ft), is built around a large main courtyard. The Great Hall and the Salon are centrally placed in its longitudinal axis, as in Castle Howard, while the Kitchen Court, Stable Court, and the corresponding facilities are in the cross axis. In contrast to the older building, the architecture at Blenheim draws on the English legacy; even its decoration expresses the national character of the monument.

Vanbrugh and Hawksmoor also gave new momentum to church architecture, which had been in a period of stagnation, by developing an enormous variety of designs.

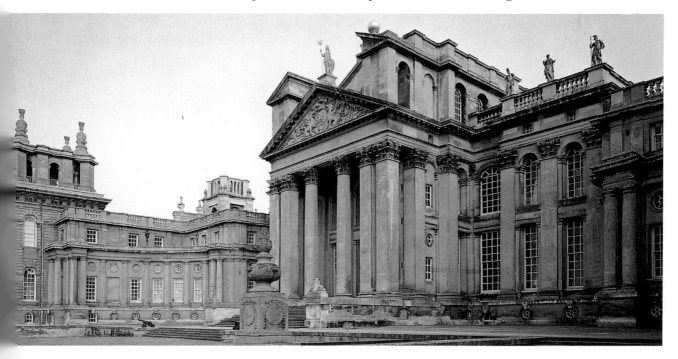

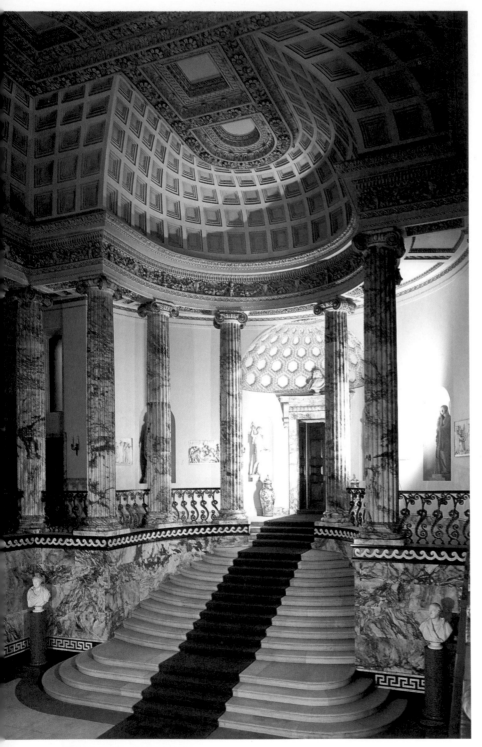

**William Kent,** Holkham Hall (Norfolk),
begun 1734, staircase

## Neo-Palladianism

The generation after Vanbrugh and Hawksmoor vehemently turned its back on the architectural concepts of Christopher Wren and his successors. This development occurred at the same time as a shift in power toward the large landowners and the upper middle classes. These architects wanted a style "founded in truth and nature," a form of architecture free of empty ostentation and quite opposed to the Roman grandeur of many of Wren's buildings.

It is certainly no coincidence, then, that a translation of Andrea Palladio's *Quattro Libri dell' Architettura*, as well as two volumes of *Vitruvius Britannicus*, all of which contained engravings of classical British buildings, appeared between 1715 and 1717. These works were published by Colen Campbell; some years later, in 1727, the drawings of Inigo Jones were also published by William Kent. Campbell and Kent were members of the circle of intellectuals associated with the art lover and architect Richard Boyle, the third earl of Burlington.

Boyle has to be seen as the real driving force behind the Neo-Palladian movement. Its goal was to return to the "right and noble rules" that were seen as having been realized in Antiquity, in Palladio's interpretation, and in the work of Inigo Jones. Thus, classical form and national tradition were the parameters that were going to determine the course of English architecture for the next several decades.

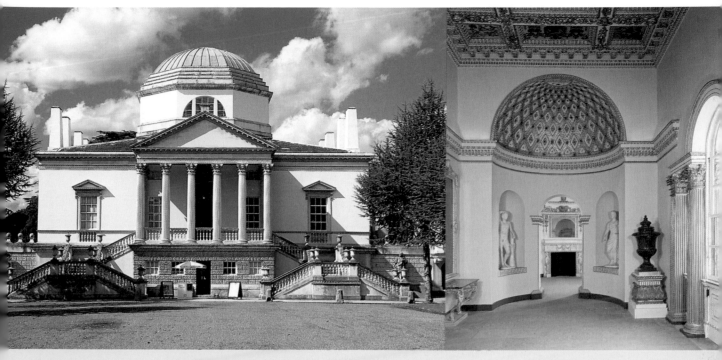

**Richard Boyle, Third Earl of Burlington,** Chiswick House (Middlesex), 1727–1729, entrance facade (left); gallery (right). With Chiswick House Burlington achieved the sublime transposition of Palladian ideas into the eighteenth century.

It was mainly secular architecture that was influenced by the concepts of the *dilettanti*, the art connoisseurs associated with Lord Burlington's circle. Burlington himself created the most sublime example of Neo-Palladian architecture. The rather modest dimensions of Chiswick House in Middlesex near London (1727–1729) already make it reminiscent of the villas in the Veneto (illus. above left). Its ground plan, a square with an octagon inserted at its center, recalls Andrea Palladio's Rotonda. A series of connected rooms surrounds the domed middle hall; toward the garden, these rooms are curved inward and extended by apses with niches for statues. Burlington based the interior on models that had been developed by Inigo Jones, who, in his turn, had adapted Palladio's concepts (illus. above right).

This country seat retains a certain intimacy despite all its extravagance. In contrast, Holkham Hall in Norfolk (begun 1734) is a monumental realization of Neo-Palladian ideals. This palace complex is probably also based on Burlington's ideas, and takes the model of Chiswick House to magnificent extremes. The high point of the complex is the entrance hall, which makes an impression on visitors similar to that of a church; its staircase, framed by columns, leads up to the *piano nobile* (illus. p. 100).

Scottish-born James Gibbs (1682–1754) was an exception among Neo-Palladian architects of the early eighteenth century and had a very individual style. He went to Rome in 1703 to prepare for the priesthood, but instead began an apprenticeship with the busy architect Carlo Fontana. Even in his first work in England, St Mary-le-Strand, Gibbs drew on Italian models—in this case, Mannerist ones. His most important work, St Martin-in-the-Fields in London, demonstrates how freely he drew upon historical models. The unconventional combination of temple facade and lofty steeple was to serve as a pattern for many parish churches in the British Isles (illus. p. 102 left).

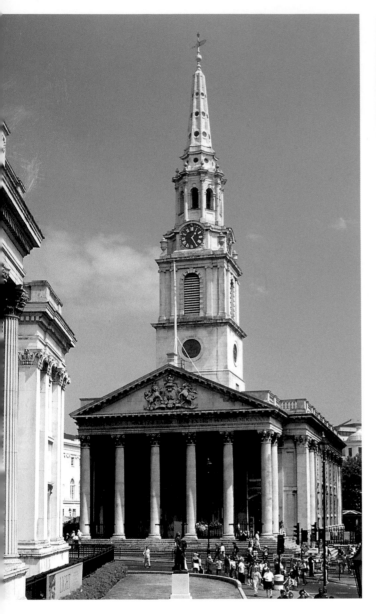

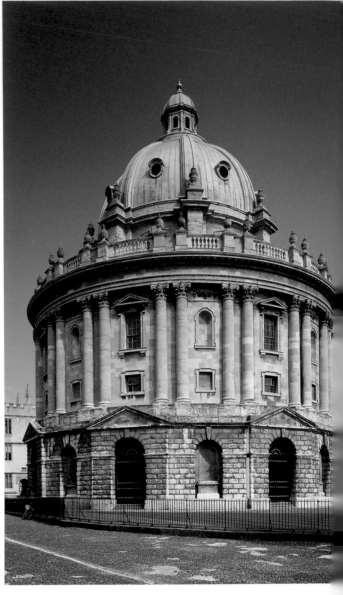

On the other hand, Radcliff Camera (1737–1749), the library at Oxford University, is completely rooted in the tradition of Italian Mannerism. The round, domed building stands on a rusticated base; double Corinthian columns structure the facade (illus. above right). Gibbs's individual style of architecture—which, however, also drew on traditional models—found many followers in conservative circles. His publications, *A Book of Architecture* (1728) and *Rules for Drawing the Several Parts of Architecture* (1732) were held in high esteem, not only in his times, but into the nineteenth century.

Bath, the English spa resort that has been famous since Antiquity for its thermal springs, became a model of urban design that integrates landscape features. From 1725 to 1782, John Wood the Elder (1704–1754) and John Wood the Younger (1728–1781/1782)—father and son—designed the center of this

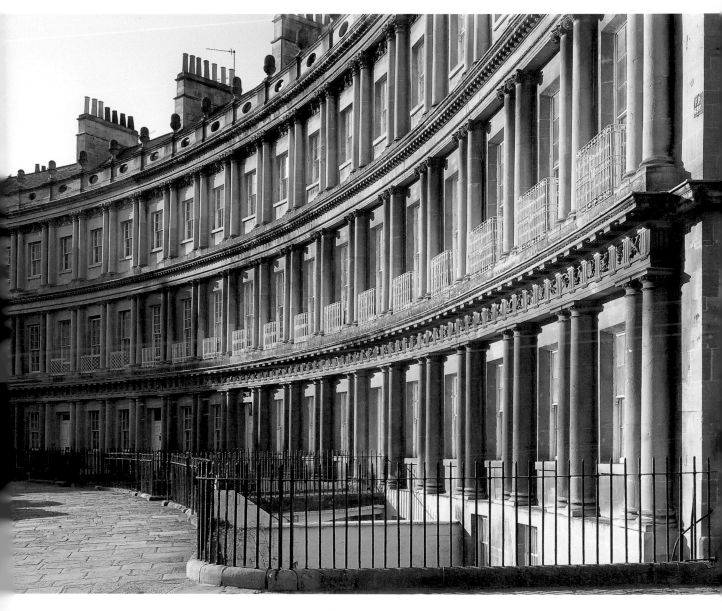

city on the Avon River according to the precepts of Palladian classicism. The mainstays of their layout are three monumental open spaces: the square-shaped Queen Square, the huge Circus with its radiating streets, and the Royal Crescent, a semi-circular complex that opens up into an expansive park and is flanked by curved connecting paths (illus. above). In its inclusion of nature, the Royal Crescent incorporates elements that almost simultaneously were determining the basic repertoire of the "English garden."

**John Wood the younger,** Bath, Royal Crescent, 1767 1775

P. 102 left: **James Gibbs,** London, St Martin-in-the-Fields, 1721–1726

P. 102 right: **James Gibbs,** Oxford, Radcliff Camera, 1737–1749

# Flanders and Holland

In the first half of the seventeenth century, Flanders flourished both economically and culturally. However, this period of prosperity gave much more momentum to the fine arts than to architecture, which remained rooted in traditional conceptions. The reason for this was the strong influence of the Counter-Reformation, which wanted to build a bulwark against Protestantism in the southern part of the (still) united Spanish Netherlands. The Netherlands' own Gothic legacy, the extremely long-lived Mannerist decorative forms, and France provided additional models. Architecture in the southern Netherlands drew on these sources without at first developing its own solutions.

The house of Peter Paul Rubens in Antwerp, which the artist himself designed, is an exception (1611–1616). This three-wing building with courtyard and garden is very irregularly constructed, and cannot be properly categorized. The facades and the fortress-like portico recall the Mannerist architecture of Italy, which Rubens had been able to study during the eight years he spent working south of the Alps. However, his series of engravings of Genoese palaces, "Palazzi di Genova" (1622), was to give more impetus to secular

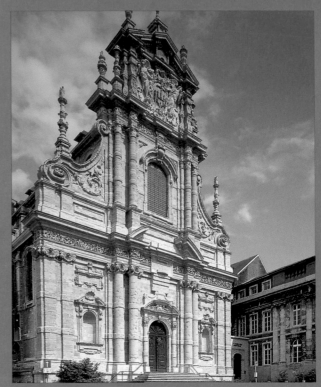

**Willem Hesius et al.,** Louvain, St Michael, 1650–1666

architecture than this example in brick and stone.

In the mid-seventeenth century, the picture changed: St Loup in Namur, the Jesuit church of St Michael in Louvain (illus. above), St John the Baptist in Brussels, and St Peter and Paul in Mechelen are all sacred buildings with extremely lavish decoration. The reconstruction of the marketplace in Brussels, which had been destroyed by French artillery in 1695, is typical of the adherence to traditional forms. The guildhouses that line it, rebuilt around 1700, are completely based on their

historical predecessors (illus. left).

The architecture of the northern provinces of the Netherlands, which were under Spanish rule until 1648, underwent a completely different development. The prevailing Calvinist faith and the decision to found the United Provinces brought about a troubled separation from the Habsburg monarchy and thus also secession from the Holy Roman Empire. This led not only to iconoclasm, but also to a fundamental change in direction for sacred architecture. Economic factors proved to be at least equally significant: In the expanding trading cities of a country that was becoming the leading maritime power, the bourgeoisie became the most important source of commissions and patronage for the arts.

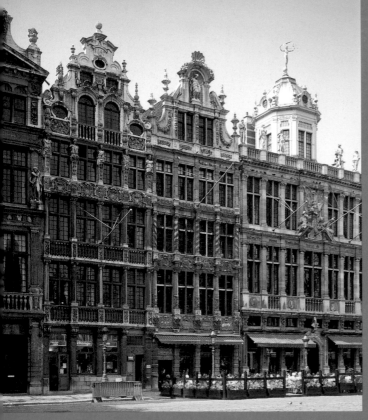

**Brussels,** facades on the Grande Place, c. 1700

**Jacob van Campen,** Amsterdam, Town Hall (now Royal Palace), begun 1648

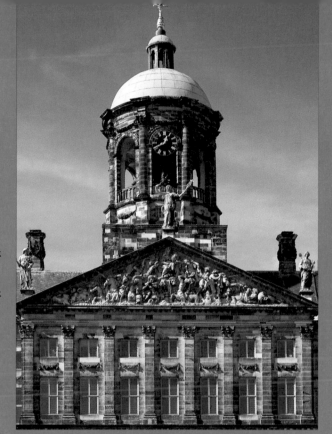

The expansion of Amsterdam, which began in 1612, was one of the first town planning projects. The "three-canal belt" and the radial plan of the extension remain impressive even today. Straight canals lined with trees and rows of houses, narrow blocks, and high brick facades are still characteristic of the city. The leading architect of this time was Hendrick de Keyser (1565–1621). His Westerkerk (illus. below left), built in 1620, and, to an even greater extent, the Noorderkerk begun in the same year (de Keyser or Hendrick Staets) embody the ideal of the Calvinist centralized church in the form that was to become accepted throughout the entire Protestant world. The main feature is the central preaching space, whose geometric elements—square, octagon, circle, or Greek cross—are arranged with deliberate sobriety and systematic clarity. In the center are the pulpit and the baptismal font, surrounded by the pews as in a theater.

In secular architecture, classical trends finally began to take over from Mannerism from 1620, influenced by France on the one hand and by English Palladianism on the other. The wealthy painter and architect Jacob van Campen (1595–1657), who probably studied in Italy, was largely responsible for their spread. The Mauritshuis (illus. right) in The Hague, which he built from 1633–1644 for the grandnephew of the Governor Frederick Hendrick, Johan Maurits, Count of Nassau-Siegen, became the model for many prestigious city and country residences. The block-like building is set atop a high base and structured by an Ionic colossal order with pediment; on the main front this is presented as a three-bay projecting section. The contrast between light-colored rough stonework and dark-red brick, and especially the hipped roof, give this palace its typical "Dutch" appearance. Van Campen's masterpiece is the Town Hall of Amsterdam (now the Royal Palace; illus. left). Work on it started immediately after the signing of the Peace of Westphalia in 1648. Its ground plan is an oblong with the monumental, church-like "citizens' hall" at its center. The imagery here is an eloquent testimony to the way the people of Amsterdam saw their city and country: The world is at the city's feet as the gods proclaim the fame of the young republic.

Toward the end of the seventeenth century, a French-influenced Baroque classicism began to prevail in the Netherlands, as elsewhere. This process was furthered by Huguenot architects who had left their native country after the Edict of Nantes was revoked and found employment in all the royal houses because of their high qualifications.

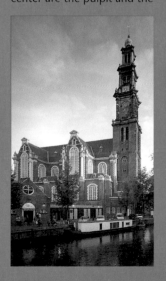

**Hendrick de Keyser,** Amsterdam, Westerkerk, 1620

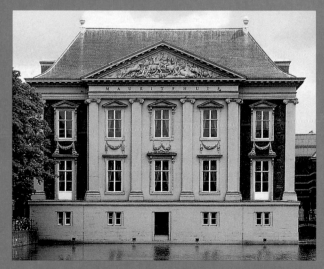

Right: **Jacob van Campen,** The Hague, Mauritshuis, 1633–1644

# The German Empire

## The Beginning

The German Empire, which in the Baroque era covered large parts of central, central-eastern and south-eastern Europe, embraced the stylistic ideas coming from Rome all at once. The Jesuit church of St Michael in Munich, founded by Duke William V of Bavaria, was a powerful demonstration of the tendencies current in the Counter-Reformation. It introduced the vaulted architecture modeled on Antiquity to the countries north of the Alps. This church, the first building of German Baroque, is the work of an unknown archi-tect. St Michael combines the uniform spatial structure of the Gesù in Rome with the German pilaster church; the large, hall-like nave is covered by a 20-meter (60-ft)-wide barrel vault resting on the walls and the barrel vaults of the chapels and galleries on the sides. The large amount of light coming in from outside and the white decoration give the interior a radiant, festive appearance. The facade, decorated with numerous statues, makes the building look like a city residence; in it, one can still clearly see the transition from the Renaissance to the Baroque (illus. below left).

The style of the Baroque pilaster church was developed further in other Jesuit churches in Dillingen (1610–1617), Eichstätt (1617–1620), and Innsbruck (1619–1621). After the end of the Thirty Years' War, it reached its zenith in the architecture of the Late Baroque.

The rebuilding of Salzburg cathedral, begun in 1614 by Santino Solari, displayed a different tendency. Its ground plan is a combination of the domed basilica and the three-conch church (illus. p. 107 right), probably a reminiscence of the Romanesque building that preceded it. The emphasis here is on the decora-

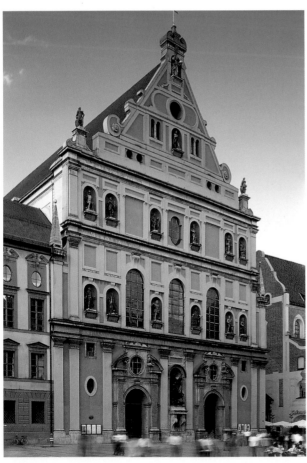

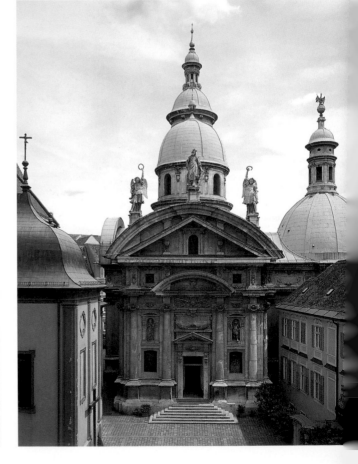

tion of the interior, with lavish stucco work articulating the architectural structure, a feature that also reached its peak of maturity in the eighteenth century.

The mausoleum of Ferdinand II in Graz (p. 106 right), which Pietro de Pomis began in 1614, became a milestone in Baroque memorial architecture. This group of buildings, consisting of a cross-plan church and an oval-domed building, was a completely independent attempt to reconcile medieval types of building with modern stylistic concepts.

With the City Hall in Augsburg (illus. below left), built from 1615 to 1620, Elias Holl created the most important secular building of the early German Baroque. The exterior of this block-like building is impressively clear-cut, almost vapid, but it houses a magnificent interior. Behind the projecting middle section of the tripartite facade, the "Golden Hall," with its beautifully decorated wooden ceiling, extends over three floors—a masterwork of structural engineering.

The start of the Thirty Years' War put an abrupt halt to this brilliant first flowering of Baroque architecture in the German Empire. The crisis into which central Europe was plunged after 1618 prevented any continuous development of the new style. This religious war split Europe into Catholic and Protestant blocs; regional, political, and economic contrasts broke down. The arts were one of the main areas to be affected by this conflict. After the war, it took a long time before the right conditions for large building projects could be re-established. However, the German territory was now divided into the Protestant north, which favored a type of classicism imported from France and Holland, and the Catholic south, which was closer to the Italian Baroque.

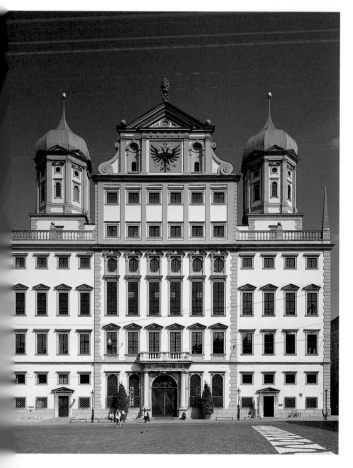

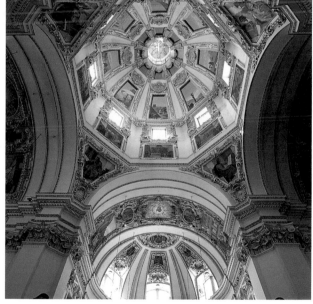

P. 106 left: **Munich, St Michael,** 1583–1597

P. 106 right: **Pietro de Pomis(?)**, Graz, Mausoleum of Ferdinand II, south of today's dome, begun 1614, completion of the interior by J. B. Fischer von Erlach, after 1687

Left: **Elias Holl,** Augsburg, City Hall, 1615–1620

**Santino Solari,** Salzburg, cathedral, begun 1614, view eastward into the crossing dome and three adjoining apses

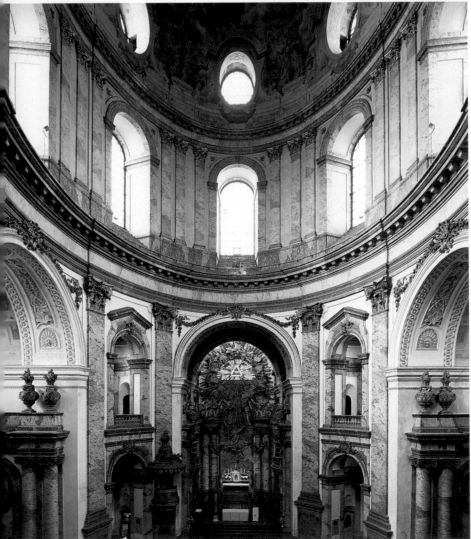

# J. B. Fischer von Erlach and J. L. von Hildebrandt

Johann Bernhard Fischer von Erlach (1656–1723) and Johan Lukas von Hildebrandt (1668–1745) were the leading architects of the German Empire. Their works combine Roman grandeur and the picturesque decoration favored by Viennese society, and influenced architecture throughout Europe.

Although they were of different temperament, both men had studied in Rome with Carlo Fontana before settling in Vienna. Fischer, from Graz, moved there in 1686/1687; Hildebrandt, who was born in Genoa, in 1701. Fischer quickly took up contact with the court. In 1689 he began teaching architecture to the future emperor, Joseph I, and in 1696 he became the first German artist to receive a title, from then on adding "von Erlach" to his name. He had an extensive all-round education, which he deepened still further through his contact with Gianlorenzo Bernini, the Jesuit priest Athanasius Kircher, and the art scholar Pietro Bellori. The fruit of this learning was the treatise *Entwurff einer historischen Architektur* (A Plan of Civil and Historical Architecture, begun 1705, published 1721), the first comprehensive architectural history of the world, which treated Egyp-

**Johann Bernhard Fischer von Erlach,**
Salzburg, University Church,
1694–1707 (above left);
Holy Trinity Church, 1694–1702
(above right);
Vienna, Karlskirche (St Charles),
1716–1737, interior (left)

tian, Chinese, and other "exot-
ic" monuments (see p. 68/69).

Fischer's early buildings are
clearly influenced by the works
of Bernini and Borromini. His
three churches in Salzburg—the
Holy Trinity Church (1694–
1702, illus. p. 108 top right),
the University Church (1694–
1707, illus. p. 108 top left) and
the Ursulinenkirche (now St
Mark's, 1699–1705)—consist of
clearly defined cubic elements
with a dynamic forward thrust.
Like their Roman models, they
are integrated into the urban
landscape—archbishop Johann
Ernst, Count von Thun, who
commissioned them, wanted to
turn Salzburg into the "Rome of
the north."

Hildebrandt's style took a dif-
ferent turn. Whereas Fischer gave
the space as a whole a dynamic
energy, Hildebrandt enlivened
the individual wall surfaces in
an extremely attractive fashion,
and thus declared himself a
typical architect of the Régence
and Rococo. The Piarist Church
in Vienna (plan 1698, built from
1716; illus. right) is a good illus-
tratiuon of his ideas.

In Vienna, these two architects
were direct rivals. Although Hil-
debrandt was the director of the
Court Planning Office from 1711,
it was Fischer von Erlach who
built the emblematic architec-
tural work of the Austrian Habs-
burgs: the Karlskirche.

Fischer worked out a concept
that combines a votive church—
the pledge to build it was made

**Johann Lucas von Hildebrandt,**
Vienna, Piarist Church, designed
1698, begun 1716

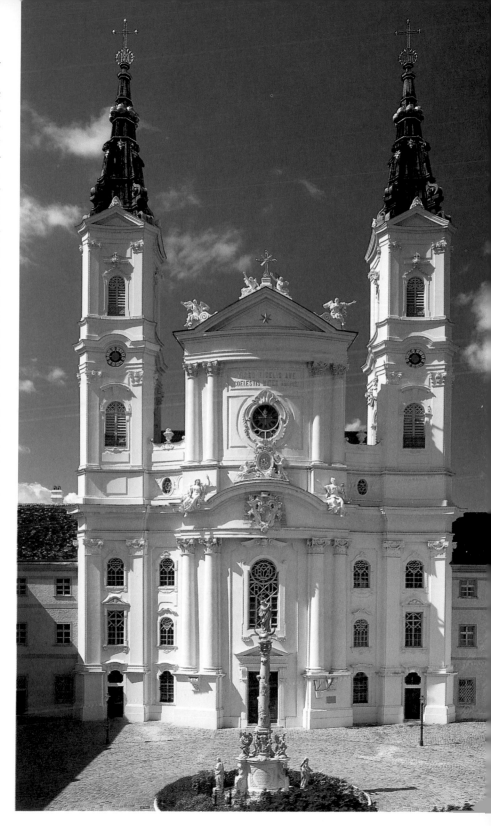

during the year of the plague in 1713—with imperial grandeur: a sacred monument of the *pietas Austriaca* (illus. right). The building is dominated by the high, elevated dome that spans the oval interior. The dome rises up picturesquely behind a classical portico framed by two Roman-style triumphal columns and low side towers. The two spiral columns are an allusion to the Temple of Solomon and the Pillars of Hercules, the emblem of the House of Habsburg. The facade is a splendid example of complex architectural iconography. It evokes the political dimension of the empire—its ancient roots and the emperor's claim to Spain. Here, Fischer von Erlach created a truly "historical" form of architecture in a spectacular variation on his Salzburg churches. The broad front of the Karlskirche is, admittedly, no more than a magnificent facade. Behind its expansiveness is concealed a far narrower church interior in the form of a longitudinal oval, which is, however, very lavishly decorated (illus. p. 108).

The Imperial Library, Vienna, one of the most superb interiors of the Baroque and the second-oldest secular example of this type of building (Wolfenbüttel has the oldest), was built by Fischer von Erlach in the final years of his life (illus. p. 111). The library was originally planned as part of a magnificent extension of the imperial palace, which was stopped by the war against the Turks. The library, based on plans by Fischer, was the only building completed;

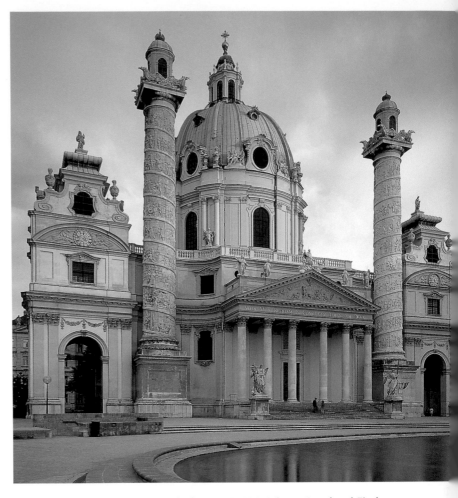

**Johann Bernhard Fischer von Erlach,** Vienna, Karlskirche, 1716–1737

P. 111: **Johann Bernhard Fischer von Erlach,** Vienna, Imperial Library, 1723–1735

Fischer's son Joseph Emanuel (1693–1742) finished the work after his father's death in 1723. Whereas the exterior shows a leaning toward French architecture, Fischer once again chose an oval as the basic shape for the interior, a form he had already used to great effect in his churches. In the Imperial Library, two barrel-vaulted rooms are built onto the central domed space; one is dedicated to the science of peace, and the other

to the science of war. Corinthian double columns are used to divide off these rooms, again a reference to the Pillars of Hercules. The complex allegorical pictures and sculptures are based on the themes of war and peace exemplified by the two side wings of the library; they were executed by Daniel Gran according to a concept by the court scholar Conrad Adolph von Albrecht. They culminate in the glorification of Charles VI: A statue

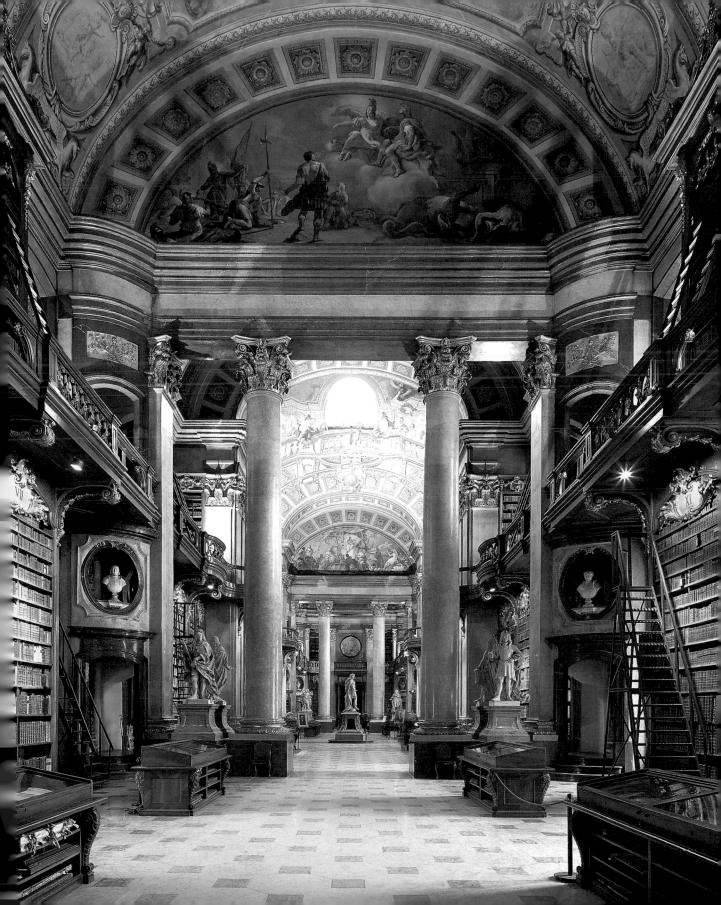

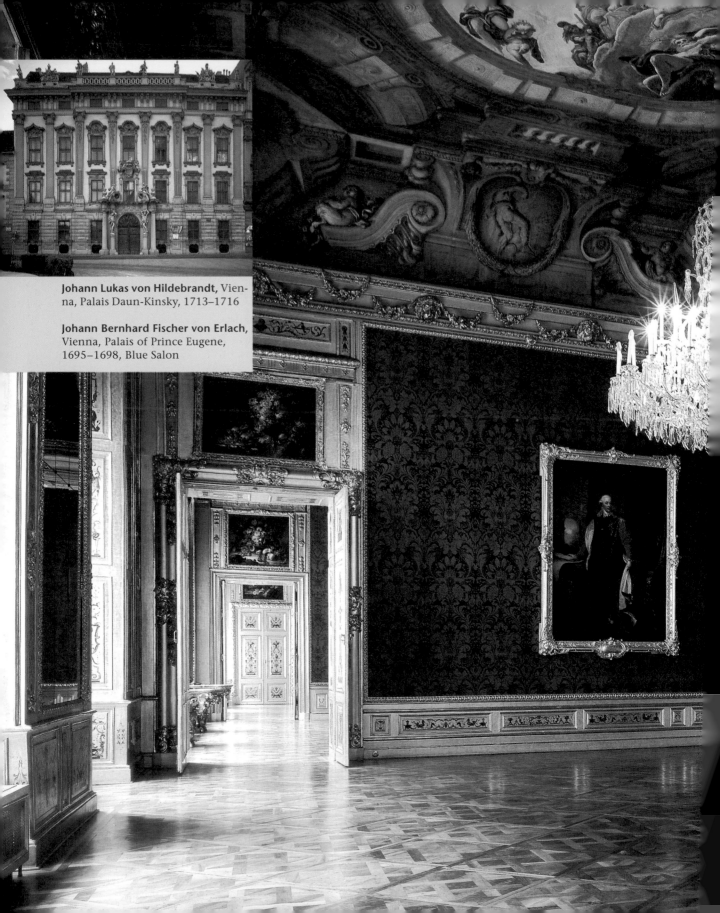

**Johann Lukas von Hildebrandt,** Vienna, Palais Daun-Kinsky, 1713–1716

**Johann Bernhard Fischer von Erlach,** Vienna, Palais of Prince Eugene, 1695–1698, Blue Salon

of the king as Hercules Musarum was set up in the middle of the oval, and his apotheosis is the subject of the dome fresco.

Fischer and Hildebrandt also vied with one another in their buildings for the Viennese aristocracy. A significant example is the Palais of Prince Eugene. The prince had at first commissioned Fischer to build his winter palace in Himmelpfortgasse (illus. left). Fischer designed the core building with its seven-window front, splendid halls, the plastically accentuated facade, and the mythological reliefs in the portico. His epochal achievement was the conception and construction of the elegant staircase. It is lined by sculptures glorifying the deeds of the famous prince, who takes his place among the heroes—a feature that occurs again in the Upper Belvedere. Around 1700, however, the prince decided on a radical change of plans and an extension of the building, and entrusted Fischer's rival Hildebrandt with these tasks.

However, Hildebrandt's most important city palace is probably the Palais Daun-Kinsky, which was built between 1713 and 1716 for Imperial Count Daun. Here, the architect abandoned the usual projecting middle section on the main facade. Instead, he emphasized the entrance with a protruding concave portal with a burst pediment (illus. p. 112 top). The entablature is carried by atlantes, and there are allegorical figures on the fragments of pediment that bear witness to the virtues of the owner.

113

## The Belvedere

Prince Eugene, field marshal and diplomat, was also an art patron and collector. After his victory over the Turks near Zenta (1697), he had two unique palaces built in Vienna: the winter palace that has already been mentioned, which was begun by Fischer von Erlach and extended by Hildebrandt, and the Belvedere summer palace, for which Hildebrandt alone was responsible. The terracing of the hilly site on Rennweg began before 1700, and the work on the Lower Belvedere was carried out from 1714 to 1716. The palace is designed as a single long building, an original combination of residence and orangerie. Only the three middle sections have two floors; here one finds the splendid Marble Hall with its extravagant allegorical decorations.

The Upper Belvedere was at first intended only as the architectural climax of the park. However, the building Hildebrandt erected from 1721 to 1722 became the crowning achievement of European palace architecture. A mighty architectural backdrop towers up at the top of the ascending terrain; its outline rises impressively toward the middle section, whose arches open onto the lake. A wealth of relief decoration adorns the facades. With this arrangement based on the combination of various independent elements, the French pavilion system made its debut German architecture.

The building barely has any depth, but it still possesses a magnificent interior: The visitor

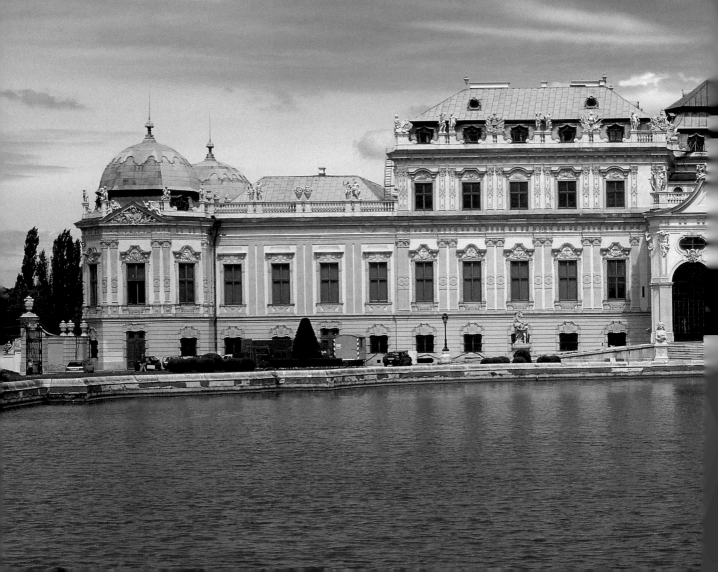

first encounters a stairway decorated with trophies, the prelude to the prince's "Miraculous War and Victory Camp" that is the theme of the entire building. From here, one ascends into the Great Hall or goes down into the *Sala Terrena*, whose vaults are supported by powerfully muscular atlantes.

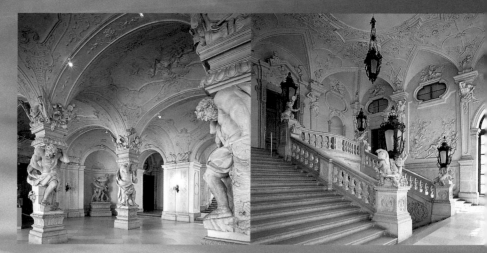

**Johann Lucas von Hildebrandt,** Vienna, Upper Belvedere, 1721/1722, *Sala Terrena* (right) and staircase (far right)

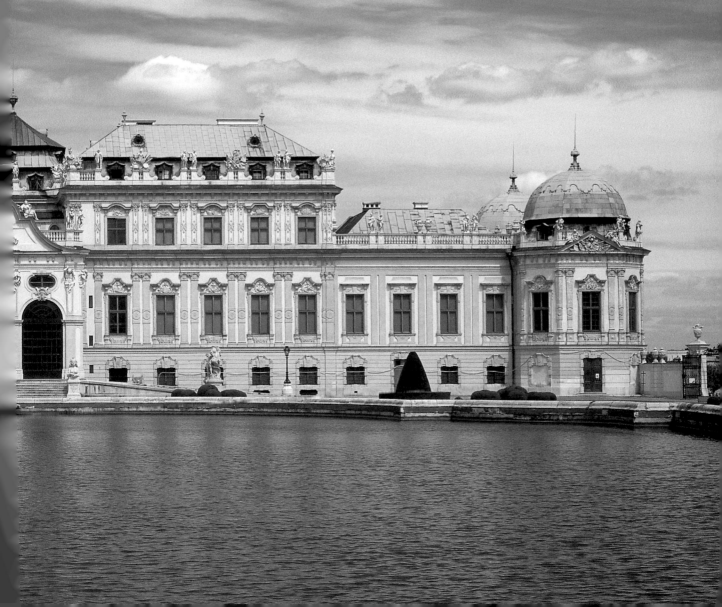

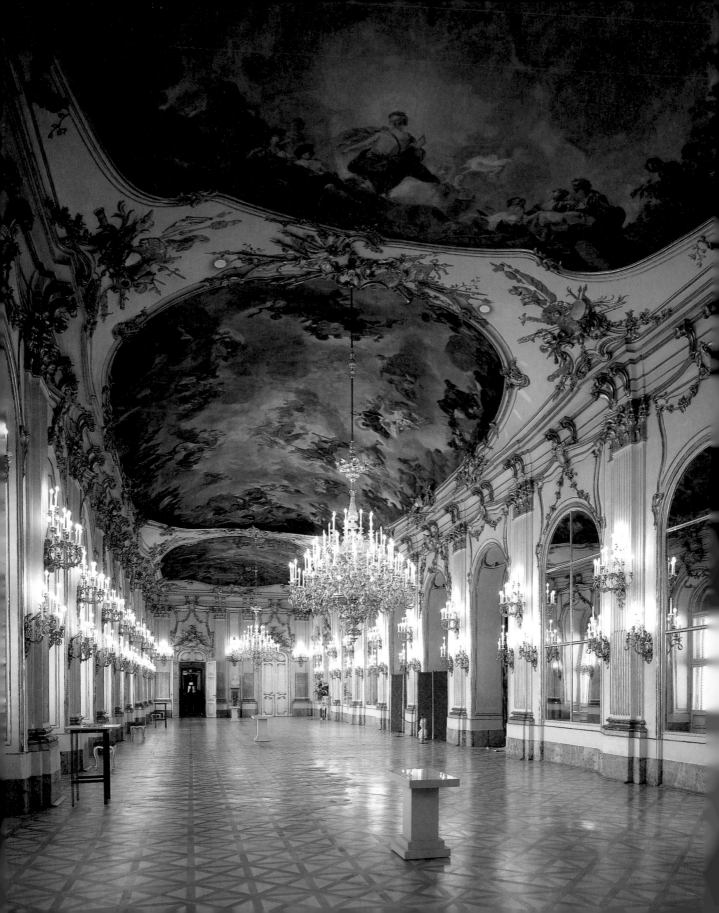

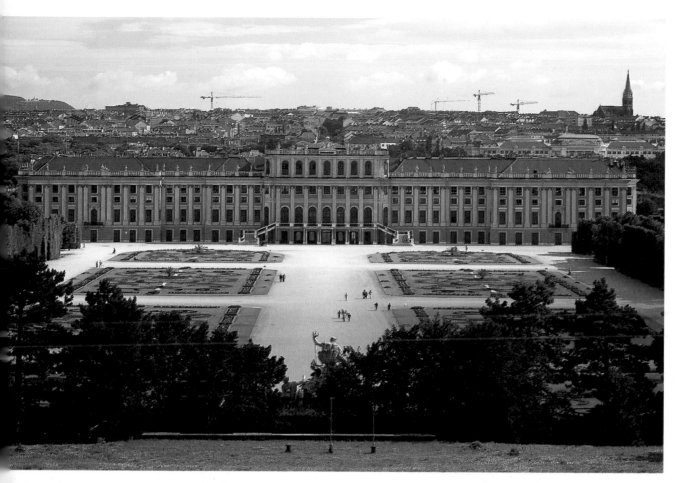

P. 116 and above: **Johann Bernhard Fischer,
Joseph Emmanuel Fischer von Erlach and
Nikolaus Pacassi,** Vienna, Schloss Schönbrunn,
begun 1696, alterations 1735 and 1744/1749,

Great Gallery with frescoes by
Gregorio Guglielmi, 1760 (p. 116),
garden facade (above)

## Schloss Schönbrunn

If Schloss Schönbrunn had been built according to the ideas of Fischer von Erlach, it might have surpassed even Versailles. The plan for a summer palace on a sloping site dates from 1688. The building was to be the "epitome of imperial architecture" and was intended to proclaim the fame of Emperor Leopold I throughout the world: a huge complex from which the gaze could roam as far as Hungary.

However, a growing number of voices demanded that this magnificent first plan remain only an idea. Perhaps, however, it was only the empty state coffers that made it necessary to find a "more modest" solution. In any case, Fischer produced some altered plans that were carried out between 1696 and 1713. And even this building—whose plan is contained in Fischer's book *Ein Entwurff der historischen Architektur*—underwent some con-

siderable alterations under Empress Maria Theresa; for example, Fischer's central domed hall was destroyed by the insertion of galleries. The garden facade seen today in the version by Nikolaus Pacassi (illus. above). The interior decoration is also for the most part from the era of Maria Theresa; for instance, the Great Gallery contains frescoes by Gregorio Guglielmi extolling the glory of Austria and its provinces (illus. p. 116).

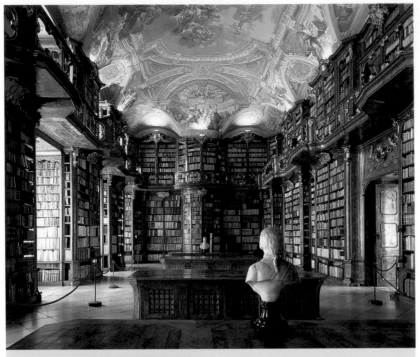

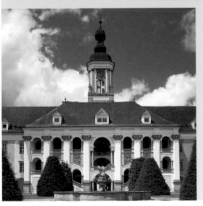

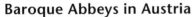

**Carlo Antonio Carlone and Jakob Prandtauer,** St Florian, Augustine monastery and collegiate church, 1686–1724, library, 1718–1724 (above); staircase, 1706–1714 (left). The staircase of the Augustine monastery St Florian is among the most elegant of its kind. It was begun by Carlo Antonio Carlone and continued after his death in 1708 by Jakob Prandtauer. Prandtauer's greatest contribution is to the big Palladio motif in the center axis.

## Baroque Abbeys in Austria

The splendor of the palaces could not fail to influence the architecture of convents and monasteries; the prelates of important abbeys were keen on pomp and patronized architecture in the same way that secular rulers did. A splendid example of this is the Benedictine abbey of Melk on the Danube, where Abbot Berthold Dietmayer had

his architects and sculptors create a Baroque masterpiece integrating several art forms.

In 1701 Dietmayer commissioned the Tyrolean sculptor and architect Jakob Prandtauer (1660–1726) to rebuild the historic fortified monastery. The abbot and the architect created an ensemble that is unique in its integration into the landscape, its functionality, and its

evocation of tradition. The picturesque facade of the domed church with its two towers rises up majestically over a steep spur above the Danube Valley (illus. above). In front of it is a balcony that provides a magnificent view of the surrounding countryside, framed by the architecture. The 240-meter (750-ft)-long front of the abbey faces the south and is designed to be

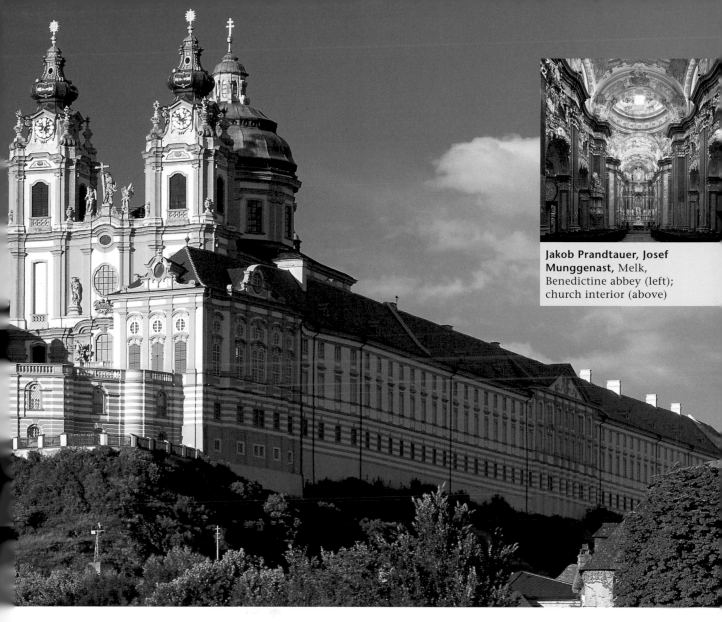

**Jakob Prandtauer, Josef Munggenast,** Melk, Benedictine abbey (left); church interior (above)

visible from a great distance. Behind this facade are the splendid Marble Hall and the Imperial Chambers, which were furnished in such a way as to impress high-ranking visitors. The library is situated on the north side of the ridge; its opulent decoration evokes the triumph of divine wisdom. The vibrant architecture of the abbey church, on the other hand, is enhanced by scenes from the life of St Benedict (illus. above right). This spiritual center in the west is opposed in the east by the extensive prelate's courtyard and the working quarters. The center of the abbey is the prelature, the residence of the abbot. Neither Dietmayer nor Prandtauer lived to see the completion of this ambitious project; Abbot Adrian Prieml and Prandtauer's pupil Josef Munggenast finished the work.

In addition to Melk, Prandtauer was also responsible for other important monasteries, including Kremsmünster and St Florian in Upper Austria, where he completed the open staircase of the architect Carlo Antonio Carlone (1635–1708) from 1708 until 1714, and built the magnificent marble hall (1718–1724).

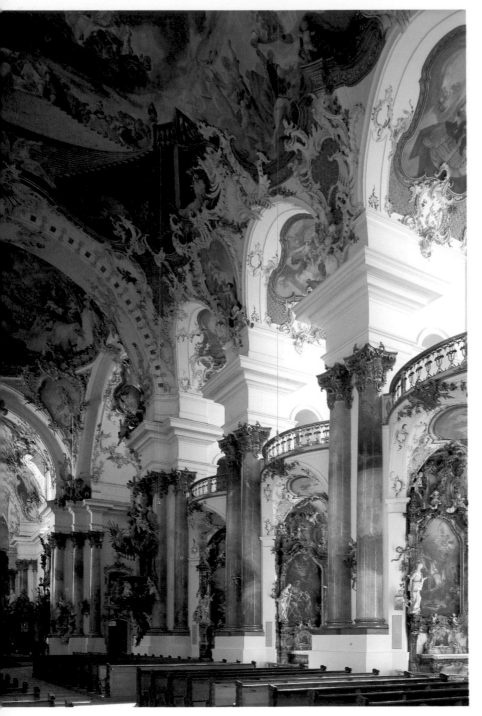

**Michael Johann Fischer,**
Benedictine church, Zwiefalten,
1738–1765, interior

P. 122/123: **Wiblingen near Ulm,**
library of the former Benedictine
monastery with frescoes by Martin
Kuen, 1744

## Baroque and Rococo in Swabia

The Swabian region has produced many extraordinary buildings, particularly in the field of church and monastic architecture. Anyone who has visited the pilgrimage churches of St Peter and Paul in Steinhausen or Unsere Liebe Frau (Our Blessed Lady) in Birnau (illus. p. 6) is unlikely to forget the overwhelming impression made by the brightly-lit interiors and the perfect interplay of architecture and decoration.

The enormous upsurge that took place in southwestern German church architecture was mainly due to the representatives of the Vorarlberg school of architects. Together with the stucco workers from Wessobrunn, they determined the course of architecture in the region. The Vorarlberg architects, whose bible was the *Auer Lehrgänge*, a two-volume book containing both theoretical and practical examples, favored pillared hall churches with chapel niches and galleries. This type of church had been derived from the Jesuit architecture of the sixteenth century; now, it was adapted to the style of the Late Baroque. A typical feature is the gleaming, light-colored stucco decoration, which effectively emphasizes the structure of the room. The clear longitudinal layout of the buildings gradually gave way to centralizing and vibrant spaces that were more in the Rococo style.

The monastic church of Weingarten, which Caspar Moosbrugger built in collaboration with Donato Giuseppe Frisoni from

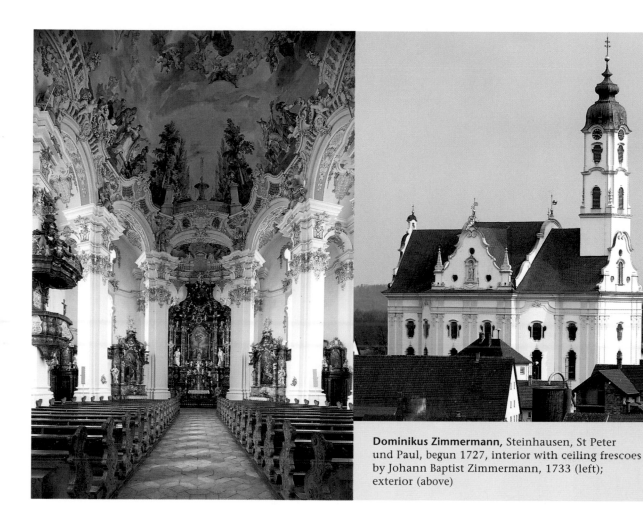

**Dominikus Zimmermann,** Steinhausen, St Peter
und Paul, begun 1727, interior with ceiling frescoes
by Johann Baptist Zimmermann, 1733 (left);
exterior (above)

1715 to 1723, forms the central point of an extensive monastery complex that was never completely finished. It displays the twin-towered facade favored by the Vorarlberg architects, together with the projecting, convexly curved middle section that Fischer von Erlach introduced in Salzburg. The noble lines of the interior are emphasized by white stucco; the illusionistic ceiling paintings by Cosmas Damian Asam extend its architecture into the heavenly spheres.

Festive white is also a dominant feature in the pilgrimage church of Steinhausen. It was built from 1727 to replace an older building. Dominikus Zimmermann (1685–1766) gave it the shape of an ellipse; it contains ten freestanding pillars that support the coved vault with its frescoes (illus. above). In the Benedictine church of Zwiefalten (1738–1765), Johann Michael Fischer (1692–1766) created "a truly magnificent series of rooms full of picturesque vitality" (Georg Dehio; illus. p. 120).

The epitome of Upper Swabian architecture and decoration is reached in Birnau on Lake Constance, where Peter Thumb, with the sculptor and stucco worker Joseph Anton Feuchtmayer (1696–1770), designed an extravagant and magnificent artistic whole (illus. p. 6).

The standards set in the field of church architecture applied even more strongly to monastic libraries as temples of knowledge. In Wiblingen, near Ulm, one of the most impressive libraries of its time is preserved (architecture Christian Wiedemann [?], frescoes Martin Kuen, 1744, illus. p. 122/123).

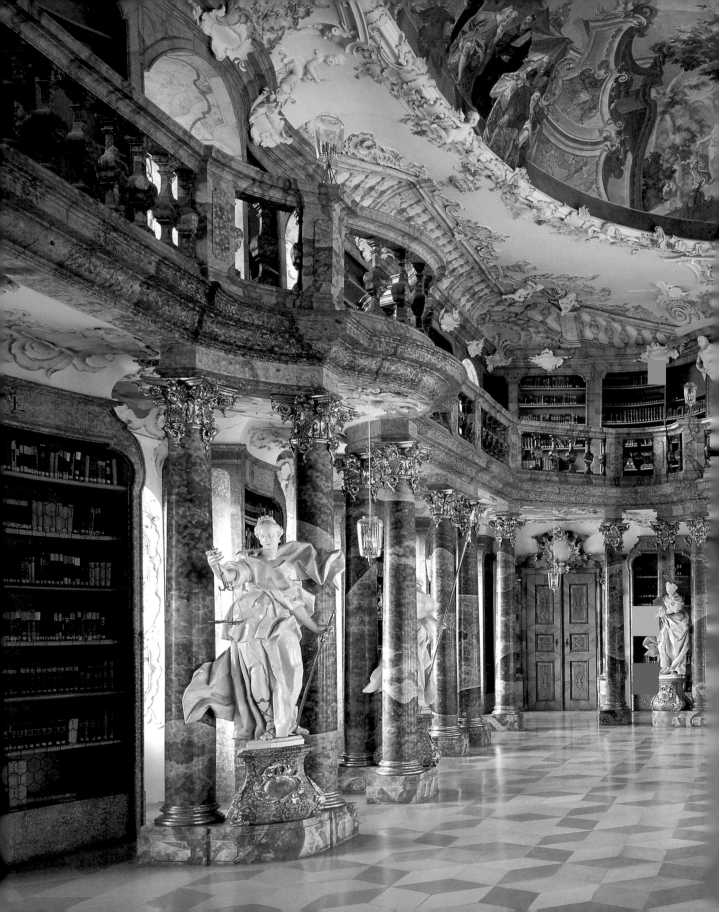

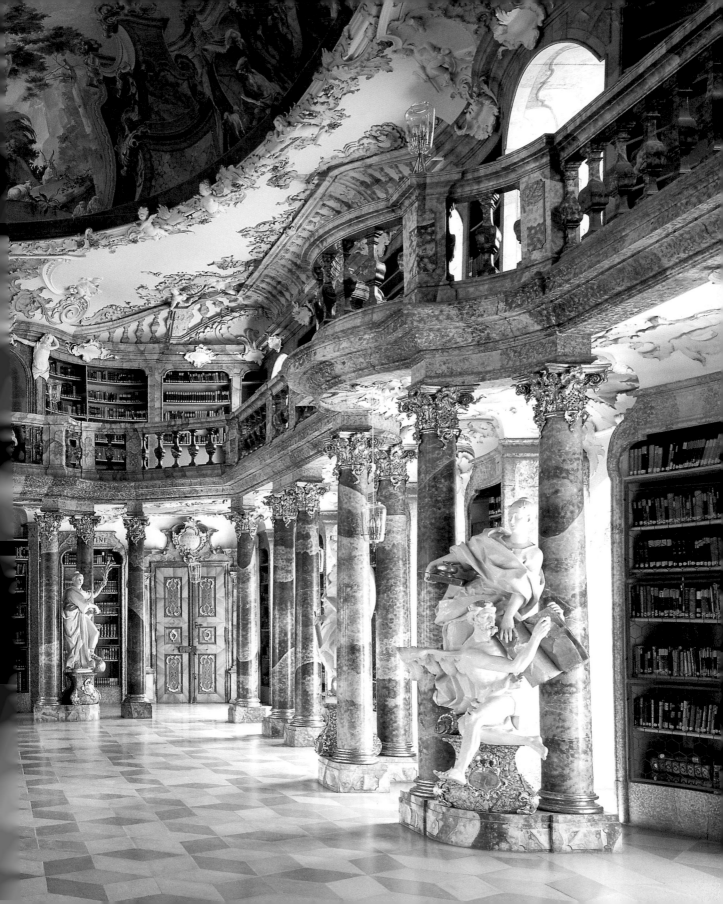

# Switzerland

Swiss Baroque architecture was influenced by many styles—differences of confession and regional contrasts left clear traces, especially in the seventeenth century. At the beginning of the eighteenth century, the powerful Late Baroque style of the Vorarlberg school began to prevail. Its characteristics are the pillared hall church, the twin-towered facade, and stucco decoration that complements the architecture. The collegiate church in Solothurn, which was built from 1680 to 1689 under the direction of the Jesuit architect Heinrich Mayer, set the stage for the successful further development of the Vorarlberg style of architecture in Switzerland (illus. right). In the abbey church in Einsiedeln, the pillared hall church already incorporates ingenious variation. When rebuilding it, Kaspar Moosbrugger (1656–1723), from Au in the Bregenz Forest, devised a complex spatial structure combining various liturgical requirements. Einsiedeln was an important place of pilgrimage due to its Black Madonna, a statue reputed to have miraculous powers. In the church (begun 1719), the architect created a magnificent synthesis of central-plan and longitudinal spaces. Behind the outwardly curved twin-towered facade is an octagon containing the Lady Chapel, followed by the transept-like preaching space and the light-filled area under the dome with Cosmas Damian Asam's monumental *Nativity of Christ*. An illusionistic choir screen divides the public area from the choir, a longitudinal room that had already been built by Hans Georg Kuen from 1674 to 1680 and

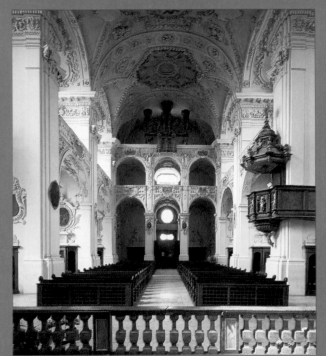

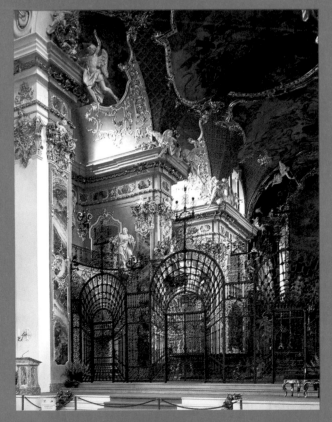

was further altered by the addition of the upper choir and sacristy in around 1750.

Moosbrugger built many other monasteries, including Weingarten in Swabia, Disentis, and Muri. His plans for the Benedictine church in Sankt Gallen (1721) were rejected, however, along with those of several other architects. In the end, Peter Thumb (1681–1766) was appointed to the task (from 1761). Again, the combination of a longitudinal and a central-plan space is the dominant feature, which in this case also affects the exterior of the building. However, the rotunda that cuts through the middle of the nave is barely perceptible from inside (illus. p. 125 top left). The pilasters are nearly freestanding, which creates a surprisingly expansive impression. The animated facade with its two towers was built in collaboration with the sculptor Joseph Anton Feuchtmayer, while the profusely decorated library was created by Thumb, Gabriel Loser (*boiserie* = wood paneling) and Johann Georg and Matthias Gigl from Wessobrunn (stucco work; illus. p. 125 top right and bottom).

Above: **Heinrich Mayer,** Solothurn, Jesuit church, 1680–1689

Left: **Hans Georg Kuen, Kaspar Moosbrugger et al.,** Einsiedeln, Benedictine abbey, newly planned after 1691, built after 1719, view of the abbey church's choir, built after 1674

P. 125: **Peter Thumb,** St Gallen, abbey church, 1755–1766, interior (left); exterior (right); library with furnishings by Gabriel Loser (bottom)

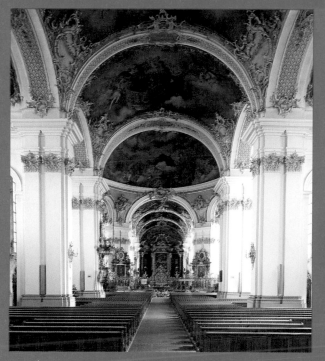

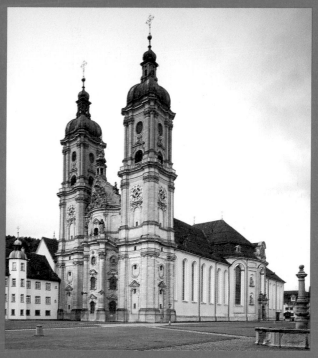

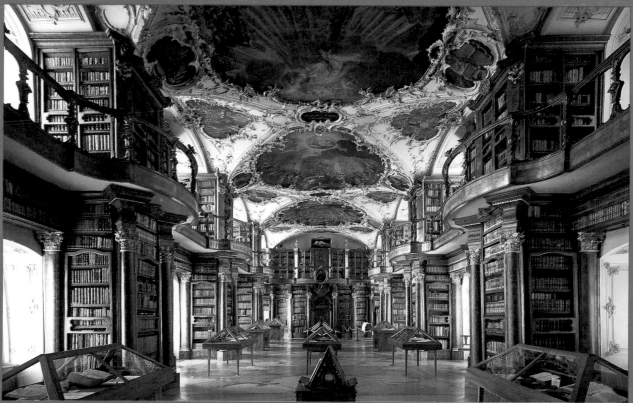

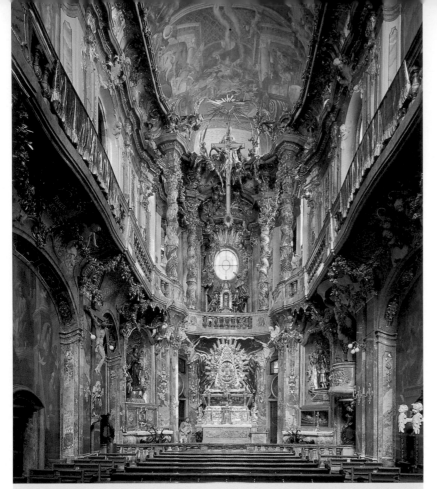

## Baroque and Rococo in Bavaria

Baroque and Rococo architecture in Upper Bavaria is just as spectacular as that in Swabia. Here, too, Vorarlberg architects and stucco workers from Wessobrunn worked together. One of the earliest examples of their collaboration, St Lorenz in Kempten, is on Bavarian soil. But this staid work of Michael Beer was to have far less influence on future developments than the elegant style of Johann Michael Fischer: the collegiate church in Diessen on Lake Ammer (1732–1739) shows his supreme skill in composing lively, elegant facades (illus. p. 127 top).

The brothers Cosmas Damian Asam, architect and painter (1686–1739), and Egid Quirin Asam, sculptor and stucco worker (1692–1739), were doubtless the most talented and versatile artists of the German—if not the European—Rococo. They studied in Rome, then returned to Bavaria in 1714, where their scenographic, mystical masterworks fusing reality and illusion can be found in many places. They combined genres and used every technical and decorative means to create what was later considered the epitome of the Baroque *gesamtkunstwerk*, a total work of art in which all the major art forms are inseparably integrated into one overarching effect.

Only the most important of the Asams's works can be listed here, such as the dramatic representation of St George, and the dome frescoes in the abbey

**Egid Quirin Asam and Cosmas Damian Asam,** Munich, St Johann Nepomuk, also called Asam church, 1733–1746, interior (above); facade (right)

The so-called Asam church was built as a private donation of the sculptor Egid Quirin Asam next to his family's dwelling in Sendlinger Strasse. Its interior is presented according to Bernini's ideas as *theatrum sacrum,* as dramatic *gesamtkunstwerk.*

church of Weltenburg (1717–1736; illus. p. 127 bottom), the altar in the monastic church in Rohr (1717–1725), and the "Asamkirche" (actually St Johann Nepomuk) in Munich. The latter served as the private chapel and burial place of Egid Quirin, and was built next to the residence of the Asam family in Munich (1733–1746; illus. p. 126).

As the court architect in Munich, François Cuvilliés designed the most elegant interiors of the Bavarian Rococo, for example, the hunting lodge of Amalienburg in the park of Schloss

**Johann Michael Fischer,** Diessen am Ammersee, Abbey church of St Maria, 1732–1739

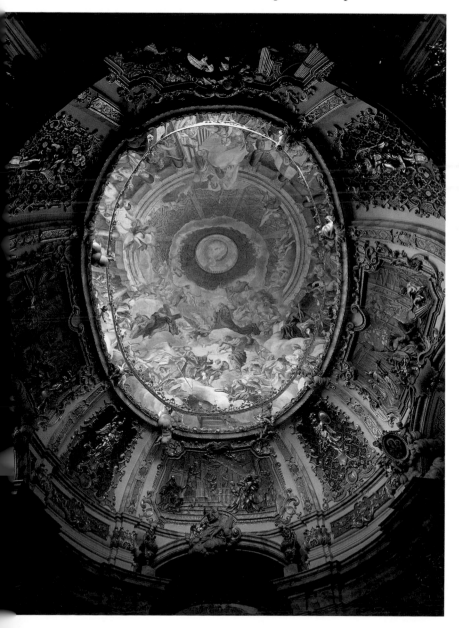

**Cosmas Damian Asam,** Weltenburg, church of the Benedictine abbey, 1717–1736, view of the dome

The theme of the dome fresco is the triumph of the Church, a topic that is vehemently depicted in an architectural setting that is flooded with light. Relief fields in stucco with scenes from the life of St Benedict and representations of the four archangels build a frame for the illusionistic scene. In the dome reliefs Cosmas Damian Asam appears as a demi-figure and smilingly appreciates his work.

127

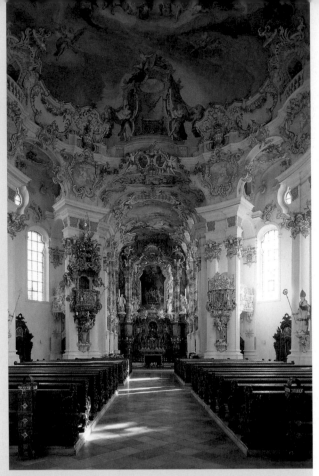

**Dominikus Zimmermann,** Wies near Steingaden, pilgrimage church, 1745–1754, view into the choir and into the dome (right); view from southwest (below)

P. 129: **Johann Michael Fischer,** Ottobeuren, Benedictine abbey church, design 1732, begun 1748, choir with stucco work by Johann Michael Feuchtmayer

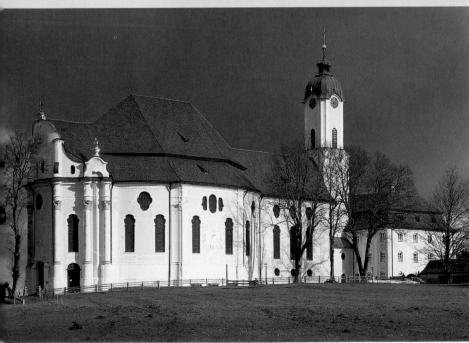

Nymphenburg with its circular Hall of Mirrors (illus. p. 145 bottom).

In the year 1738, a farmer's wife in Wies experienced a miracle: her plain wooden statue of the Scourged Christ began to weep. When a stream of pilgrims began to pour in, the monks from the nearby Steingaden monastery decided to build a pilgrimage church. Dominikus Zimmermann was commissioned in 1746 to carry out their conception. Built on a more or less elliptical ground plan, the church displays the sensuous nature of the Rococo style better than any other: architecture, stucco, sculpture, and painting merge to form a weightless, seemingly celestial whole (illus. left).

The architectural history of the Benedictine abbey of Ottobeuren goes back to the eighth century, and is closely tied up with the history of the German Empire (illus. p. 129). When it was decided to rebuild the monastery church in the Baroque style in the eighteenth century, the most famous masters were called in, including Dominikus Zimmermann. In the end, however, a plan by Simpert Kraemer was accepted; it was carried out from 1748 by Johann Michael Fischer, who made some radical changes to the elevation. Ottobeuren is one of the major works of southern German Late Baroque.

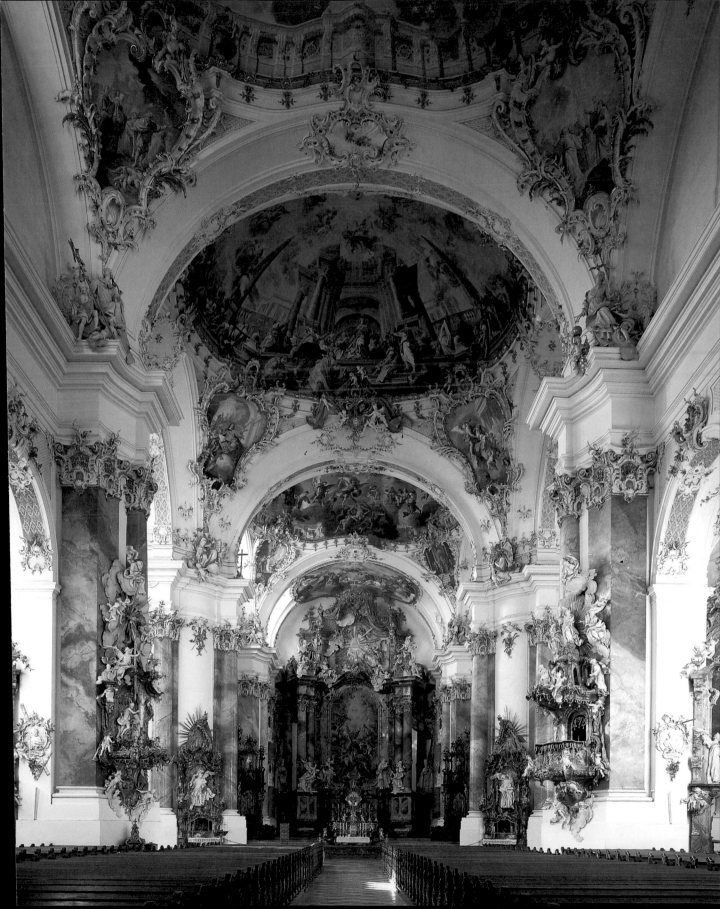

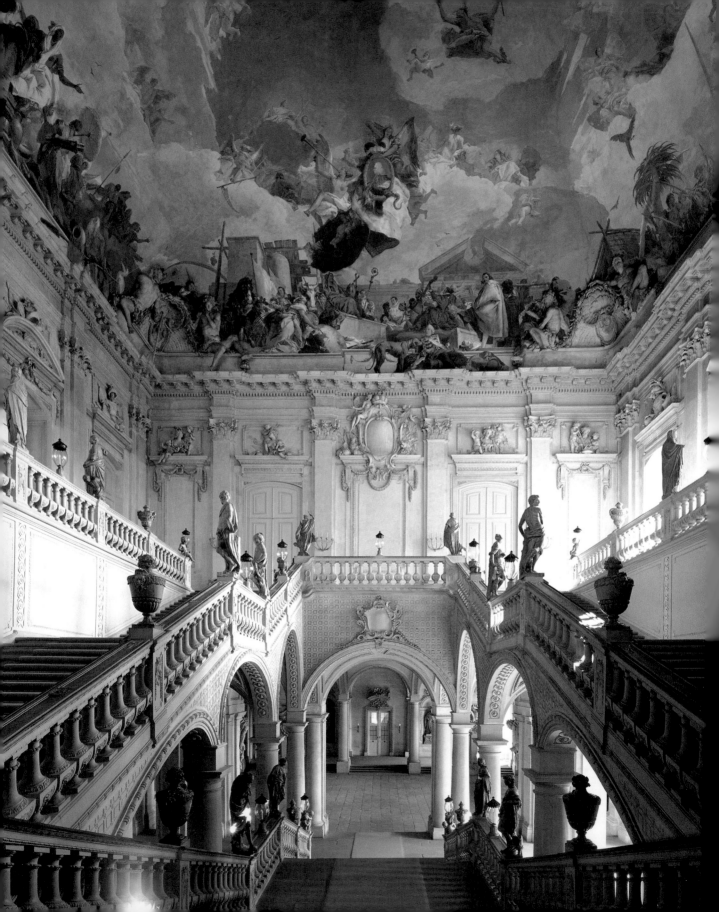

## Balthasar Neumann

From the cannon and bell foundry to becoming a celebrated court architect—this was the career path of Balthasar Neumann (1687–1753), who had an unrivalled influence on German architecture of the eighteenth century. His works are inseparably associated with the prince-bishops of the House of Schönborn, whom he served his whole life long.

Neumann did not take on his first commission, the Schönborn burial chapel in Würzburg Cathedral, until 1719, when he was already 32 years of age. In the same year, Johann Philipp Franz von Schönborn appointed this artillerist—who, despite his technical talent, was completely inexperienced in the field of architecture—to carry out the planning of the Würzburg Residenz, one of the largest and most demanding projects of the time (illus. right, below, and p. 130). However, members of the large Schönborn family assisted at every stage of the planning.

Neumann's plans came under external scrutiny, and he himself went on study trips to Paris and Vienna. Maximilian von Welsch from Mainz and the Viennese court architect Johann Lukas von Hildebrandt both made proposals that influenced the final execution.

Despite this rather complicated planning process, the Würzburg Residenz is the work of Balthasar Neumann; he worked on this palace, the most magnificent in Germany, until his death. The building is constructed around a cour d'honneur, as in Versailles. The middle section contains the vestibule with its two-flight staircase, and behind this the oval *sala terrena*, which leads to the garden. The huge staircase (illus. p. 130), which takes up the entire height of the palace, is a unique feature. Its vault, measuring 32 x 18 meters (99 x 55.5 ft), is a masterly technical achievement. It is decorated with frescoes by Giovanni Battista Tiepolo (illus. p. 130), and spans the stairs

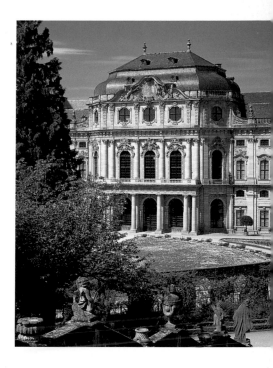

**Maximilian von Welsch, Johann Lukas von Hildebrandt, Balthasar Neumann et al.,** Würzburg, Residenz, 1720–1754, central tract of the garden facade (above); court facade (below); staircase with the ceiling frescoes by Giovanni Battista Tiepolo, 1735 respectively 1751–1753 (p. 130)

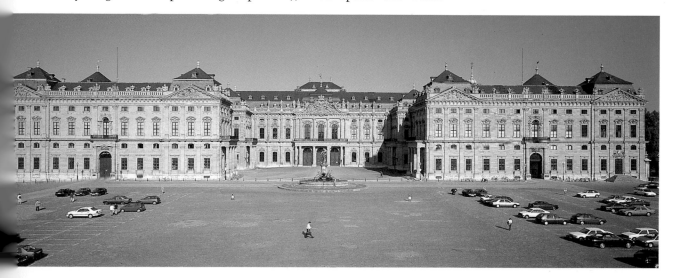

leading up to the Kaisersaal (Imperial Hall). The chapel, with its vibrant forms, is also a stroke of artistic genius in which architecture, sculpture, and painting fuse to create a glorious spectacle.

Neumann designed and built several grand staircases, including that in Brühl, near Cologne (see p. 11). This creative engineer and architect also found spectacular solutions in the field of church architecture. The pilgrimage church of Vierzehnheiligen ("Fourteen Saints," 1742–1772; illus. below) is an ingenious compromise, as Neumann had to correct the catastrophic mistakes made by his building supervisor, Gottfried Heinrich Krohne. On top of the existing foundation walls, he placed a brilliantly conceived ground plan of ovals and circles with the scenographic shrine of the helper saints at its center. Neumann made great artistic use of its unusual position in front of the crossing.

If Vierzehnheiligen is a feast for the senses, Neresheim (begun 1745) is a feast for the intellect: this abbey church in radiant white with its freestanding columns is a masterpiece both from a constructive and an aesthetic viewpoint (illus. p. 133). After Neumann's death, the building at first remained without a ceiling, as the monks did not want to let anyone else undertake the stone vaulting. In the end, it was decided to put in timber vaulting.

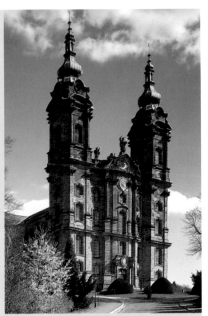

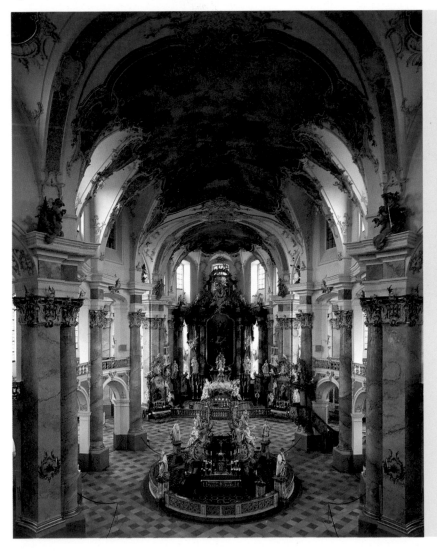

**Balthasar Neumann,** pilgrimage church Vierzehnheiligen, 1743–1772, facade (above) and interior with pilgimage altar and altar shrine (left)

P. 133: **Balthasar Neumann,** abbey church Neresheim, begun 1745, interior and view into the vaulting with frescoes by Martin Knoller, 1770–1775

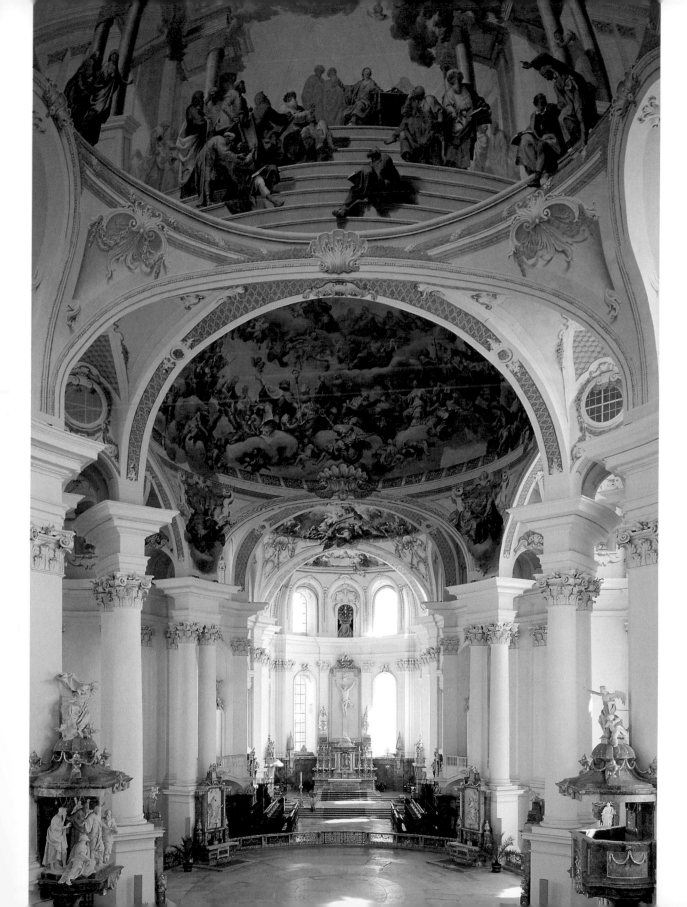

## Schloss Weissenstein near Pommersfelden

Lothar Franz von Schönborn was able to gain the services of the leading European architects even for his summer residence. Schloss Weissenstein was built between 1711 and 1718 as a successful collaboration between Johann Dientzenhofer, Maximilian von Welsch, and Johann Lukas von Hildebrandt, the architect of Schloss Schönbrunn in Vienna. In fact, it was this imperial building that Schönborn, who had now been elected an electoral prince, intended to emulate. The architecture and interior decoration of the corps de logis (central block) with its splendid three-flight staircase, the *Sala Terrena* in the style of a grotto, the vestibule, and the magnificent Marble Hall all pay homage to the prince and set new standards for the time (illus. below and p. 135).

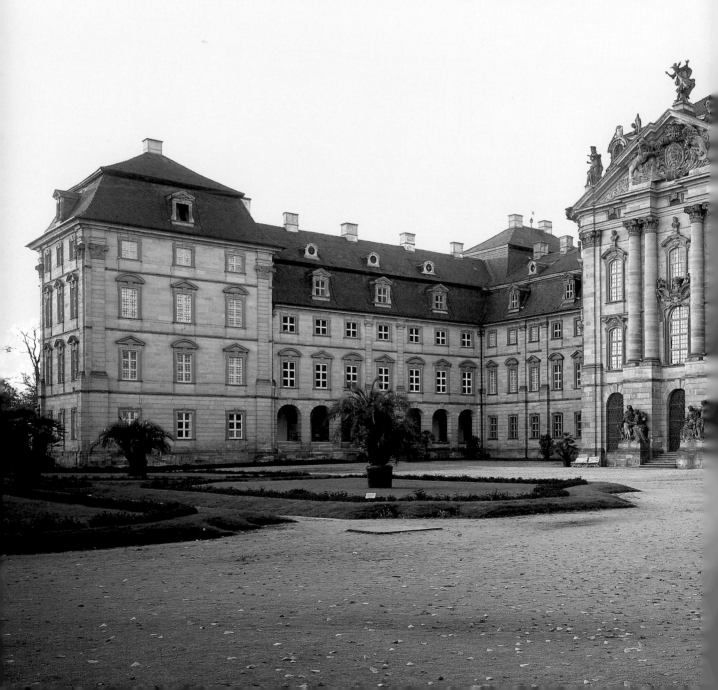

**Johann Dientzenhofer and
Johann Lukas von Hildebrandt,**
Schloss Weissenstein near Pommers-
felden, 1711–1718, court view (left);
staircase (right); and ceiling frescoes
(below) by Giovanni Marchini and
Rudolf Byss

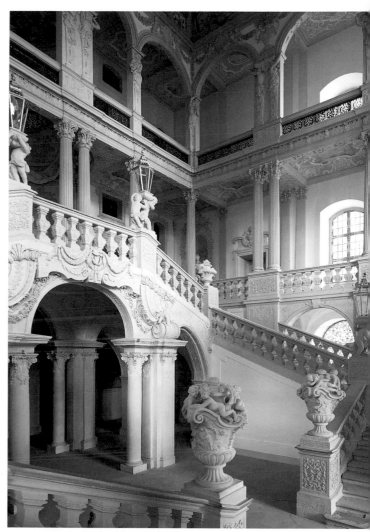

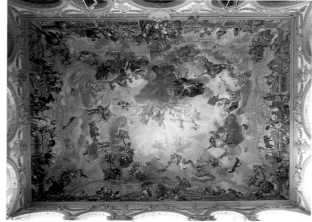

135

# The Dientzenhofer Family of Architects

The town of Flintsbach in Upper Bavaria was the home of the Dientzenhofer family, which produced five gifted architects. The search for commissions, travels, and marriage took the sons and grandsons of the bricklayer Georg Dientzenhofer above all to Bohemia, Franconia, and the Upper Palatinate, where around 250 buildings are attributed to their name. Drawing on Italian models, they developed their own unmistakable style, and gave Baroque architecture between Bamberg and Prague an international standing.

Georg Dientzenhofer (1643–1689) is the oldest of this clan of architects. He is first recorded in Prague along with his brothers Christoph, Leonhard, and Johann. In around 1682 he settled in Waldsassen, where he built the pilgrimage church of Kappel without payment, as thanks for the "humbling of Turkish pride" (1685–1689; illus. right). The church is a prime example of how architecture itself can be symbolic: the trefoil-shaped ground plan is a reference to the Holy Trinity. Georg's formal language takes on far more Roman features in the facade of the Jesuit church of St Martin in Bamberg (1686–1690), a work that set the stage for the Baroque restyling of this diocesan town. Leonhard Dientzenhofer (1660–1707) was also active in Bamberg; parts of the Neue Residenz and the Benedictine monastery church of St Michael are his work.

Christoph Dientzenhofer (1655–1722) was the only

**Georg Dientzenhofer,** Kappel near Waldsassen, pilgrimage church, 1685–1689

brother to remain in Bohemia his entire life. His main works, St Nicholas on the left bank in Prague (begun 1703), and the monastery church of St Margaret in Břevnov (1710–1715) demonstrate a thorough knowledge of the works of Guarino Guarini in their animated spatial structure, the skillful vault construction, and the lively articulation of the facades. Christoph worked together with his son Kilian Ignaz (1689–1751) in the Loreto Convent in Prague, where the Casa Santa, a copy of the Virgin Mary's house in Nazareth, is venerated. Legend has it that this house was carried to the Italian town of Loreto by angels. Father and son built the elegant Late Baroque facade in front of this extensive complex, which had been begun in 1626 (1721; illus. left).

**Christoph and Kilian Ignaz Dientzenhofer,** Prague, Loreto monastery, facade, 1721

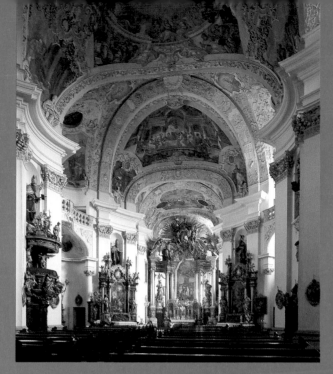

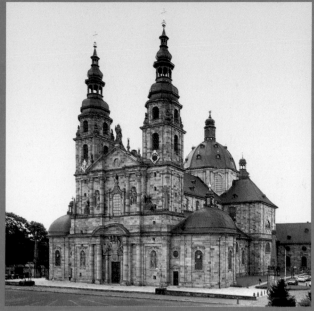

Johann Dientzenhofer,
Banz, Benedictine abbey,
church interior, 1710–1719

In 1735, Kilian Ignaz completed the richly decorated Church of the Nativity at the rear of the convent.

Johann Dientzenhofer's (1663–1726) career, like that of his brothers, began in Prague. From Waldsassen he came to Bamberg, where he came in contact with the powerful prince-bishop Lothar Franz von Schönborn, who enabled him to take a study trip to Italy. Upon his return, the prince-bishop appointed him as architect in the abbey in Fulda, and, in 1711, as court architect in Bamberg. The cathedral in Fulda, which Johann Dientzenhofer built from 1704 to 1713, is one of the great German churches built on the model of the Roman Gesù (illus. above right). In Banz, the experiences of his family in Bohemia and thus the influence of Guarini can be seen more strongly. In this monastery church situated

high above the banks of the Main, the architect plays brilliantly with the spatial dynamics. The bays of the ground plan form a staggered arrangement with those of the vaults; the room seems to be in a state of gentle oscillation (1710–1719, illus. above). From 1711, Johann Dientzenhofer worked on the summer residence Schloss Weissen-

stein near Pommersfelden. Although Johann Lukas von Hildebrandt and Maximilian von Welsch had some influence on the planning process, the concept of this palace, laid out as an open "horseshoe," is thought to be mostly his work (1711–1721; see also p. 134–135).

Christoph Dientzenhofer's son Kilian Ignaz belongs to

Johann Dientzenhofer,
Fulda, cathedral,
1704–1713

a different generation in an artistic sense as well. Kilian Ignaz assisted his father in Prague, and adapted his "Guarinesque" style to the vivid style of the Late Baroque. His trips to Vienna in the 1720s and a period of training under Lukas von Hildebrandt acquainted him with Austrian villa and palace architecture. The Villa Amerika, which he built from 1717–1720 on what was then the edge of Prague, bears eloquent witness to these experiences (illus. left). Of Kilian Ignaz's countless churches, the later examples deserve special mention: for example, St Mary Magdalene in Karlovy Vary (1732–1739) or St John on the Rock (1729–1739) in Prague. They are among the most beautiful works of the Bohemian Baroque.

Kilian Ignaz Dientzenhofer,
Prague, Villa Amerika,
1717–1720

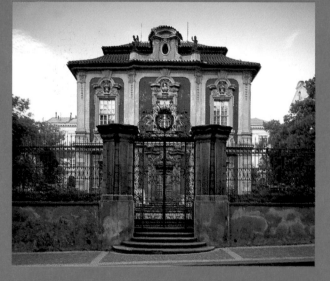

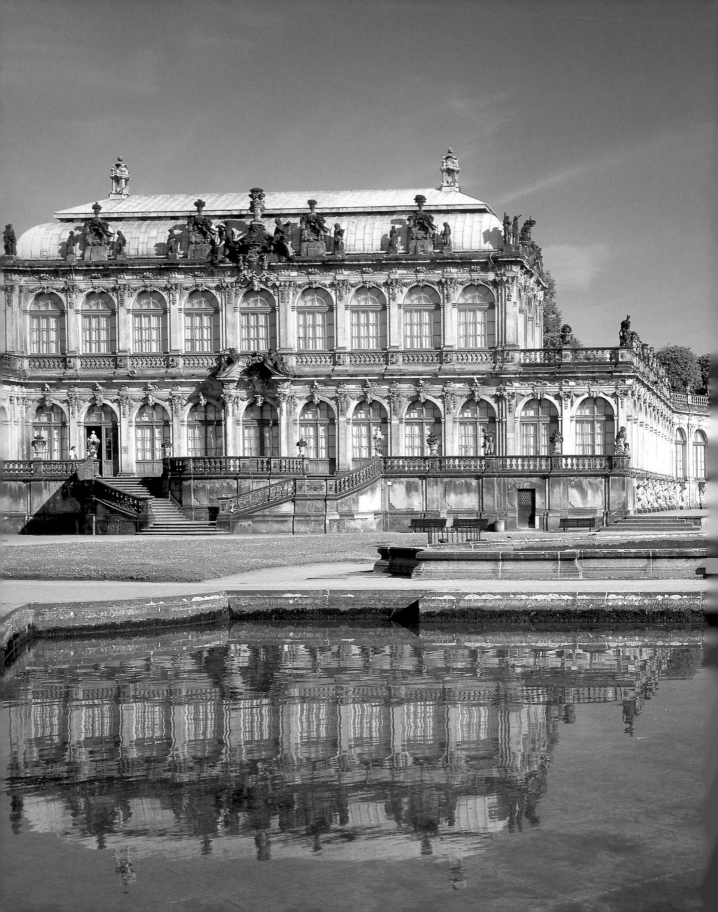

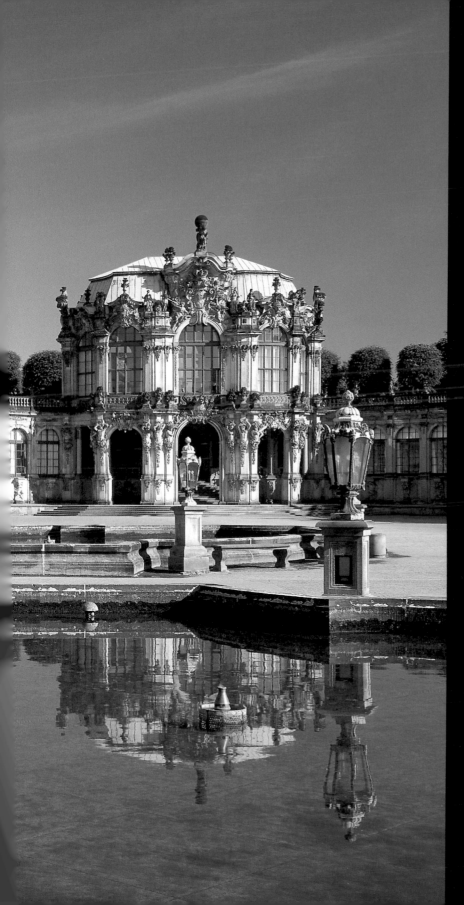

## Dresden and Environs

It was under the splendor-loving elector and later Polish king Frederick Augustus I, Augustus the Strong—and his son, the passionate art collector Frederick Augustus II, that Saxony experienced the most glorious moments in its history. There is every reason to speak of the years between 1694 and 1763 as the "Augustan era," an epoch in which culture and the arts flourished as they did in Antiquity.

The masterpiece and symbol of Saxon absolutism is the Zwinger, which takes its name from a former bastion. This magnificent Rococo building (illus. left) was executed between 1709 and 1728 by the architect Matthäus Daniel Pöppelmann (1662–1736) and the sculptor Balthasar Permoser (1651–1732). The Zwinger was originally a tournament ground, whose temporary wooden architecture was transformed into stone buildings in a unique way. Pöppelmann's "Roman amphitheater," erected in 1709 for a visit by the Danish king, was gradually turned into the magnificent "court festival ground," whose buildings now house the extensive art collections of the Saxon rulers. However, only the square courtyard with its halls and connecting galleries and the exedrae on the cross axis were completed. At its vertex Pöppelmann erected two elegant oval buildings, the Carillon Pavilion and the Wall Pavilion, which

**Matthäus Daniel Pöppelmann,**
Dresden, Zwinger with Wall Pavilion,
1709–1728

Balthasar Permoser enlivened with allegorical and mythical sculptures. The complex is entered through the *Kronentor* (crown gate), a playful, exuberant gate of honor (illus. p. 10). The fourth side was not enclosed until the nineteenth century by the gallery of Gottfried Semper. Despite changes in conception, the Zwinger has retained the character of a backdrop: It is an architectural Arcadia, an idyllic dream of oneness with nature.

Smiling herms—shafts surmounted by half-length male figures—carry the weight of the entablature on the Wall Pavilion. Its ledges are decorated with satyrs, fauns, and floral patterns; Hercules raises the globe above his head; and nymphs bathe in an artificial grotto. The galleries are also orangeries. Originally, the way the grounds opened out onto the banks of the Elbe River was intended to make the com-

bination of tamed and untamed nature even more apparent.

Besides the Zwinger, there were also notable sacred buildings that gave the city its distinctive appearance: for example, the Protestant Frauenkirche (1726–1739) by Georg Bähr with its double dome and impressive interior (illus. above right), and the no less impressive Catholic Hofkirche (1739–1755)—Augustus the Strong had converted to Catholicism in order to wear Poland's crown—by Gaetano Chiaveri. The aristocracy also commissioned several luxurious city palaces. Until its destruction in 1945, this "Florence on the Elbe" was considered the most beautiful Baroque royal seat in Germany (illus. above left).

August the Strong's architect, Pöppelmann, who came from Westphalia, left masterpieces outside of Dresden as well, works that have given Saxony's archi-

tecture its unique splendor. Among other things, from 1723 to 1736 he was in charge of the Baroque re-styling of Schloss Moritzburg northwest of Dresden. The hunting lodge built around the mid-sixteenth century was retained, but extended to become a picturesque building with four towers, palatial rooms, and terraces (illus. p. 141 top). Together with Zacharias Longuelene, Pöppelmann also worked on Schloss Pillnitz, the summer residence of the Wettins, which Augustus had redesigned as a "palace for park and water festivals." In 1720, the "water palace" was built, and three years later, further inland, the "mountain palace," which is almost identical in appearance. The "Indian" (East Asian) decoration of their facades and the unusual curved roofs show how exotic elements were making their way into European architecture.

P. 140 left: **Bernardo Bellotto,** view of Dresden with Augustus Bridge, Frauenkirche, palace, and Hofkirche, 1748, Dresden, Staatliche Kunstsammlungen

P. 140 right: **Georg Bähr,** Dresden, Frauenkirche, 1726–1739; interior before its destruction in World War II

Right: **Matthäus Daniel Pöppelmann,** Schloss Moritzburg, 1723–1736

Below: **Matthäus Daniel Pöppelmann, Zacharias Longuelune et al.,** Schloss Pillnitz, Bergpalais (mountain palace), 1723

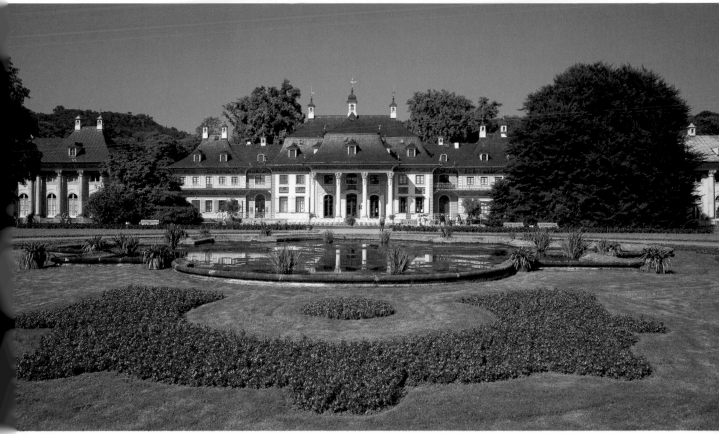

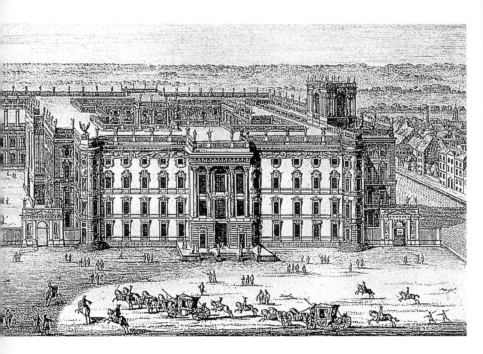

**Andreas Schlüter,** Berlin, Royal Palace, begun 1698; torn down 1950, original design

## Berlin and Potsdam

The conditions that made it possible for Berlin and Potsdam to rise to prosperity after the Thirty Years' War were created by Frederick William, the Great Elector, and his successor, Frederick III, who had himself crowned as Frederick I, the first Prussian king, in 1701. The expansion of the two royal seats was not long in coming: At the start of the eighteenth century, they were embellished by new urban complexes and splendid Baroque buildings.

Like the Saxons, the Prussian rulers liked to have a landscape with rivers and lakes surrounding their palaces. In 1698, Andreas Schlüter (1664–1714) was commissioned to rebuild the Berlin Royal Palace on the Spree island (illus. above). The palace,

which included parts of the elector's residence, was to form part of a magnificent urban complex. However, only the garden wing and its courtyard with highly articulated, Berniniesque facades were completed. Owing to some dire planning mistakes, Schlüter fell out of favor, and Johann Friedrich Eosander von Göthe took over the job.

Under Frederick II (Frederick the Great), who reigned from 1740 to 1786, Prussia experienced a cultural golden age: "Old Fritz" brought artists and philosophers to his court and dabbled himself in architecture. In Georg Wenzeslaus von Knobelsdorff (1699–1753), the king found the ideal "Supervisor of All Royal Palaces and Gardens," one who was able to realize his ambitious ideas. These included

the extension of the Potsdam Royal Palace, the Unter den Linden opera house, and the rebuilding of the east wing of Schloss Charlottenburg (illus. p. 143 right). However, his masterpiece was Schloss Sanssouci in Potsdam, completed in 1747 after only two years of work.

This building, situated in an extensive park, was intended by Frederick II to be an intimate, if luxuriously furnished, summer residence: a *maison de plaisance* (house of pleasure). Sans souci, "free of care," is its underlying

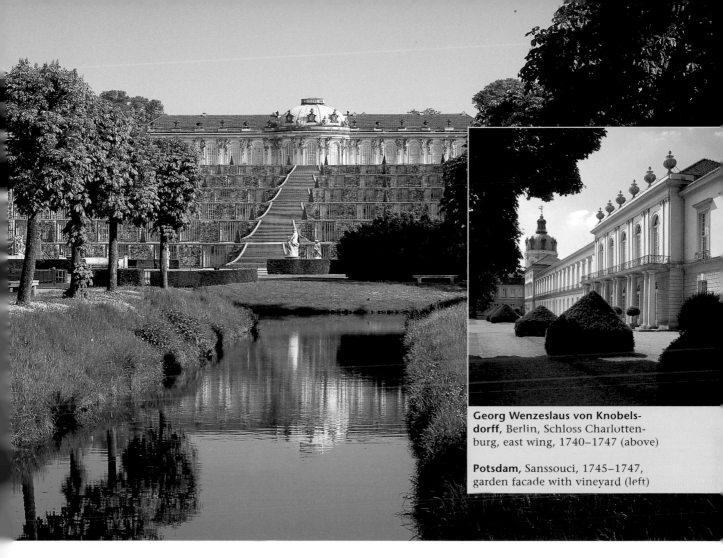

theme, and an indication that ceremony would soon cease to be the sole determining influence on the way people lived and resided. The serene three-winged building standing at the top of an artificial, terraced vineyard came to be seen as the epitome of "Frederickian Rococo" (illus. above; also see p. 144/145). The oval hall on the ground floor has an interior decorated with 16 marble columns and gilding. The dome is crowned by a crystal skylight that imitates the opening of the Roman Pantheon.

The paintings and sculptures allude to Bacchus, the god of wine, and to the royal patron who commissioned them. Depictions of Hermes with satyrs and nymphs and sensuous representations of natural forces adorn the facades. It was in these surroundings that Frederick held his social events; and in the gardens full of allusions to classical Antiquity, the "Philosopher of Sanssouci" created his own personal Arcadia.

The king himself helped design the palace. He sketched out the ground plan, and even broke with his court architect Georg Wenzeslaus over the final execution. The cause of the quarrel was a small, but important detail: whereas Frederick wanted to be able to step directly from the palace into its gardens, Knobelsdorff wanted to place the building on a raised base to increase its prominence. The view of the palace from the park shows clearly how justified Knobelsdorff's idea was. However, he did not have his way—the king's will was done.

# Rococo

Eighteenth-century art has many faces; Rococo is doubtless the most charming of them. Its exuberant character, its playful grace, its eroticism and exoticism delighted patrons throughout Europe, who dreamt of a return to the lost paradise as depicted in pastoral poetry.

**Potsdam,** New Chambers, Ovid gallery, detail of the ceiling decoration, rocaille ornament, begun 1747

The term Rococo was first used in critical literature at the end of the eighteenth century, probably to make fun of the extravagant forms of ornamentation that were current at the time. The etymological origins of the word are not clear: It is either derived from *rocaille,* French for pebble-work, or comes from a distorted form of the Portuguese word for irregular pearls. The Rococo style dominated the period between 1710 and 1760, at different times depending on the region. The artistic impetus for the new style came from France where, at the start of the eighteenth century, a new philosophy of life had begun to take hold, one opposed to the pomp and theatricality of the High Baroque. The aristocracy and upper classes in particular were looking for refinement in their private lives, for naturalness, intimacy, and individuality. This rejection of the restrictive ceremony of the court, the erosion of hierarchies, and the loss of authority made philosophers begin to call for freedom and rationality—qualities that seemed attainable only in a harmony with the laws of nature.

The art of the Rococo reflects this development on various levels. Firstly, completely different patrons and buyers evolved. The court was replaced by private art lovers who like playing the role of patrons. The art trade, gallery-dealerships, and art criticism grew up and flourished to serve this new clientele. The personality of the artist, his sensitivity and imagination were given a new status.

The Rococo began as a style of decoration that had freed itself of the structural corset imposed by the High Baroque. At first, it was used only to decorate interiors, which it covered completely with a delicate gossamer of

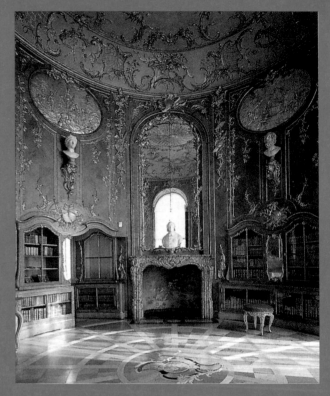

**Potsdam,** Schloss Sanssouci, library, 1745–1747

filigree stucco—as in the Hôtel de Soubise (see p. 86). Characteristic features of the style are also the articulation of walls using panels, mirrors, and door pediments, as well as ceilings with arched or flat sections. They often served to conceal the division of wall and ceiling or to extend the room illusionistically. Cartouche and lambrequin are often used as framing motifs, as well as shell-work, which, in the form of *rocaille,* had its triumph here (illus. above left).

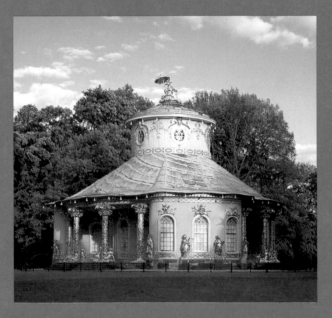

**Johann Peter Benckert and Matthias Gottlieb Heymüller,** Potsdam, Schloss Sanssouci, Tea Pavilion in the palace garden 1754

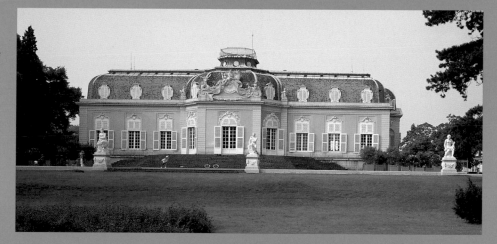

Most of these elements had already been used during the entire Baroque period, some even during the Renaissance and the Mannerist periods. During the Régence (1715–1723), the rule of the duc d'Orléans, however, they took on a life of their own and pushed the architectural structure into the background—at first in symmetrical forms, and later in asymmetrical ones that obscured all else. In the 1730s, this style of surface decoration was adopted in most European centers and also used for exteriors, unlike in the country of its origin. Engravings played an important role in disseminating the motifs: here, it is important to mention Gilles-Marie Oppenord and Juste-Aurèle Meissonier, who provided the most beautiful patterns. In Germany, the "Frederickian Rococo" had a special status. Frederick II, the philosopher-king of Sanssouci, had his summer residence built in a vineyard; he himself provided the designs for the building,

**Nicolas de Pigage,** Schloss Benrath, garden facade, 1756–1757

which was intended for recreation and comfort (see p. 142/143). The idyllic, elegant interior decoration (Johann August Nahl, Johann Michael, and Johann Christian Hoppenhaupt) plays with the idea of nature in a hundred different ways, imitating arbors, tendrils, and birds. It is among the most beautiful things the German Rococo produced (illus. p. 144 top). The Chinese Tea Pavilion is based on another theme. Its realistic figures were created by Johann Peter Benckert and Matthias Gottlieb Heymüller. Here, passionate admiration for Asian art and the yearning for exoticism were realized on a monumental scale (illus. p. 144 bottom).

Left: **Johann Wilhelm Lanz,** *The Toilette of Venus,* 1760, porcelain, height 55 cm/ 21.5 in, Munich, Residenz

Right: **François de Cuvilliés,** Munich, Amalienburg in the park of Schloss Nymphenburg, interior, 1734–1739

The leading master of Bavarian Rococo was François de Cuvilliés, whose banquet hall in the Amalienburg hunting lodge in the park of Schloss Nymphenburg park is a truly enchanting work: delicate, filigree light-blue and silver stucco adorns the walls and roof, reflected on many sides by large crystal mirrors that make the circular room seem endless (illus. below).

Around the middle of the century, early classicizing elements began to enter Rococo decoration. Schloss Benrath, a work of Nicholas de Pigage from Lorraine, testifies to the emerging change in style (illus. above). Ornamental accessories and crafts cannot be dealt with in depth here; they, too, attained a new refinement during the Rococo. Artists reached outstanding heights in the areas of furniture, wall paneling, gold work, and, above all, porcelain (illus. left).

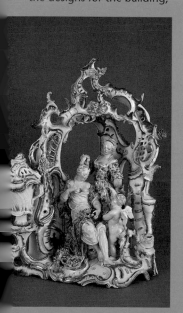

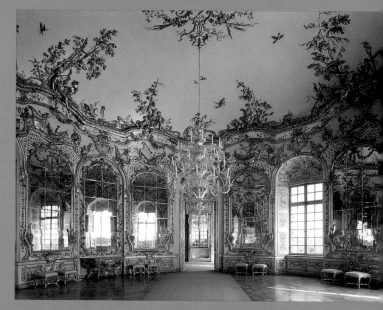

## J. C. Schlaun and Baroque Architecture in Westphalia

Johann Conrad Schlaun's (1694–1773) work for Clemens August of Bavaria shows clearly just what a partnership between a patron and an artist could achieve. Under the patronage of this elector-archbishop of Cologne, Westphalia produced some outstanding examples of Late Baroque architecture.

Schlaun was a pupil of Balthasar Neumann, and worked with him in Würzburg in 1720. He traveled to Rome, Paris, and Munich, recording the main works of Baroque architecture in drawings. From 1724 he worked in Münster, and became the favorite architect of the Westphalian aristocracy. In 1725 Schlaun entered the service of archbishop Clemens August, and was immediately entrusted with a difficult task: the building of Schloss Augustusburg in Brühl, which was to be turned from a moated castle into a summer palace (illus. 148/149). Schlaun's plans appear not to have satisfied the archbishop;

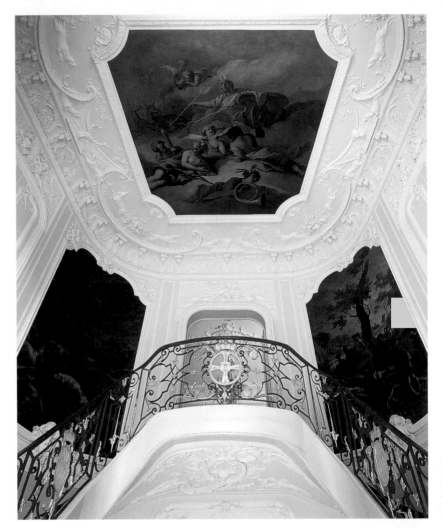

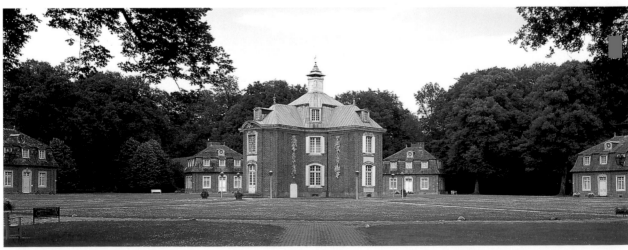

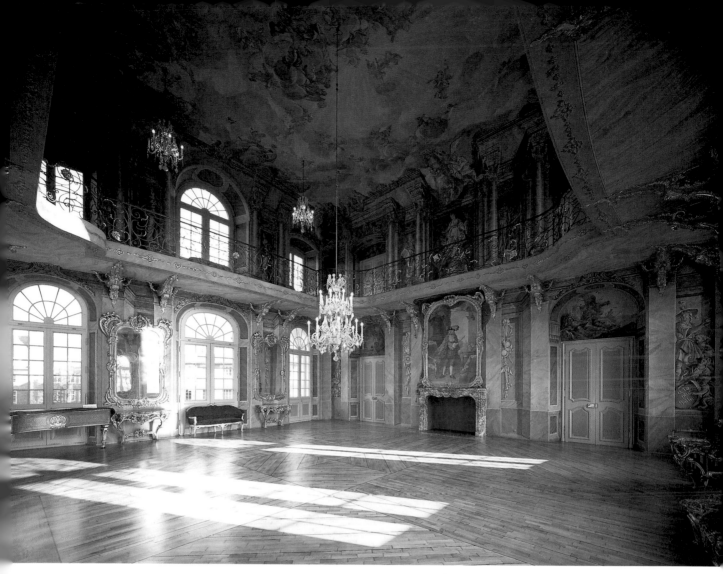

**Johann Conrad Schlaun,** Münster,
Erbdrostenhof, 1749–1751, Grand
Salon (above); and facade toward the
cour d'honneur (right)

P. 146 top and bottom: **Johann
Conrad Schlaun,** hunting lodge
Clemenswerth near Sögel, 1736–
1750, full view (below) and
view into the staircase with
hunting scenes by Gerhard
Koppers, 1745 (above)

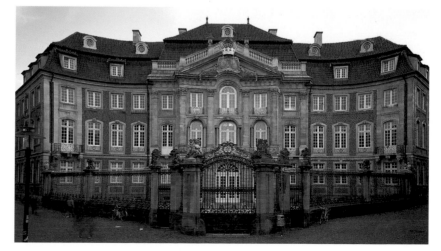

the latter called in the Munich court architect François Cuvilliés (1695–1768), who took over the task. The magnificent staircase was then built by Balthasar Neumann from 1741–1744 (illus. p. 11 and p. 149).

Schlaun's planning for the Clemenswerth hunting lodge (begun 1740) near Sögel was altogether more successful. Here, Schlaun succeeded in an unusual achievement: He conceived the idyllically situated complex as an ensemble of pavilions, rather like a group of tents in stone.

In Münster, Schlaun built the Clemenskirche from 1745–1753. His acquaintance with Bernini's and Borromini's architecture is quite clearly recognizable in the church's curved ground plan. However, his main work is the Erbdrostenhof, the town palace of Baron Droste zu Vischering (1749–1751; illus. p. 147 bottom). The building is cleverly harmonized with the triangular cour d'honneur: The projecting middle section, which is articulated by a colossal order of pilasters and crowned by a mighty pediment, is framed by concavely curved wings. The center window cuts into the entablature, a feature that displays Schlaun's knowledge of Roman and late classical architecture. Behind the facade is situated the banquet hall, which extends over two stories with its illusionistic murals (illus. p. 147 above). While the design of the Erbdrostenhof takes its lead from French and Austrian palaces, Schlaun also incorporated local traditions by using yellow Baumberg sandstone—quarried near Münster—and red brick, employing them in the Baroque design of the facade. The walls were built of brick, while the lighter sandstone was used for creating articulations and accents.

**Johann Conrad Schlaun, François Cuvilliés,** Brühl, Schloss Augustusburg, begun 1725

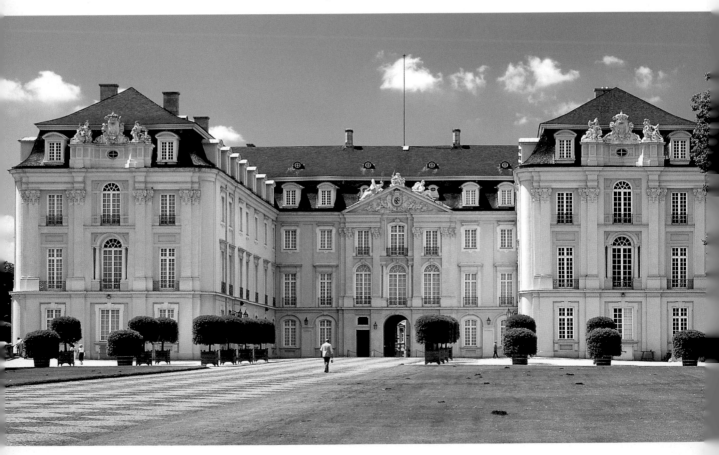

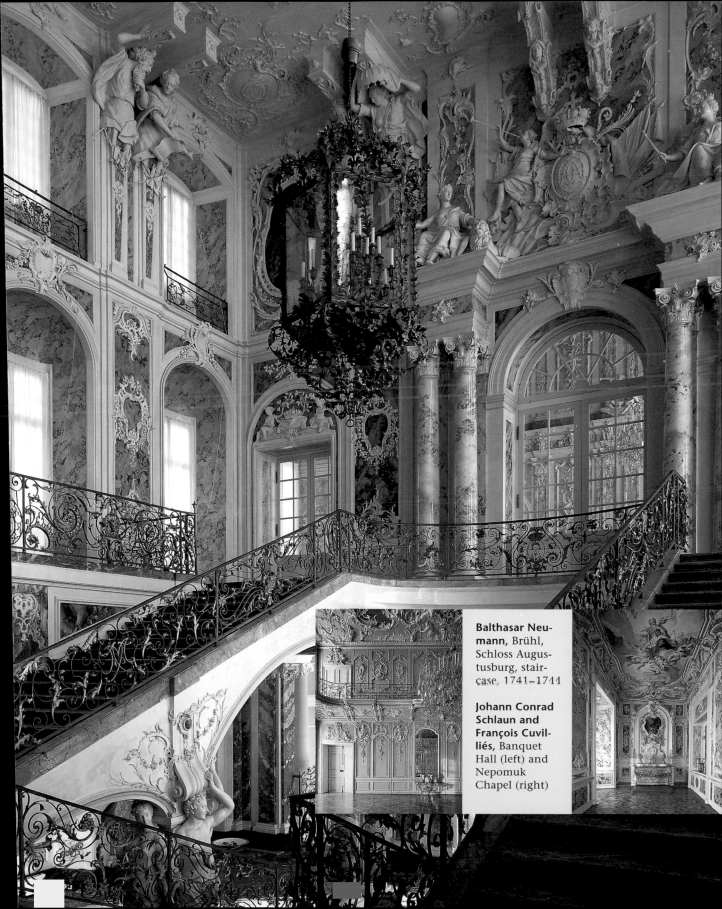

**Balthasar Neumann,** Brühl, Schloss Augustusburg, staircase, 1741–1744

**Johann Conrad Schlaun and François Cuvilliés,** Banquet Hall (left) and Nepomuk Chapel (right)

# Baroque Architecture in Scandinavia

The countries of northern Europe made important contributions to the architecture of the Baroque era, not so much in a typological regard, but rather in the aesthetic treatment of surfaces. The combination of brick walls and sandstone decoration, and roofs with copper gave a welcome opportunity to play with colors and structures. In many cases, the Netherlands provided Scandinavian architecture with its models. But in the second half of the seventeenth century, Italian and French elements increasingly began to prevail in northern Europe. The court and the aristocracy, which retained its central social position even after Protestantism took over, provided the commissions. In some cases, the bourgeoisie also came to the fore as patrons. In Norway, whose crown was united with that of Denmark, aesthetic efforts were more focused on works of art.

*Denmark*: With Copenhagen's extension to become a modern royal seat under Christian IV, a short golden age of Mannerist, Early Baroque architecture began. It was strongly influenced by Dutch models. One building that demonstrates this is the Stock Exchange (begun 1619), built by Hans van Steenwinkel the Younger, a broad building with tall mansard windows and dwarf gables (illus. below). The king himself is said to have drawn up plans for it. Charlottenborg Palace, begun in 1672, marked the beginning of Baroque classicism in Denmark. The most important force in

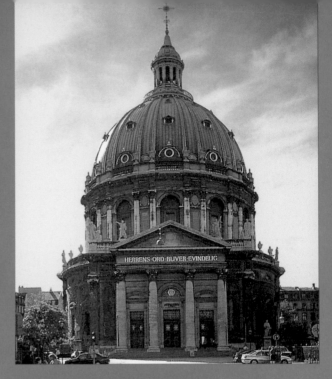

Danish architecture at this time was Lambert van Haven (born 1630), who trained in Italy as an architect and painter; his works also show Dutch traits.

**Nicolaj Eigtved,** Copenhagen, Frederikskirke, 1649 and 1849

Around the mid-eighteenth century, architecture reached a new high point: work on extending the Amalienborg Square and the Frederikskirke (Frederik's Church; illus. above) began in 1754. This urban complex was inspired by French models and became the most important work of the Danish Rococo. The ensemble was designed by Nicolaj Eigtved (1701–1754), a widely traveled gardener and amateur architect who had studied with the Saxon court architect Pöppelmann.

*Sweden*: Swedish architecture also took its bearings from Dutch Mannerism, at first, but the decisive turn to

**Hans van Steenwinkel the Younger,** Copenhagen, Stock Exchange, 1619–1631 and 1639–1674

**Nicodemus Tessin the Elder,** Drottningholm Palace near Stockholm, 1662–1685

Baroque classicism came as early as 1639 with the appointment of Simon de la Vallée (died 1642) from France to the Swedish court. His son Jean de la Vallée (1620–1696) and his pupil Nicodemus Tessin the Elder (1615–1681) gained Swedish Baroque architecture an international reputation. The Riddarhuset (House of the Nobility) in Stockholm, which was designed by Simon de la Vallée and built, with some changes, by Jean de la Vallée and Justus Vingboons from Holland, was the building that epitomized the new style (bottom). The main facade is structured by a colossal Corinthian order, and the slightly projecting middle section is accentuated by a low pediment; brick and light sandstone form an effective contrast.

Nicodemus Tessin the Elder was appointed court architect in 1649. Shortly after this, he set off on a long journey on which he visited the main architectural works in Germany, Italy, France, and Holland. In his most important work, Drottningholm Palace (begun 1662), he at first drew on the conception of Vaux-le-Vicomte, but doubled the corps de logis and added side wings and corner pavilions to it (illus. above). This created a building with two courtyards; the interior of the palace is dominated by a monumental staircase. The execution of the building and the design of the extensive gardens were carried out by his son, Nicodemus Tessin the Younger (1654–1728), and only completed in 1685. The Carolean Mausoleum of Riddarsholm church, with its monumental Roman Baroque forms, was also only completed decades after it was started, in 1671 (illus. right).

Nicodemus Tessin the Younger took over from his father as Swedish court and palace architect in 1681. He also went on study trips all over Europe. His main work, the rebuilding of the Royal Palace of Stockholm (1690–1754), which had been destroyed by fire, shows his familiarity with Bernini's last plan for the Louvre and with the Palazzo Chigi-Odescalchi; however, Tessin imitated his models in a somewhat more sober style (illus. middle left).

Opposite the palace, Tessin built his own city

**Nicodemus Tessin the Younger,** Stockholm, Royal Palace, 1697–1754

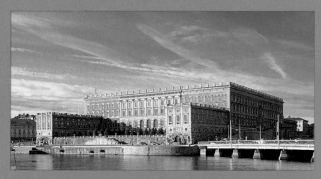

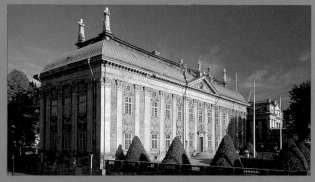

**Simon and Jean de la Vallée, Justus Vinboons,** Stockholm, Riddarhuset, 1641–1674

**Nicodemus Tessin the Elder,** Stockholm, Baroque addition (mausoleum) of the Riddarsholmkirke, completed 1671

residence, an architectural showpiece in which he combined the ground plan concepts of French hôtel architecture with elements from the elevations of Roman villas.

# Sculpture of the Baroque

## Italy

Like Baroque architecture, the sculpture of the Baroque also began in Rome. It, too, was employed primarily in the service of God, which naturally also included the worldly splendor of the papal court. It was used for other purposes as well, however: during the Counter-Reformation, sculpture became an effective propaganda tool for the Catholic Church.

Even in Antiquity, sculpture had enjoyed a preeminent status among the arts, working as it did with rhetorical structures. Now it was given the task of illustrating transcendental ideas through its plastic presence and its illusionistic power. The *concetto*, the intellectual concept, was accorded a fundamentally important role. It united complex ideas, informed artistic strategies and allusions, and took these to the height of their expressive power.

Since the Renaissance, the artistic intention behind sculpture had undergone a radical change: the emphasis had shifted from the classical ideal of perfecting what was found in nature to a virtuosic, exaggerated treatment of its subjects—artists

**Giovanni da Bologna (Giambologna),** Rape of the Sabines, 1581–1583, marble, height 410 cm/13 ft 6 in, Florence, Loggia dei Lanzi, Piazza della Signoria

wanted to show that they could outdo nature.

The Mannerism of the sixteenth century (It. *maniera* = manner, fashion) provided the soil for the strongly expressive forms of the Baroque. The *figura serpentina*, for instance, as seen in the example of the *Rape of the Sabines* by Giambologna (illus. p. 152), demonstrates several features that were to be adopted by Baroque sculpture: the skillful spiral structure, the tactile three-dimensionality of the composition, the dramatic movement, and the fact that it can be viewed from all sides, forcing viewers to change their position.

Other stylistic elements were added in this time period, such as the delicate treatment of surfaces, and, most importantly, the psychological exploration of the figures or groups of figures, which are captured at the moment of highest tension. This *transitory moment* is illustrated by the *St Sebastian* of Alessandro Vittoria (1525–1608). Struck by an arrow shot by his tormentors, the beautiful body of the martyr slumps in an expressive fashion (illus. right).

**Alessandro Vittoria,** *St Sebastian,* c. 1600, marble, height 170 cm/5 ft 7 in, Venice, S Salvatore

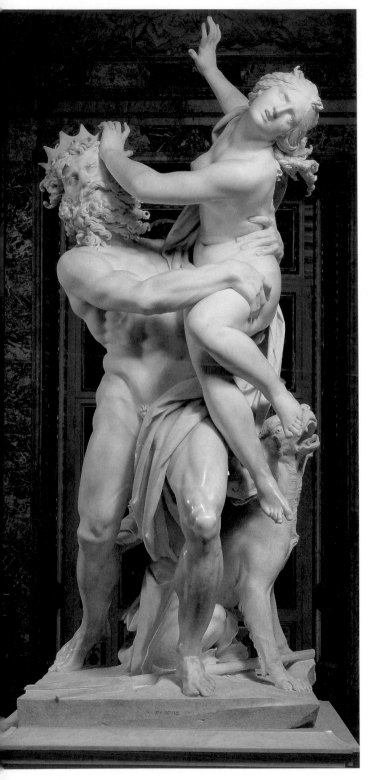

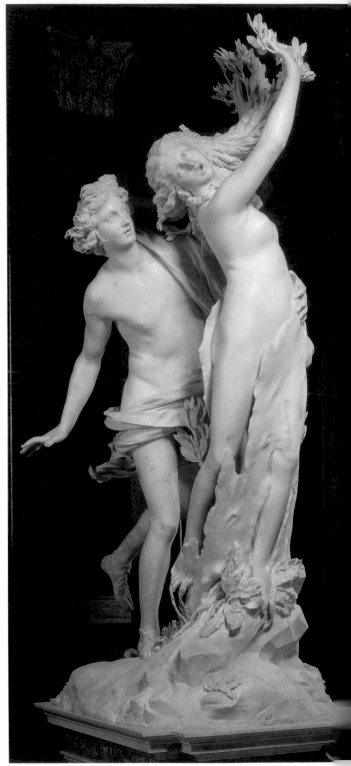

## Gianlorenzo Bernini

The works of Gianlorenzo Bernini (1598–1680) are the epitome of Roman Baroque sculpture; no other sculptor, with the possible exception of Michelangelo, had as lasting an influence on a genre as he did.

Bernini's work is inseparably bound up with the papal court. When Bernini, who was born in Naples, came to Rome with his father in 1605, he found his first patron and supporter in Cardinal Scipione Borghese. This was the start of a unique career. Bernini ended up creating spectacular masterpieces for four popes: Urban VIII, Innocent X, Alexander VII, and Clement IX. His early works, done while in the service of the Borghese family, include *Pluto and Proserpina* (1621–1622; illus. p. 154 left), and *Apollo and Daphne* (1622–1623; illus. p. 154 right), which were created for the Villa Borghese. They show the young artist's acquaintance with the works of classical Antiquity. With these sculptures, Bernini attracted the attention of Maffeo Barberini, who ascended the papal throne in 1623 as Urban VIII.

Alongside his substantial work on St Peter's Basilica (see p. 26–28), Bernini continued to produce magnificent secular works. Among these, his expressive portrait busts have a special status. In 1632, he finished a bust of his patron, Cardinal Borghese, whom he portrayed in the act of speaking (illus. above right). The realistically depicted countenance of Constanza Bonarelli, to whom Bernini had a passionate attachment, is even more expressive (1636–1637; illus. above left). The bust of Louis XIV, on the other hand, shows the dignity that distinguished the absolutist ruler (illus. above middle); he is shown from below.

Bernini's greatest works are to be found in St Peter's. Work on the baldachin above the Tomb of St Peter and the papal altar began in 1624. Shortly afterward,

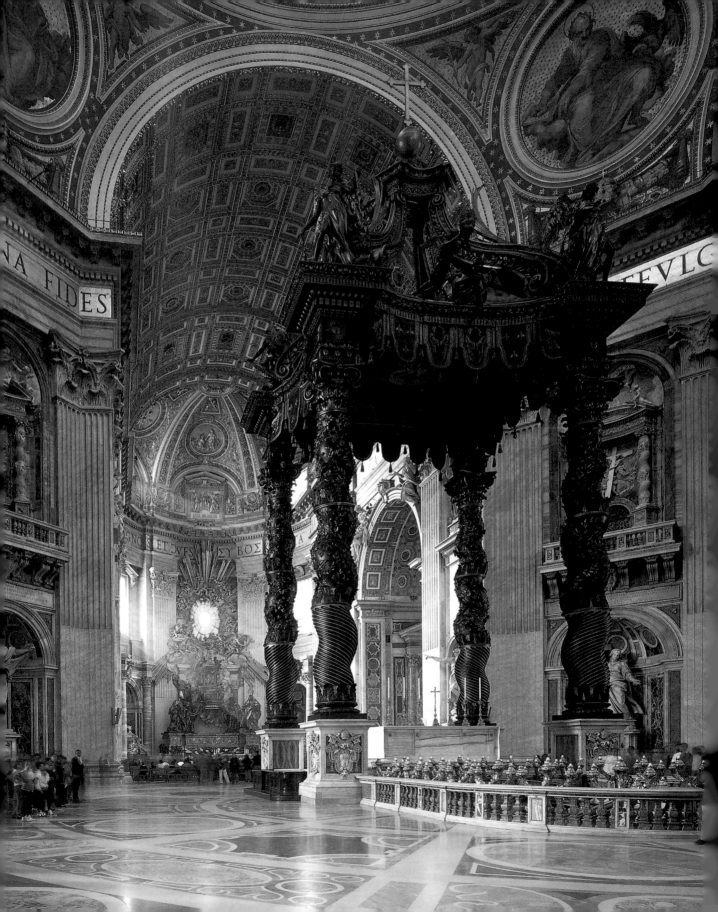

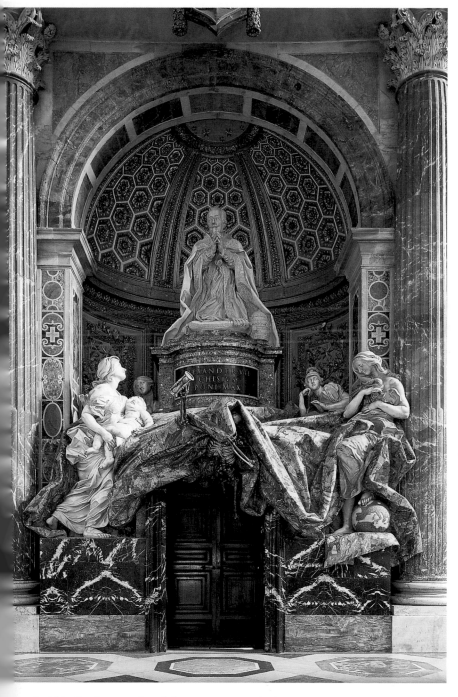

P. 156: **Gianlorenzo Bernini,** Ciborium, 1624–1633, marble, bronze, and gold, Rome, St Peter

**Gianlorenzo Bernini,** Tomb of Alexander VII, 1672–1678, marble and guilded bronze, Rome, St Peter

he was commissioned to decorate the piers in the crossing of St Peter's with statues. Both these tasks, which form part of an overall concept, became artistic and conceptual revelations: the bronze ciborium with its four twisting columns recalls the Constantinian Church of St Peter and the Temple of Solomon in Jerusalem (illus. p. 156). To this day, however, it is still disputed whether Bernini was solely responsible for the columns and their ornate crown; Borromini, who was working on St Peter's at the same time, would also have been capable of a similarly powerful design. The statues in the crossing, which are over 4 meters/12 ft high, include Bernini's figure of St Longinus in a state of ecstasy at the moment of his conversion; the others are the work of François Duquesnoy, Francesco Mocchi, and Andrea Bolgi. Between 1657 and 1666, alterations were carried out on the apse with the "Cathedra Petri," the venerable Throne of St Peter, which Bernini turned into a visionary work integrating various art forms.

The two papal tombs that Bernini constructed in St Peter's are also exceptional achievements of Baroque art. Whereas Urban VIII (died 1644) is depicted in an imperial manner, clothed in all the power of his office, Alexander VII kneels down humbly, although no less self-confidently, among the personifications of Justice, Wisdom, Compassion, and Truth. Death is omnipresent: a skeleton emerges from under the pall covering the bier, and brandishes an hourglass in a

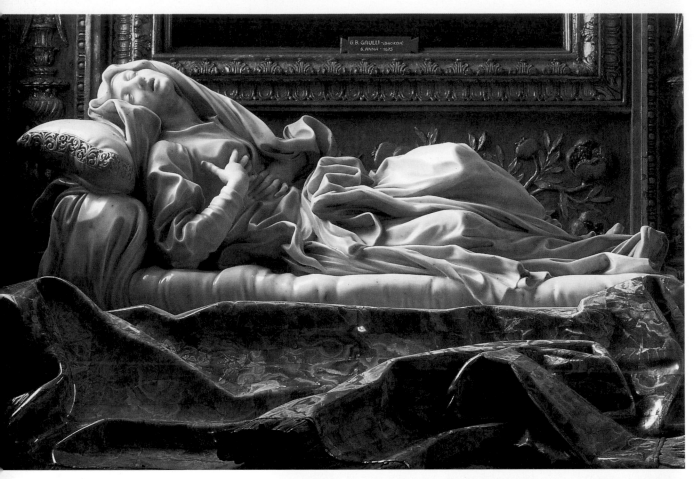

**Gianlorenzo Bernini,** *The blessed Ludovica Albertoni*, 1671–1674, marble and jaspis, length 188 cm/ 6 ft 2 in, Rome, S Francesco a Ripa

Right and p. 159: **Gianlorenzo Bernini,** Donor's balcony. Members of the Cornaro family (right) witnessing the Ecstasy of St Theresa of Ávila (p. 159), details of the decoration of the Cornaro Family Chapel, 1647–1652, Rome, S Maria della Vittoria

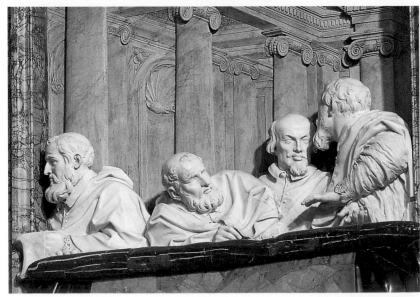

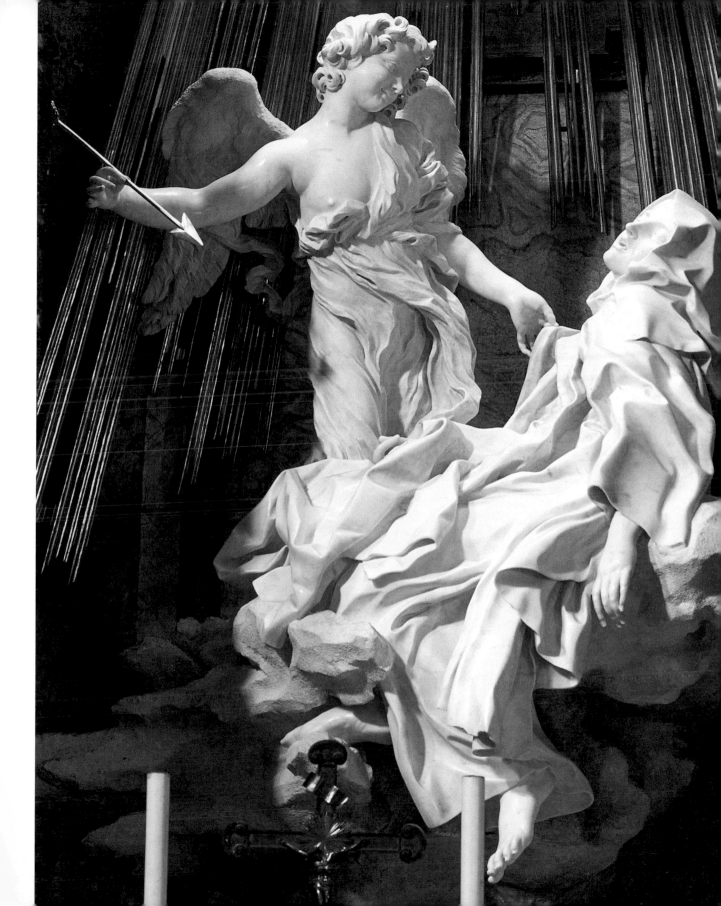

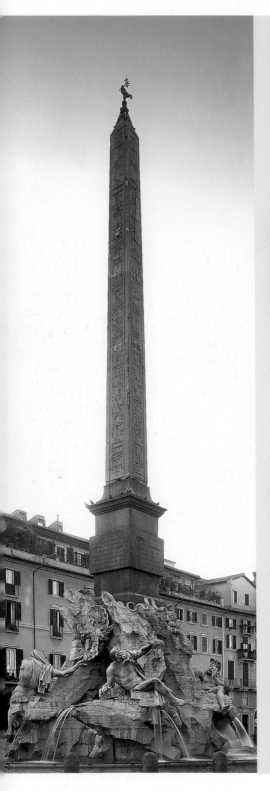

**Gianlorenzo Bernini,** Fountain of the Four Rivers, 1647–1651, full view and details, marble and travertine, Rome, Piazza Navona

threatening gesture (illus. p. 157). Like power and the transitory nature of life, ecstasy and eroticism also formed part of Baroque experience. Here, too, Bernini discovered fascinating forms of expression. St Theresa of Ávila, for example, waits in rapture for the spear thrust of the angel who has appeared to her in a vision. Bernini places the scene in a theater-like chapel, in which the chapel donors, the Cornaro family, watch the mystic occurrence (1647–1652; illus. p. 158 below and p. 159). And anyone looking at the statue of the blessed Ludovica Albertoni writhing in ecstatic arousal on her bed of blood-red jasper becomes a voyeur (1671–1674; illus. p. 158 above).

Fountains decorated with statues became a favorite artistic genre. The combination of sculpture, architecture, and town planning, and the unification of nature and artifact required striking *concetti*, virtuosity, and technical skill. Bernini also created masterpieces in this field. The Fountain of the Four Rivers in the Piazza Navona with its powerful river gods and the exotic attributes of the various continents is a homage to Innocent X as a ruler of worlds and of peace (begun 1647; illus. left). The designs for the Fontana del Moro (1653–1655; illus. p. 161 left) and for the obelisk resting on the back of an elephant in the Piazza S Maria sopra Minerva (1666/1667; illus. p. 161 right) show once again Bernini's outstanding intelligence and his unique wealth of invention.

**Gianlorenzo Bernini,** Fontana del Moro, 1653–1655, full view and detail, marble, Rome, Piazza Navona

Right: **Gianlorenzo Bernini,** Obelisk, 1666/1667, marble, Rome, Piazza S Maria sopra Minerva

## Before and after Bernini

Of course, many other Italian sculptors also created masterpieces. The recumbent figure of St Cecilia that Stefano Maderno (1576–1636) executed for S Cecilia in Trastevere is an extremely striking work (illus. below). Stretched out on a marble slab as if slaughtered, the lifeless body still reveals its former sensuousness. The head of the executed martyr is turned away from the viewer; the death of the saint can only be indirectly sensed. Maderno's moving marble statue, sculpted in 1599/ 1600, already embodies artistic strategies that are completely Baroque in outlook: The entire suffering of the young saint is captured in a single moment, the transition from life to death.

Among the pioneers of the Baroque are also Pietro Bernini (1562–1629), father of Gianlorenzo, who designed picturesque reliefs in S Maria Maggiore, and Francesco Mocchi (1580–1654), who redefined the genre of the classical equestrian statue. The bronze statues for Ranuccio and

Alessandro Farnese that adorn
the Piazza dei Cavalli in Pia-
cenza show horse and rider in a
state of intense motion (1620–
1625; illus. p. 162 top). Mo-
cchi's most important work is *St
Veronica with the Holy Shroud*,
one of the figures in the cros-
sing of St Peter's, who seems to
be striding tempestuously out
of her niche.

The statue of St Andrew by
François Duquesnoy (1597–
1643), born in Brussels, is
another of the quartet of sculp-
tural figures in the crossing,

for which Bernini provided the
overall concept. Bernini's influ-
ence is also clearly to be seen in
the dramatic gesture of the apos-
tle, who is artfully entwined
in the arms of his wooden cross
(1629–1633; illus. below left).
The classical figure of S Susanna
in the Roman church S Maria di
Loreto has a completely differ-
ent character (1629–1633; illus.
below right). Her beauty, cast in
the ancient mold, and her grace
and harmony reveal a com-
pletely different ideal, one that
stands in stark contrast to Ber-

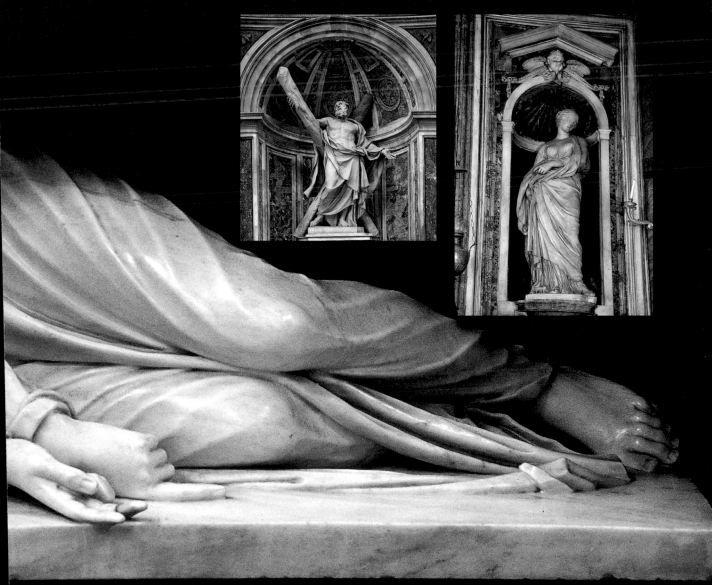

**Alessandro Algardi,** Bust of Camillo (or Benedetto?) Pamphili, after 1647, marble, Rome, Palazzo Doria

Right: **Alessandro Algardi,** *The Meeting of Attila and Pope Leo I,* 1646–1652, marble relief, Rome, St Peter

P. 165 bottom: **Camillo Rusconi,** *St Matthew,* 1708–1718, marble, over-life size, Rome, S Giovanni in Laterano

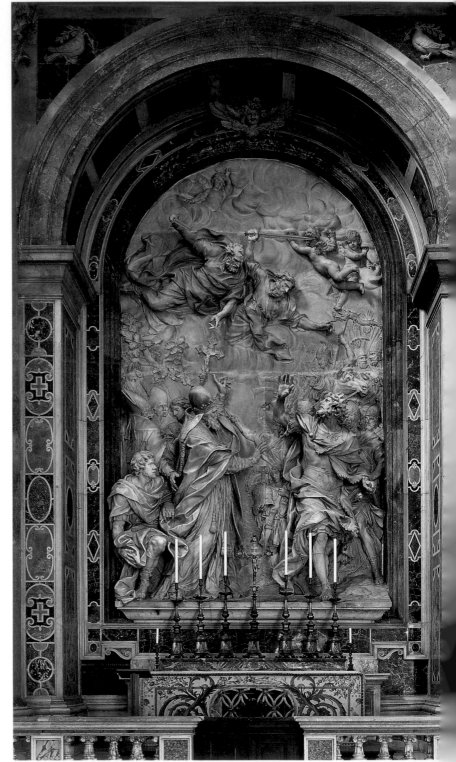

nini's ecstatic approach. Susanna is one of the few Baroque statues that is inclined toward the viewer; her counterparts all look upward to heaven in rapture.

Another influential artist was Alessandro Algardi (1598–1654). He was born in Bologna, where he attended the "Academy" of Ludovico Carracci, in which he developed his classical style. In 1625 he settled in Rome, working at first for Cardinal Ludovisi. Innocent X became his patron and supporter, and Algardi rose to become the leading Roman sculptor. The monumental marble relief *The Meeting of Attila*

*and Pope Leo I* shows how a vision stops the war-hungry leader of the Huns being stopped from destroying Rome by a vision. The work was received enthusiastically by the artist's contemporaries (1646–1652; illus. p. 164). Algardi used varying grades of relief as one means of bringing out the different levels of meaning. While the main scene involving Leo I and Attila emerges from the background in high relief, the vision of the popes, successors of St Peter and thus apostolic princes, projects less; and the top portion is being in even lower relief.

Algardi's gifts of observation virtually predestined him to be

**Ercole Ferrata,** *The Stoning of S Emerentiana,* begun 1660, marble relief, Rome, S Agnese in Piazza Navona

**Antonio Raggi,** *The Death of S Cecilia,* 1660–1667, marble relief, Rome, S Agnese in Piazza Navona

a portraitist. He created two of his most expressive portraits for the Pamphili family: the marble busts of Olimpia Maidalchini and Camillo (or Benedetto?) Pamphili (after 1647; illus. p. 164 top).

Two sculptors from the region near Como, Antonio Raggi (1624–1686) and Ercole Ferrata (1610–1686), both of whom were trained by Bernini and Algardi, took the genre of the relief to new heights. They began their work in S Agnese in Agone in Piazza Navona in 1660, decorating its cross arms with large sculpted altarpieces.

Raggi's work *The Death of S Cecilia* contains a large number of figures in different states of activity and emotion; here, too, the respective depth of the relief serves to underscore the hierarchy of the various scenes (illus. above right). Ferrata's *Stoning of S Emerentiana* uses far fewer fig-

ures, and the structure of the picture is much clearer. The central figure, the saint, who remains unaffected by the stones thrown by her tormentors—she is already about to receive the victor's laurels—stands in isolation amid the groups of people that are pressing and fleeing right around her, but who are nonetheless unable to reach her (illus. above left).

Ferrata's partner, Camillo Rusconi (1658–1728) from Milan, would carry the Roman Baroque forward into the eighteenth century. One example for the stylistic development that took place after Bernini is the figure of St Matthew that Rusconi sculpted for the Lateran Basilica. Here, the artist foregoes a filigree, detailed treatment of the surfaces, and concentrates instead on ampleness and boldness of form (1708–1718; illus. left).

# Spain

Baroque sculpture in Spain followed its own course. Largely uninfluenced by the Roman discourse, it tended to be strictly realistic, rendering the ideas of the Counter-Reformation in artistic form.

The *pasos*, lifelike wooden figures and groups of figures that were carried during Holy Week processions, were a typical form of sculpture in Spain, and gave rise to an entire genre. Their blunt realism moved the people in the streetswho followed the processions to have compassion with the Redeemer. To increase their dramatic, expressive effect, the colored statues were provided with various additional accessories such as wigs made of real hair, eyes and tears of crystal, wounds of red leather or cork.

One of the earliest examples of this genre is the The *Raising of the Cross* by Francisco Rincón (born 1567), which—like most

**Francisco Rincón,** *Paso* (procession group) with the Raising of the Cross, 1604, painted wood, life-size, Valladolid, Museo Nacional de Escultura

**Gregorio Fernández,** *Paso* (procession group) with Descent from the Cross, 1623–1625, painted wood, over life-size, Valladolid, Vera Cruz

masterpieces of Spanish sculpture—can be seen in the Museo Nacional de Escultura in Valladolid (1604; illus. above). This ensemble, consisting of life-size figures, shows the dramatic moment at which the cross bearing the figure of Christ is pulled upright by soldiers, and the Savior turns his head to one side in pain. The *Descent from the Cross* by Gregorio Fernández (1576–1636) was also used for processions. It is an enormously difficult compositional achievement that vividly captures the first moment as the body is removed from the cross (1623–1625; illus. left). *Christ at the Scourging Post* also represents an iconographic innovation: The low shaft of the column forces

the broken body to adopt a far more humble pose than the more customary, higher martyr's column (c. 1619; illus. below).

Gregorio Fernández was the most important Spanish artist of the first half of the seventeenth century. He was born in Lugo, the son of a sculptor, and made a career in Valladolid, a city that rose to become a center of Spanish court art from the late sixteenth century. At first, he worked with Rincón, but began to take on commissions in his own right in the 1620s and went on to establish a flourishing workshop. Between 1625 and 1632 he constructed the magnificent retable in the cathedral at Plasencia, dedicated to the life of the Mother of God (illus. below). This monumental work is one of a whole series of architectural "altarpieces" covering entire walls that decorated the apses of numerous Spanish churches from the fifteenth century.

Not only Castille, but Andalusia and, in particular, Seville produced magnificent artistic achievements. The discovery of America marked the beginning of a period of prosperity for this seaport. The realistic, yet always elegant works of Juan Martínez Montañés (1568–1649) were the chief object of admiration here. His *St Jerome*, whose muscles and veins stand out beneath the leathery skin, is a masterpiece of Early Baroque carving (1611; illus. p. 168 left).

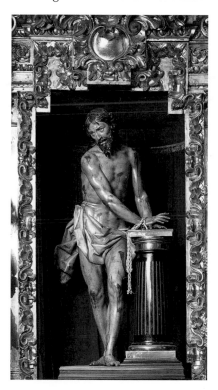

**Gregorio Fernández,**
*Christ at the Scourging Post,*
c. 1619, painted wood,
177 cm/5 ft 9 in,
Valladolid, Vera Cruz (above);

**Gregorio Fernández,**
Retable, 1625–1632, wood,
sculptures painted,
Plasencia, cathedral (right)

The architect, painter, and sculptor Alonso Cano (1601–1667) as well as Alonso de Mena were active in Granada at the same time. De Mena produced two fine pupils: his son Pedro (1628–1688), and Pedro Roldán (1624–1699). Both of them broke new ground in Spanish sculpture. Pedro de Mena's *Penitent Magdalene* embodies the deep mysticism and emotionality of Andalusia like almost no other work (1664; illus. below middle). Pedro Roldán's *Entombment of Christ* on the middle panel of the retable in the Hospital de la Caridad in Seville displays theatrical expression and powerful dynamic force (1670–1672; illus. p. 169). Incidentally, Roldán's daughter Luisa (1654–1704) was one of the few famous female sculptors of the Baroque era.

Toward the end of the seventeenth century, a more expressive formal language began to prevail in Seville as well. One demonstration of this is the *Dying Christ (El Cachorro)* of by Francisco Ruiz Gijón, in which Christ's emaciated body struggles against death; even the loincloth seems to writhe in agony. The highest pitch of dramatic expression is achieved without a doubt by the *The Head of St Paul*, a masterpiece by Juan Alonso Villabrille (1707; illus. p. 171 top left). The apostle's severed head, with lips opened in agony and a dying gaze, lies on a sort of rocky background; it is hard to imagine a more cruel scene. Although there are parallels to

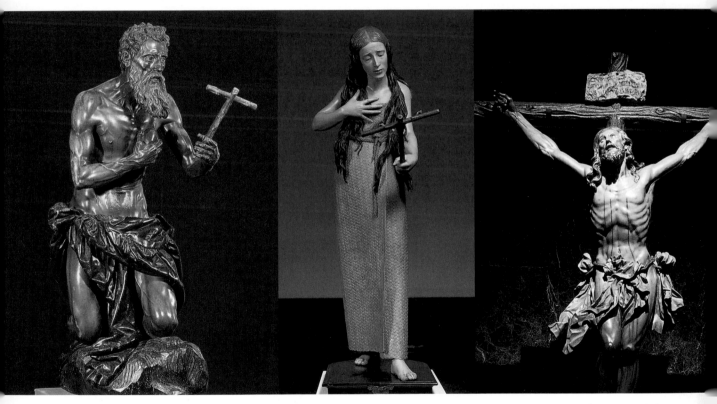

**Juan Martínez Montañés,** *St Jerome,* 1611, painted wood, height 160 cm/ 5 ft 3 in, Santiponce, Monasterio de S Isidoro del Campo (Seville)

**Pedro de Mena,** *Penitent Magdalene,* 1664, painted wood, height 165 cm/ 5 ft 5 in, Valladolid, Museo Nacional de Escultura

**Francisco Ruiz Gijón,** *Dying Christ (El Cachorro),* 1682, painted wood, height 184 cm/6 ft 1 in, Seville, Capilla del Patrocinio

P. 169: **Pedro Roldán,** *The Entombment of Christ,* 1670–1672, painted wood, over life-size, Seville, Hospital de la Caridad

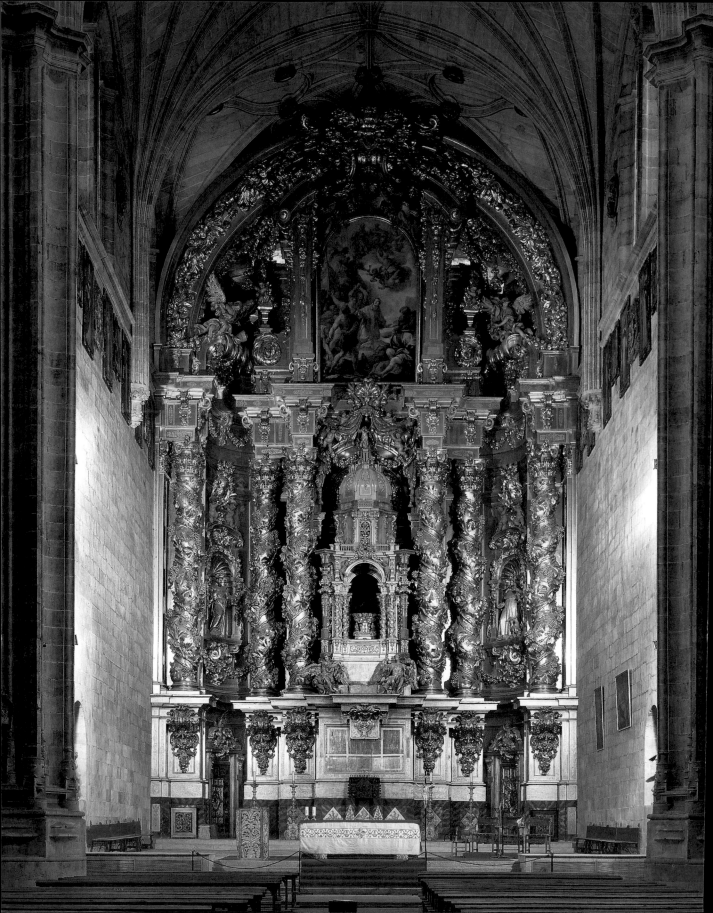

Juan Alonso Villabrille, *The Head of St Paul*, 1707, painted wood, height 55 cm/22 in, width 61,5 cm/24 in, Valladolid, Museo Nacional de Escultura

P. 170: **José Benito de Churriguera**, Altar retable, 1693, Salamanca, S Esteban

P. 172/173: **Narciso de Tomé**, *El Transparente*, 1721–1732; marble and bronze, Toledo, cathedral

be found in "St John dishes" (platters decorated with the severed head of John the Baptist), it is seldom that a subject like this has been depicted in such a drastic fashion. Just a few years later, the works of Francisco Salzillo were to usher in the Rococo, a far more charming, lighthearted style.

Spanish artists also produced unique achievements in their splendid decorations for retables, which in their hands became monumental gesamtkunstwerke integrating several art forms. The name of the Churriguera family is inseparably linked to this process; in fact "Churriguerism" became synonymous with "over-extravagant decoration." The sculptor José Ratés y Dalmau from Barcelona took five sons of a deceased relative, Josep de Xuriguera, into his workshop. After his death in 1684, all of them—José Benito, Manuel, Joaquín, Alberto, and Miguel—distinguished themselves as architects and retable-makers in their own right. The oldest of the five, José Benito de Churriguera (1665–1725), built the retable in the monastery church of S Esteban in Salamanca in 1693. Its highly molded structure, twisted "Solomonic" columns, and lavish, gilded decoration inspired hundreds of imitations (illus. p. 170).

Narciso de Tomé (documented 1715–1742) and his brother Diego created the most spectacular work of the Spanish Baroque, *El Transparente*, in the cathedral of Toledo (illus. p. 172/173). This monument, built between 1721 and 1732, is a sort of *camarín*, a separate room for keeping the Holy Sacrament. It is constructed as a large, concave retable, at the center of which the Mother of God is seated on a throne. Above her, the Last Supper is depicted. An opening in the vault admits daylight, suggesting a view into heaven, which is envisioned as a radiant, surging mass of angels and saints. Architecture, sculpture, and painting complement one another so perfectly that *El Transparente* was seen by contemporaries as an "Eighth Wonder of the World." From a neoclassicist viewpoint, however, the work was the height of decadence.

**Tomás de Sierra**, altar retable, 1704, detail (above), full view (below), Medina de Rioseco, Iglesia de Santiago

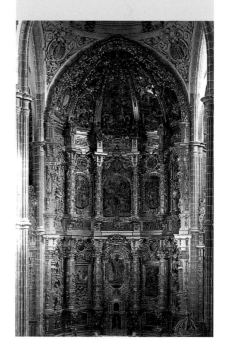

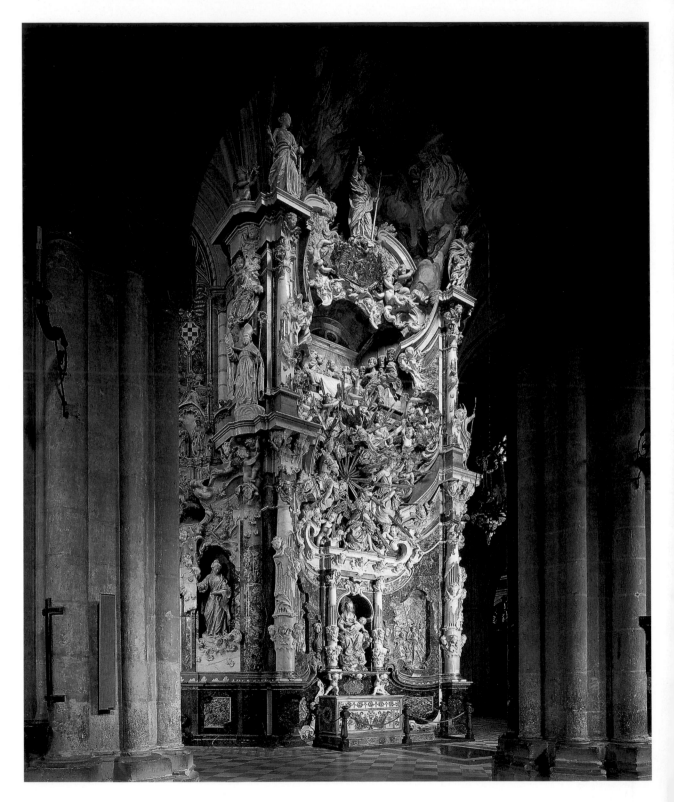

172

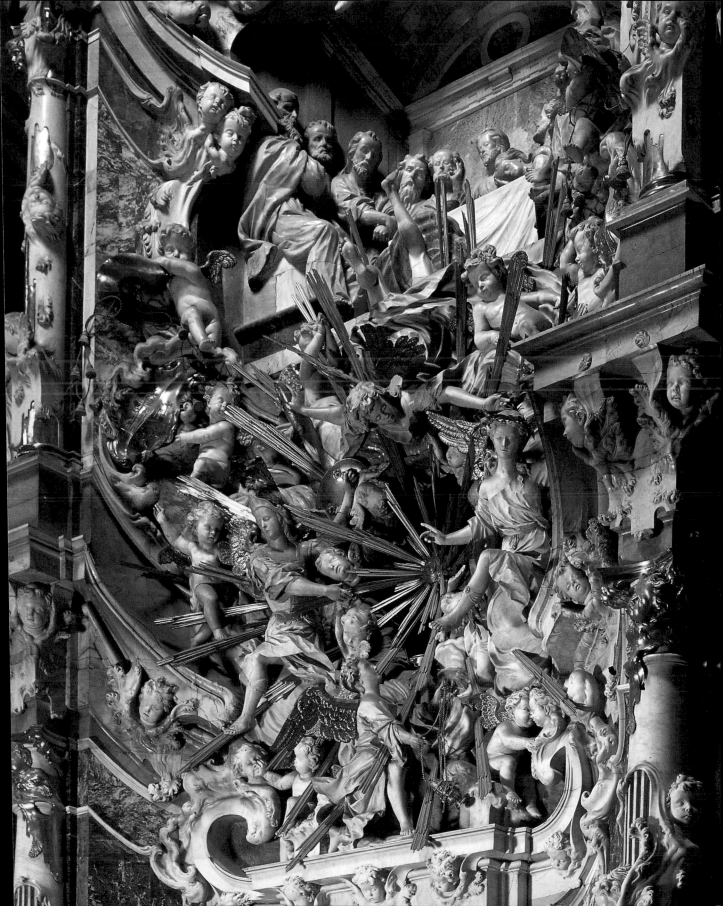

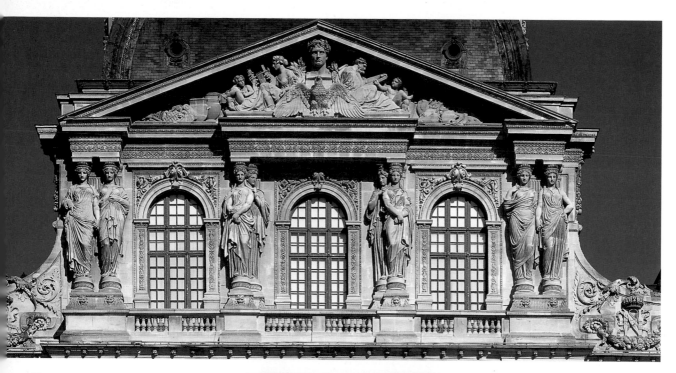

# France

French sculpture of the Baroque was, almost without exception, created in the service of the absolutist court. It reached its artistic zenith under Louis XIV (1643–1715), contributing to a glorification of the monarchy to an extent that had not yet been seen. While the Baroque style and the classical style imitating works of Antiquity had been on more or less equal footing in the first half of the seventeenth century, in the period that followed, the classicizing ideal prevailed. In this regard, the Académie Royale, founded in 1648, played an important role, imposing its guidelines on artistic production in the kingdom.

Just how much the approach of the Grand Siècle in France differed from that in Rome is shown by the fact that Bernini's

Top: **Jacques Sarrazin,** Caryatids on the Pavillon de l'Horloge, 1636, marble, Paris, Louvre

Above: **Pierre Puget,** *Milo of Crotona,* 1672–1682, marble, height 270 cm/ 8 ft 10 in, Paris, Louvre

P. 174: **François Girardon,** Tomb of Cardinal Richelieu, 1675–1694, marble, Paris, Chapelle de la Sorbonne

designs were repeatedly rejected. His sculptures did not conform to French ideals, as had also been the case with his plans for the Louvre. A characteristic example is the fate of an equestrian statue of Louis XIV: It was altered to become a monument to Marcus Curtius and banished to a back corner of the park at Versailles.

One of the few sculptors to "model" power and emotions in Bernini's style was Pierre Puget (1620–1694) from Marseilles, who became a leading representative of naturalistic sculpture following his sojourns in Genoa and Rome. His *Milo of Crotona,* which he created from 1672 to 1682 for the park of Versailles, shows the famous wrestler as described by Ovid in his *Metamorphoses:* an aging athlete having difficulties fending off the lion's attack (illus. middle).

The classicizing style in French sculpture met with far greater success. As early as the sixteenth century, it had been represented by outstanding proponents including Jean Goujon and Germain Pilon. In the seventeenth century, Jacques Sarrazin (1592–1660) translated the classical forms into the language of his time. His caryatids at the Pavillon de L'Horloge, the middle section of the west wing of the Cour Carrée that was built under Louis XIV, clearly draw on classical models (illus. p. 175). As one of the founders of the Académie Royale, Sarrazin actively promoted the study of Antiquity.

François Girardon (1628–1715) perfected French Baroque classicism in his works for the Versailles park and in the tomb of Cardinal Richelieu in the Chapelle de la Sorbonne. This monument, executed between 1675 and 1694, shows the great statesman lying on his deathbed, supported by Religio (religion) and mourned by Scientia (science); it is a perfect expression of the polarities of the time (illus. p. 174).

P. 177 top: **Gilles Guérin, Balthasar and Gaspard Marsy,** *Sun Horses,* 1668–1675, Versailles, park

P. 177 bottom: **Jean-Baptiste Tuby,** Apollo Fountain, detail, 1668–1670, gilded lead, Versailles, park

**François Girardon,** *Apollo Tended by the Nymphs,* 1666–1675, marble and natural rock, life-size, Versailles, park

## Sculptures in the Park at Versailles

A much more carefree philosophy is seen in the fountains of Versailles. The unique *Apollo Tended by the Nymphs* (1666–1675; illus. p. 176), the thematic and visual climax of the palace gardens, is Girardon's most serene work. Exhausted from his ride on the sun chariot, the god of light is bathed and anointed by nymphs—naturally, a parable alluding to Louis XIV's daily schedule. As a counterpart to this sculpture, Gilles Guérin and the Marsy brothers created the group of sun horses being taken to drink by Tritons (1688–1675; illus. right). Jean-Baptiste Tuby also took up the same theme; he designed the Fountain of Apollo on the main axis of the park (1668–1670; illus. below).

### Antoine Coysevox

Another artist who provided sculptures for Versailles was Antoine Coysevox (1640–1720). He was, above all, a brilliant portraitist. Born in Lyon, he came to Paris in 1657, where he was appointed *Sculpteur du Roi*, the royal sculptor, in 1666. In 1702, he took over the position of director at the Paris Academy. For the Salon de la Guerre in the palace at Versailles, he created the famous monumental stucco relief showing Louis XIV as the conqueror of his enemies. Dressed as a Roman emperor, the king rides over his dying foes and waits to be crowned by Fama. Among Coysevox's later works, executed as commissions for the aristocracy, is the cenotaph of Cardinal Mazarin, who, very much alive and in full possession of his power and dignity, kneels on his monument (1689–1693; illus. p. 180). At the foot of the sarcophagus sit allegorical figures of Prudentia, Pax, and Fidelitas (the first two being works by Jean-Baptiste Tuby), illustrating the virtues of the deceased. The fountains representing the four seasons with the divinities Flora, Ceres, Bacchus, and Saturn were executed according to drawings by Le Brun (illus. p. 178/179).

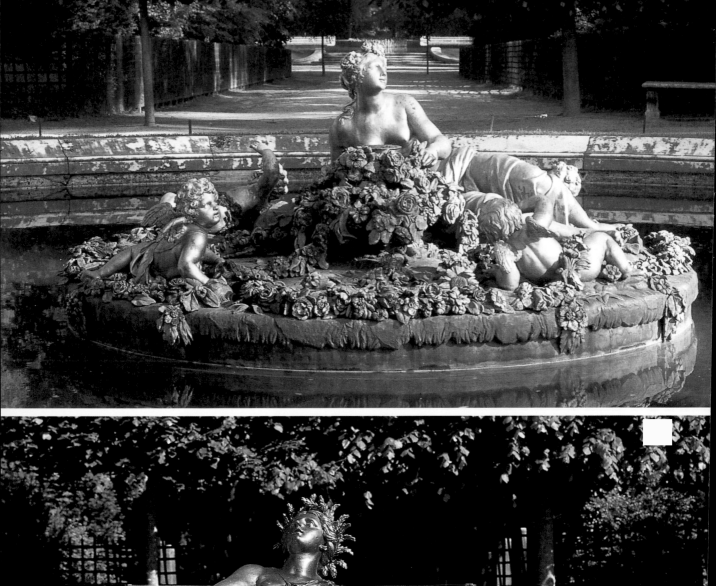

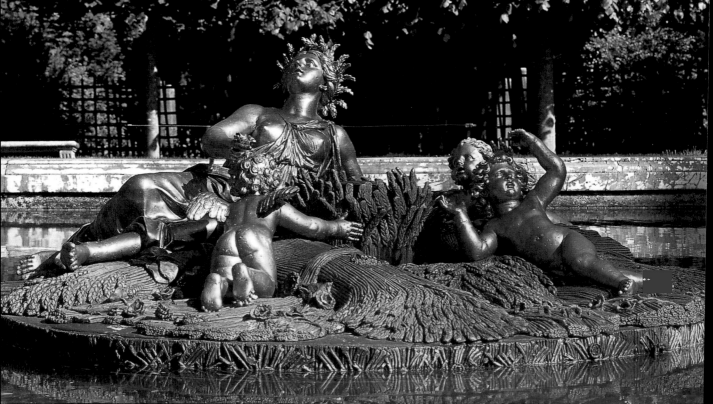

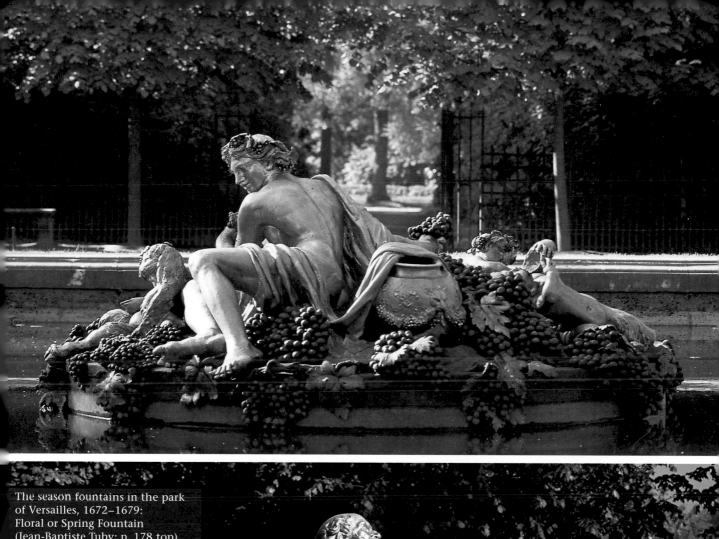

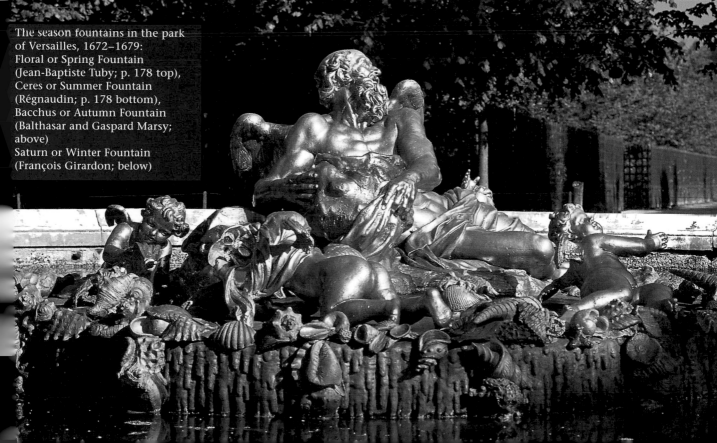

The season fountains in the park
of Versailles, 1672–1679:
Floral or Spring Fountain
(Jean-Baptiste Tuby; p. 178 top),
Ceres or Summer Fountain
(Régnaudin; p. 178 bottom),
Bacchus or Autumn Fountain
(Balthasar and Gaspard Marsy;
above)
Saturn or Winter Fountain
(François Girardon; below)

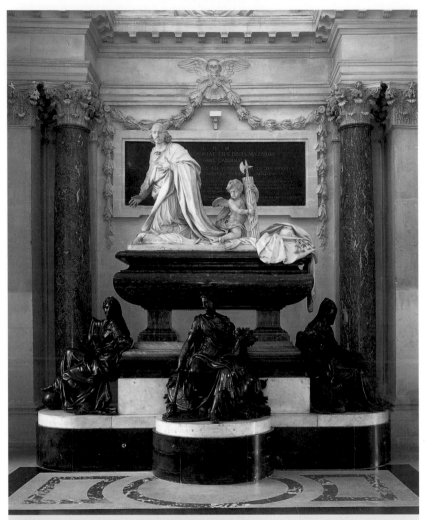

**Antoine Coysevox,**
Tomb (kenotaph) of
Cardinal Mazarin,
1689–1693, marble and
bronze, Paris, Institut
de France

**Jean-Baptiste Tuby,**
Prudentia, detail of the
tomb of Cardinal
Mazarin, 1689–1693,
bronze, height 140 cm/
4 ft 7 in, Paris, Institut
de France

## The Eighteenth Century

The works of Coysevox's nephews and co-workers Nicolas and Guillaume Coustou demonstrate how Rococo infiltrated the strictly classicizing approach of French sculpture. However, their famous pupil, Edmé Bouchardon (1698–1762), turned once again to a formal language based on models from Antiquity: the Fontaine Grenelle, the Fountain of the Four Seasons in Paris, points toward the classicism of the latter part of the eighteenth century.

Bouchardon's contemporary, René Michel Slodtz (1705–1764), scion of a Flemish family of sculptors, drew once more on the formal principles of the Roman Baroque. In the funerary monument to Languet de Gergy in St Sulpice in Paris, the viewer witnesses a dramatic confrontation between the Grim Reaper and an angel who is trying to keep the cloak of death away from the pleading nobleman (1753; illus. p. 181 bottom).

Jean Baptiste II Lemoyne (1704–1778) and his pupil Jean Antoine Houdon (1741–1828) are considered the most important French portraitists of the eighteenth century. They reflect the ambivalent way people were seen at the end of the Baroque era: The courtly, formal pose of the Comte de la Tour d'Auvergne is already infused with elements of an individual personality (1765; illus. p. 181 top left), and Houdon's bust of Mademoiselle Servat (1777; illus. p. 181 top right) suggests a deep humanity despite all its stylization.

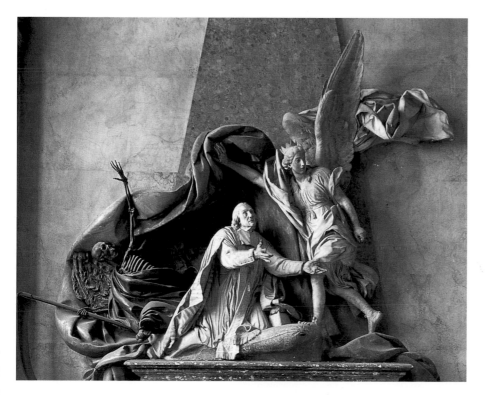

Above left: **Jean-Baptiste II Lemoyne,** Bust of Comte de la Tour d'Auvergne, 1765, marble, height 71 cm/28 in, Frankfurt a. M., Liebieghaus

Above: **Jean-Antoine Houdon,** Bust of Mademoiselle Servat, 1777, marble, height 76,5 cm/ 30 in., Frankfurt a. M., Liebieghaus

**René Michel (Michel-Ange) Slodtz,** Tomb of Languet de Gergy, 1753, marble, Paris, Saint-Sulpice

# Netherlands

Hendrick de Keyser (1565–1621) was a city architect, as well as being the most talented Baroque sculptor in the northern Netherlands. His main work, which was completed by his son, is the tomb of William the Silent, Prince of Orange (1614–1622; illus. below), situated in the Nieuwe Kerk in Delft. This is a "praalgraf," an architecturally elaborate mausoleum, set up within the polygon of the choir. The deceased prince appears twice under the late Mannerist baldachin: once as a recumbent marble effigy, and once as a bronze statue in a sitting pose, surrounded by allegories of Justice, Liberty, Religion, and Courage. After de Keyser's death, Dutch sculpture began to stag-

nate. Masters from the Flemish south started working in both parts of the country. Of these, the sculptors Artus Quellinus the Elder (1609–1668) and Lucas Fayd'herbe (1617–1697) were particularly outstanding. They both belonged to the group of artists associated with Rubens, and carried his style into the third dimension. Artus Quellinus the Elder was a pupil of François Duquesnoy in Rome, then worked in Antwerp. In 1650, he settled in Amsterdam, where he worked on the sculptures decorating the City Hall (see. p. 105) and created the group of four caryatids in the law court. The marble bust of Anton de Graeff (illus. right) was created in 1661; it shows the subject in a dignified pose and formal clothing.

The sculptor and architect Lucas Fayd'herbe also had close contact with Rubens, living and working in his house from 1636–1639. After returning to his native city of Mechelen, he worked on alterations to various churches there. In the cathedral, he built the high altar (design W. Hesius), as well as creating the unconventional tomb of Archbishop Andreas Cruesen (before 1666?; illus. p. 183 bottom), probably while the latter was still alive. This work shows a familiarity with Rubens' work. The archbishop is kneeling in front of the Risen Christ. He is wearing full vestments, but has put aside his miter. Behind him, Chronos turns away, thus signalizing the approach of death.

In contrast to Fayd'herbe's eclectic style, the Quellinus pupil Rombout Verhulst developed a very sensitive formal vocabulary. His tomb for Johan Polyander van Kerkhoven in the Pieterskerk in Leiden shows the deceased sleeping, his head resting on his hand, his features relaxed (1663; illus. above). The skin and hair are depicted naturalistically; the costly cloth of his robe lies in deep folds.

It was not only in the field of funerary sculpture that there were outstanding achievements. From 1695 to 1699, the Jesuit church in Louvain was given a Baroque pulpit adorned with many figures; in 1773, when the order was disbanded, it was taken to Stes-Michel-et-Gudule in Brussels (illus. p. 184/185).

This artistically and intellectually ambitious work was created by Hendrik-Frans Verbrugghen (1654–1724), who had worked previously in Antwerp. Its iconographic program deals with the story of salvation, which finds its counterpart in the Old Testament. The enclosed platform rests upon a massive tree trunk, whose branches grow up over the sound-board. In front of this pretty backdrop is an affecting scene of the expulsion from paradise, which gains added dramatic effect from the presence of Death. The Madonna of the Crescent Moon, who appears high above the sound-board with the boy Jesus, promises redemption. The body of the pulpit recalls a globe of the world, resting on the backs of Adam and Eve.

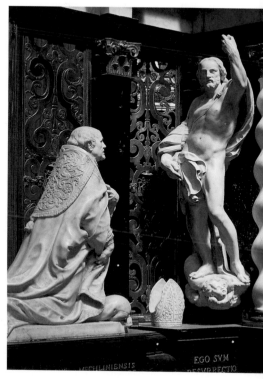

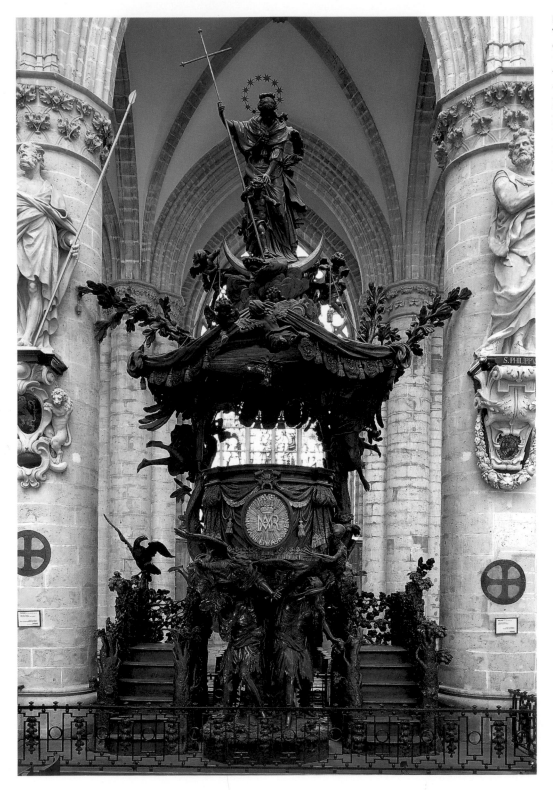

**Hendrik Frans Verbrugghen,** Chancel, 1695–1699, full view (left) and detail of the pulpit with the Expulsion from Paradise (opposite), oak wood with gold, height c. 7 m/ 22 ft 11.5 in, Brussels, Saints-Michel-et-Gudule

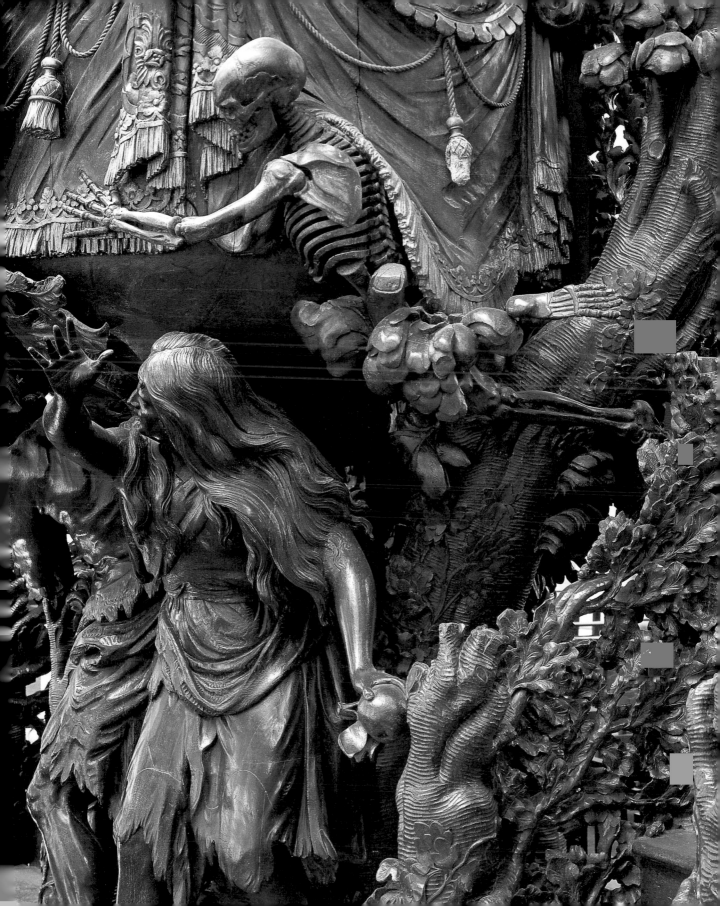

# Sculpture in England

Following the process of secularization and iconoclasm, English sculpture had difficulties maintaining the standards set in its medieval period of glory. The only sculptor of international status was Nicholas Stone the Elder (1586–1647), who studied with Hendrick de Keyser (see p. 105) in Amsterdam and s'Hertogenbosch, later becoming his son-in-law. For this reason, the roots of his outstanding work, which consists chiefly of funerary monuments, are to be found in Holland. As an architect, Stone assisted Inigo Jones (see p. 95) in the building of the Banqueting House and the portico of St Paul's Cathedral in London, among other things. His two most important works in marble were done around 1617: the tomb of Sir William Curle in Hatfield, Hertfordshire (illus. above), and that of Lady Elizabeth Carey in Stowe-Nine-Churches, North-

**Nicholas Stone the Elder,** Tomb of Sir William Curle, c. 1617, marble, Hatfield, Hertfordshire

**Louis François Roubiliac,** Bust of Dr John Belchier, 1749, marble, life-size, London, Royal College of Surgeons of England

amptonshire (illus. below). Both these works depict death with frank naturalism. The naked body of Sir William Curle is covered only by a winding sheet, but the

decaying body still radiates a composed dignity. In this moving depiction, Stone uses a motif employed by the Frenchman Germain Pilon, who represented King Henry II and Catherine de Médicis in a similarly affecting manner in the sixteenth century. In Stone's work, however, the degree of relief is much reduced: Sir William's body barely projects

above the slab and seems to have sunk into the ground. The unusual way the reclining effigy is turned to one side takes up a motif used in English sculpture of the

**Nicholas Stone the Elder,** Tomb for Lady Elizabeth Carey, c. 1617, marble, life-size (detail above), Stowe-Nine-Churches, Northamptonshire

Gothic period. Lady Elizabeth Carey, on the other hand, is lying stretched out on a catafalque. Her right hand rests on her breast, and is no longer joined with the left in a gesture of prayer, as was usual in earlier works. In both monuments, the sculptor has introduced innovative motifs into the Baroque sepulchral sculpture of England.

Whereas Nicholas Stone the Elder dominated sculpture in the seventeenth century, Louis François Roubiliac (c. 1703–1762), who was born in Lyons, was the main influence in the early eighteenth century. Roubiliac studied with Balthasar Permoser in Dresden and with Nicolas Coustou in Paris. In 1730, the Paris Academy awarded him the second prize for sculpture. In 1735 he settled in England, achieving success with portrait busts and monuments. Roubiliac's fame was secured by his famous statue of Georg Friedrich Handel for Vauxhall Gardens in London. It was executed in 1738, while the composer was still living, and shows him sitting down playing the lyre. In 1761, Roubiliac built Handel's tomb. His virtuosic portraits are realistic likenesses of the subjects, who appear in simple, contemporary clothing, like Dr John Belchier (1749; illus. p. 186 top right). Roubiliac's masterpiece is the moving monument to Joseph and Lady Elizabeth Nightingale in Westminster Abbey in London (1760, illus. right). As in many comparable monuments of the eighteenth century, an isolated depiction of the deceased is no longer the main feature. Instead, the sculptural ensemble tells a story that elicits viewers' compassion. In this case, it concerns the fate of young

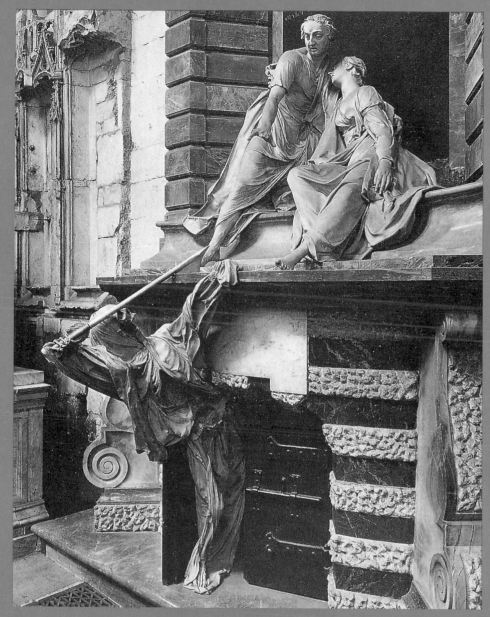

Mrs Nightingale, who was so frightened by a flash of lightning while on the terrace of her house that she lost her unborn child and died. Death emerges from the dark vault that opens up under the terrace and aims his sword at the woman, who sinks into her husband's arms.

But he cannot prevent the catastrophe; death's triumph is inevitable. Even though the monument hints at the beginnings of classicism, the intensification of the tragic element and the animated composition clearly reveal the influence of Bernini. Roubiliac had studied the latter's works while on a trip to Rome in 1752.

**Louis François Roubiliac,** Sepulchre monument for Joseph and Lady Elizabeth Nightingale, 1760, marble, London, Westminster Abbey

187

**Hans Krumper,** Duke Albert of Bavaria, standing sculpture from the tomb of Emperor Ludwig of Bavaria, 1619–1622, bronze, over life-size, Munich, Frauenkirche

# German Empire

## The First Half of the Seventeenth Century

The turmoil of the seventeenth century, above all the Thirty Years' War, had prevented any continuous development of Baroque sculpture within the borders of the German Empire. Divided among 35 small states, torn between Protestant iconoclasm and the artistic rhetoric of the Counter-Reformation, sculpture in the middle of Europe was subject to the widest range of conditions imaginable. This also had its advantages, however. Individual trading cities and royal seats, such as Augsburg, Nuremberg and Munich, Danzig, Prague, and Vienna, were in a position to attract a broad variety of creative talent. It was mainly Flemish and Dutch artists who brought stylistic innovations and technical skills—like casting in bronze—to Germany. Most of them had done their training in Italy; now, they brought Mannerist and Early Baroque styles from Florence and Bologna to the countries north of the Alps, which were still under the influence of the late Middle Ages.

A characteristic case is Hubert Gerhard, a sculptor in bronze born in around 1540 in Amsterdam (died 1622/1623). He was a pupil of Giambologna. In 1581 he entered the service of the Fugger family in Augsburg, where he built the Augustus Fountain for the occasion of the city's 1600th anniversary. One of the first monumental fountains in Germany, it clearly shows the influence of Florentine Mannerism. For St Michael's in Munich, he executed the larger-than-life bronze statue of the church's patron saint, who is running his lance through the blinded Satan in a dramatic gesture (1588; illus. p. 189 bottom middle).

The state of Bavaria has Gerhard's pupil, Hans Krumper from Weilheim (1570–1634), to thank for its emblem, the statue of the *Patrona Boiariae* on the facade of the Munich Residenz (1615; illus. p. 189 bottom left). As well as this popular statue of the Mother of God, Krumper and his founders executed several funerary monuments, which are some of the most important works in the field of bronze sculpture. The splendidly robed statues of dukes that adorn the monument of Ludwig of Bavaria in the Frauenkirche were done as part of the—uncompleted—mausoleum of William V (illus. left).

Like Hubert Gerhard, Adriaen de Vries (c. 1560–1626) from the Netherlands and Hans Reichle from Schongau (c. 1570–1642) trained in Giambologna's workshop. Both created grand masterpieces for the Imperial Free City of Augsburg: de Vries executed the Mercury and Hercules fountains from 1596 (illus. p. 189 bottom right), and Reichle carried out the splendid group with the Archangel Michael on the facade of the Zeughaus between 1603 and 1606 (illus. p. 189 above). It is a perfect demonstration of Baroque stylistic principles: presented as if in a theater, the figures play their parts with expansive, dramatic gestures.

Right: **Hans Reichle,** Group with St Michael, 1603–1606, bronze, over life-size, Augsburg, Zeughaus

Below left: **Hans Krumper,** *Patrona Boiariae*, 1615, bronze, height c. 300 cm/9 ft 10 in, Munich, Residenz

Below center: **Hubert Gerhard,** The Archangel Michael, 1588, bronze, over life-size, Munich, St Michael

Below right: **Adriaen de Vries,** Hercules Fountain, 1596–1602, marble and bronze, Augsburg

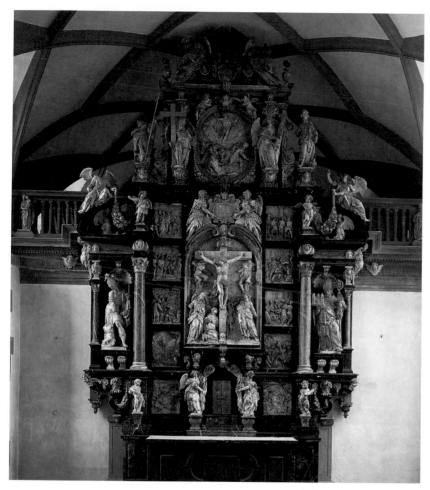

The execution of retables and memorial plaques gave wood-carvers and stonemasons plenty to do. Although the powerful Lady Altar by Jörg Zürn (1607–1635; illus. p. 190) clearly is influenced by Late Gothic *schnitz-altäre* (carved altars) the architecturally framed scenes are informed by an exciting dynamism. For the Passion Altar in Aschaffenburg, Johannes Juncker (c. 1582–after 1623) chose red and black marble, setting off the scenic reliefs and the vividly depicted figures of the saints in dramatic fashion (illus. left).

Sculptors in Protestant regions were also prolific. The Wolff family of sculptors, consisting of the father Eckbert the Elder and sons Eckbert the Younger and Jonas, was employed at the court in Bückeburg. They left behind highly expressive works in the Golden Hall of the Residenz and in the palace chapel, including the famous altar table supported by life-size kneeling angels (between 1601 and 1604).

P. 190: **Jörg Zürn**, Lady Altar, 1613–1616, lime wood, not painted, Überlingen, parish church

Above: **Johannes Juncker,** Passion Altar, 1609–1613, black and red marble, alabaster, Aschaffenburg, palace chapel

Right: **Georg Petel,** *Ecce Homo*, 1630/1631, painted lime wood, height 175 cm/5 ft 9 in, Augsburg, choir of the cathedral

As well as these large-scale public sculptures, the sculptors of the early seventeenth century also created a number of devotional works that manifest the expressive wealth of their epoch. In this regard, one should mention the bronze statue of *Man of Sorrows*, a deeply moving work by Adriaen de Vries from 1607, and the *Ecce Homo* of Georg Petel (1601/02–1634), which depicts the Scourged Christ with reserved pathos (illus. right). Petel's friends included François Duquesnoy in Rome, Anthony van Dyck in Genoa, and Peter Paul Rubens in Antwerp. He was an uncommonly gifted sculptor, and took German sculpture to a very high level.

## The Second Half of the Seventeenth Century

The German Empire recovered from the disaster of the Thirty Years' War only slowly; there was little demand for artists and works of art. The appearance of Justus Glesker on the scene is thus all the more amazing: around the middle of the century, he executed the Roman-influenced crucifixion group for Bamberg Cathedral (1648–1653; detail below right). The career of this sculptor, who came from Hameln and trained in Italy, remains mysterious; and it is difficult to categorize his works stylistically.

Not until the last quarter of the century did German sculpture gradually regain ground, largely due to the traditions of craftsmanship upheld by workshops in the Alpine region. Thomas Schwanthaler (1634–1707), who came from Ried, Innkreis, worked in the district of Innviertel and the Salzkammergut region where he built the splendid, gilded double altar of St Wolfgang am Abersee (1675/1676; illus. below). Meinhard Guggenbichler (1649–1723), who worked in the nearby monastery of Mondsee, had an almost unrivalled ability to endow his wooden statues with intimate feeling (illus. right).

Matthias Rauchmiller (1645–1686) came from Lake Constance to Antwerp, then went to the Rhineland before ending his career in Vienna. His work combines southern German and Dutch styles. In the Liebfrauenkirche (Church of Our Lady) in Trier, he executed the magnificent monument of Karl von Metternich (1675; illus. p. 193 top). Its realism opened a new chapter in German portrait art. The elegant, half-reclining marble effigy only partly obeys the dictates of courtly protocol; Rauchmiller was interested in people as individuals, in capturing the moment. The canon appears to leaf through a book in critical appraisal; his sumptuous robes are creased, his hair disheveled.

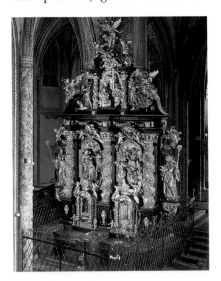

Above: **Meinrad Guggenbichler,** Christ with the thorny crown, c. 1682, painted wood, slightly less than life-size, Mondsee (Salzkammergut), former abbatial church

Right: **Justus Glesker,** Mary Full of Sorrow from the crucifixion group in the Bamberg cathedral, 1648–1653, wood, newly gilded, total height 220 cm/7 ft 2.5 in, Bamberg, cathedral

Left: **Thomas Schwanthaler,** Detail from the double altar of St Wolfgang, 1675/1676, St Wolfgang am Abersee, Salzkammergut

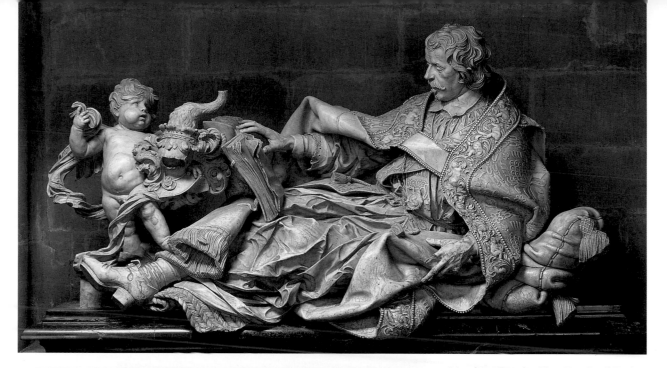

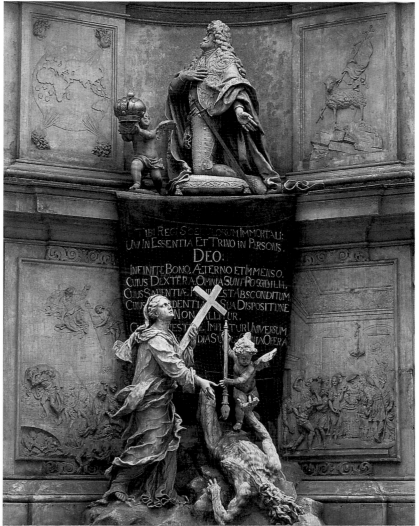

**Matthias Rauchmiller,** Tomb of Karl von Metternich, 1675, marble, slightly over life-size, Trier, Liebfrauenkirche

Left: **Paul Strudel,** Emperor Leopold I and the Allegory of Faith, detail from the column of the Holy Trinity, 1692, marble, over life-size, Vienna, Graben

When Vienna was stricken by a plague epidemic in 1678/1679, Emperor Leopold I pledged to build a wooden column dedicated to the Holy Trinity. In 1682 it was decided to replace this with a marble monument, for which Rauchmiller provided the first plans. When the artist died in 1686, the plans were modified by Johann Bernhard Fischer von Erlach and Ludovico Burnacini, and finally completed by Paul Strudel and his assistants in 1692. Strudel is responsible for the design of the key scene, in which the allegory of Faith triumphs over the plague, depicted as an ugly old hag (illus. left).

193

## The Eighteenth Century

The sculptor and architect Andreas Schlüter (1664–1714), who was born in Danzig, produced his magnificent sculptural works at the start of the eighteenth century. He first worked in Warsaw, before being appointed court sculptor at the electoral court of Brandenburg by the elector Frederick III in Berlin in 1694. From 1698 he was also entrusted with architectural tasks (see p. 142). His early masterpieces include the helmets and masks that he executed to adorn the Zeughaus. The *Dying Warrior*, which decorates a keystone in the courtyard of the former arsenal, is a deeply moving depiction of human suffering in the face of death. There are few works of European sculpture that give this subject a more striking treatment.

With the equestrian statue of the Great Elector, Schlüter not only created one of the most famous monuments of the Baroque, but also the first large-scale equestrian monument on German soil (1698–1708; illus. right). It originally stood on the Lange Brücke (Long Bridge) in view of the Royal Palace. It survived World War II on the bed of Lake Tegel, and in 1952 was placed in the location where it is to be seen today, in the main courtyard of Schloss Charlottenburg. Michelangelo and Bernini had a strong influence on this dynamic, animated figure majestically reining in its impetuous mount. The pedestal is flanked by enchained slaves, whose powerful gestures form a transition into the surrounding space; they

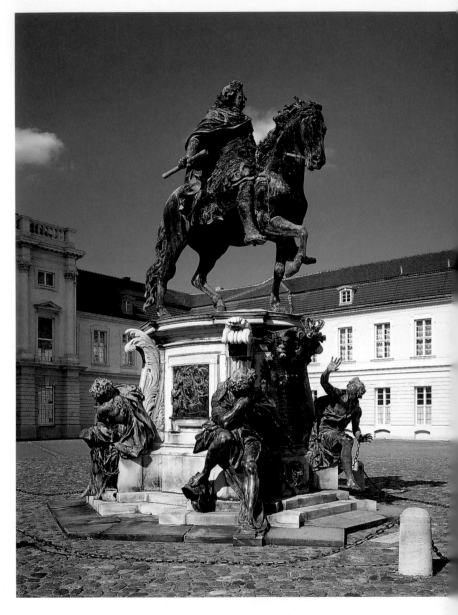

were executed by other artists to Schlüter's plans.

Balthasar Permoser (1651–1732) worked for the neighboring Saxon court from 1689. A farmer's son from the Chiemgau region, he studied sculpture in Italy for 14 years, in particular the late works of Bernini. Permoser's most important works

**Andreas Schlüter,** equestrian statue of the Great Elector Friedrich Wilhelm I, 1698–1708, bronze on stone socle, total height 560 cm/18 ft 4.5 in, Berlin, Schloss Charlottenburg

P. 195: **Balthasar Permoser,** Herm pilasters, 1711–1718, Dresden, Zwinger

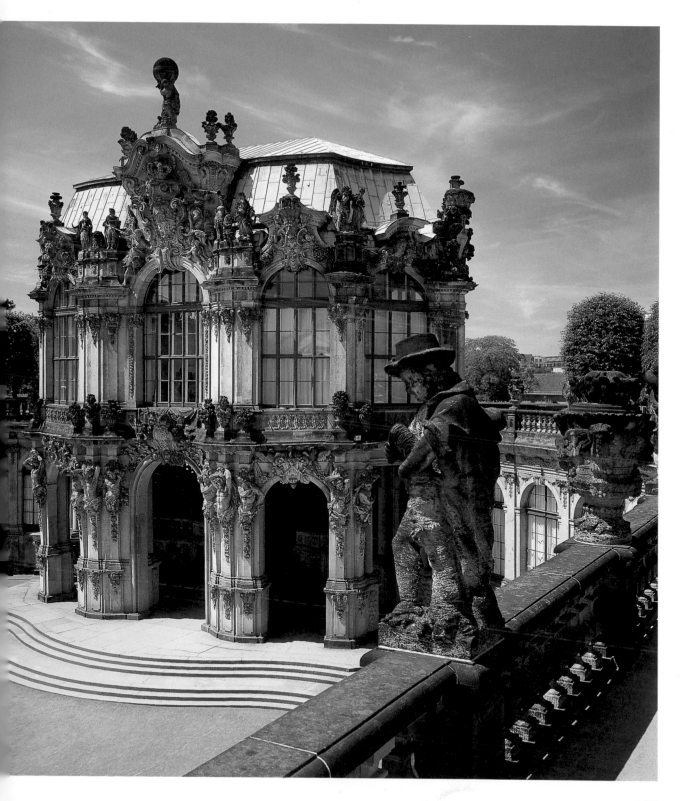

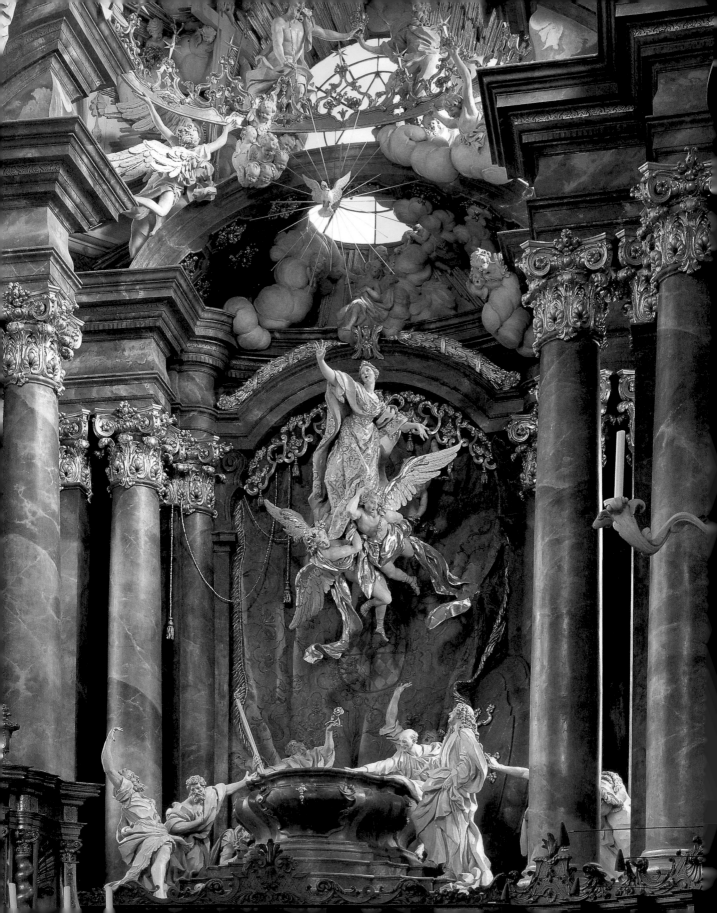

P. 196: **Egid Quirin Asam,** *Assumption of the Virgin*, 1721–1736 or 1717–1725, Rohr, abbey church of the Augustine monastery and collegiate

Left: **Johann Anton Feuchtmayer,** *St Joachim*, 1749, stucco, life size, Birnau, pilgrimage church

Right: **Franz Ignaz Günther,** *Pietà*, 1758, painted wood, Kircheiselfing near Wasserburg, St Rupertus

Below: **Johann Christian Wenzinger,** *Genius in Sorrow* from the Mount of Olives in Staufen, 1745, painted terracotta, height 54 cm/21 in, Frankfurt a. M., Liebieghaus

are the bucolic herm pilasters of the Zwinger in Dresden (now with many additions), which are a congenial adjunct to the festive architecture of Matthäus Daniel Pöppelmann (1711–1718; illus. p. 195, see also p. 138/139). Outstanding among Permoser's later works is the *Apotheosis of Prince Eugene*, in which the artist gave free rein to his individual, unconventional artistic language.

Bernini's art also influenced the Asam brothers, Cosmas Damian (1686–1739) and Egid Quirin (1692–1750). They, too, took a study trip to Rome before creating their illusionistic masterpieces in the region of Bavaria and the Upper Palatinate (see p. 126/127). While Cosmas Damian worked primarily as a painter, Egid Quirin, a sculptor and stucco worker, decorated their jointly conceived interiors with vivid and visionary art works. Two magnificent examples of their theatrical interior

design and dramatic use of light are the altar of the *Assumption of the Virgin* in Rohr (1721–1736 or 1717–1725; illus. p. 196), and the high altar of St George in Weltenburg. The viewer encounters a splendid spectacle, a true *theatrum sacrum* that cannot fail to make an impression.

Whereas the Asam brothers are seen as the founders of Bavarian Rococo, Ignaz Günther (1725–1775) is considered the artist who perfected it. In Günther's works, the ecstatic pose of the figures gives way to a reserved, yet no less moving, intimacy. The theme of the pietà, to which he returned again and again throughout his life, gives a deep insight into the artist's development. Whereas the early pietà in Kircheiselfing emphasizes the intimacy of the mother's grief (1758; illus. above), another version done 16 years later depicts mourning of a heroic, idealized kind.

Joseph Anton Feuchtmayer (1696–1770) also focused on the expressive depiction of emotion; he found the medium of stucco sculpture to be the most congenial to his talents.

Johann Christian Wenzinger from Breisgau, who trained in Italy and the Paris Academy,

worked in the Upper Rhine region. He achieved fame chiefly with his naturalistic terracotta sculptures. The figures of the Mount of Olives in Staufen (1745; illus. p. 197 bottom)—which include a self-portrait depicting the artist as an observer of the event—clearly show his struggle for directness of expression.

The works of Georg Raphael Donner (1693–1741) from Lower Austria combine Late Baroque and classicizing features, allowing him to serve as a bridge between the old and new styles.

Donner found lead casting the form of expression most suited to his talents, and he used it to produce classic, elegant forms. Between 1737 and 1739, he created the Mehlmarkt or Providentia Fountain (now the Danube Well) in Vienna: Reclining allegories of the rivers Ybbs, Enns, March, and Traun flow into the mighty Danube, represented by the waters in the fountain basin itself (illus. p. 199). The pietà in the Gurk Cathedral is one of his late works; it is also cast in lead (1740/1741; illus. below).

Joseph Thaddäus Stammel (1699–1765), who was active in Austria, devoted his life to the decoration of the abbey library in Admont. *Hell* and *Death* are eloquent examples of his art; they form part of the group of the *Four Last Things*, which he carved in wood around 1760 (illus. p. 200 bottom).

The lighthearted aspect of the eighteenth century that goes with Rococo was well represented by the Bohemian Adam Ferdinand Dietz (or Tietz, 1709–1777), who was appointed to decorate the

**Georg Raphael Donner,** *Pietà*, lead, height 220 cm/7 ft 2.5 in, width 280 cm/9 ft 2 in, Gurk, cathedral

P. 199: **Georg Raphael Donner,** Mehlmarkt or Providentia Fountain, 1737–1739, lead-tin alloy, height 337 cm/11 ft 0.5 in, Vienna, Österreichische Galerie

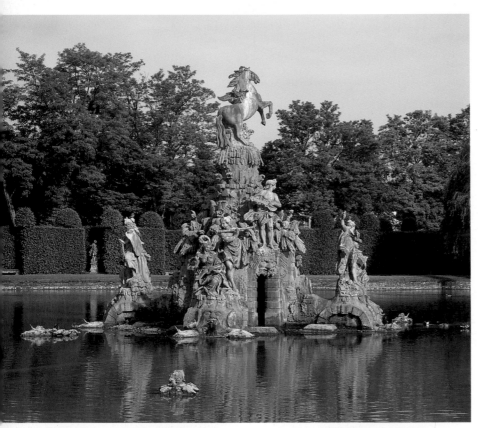

**Adam Ferdinand Dietz (Tietz),**
*Parnassus,* 1766, sandstone, formerly guilded, Veitshöchheim near Würzburg, palace park

P. 201: **Franz Xaver Messerschmidt,**
Four character heads, 1770–1783.
*The Arch-Evil* (top left), tin-lead alloy, height 38,5 cm/15.2 in
*The Hanged* (top right), alabaster, height 38 cm/15 in
The Lecher (bottom left), marble, height 45 cm/17.5 in
The Beaked (bottom right), alabaster, height 43 cm/17 in, all four in Vienna, Österreichische Galerie

Below: **Joseph Thaddäus Stammel,**
*Hell* (left) and *Death* (right) from the *Four Last Things* group, c. 1760, bronzed wood, 250 cm/8 ft 2.5 in, Admont, abbey library

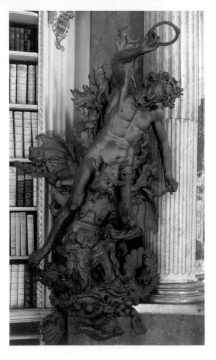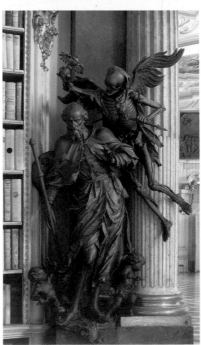

palace gardens in Franconia and Trier. His decorative sandstone figures with their mythological and allegorical content—as seen here in *Parnassus* in the park of Veitshöchheim near Würzburg—show both imagination and artistic skill (1766; illus. above).

This survey concludes with the spectacular character heads by Franz Xaver Messerschmidt (1736–1783). These grimacing self-portraits, whether they reflect the fascination of madness or depict natural emotions, were fashioned on the threshold of a new era, the epoch of the Enlightenment (1770–1783; illus. opposite).

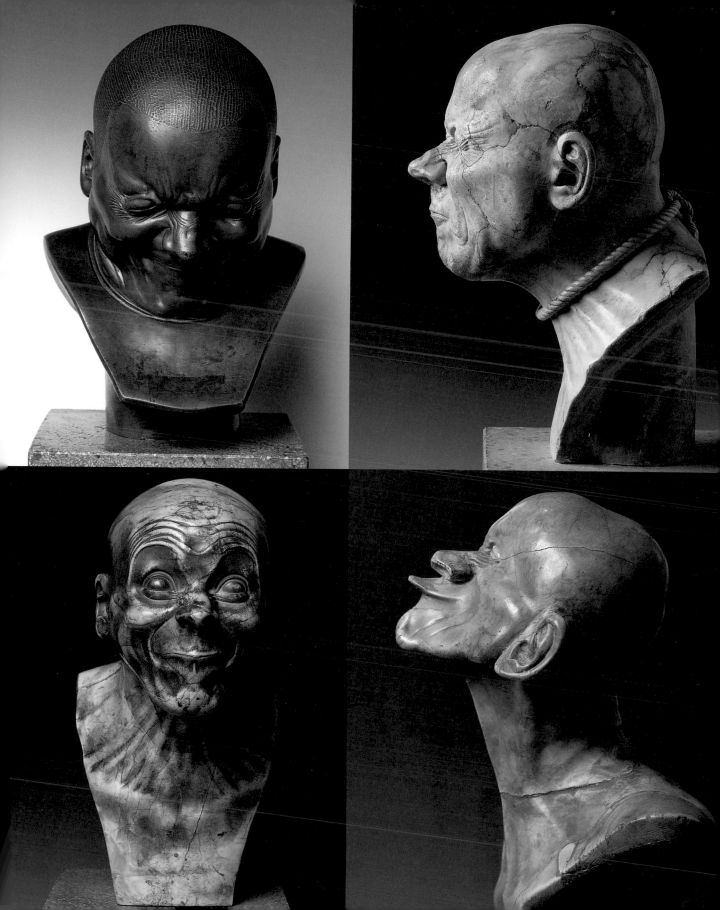

# Vanitas/Memento Mori

**Paul and Peter Strudel,** *St Mary in sorrow*, from the altar of the Imperial Vault, 1711–1717, Vienna, Kapuzinerkirche

uninhibited enjoyment of life's pleasures contrast with deep religious beliefs and an awareness of the inevitability of death. In the Baroque, the motto *memento mori*, "remember that you must die," became the leitmotif of a turbulent society oppressed by existential fears. The theme of *vanitas*, the futility of human existence, ran through all the arts. It is no coincidence that the opulent still lifes of the time often contain subtle references to the transitory nature of life, such as a worm, a rotten berry or a partly-eaten piece of bread. Other popular *vanitas* motifs are more obvious: the pocket watch, the overturned glass, the burnt-out candle, the skull. When personified, *Vanitas* appears most often as a female figure with a mirror,

underlining the vice of vanity. Popes and princes cultivated an ostentatious awareness of death; several slept next to their open coffins and had monuments to themselves erected during their life-times—which was also meant to secure their posthumous fame. The papal tombs by Bernini in St Peter's Basilica

(see p. 157) bear eloquent witness to this attitude. On Urban XIII's tomb, Death is writing the pope's name—he has not yet made the final stroke. Alexander VII kneels, as if alive, above a door that is shown to be the doorway to death: Death himself, portrayed as a skeleton with an hourglass, acts as doorman. The redecoration of Charles VI's tomb in the Imperial Vault in Vienna was also a striking example: Charles's daughter, Maria Theresa, had the rocaille ornaments at the coffin corners replaced with crowned skulls; the tomb—designed by Fischer von Erlach and Daniel Gran, among others—did not seem adequate to her as it stood (illus. above and below left).

No one characterized the theme of transitory existence more vividly than the Spanish Baroque writer Calderón de la Barca. In his allegorical play *El Gran Teatro del Mundo* (The Great Theater of the World), first performed in 1645, he applied the ancient topos of "life as a play" to his own times. In the course of the play, "the World" gives every actor, whether king or beggar, the requisites appropriate to their station. The actor enters the stage through one door, "the Cradle," and leaves it through another, "the Grave." This is the moment in which the actors have their "insignia" taken from them once more and see whether or not they have fulfilled their role or not. The discarded symbols of power in the painting by Pieter Boel

**Tomb of Emperor Charles VI,** c. 1750, detail (above); full view (below), Vienna, Imperial Vault

The art of the Baroque often takes on confusing forms. Extravagant displays of material splendor and an

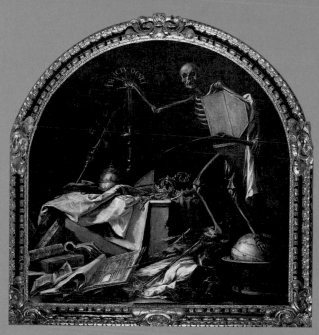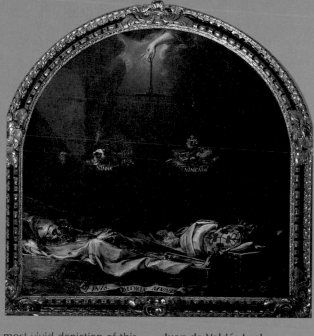

illustrate precisely this dramatic moment, which decides over the "illusion" and "disillusionment" of the Baroque individual (illus. below). In Calderón's play, only the Beggar and Wisdom do not succumb to the vices of pride and vanity, thus escaping damnation.

It was also a Spanish artist who gave us the perhaps most vivid depiction of this theme in painting: Juan de Valdés Leal executed two allegories of death, *In Ictu Oculi* and *Finis gloriae Mundi* (1670–1672; illus. above),

**Juan de Valdés Leal,** *In Ictu Oculi* (left) and *Finis Gloriae Mundi* (right), 1670–1672, oil on canvas, 220 x 216 cm/7 ft 2.5 in x 7 ft 1 in each, Seville, Hospital de la Caridad

which deal with the subject of transitory existence in a profoundly disturbing fashion. In the first picture with the legend "In the Face of Death," a skeleton turns out the light of life and stops time. All the attributes of worldly power and learning are in disarray. The second painting, "The End of Worldly Fame," shows corpses in various stages of decomposition, including those of a bishop and a knight of the Order of Calatrava. Above them appears the hand of Christ with a set of scales upon which the Seven Deadly Sins are weighed against the symbols of a Christian life.

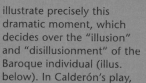

**Pieter Boel,** Large Vanitas Still Life, 1663, oil on canvas, 207 x 260 cm/6 ft 9.5 in x 8 ft 6 in, Lille, Musée des Beaux Arts

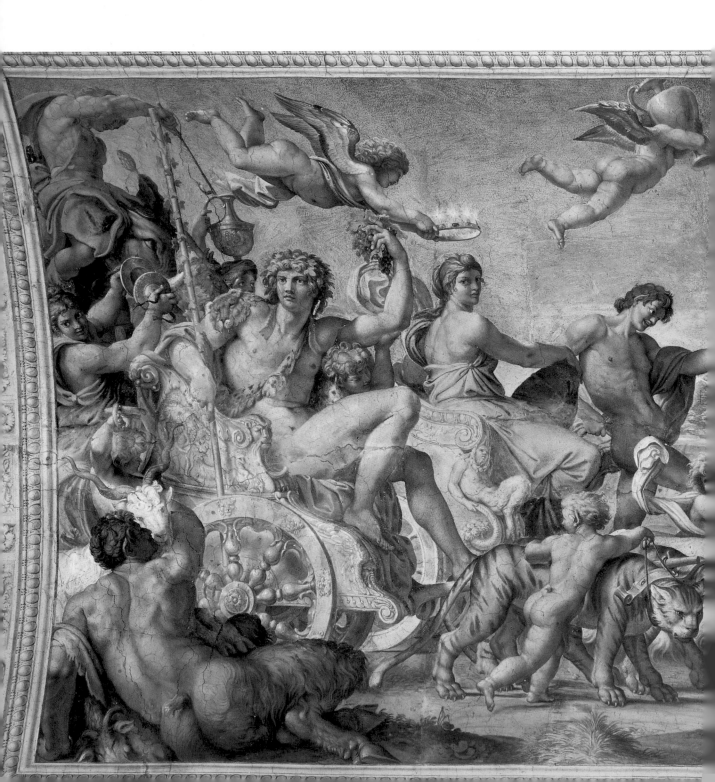

**Annibale Carracci,** *Triumph of Bacchus and Ariadne*, 1597–1604, central painting of the ceiling frescoes of the Galleria Farnese, Rome, Palazzo Farnese

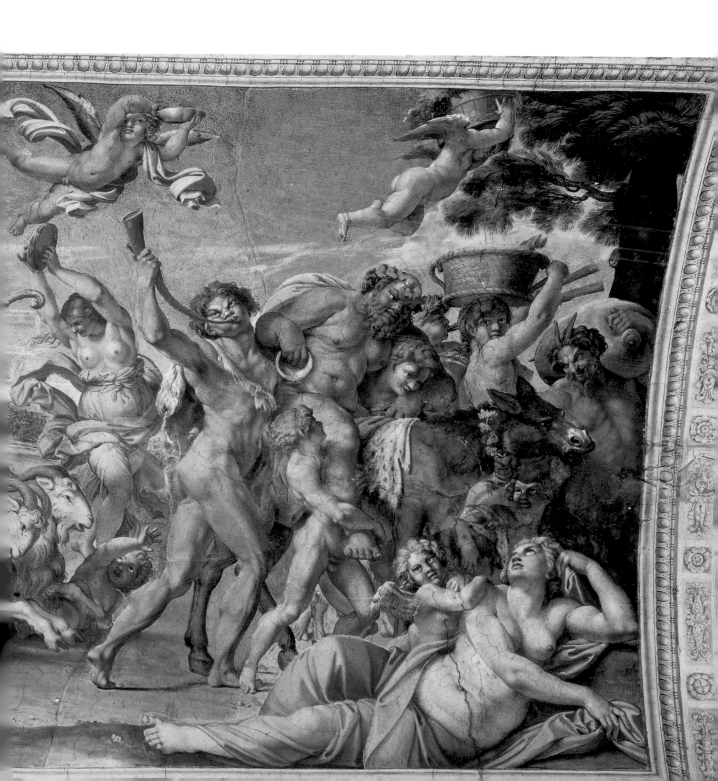

# Italy

The roots of Italian Baroque painting lie in Bologna, where Ludovico Carracci (1555–1619) had developed early "Baroque" compositions: His paintings have a clear spatial structure, the action is limited to a few protagonists, and the figures are natural, voluminous, and frequently drawn from nature. Ludovico's cousins Agostino and Annibale (1557–1602 and 1560–1609 respectively) followed his example. Annibale's *Butcher's Shop* is a fine example of the new style. It is a kitchen scene in the Dutch tradition, in which the young artist exploits the picturesque side of his father's profession (before 1583; illus. below).

In order to teach their apprentices a natural manner of composition, the Carraccis founded an academy, later known as the Accademia degli Incomminati, which was to guide young talents "onto the right path." Many of the great painters of the seventeenth century did, in fact, attend this school. Agostino and Annibale moved to Rome in 1595, where they contributed to the lasting success of the new, anti-Mannerist style.

For Annibale in particular, Odoardo Farnese became the most important patron. After a trial piece, the cardinal commissioned him to carry out the frescoes in the gallery of his family palace, which Annibale completed between 1597 and 1604 with the help of Agostino and his own pupil, Domenichino. In the process, he created one of the most magnificent ceiling decorations of all time: the barrel vault, 20 meters long and 6 meters wide (61.5 ft x 18.5 ft), is completely covered in frescoes, like the ceiling in Michelangelo's Sistine Chapel. The center is taken up by the long main painting showing the *Triumph of Bacchus and Ariadne*, which is surrounded by other (amorous) adventures of the gods and heroes (illus. p. 204/205).

Elements of illusionistic architecte (fictive architecture), stone-colored atlantes, and realistic *ignudi* (nude figures) deceive the viewer's senses.

Almost at the same time as the Carracci, Michelangelo Merisi (1573–1610) from Lombardy, who was called Caravaggio after his home town, was conquering the art scene on the Tiber. His genius was, and continues to be, surrounded by scandal. The unvarnished realism of his altarpieces, which were regularly the object of official complaints or even rejections, together with his impetuous and uncompromising character, gave the artist a legendary status even during his lifetime.

Caravaggio received his first major commission in 1597: the decoration of the Contarelli Chapel in S Luigi dei Francesi, where he depicted the *Calling*, *Inspiration*, and *Martyrdom of St*

P. 206: **Annibale Carracci**, *The Butcher Shop*, before 1583, oil on canvas, 190 x 271 cm/ 6 ft 3 in x 8 ft 11 in, Oxford, Christ Church College

Above left: **Caravaggio**, *Crucifixion of St Peter*, 1601, oil on canvas, 230 x 117 cm/7 ft 6.5 in x 3 ft 10 in, Rome, S Maria del Popolo, Cappella Cerasi

Above: **Caravaggio**, *Madonna of the Rosary*, 1605/1607, oil on canvas, 364 x 249 cm/12 ft x 8 ft 6 in, Vienna, Kunsthistorisches Museum

*Matthew* on three separate canvases using new, dramatic lighting effects. Two of his most important works followed in 1601: the companion altarpieces in S Maria del Popolo showing the *Conversion of St Paul* and the *Crucifixion of St Peter* (illus. p. 207 left). The scenes, shown from very close up, are illuminated by a glaring light, but otherwise veiled in dramatic darkness; "simple folk" become the heroes of a biblical event. The *Madonna of the Rosary* in Vienna (illus. p. 207 right), probably painted in Naples in 1605/1607 for a church in Modena, also places the vision of the Mother of God in a very realistic setting: Besides the

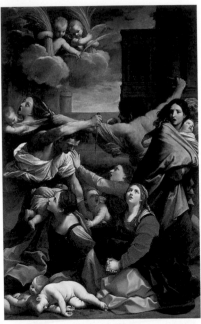

**Guido Reni,** *The Massacre of the Innocents*, 1611, oil on canvas, 268 x 170 cm/8 ft 9.5 in x 4 ft 7 in, Bologna, Pinacoteca Nazionale

P. 109: **Guercino,** *Aurora*, 1621–1623, ceiling fresco, Rome, Casino dell'Aurora (Casino Ludovisi)

Below: **Domenichino,** *Diana and her Nymphs*, 1617, oil on canvas, 225 x 320 cm/8 ft 2.5 in x 10 ft 6 in, Rome, Galleria Borghese

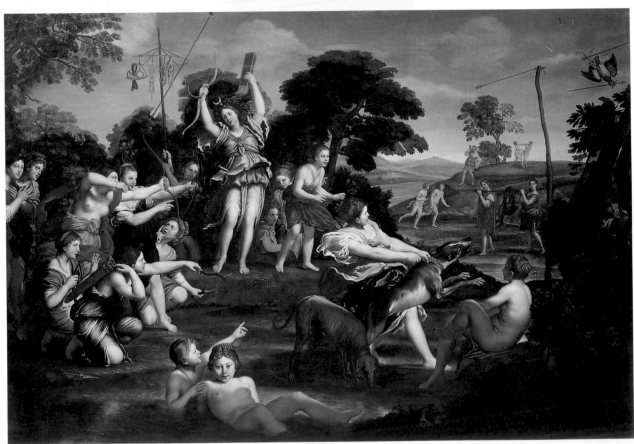

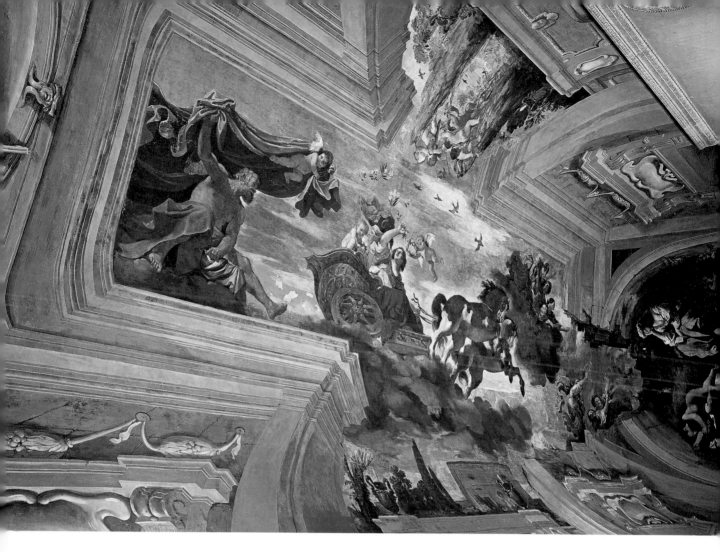

patron and the monks, peasants and other common people are present at the scene.

The classicism of the Carracci and the naturalism of Caravaggio formed the two poles between which European Baroque painting developed. Whereas Caravaggio's dramatic tenebrist technique was mostly imitated outside of Italy—in this connection, one should mention Rubens and Terbrugghen in the Netherlands, Elsheimer in Germany, Vouet in France, and Zurbarán and Ribera in Spain—the Carracci school dominated the art scene in Rome and North Italy.

Like many other painters, Guido Reni (1575–1642) from Bologna also attended the Carracci Academy from 1595, and at first followed his masters to Rome. However, he was one of the few of his fellow artists to return to his native city; he painted his masterpieces in Bologna and founded the important Bolognese school of painting there. *The Massacre of the Innocents* (1611; illus. p. 208 above) clearly shows the classical principles of composition as influenced by Raphael. However, Caravaggesque elements can be sensed in the lighting effects and the figure's dramatic gestures. In Reni's most important work, the ceiling fresco of *Aurora* in Casino Rospigliosi-Pallavicini, these features give way to a classicizing approach imitating the models of Antiquity.

The *Aurora* of Guercino (1591–1666) in Casino Ludovisi, on the other hand, is far more picturesque (1621–1623; illus. above). Its creator, Giovanni Franceso Barbieri, called Guercino (the Squint-Eyed) because of an eye

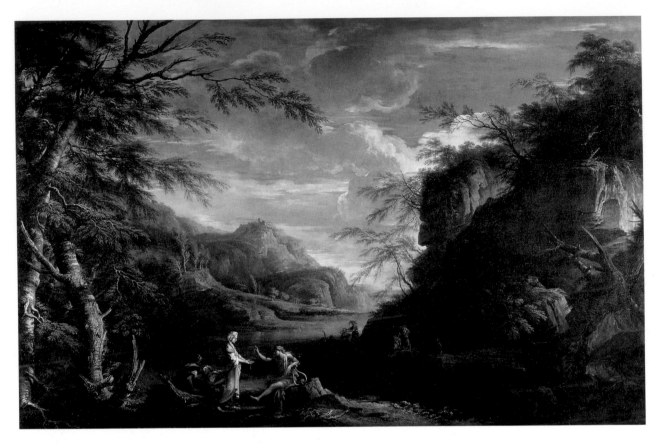

defect, was highly regarded throughout his life for his vividly narrative manner of painting, which remains undramatic despite all its contrasts.

Domenichino (real name: Domenico Zampieri, 1581–1641), who assisted the Carracci in the Palazzo Farnese, was thought by his contemporaries to be the greatest painter since Raphael for the way he depicted the "true"—idealized—beauty of nature and gave his "histories" (narrative paintings) a lyrical atmosphere. Domenichino inherited his love of natural landscapes from Annibale Carracci, and put them onto canvas "from nature," i. e. after making outdoor studies. In 1617, for a commission from Cardinal Scipione Borghese, he painted *Diana and her Nymphs*, a mythical scene based on the fifth book of Virgil's *Aeneid*; the subject was suggested to the painter by the art theoretician G. Agucchi (illus. p. 208 bottom).

In the second quarter of the seventeenth century, an increasing number of foreign artists sought their fortune in Rome. The "Bamboccianti" (from the It. *bamboccio*, a disfigured marionette, a simpleton—a nickname given to Pieter van Laer) came from the Netherlands bringing the genre of street and tavern scenes to Italy. From France came Nicolas Poussin and Claude Gellée, called Lorrain, whose classical landscapes and profound subjects came to be seen as the epitome of artistic perfection and intellectual power (see p. 222–225).

The works of the painter and architect Pietro Berrettini da Cortona (1596–1669; see p. 34/35) represented another high point in fresco painting. Between 1633 and 1639, he executed the largest ceiling painting in Rome in the Palazzo Barberini, pointing the way for illusionistic interior decoration.

The ceiling fresco in S Ignazio in Rome is a unique blend of complex theological concepts and artistic bravura. It was carried out by Andrea Pozzo (1642–1709) for the second large church of the Jesuit order. Employing count-

less figures and enchanting nuances of color, it depicts *The Apotheosis of St Ignatius* (an allegory on Jesuit missionary work; 1691–1694; illus. p. 212/213). However, the most magnificent features of the work are the virtuosic, illusionistic architectural elements suggesting that the nave opens up into the expanse of heaven. In the crossing, Pozzo was able to conjure up the non-existent dome through his painting. His treatise *Prospettiva per i Pittori Architetti* became a very influential work.

The intelligent yet temperamental Neapolitan artist, Salvator Rosa (1615–1673), worked chiefly in Florence and Rome as a painter, satirical writer, composer, and actor. At first, he received high praise for his depictions of battles, but later he devoted himself to painting fantastic, emotionally charged landscapes, like the *Landscape with Apollo and the Cumaean Sybil* (1661; illus. p. 210).

Luca Giordano (1632–1705) was a similarly enigmatic artistic personality. Possibly because of the speed at which he worked, he was also called "Luca, fà presto" ("Luca, work quickly"). Born in Naples like Rosa, he made his way to Rome and Venice in his youth, where he at first shone as a copyist of great masters. Finally, he was employed as an assistant by Pietro da Cortona. His own later, hugely varied œuvre was still marked by his appropriation of other styles. This capacity for change earned him the nickname of "the Proteus of painting."

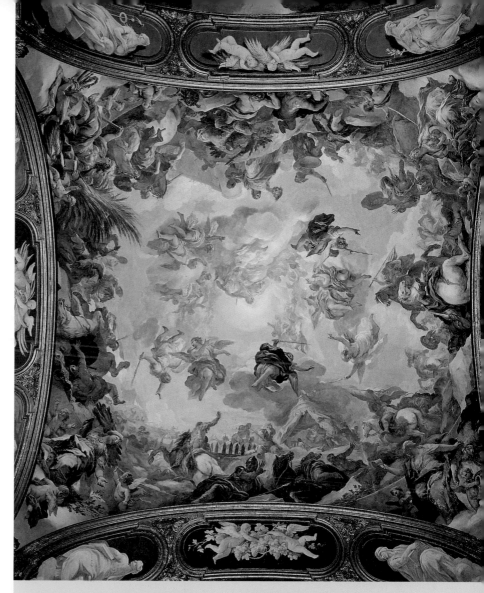

The never tiring Luca Giordano created a last decorative masterpiece at the age of 72 years. *The Triumph of Judith* in the Treasure Chapel of the Carthusian S Martino in Naples is presented as a round dance of the celestial masses who picturesquely twirl around each other in the bright, warm atmosphere. No less agitated is what happens along the rims of the fresco, the area of terrestrial life. In spite of the number of figures, the daring abridgments and the expansive gesture, the picture space appears well organized and clearly structured.

**Luca Giordano,** *The Triumph of Judith,* 1704, ceiling fresco, Naples, S Martino, Cappella del Tesoro

P. 210: **Salvatore Rosa,** *Landscape with Apollo and the Cumaean Sybil,* 1661, oil on canvas, 171 x 258 cm/ 5 ft 1 in x 8 ft 5.5 in, London, Wallace Collection

P. 212/213: **Andrea Pozzo,** *The Apotheosis of St Ignatius,* 1691–1694; ceiling fresco, Rome, S Ignazio

## Rococo Painting

European painting of the eighteenth century was dominated by Venice and its painters. Barely any court of standing wanted to be without frescoes by Tiepolo, vedute (from It. *veduta*, "view") by Canaletto, genre paintings by Guardi, or allegories by Pellegrini. For this reason, there were Venetian painters in Vienna and Madrid, in Dresden and Warsaw, in Würzburg and London.

The triumph of Venetian painting began with the work of Giovanni Battista Piazzetta (1683–1754) and his subtle, striking use of color. It paved the way for the light-filled, delicate color impressions and loose compositions of the younger artists, who turned their backs once and for all on Caravaggio's dramatic tenebrism.

Giovanni Battista Tiepolo (1696–1770) became the symbol of a new, serene, grand, yet unpompous style. His masterpiece is the ceiling paintings in the Würzburg Residenz, which glorify the diocese of Würzburg and Carl Philipp von Greiffenclau, the prince-bishop who commissioned them. The fresco in the staircase pays homage to Apollo, the patron of the arts, as well as to this Franconian Maecenas, whose fame extends to all the continents. This ambitious theme, carried out with a hint of sly humor, gave an opportunity to depict exotic motifs: for example, the allegory of America, adorned with a feather headdress, rides upon an alligator (illus. below; see also p. 130/131). Tiepolo's effective illusionism, his virtuosic treatment of color and light, and his intelligent compositions made him the greatest fresco painter of the eighteenth century—until neoclassicism, with its more sober approach, entered the scene.

Giovanni Antonio Canal, also called Canaletto (1697–1768), perfected the veduta technique of painting that had been developed in Rome in the seventeenth century. However, he was less interested in recording ancient monuments and ruins than in realistically depicting his native city of Venice. He and his pupils executed numerous light-filled views of the city, capturing the life and activity alongside the canals with precise brush strokes. Antonio's nephew and pupil, Bernardo Bellotto (1721–1780), who also called himself Canaletto after his uncle, took the art of veduta painting to central and eastern Europe. He, too, produced some unique city panoramas (illus. p. 215).

Francesco Guardi (1712–1793) made vedute more picturesque and imaginative. At the same time, he distinguished himself in other genres, painting historical pictures, pictures of saints, portraits, and theater decor. In 1782 he painted *Ladies' Concert at the Philharmonic Hall*, part of a cycle recording the celebrations of Venetian society in beguiling colors (illus. p. 215).

**Giovanni Battista Tiepolo,** *Allegory of the American Continent*, detail of the fresco in the staircase of the Würzburg Palace, 1751–1753, Würzburg, Residenz

Tiepolo's fresco in the staircase of the Würzburg palace is unique, and that not only because of its sheer size of 30 x 18 m/98.5 x 59 ft. In a grandiose conception directly in view of someone entering the staircase the ceiling fresco glorifies the last prince commissioning the building, Bishop Carl Philipp von Greiffenclau. All four continents under the rule of Apollo pay hommage to his bust. Especially attractive is the *Allegory of the American Continent* which, adorned with a crown of feathers, rides on the back of an alligator. In the background, a page serves a cup of hot chocolate.

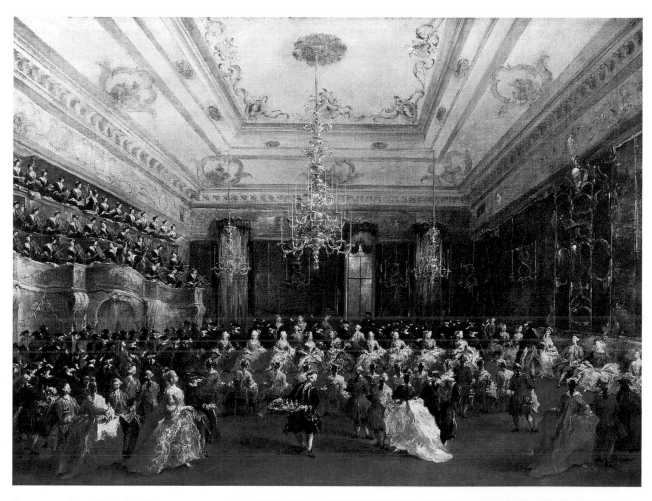

**Francesco Guardi,** *Ladies' Concert at the Philharmonic Hall*, 1782, oil on canvas, 68 x 91 cm/27 x 36 in, Munich, Alte Pinakothek

**Bernardo Bellotto, called Canaletto,** *The Basin of San Marco on Ascension Day*, c. 1735– 1741, oil on canvas, 121,9 x 182,8 cm/4 ft x 6 ft, London, National Gallery

**Diego Velázquez,** *Triumph of Bacchus*, 1629, oil on canvas, 165 x 227 cm/5 ft 5 in x 7 ft 5.5 in, Madrid, Prado

P. 217 top:
**Diego Velázquez,** *The Surrender of Breda*, 1635, oil on canvas, 307 x 370 cm/10 ft x 12 ft 2 in, Madrid, Prado

P. 217 bottom:
**Diego Velázquez,** *Portrait of Pope Innocent X*, 1650, oil on canvas, 140 x 120 cm/ 55 x 47 in, Rome, Galleria Doria Pamphili

# Spain

The "Siglo de Oro," Spain's "golden age," owes much of its fame to painting. In the course of the seventeenth century, literature and the fine arts had blossomed in an extraordinary fashion, even though the "empire in which the sun never sets" fell apart and was in a state of economic collapse.

Spanish painting was employed almost solely in the service of the Church, the religious orders, and the court. For this reason, altarpieces and devotional pictures, court portraits, and historical paintings predominated; one looks almost in vain for mythological themes or bourgeois portraits. What was popular, however, were *bodegones*, still lifes and kitchen scenes that depicted fruit, vegetables, and everyday objects with great skill, while giving them allegorical meanings.

## Diego de Silva y Velázquez

"He is the painters' painter"— Edouard Manet's comment is still completely valid. Velázquez had the extraordinary ability to record the subjects of his pictures with an unerring eye, while revealing their characters through his art.

Velázquez was born in Seville in 1599. He was greatly influenced by his period of training in Francisco Pacheco's studio, where he learnt the basic theoretical principles of his métier. Even early on, his artistic talent seems to have surpassed that of his master. In 1618 he married Pacheco's daughter Juana and started a family. In 1623 the Duque de Olivares helped him establish contact with the court of Philip IV. In 1627 he won first prize in a competition for the best historical painting, beating the established court painters, and received his first appointment as "gentleman usher" to the king. Velázquez worked at the Madrid court until he died, and was highly regarded by the king. He was knighted in 1659. His long friendship with Rubens had a great influence on his work; Rubens often came to stay in Madrid.

One of Velázquez's early masterpieces is the painting *Los Borrachos*, *The Topers* or *Rule of Bacchus*, which shows the influence of Caravaggio and Flemish models. The artist painted the god

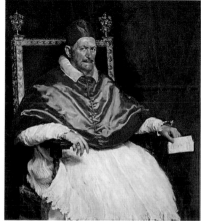

of wine amid a group of far-
mers, who have forgotten their
daily toil with the help of the
juice of the vine (illus. p. 216
top). Philip IV hung the picture
in his bedroom and gave Ve-
lázquez a trip to Italy as thanks.
The inspiration that Velázquez
gained there was to provide yet
more fuel for his extraordinary
talent.

Upon his return he painted a
number of masterpieces: unfor-
gettable portraits of the royal
family and the court jesters,
equestrian pictures, religious
works like his profoundly mov-
ing depiction of the crucifixion,
and mythological scenes like the
*Forge of Vulcan*, inspired by Titian
and Tintoretto. In 1635 he exe-
cuted the magnificent history
painting *The Surrender of Breda*
for the Salón de los Reinos (Hall
of Kingdoms) in the palace of
Buen Retiro (illus. above). With
unparalleled sensitivity, Veláz-
quez was able to turn this act of

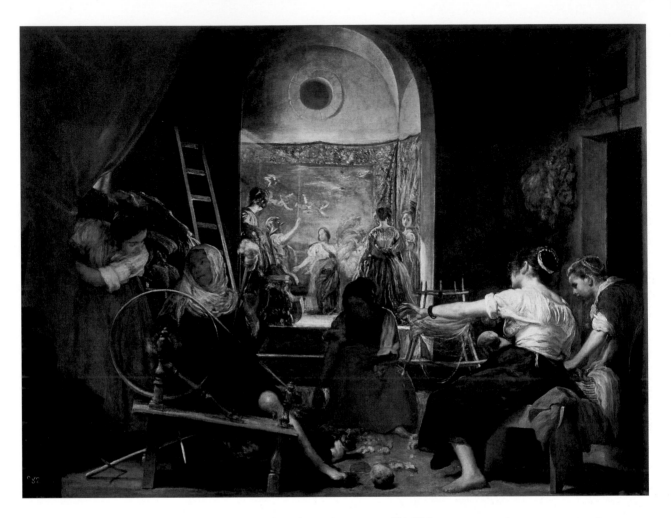

submission into a scene of mutual respect.

During his second visit to Rome, he painted the striking three-quarter length portrait of Innocent X, which captures the varied facets of the pope's personality (1650; illus. p. 217).

In the last years of his life, Velázquez did some of his most important works, whose meanings are not completely clear even today. The painting of *Las Meninas* ("The Maids of Honor"), or, to be more precise, *The Family of Philip IV*, is really a studio sitting attended by the

royal family and court staff 1656; illus. p. 219). The painter, clearly recognizable as Velázquez and wearing his decoration as Knight of the Order of Santiago (included at the king's insistence), has paused in his task, perhaps because the child's parents have entered the room, as the mirror in the background tells us. But what is really behind this seemingly accidental scene? The painting of *Las Hilanderas*, *The Spinners*, also remains enigmatic (c. 1657; illus. above), containing several layers of meaning in more than one sense.

**Diego Velázquez,** *Las Hilanderas* (*The Spinners*), c. 1657, oil on canvas, 117 x 190 cm/46 x 75 in, Madrid, Prado

This painting gives an impression of a Gobelin workshop where women pursue their work in the foreground. In a second room, lit by a shaft of light, one can see a tapis showing the story of Arachne. The mortal woman who had challenged Athena to a weaving contest was changed into a spider because the goddess disliked the topic of her work: the love affairs of the gods. Beyond these visible levels of stories the image contains further messages, though encoded, concerning the *paragone,* the competition among the arts.

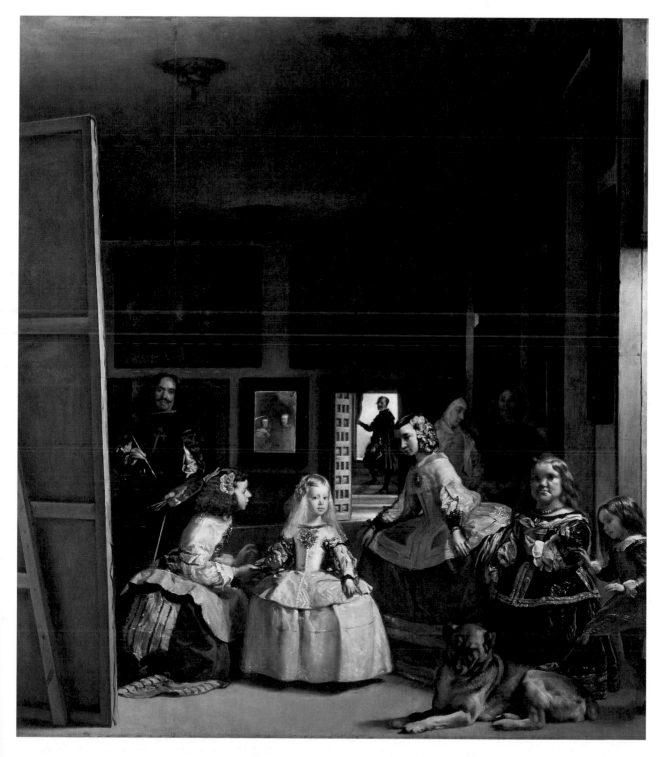

**Diego Velázquez,** *Las Meninas* (*The Family of Philip IV*), 1656, oil on canvas, 318 x 276 cm/10 ft 5 in x 9 ft, Madrid, Prado

## From Zurbarán to Murillo

Francisco de Zurbarán (1598–1664) combined the tenebrism and realism of Caravaggio with the ardent fervor of Spanish mysticism. This is demonstrated by the many cycles of paintings that he executed as commissions for monastic orders. Exhibited in monasteries and charterhouses, they inspired the monks to contemplation and to compassion with the saints. One such work is the canvas *The Apparition of Apostle Peter to St Peter of Nolasco*, which Zurbarán painted in 1629 for the Mercedarian convent in Seville (illus. below). The artist portrayed the founder of the order, who had just been canonized, at the moment of his vision. Reality and fiction are woven together in a confusing fashion. While the broken body of the crucified man seems close enough to touch, the kneeling figure of the monk, clothed in a voluminous white habit, makes an unreal impression and fades into the unarticulated brown back-

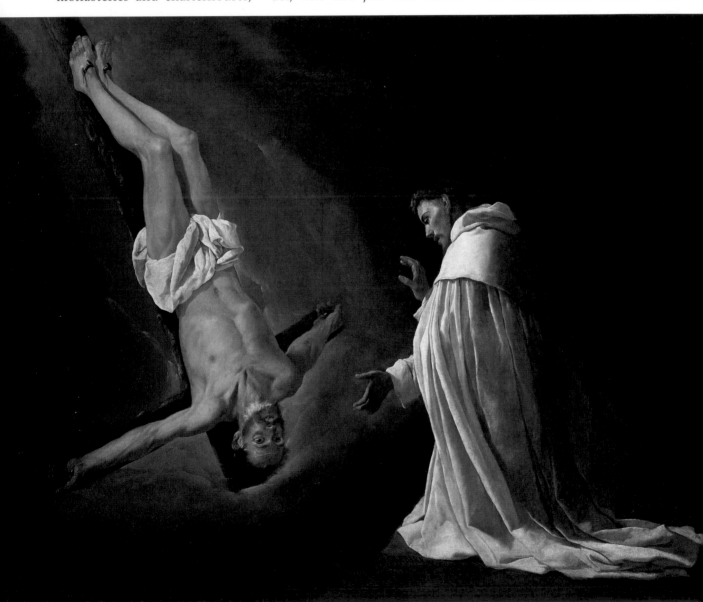

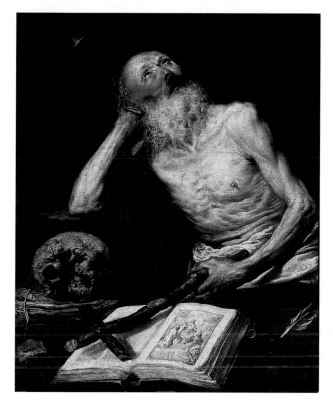

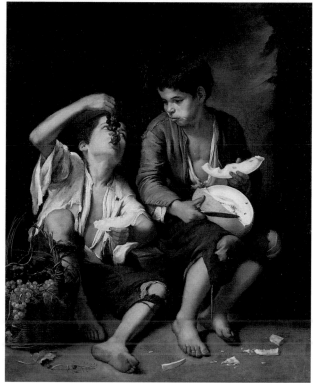

Above: **Antonio de Pereda,** *St Jerome*, 1643, oil on canvas, 105 x 84 cm/41 x 33 in, Madrid, Prado

P. 220: **Francisco de Zurbarán,** *The Apparition of Apostle Peter to St Peter of Nolasco*, 1629, oil on canvas, 179 x 233 cm/5 ft 10 in x 7 ft 8 in, Madrid, Prado

Above: **Bartolomé Esteban Murillo,** *Boys Eating Melons and Grapes*, c. 1650, oil on canvas, 146 x 104 cm/57.5 x 41 in, Munich, Alte Pinakothek

ground. Zurbarán's works are full of such disconcerting effects; his masterly, vivid manner of painting and the infinite serenity of the scenes he depicts predestined him to be a painter of magnificent still lifes as well.

Antonio de Pereda (1611–1678) can be classed as a representative of the Madrid school, which had developed its own style by the mid-seventeenth century. He, too, scored his greatest successes with paintings of the saints and *bodegones*. His *St Jerome* in the Prado in Madrid shows the hermit with his attributes: the cross and the

extremely realistically depicted skull (1642; illus. above left). At the same time, this painting is an homage to Albrecht Dürer, whose *Last Judgement* from *The Small Passion* series (1509–1511) can be seen at the bottom edge of the picture.

In the second half of the century, Bartolomé Esteban Murillo (1618–1682) came onto the scene. His completely different artistic style anticipated the trends of the eighteenth century. Instead of the ascetic severity of Ribera or Zurbarán, Murillo gave his saints—above all, his many Madonnas—a serene beauty, gen-

tleness, and charm, perhaps traits like those possessed by the young girls of his native city of Seville. In the same way, street urchins served as models for his genre paintings, for example *Boys Eating Melons and Grapes*, which he painted around 1650 (illus. above right). A brightening of the palette can be clearly seen; delicate colors and flowing brush strokes produce a warm, relaxed atmosphere well-suited to depictions of everyday life.

Murillo enjoyed great popularity throughout his life. His contemporaries considered him the equal of Raphael and Titian.

221

# France

The "golden age" of French Baroque painting began in the second quarter of the seventeenth century—in Rome. The Frenchman Simon Vouet was appointed to the highly regarded position of *principe* of the Accademia di San Luca in 1624, Nicolas Poussin turned his back on Paris and created his profoundly classical works on the Tiber, and Claude Gellée, called Lorrain, developed his light-filled, ideal landscapes under the influence of Italy. Other painters, such as Georges de la Tour and the Le Nain brothers, followed Caravaggio's example. All of these artists' experiences had a stimulating effect on painting in the various regions of France until Parisian court art became the dominant influence in 1648, when the Académie Royale was founded. Although it did not count any important masters among its

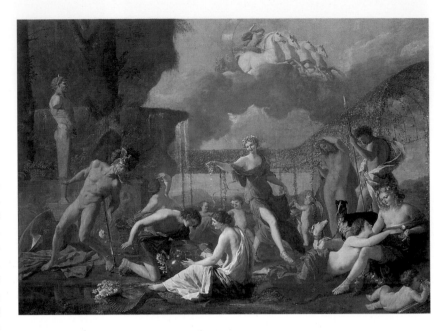

Nicolas Poussin, *Empire of Flora*, 1631, oil on canvas, 131 x 181 cm/51.5 x 71 in, Dresden, Gemäldegalerie Alter Meister

Nicolas Poussin, *Self-Portrait*, 1650, oil on canvas, 98 x 74 cm/38.5 x 29 in, Paris, Musée du Louvre

members, the standards of "The Academy" strictly dictated the course of art in the second half of the seventeenth century.

## Nicolas Poussin

Nicolas Poussin was born in 1594 near Les Andelys in Normandy. The son of poor parents, he trained at first under a provincial painter before working with Philippe de Champaigne and Lallemand in Paris from 1612. There, he was already studying the works of Raphael and Giulio Romano in the form of engravings. After two fruitless attempts, he managed to make it to Rome in 1624, where he found a learned teacher in the poet Giambattista Marino.

Marino introduced him to Roman mythology and the writings of Ovid. Classical learning and its philosophical and moral

tenets were to affect Poussin's art throughout his life.

Poussin painted most of his works for private patrons. In them, he showed his preference for clear, balanced compositions and a coloring influenced by Venetian and northern Italian models. He attached great importance to *disegno*, the drawing, which in the later dispute between the Poussinists and the Rubenists was viewed as a betrayal of color.

Poussin's painting was anything but "academic," however. His *Empire of Flora* is delicately and charmingly painted (1631; illus. above); it is, in fact, an allegory of the constant changes of existence. The delightful goddess of flowers dances amid numerous gods and heroes who have been changed into flowers, mostly through misfortune.

Among others, one can see Narcissus, who fell in love with his own reflection; Hyacinthus, killed by a discus thrown by his lover Apollo; and Adonis, from whose bleeding wound grew the adonis or pheasant's-eye.

In 1640 Poussin acceded to a request of Louis XIII to decorate the Grande Galerie of the Louvre with scenes of Hercules. However, the intrigues and political atmosphere at the Paris court caused him to return to Rome again in 1642, where he now settled for good, increasingly devoting his attention to subjects involving art theory and philosophy. The story of Pyramus and Thisbe (1651; illus. below) gave Poussin the opportunity to depict a landscape with a thunderstorm. The tragic story of two lovers who become the victims of an error and kill themselves becomes an—albeit splendid—scene at the margin of a no less magnificent representation of elemental forces.

Poussin's self-portraits are among the greatest achievements that have been produced in this genre. Only a few months apart, he painted the *Self-Portrait with Pencil*, now in Berlin, and the proud, half-length portrait in the Louvre (1650; illus. p. 222 bottom), which was probably done for his friend and patron Fréart de Chantelou. This last shows the master dressed in a dark robe, his head, with its curling mane of hair, turned toward the viewer in a dignified manner. The little finger on his right hand has a precious ring on it. Poussin is posing in his studio in front of an upright stack of framed canvases that convey concepts of art theory or references to his friendship with Chantelou in more or less cryptic form. This profound and masterly work reveals all the complexity of an extraordinary personality. Poussin died in Rome in 1665.

**Nicolas Poussin,** *Stormy Landscape with Pyramus and Thisbe,* 1651, oil on canvas, 192.5 x 273.5 cm/6 ft 4 in x 9 ft, Frankfurt a. M., Städelsches Kunstinstitut

## Claude Lorrain

Claude Gellée (1600–1682), who was named Lorrain after his native Lorraine, arrived in Rome in 1627, almost at the same time as Poussin. A trained pastry chef, he at first only possessed amateur skills as a painter. He further developed these in Naples by working with the veduta painter Gottfried Wals. Encounters with the landscape painters Paul Brill and Adam Elsheimer were to be decisive for his art: He combined their Nordic, detailed style with the generous, heroic staffage of Annibale Carracci. In addition, Poussin inspired him to depict scenes from Antiquity.

*Port Scene with the Embarkation of St Ursula* (1642; illus. below) places this legendary event in the idealized, classical setting of a Roman port. In front of the massive columns of a round temple, a monumental version of Bramante's Tempietto in Rome, the saint watches the departure of the 11,000 virgins,

who, like herself, were to suffer a martyr's death in Cologne. Claude manages to charge the gentle, evening atmosphere with an oppressive foreboding, and thus give a premonition of their tragic end.

This wealth of nuances and moods, and the exact observation of nature, were to reach their high point in Claude's late works. An example of this is *Landscape with Noli Me Tangere* (illus. above), which was painted in 1681, just one year before the painter's death. The scene of the meeting between Mary Magdalene and Christ is set in a wide landscape veiled in early morning mists. Extremely subtle details indicate that it is a biblical landscape: The three crosses of Golgotha, the open tomb to the right, and the appearance of Christ in a fenced garden are superbly integrated into the landscape, which was composed from Claude's own studies.

Claude's paintings were frequently imitated, which is probably why he began recording his ideas in drawings done with pen or brush. Around 200 hundred of these drawings were collected together in one volume and published as *Liber Veritatis* in 1777, engraved by Richard Earlom. In addition to this record, Claude kept track of the location of his pictures, thus becoming the first artist to demand a sort of copyright. Like Poussin, Claude spent almost his entire life in Rome, where he died in 1682.

**Claude Lorrain,** *Landscape with Noli Me Tangere*, 1681, oil on canvas, 84.5 x 141 cm/33 x 55.5 in, Frankfurt a. M., Städelsches Kunstinstitut

P. 224: **Claude Lorrain,**
*Port Scene with the Embarkation of St Ursula*, 1642, oil on canvas, 113 x 149 cm/44.5 x 58.5 in, London, National Gallery

**Georges de la Tour,** *The Card Shark,* c. 1625, oil on canvas, 106 x 146 cm/42 x 57.5 in, Paris, Musée du Louvre

The elegantly clad lady of noble lineage is sitting opposite a trio of cardsharks, who make their dishonest intentions clear to the viewer. La Tour, who painted numerous striking pictures of saints, shows here that he was also a critical observer of society.

Below: **Charles Le Brun,** *Chancellor Seguier at the Entry of Louis XIV into Paris in 1660,* 1660, oil on canvas, 295 x 351 cm/9 ft 8 in x 11 ft 6 in, Paris, Musée du Louvre

Le Brun was indebted to Pierre Séguier for many reasons. Séguier, who was chancellor to Louis XIV, supported the artist from the start and opened many doors for him.

## From De la Tour to Le Brun

Not all French artists sought their fortune in Rome. Georges de la Tour (1593–1652) from Lorraine, the most important interpreter of Caravaggio's tenebrism in France, is not recorded as having been in Italy, although his stylistic development is hardly imaginable without a trip to the region to the south of the Alps. *The Card Shark*, which was probably painted around 1625 (illus. p. 226 top) and his unconventional work *St Sebastian Tended by Irene*, which was so highly regarded by Louis XIII, are also difficult to explain unless he had an intimate knowledge of Caravaggio's works.

The career of the Le Nain brothers—Antoine (1588–1648), Louis (1593–1648) and Matthieu (1607–1677)—also poses a mystery. They painted their main works between 1641 and 1648, and signed them jointly. As members of The Academy, they were held in high esteem. However, their style was diametrically opposed to that of court art: Their repertoire consisted above all of peasant scenes and realistic genre pictures. There can be no doubt that the brothers had Velázquez's *Forge of Vulcan* in mind when painting their version of *Venus at the Forge of Vulcan* (1641; illus. above right), but their works are characterized by a strange calmness and alienation. Vulcan is motionless, almost frozen, as he becomes aware of the presence of his wife, Venus, who has been unfaithful to him several times with Mars, the god of war.

**Matthieu and Louis Le Nain,** *Venus at the Forge of Vulcan*, 1641, oil on canvas, 150 x 115 cm/59 x 45.5 in, Reims, Musée des Beaux-Arts

The most influential artistic personality of the seventeenth century in France was, without a doubt, Charles Le Brun (1619–1690). This talented son of a sculptor had an exceptional career; he became the leading figure of absolutist artistic life. He was the *Premier Peintre du Roy*, a founding member and director of the Royal Academy, and director of the Gobelins factory. He raised the court art of Colbert and Louis XIV to become the accepted model. One example of his solemn style is the painting *Chancellor Seguier at the Entry of Louis XIV into Paris in 1660* (1660; illus. p. 226 bottom).

## Rococo Painting

The new mood prevalent in French society at the start of the eighteenth century (see p. 144/145) received its most charming expression in painting. The relaxation of manners, a new form of sensuous perception, and the stirring of emotions gave rise to intimate works that were far different from the grand, formal pictures of the seventeenth century.

No one expressed the spirit of his times better than Antoine Watteau (1684–1721), who came to Paris in 1702 from the Flemish city of Valenciennes, start-

**François Boucher,** *Madame de Pompadour*, 1759, oil on canvas, 86 x 66 cm/34 x 26 in, London, Wallace Collection

**Antoine Watteau,** *The Embarcation for Cythera*, 1718/1719, oil on canvas, 192 x 130 cm/75.5 x 51 in, Berlin, Schloss Charlottenburg

This painting by Watteau exists in three almost identical versions. The oldest one, which is comparatively modest, is to be found in the Frankfurt Staedel and dates from around 1710. In 1717 he painted a more elaborate version to apply for the Paris Academy (now in the Louvre). In 1718/1719 he executed the painting that is now in Berlin; it is considered the best of the series.

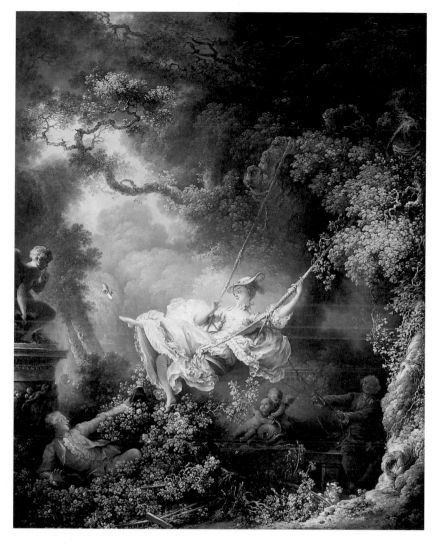

**Jean Honoré Fragonard,** The Swing, 1765, oil on canvas, 81 x 65 cm/32 x 25.5 in, London, Wallace Collection

Even though Fragonard was a member of the Parisian Académie, he seldom worked for the court or the aristocracy. His patrons were art connoisseurs, actors, and artists who were delighted by his carefree and often frivolous depictions. Fragonard is considered one of the greatest painting talents of the eighteenth century in France. His relaxed, vital brush stroke and his delicate, half-pastose application of paint remained unsurpassed. However, with the emergence of classicism he was largely forgotten.

ing out as a copyist. In 1717 he applied for acceptance into The Academy with the painting *Embarcation for Cythera* (illus. p. 228 bottom). He was the first painter to hold the title *peintre de fêtes galantes*, a sign of how much the genre depicting cultivated social gatherings had gained in importance. Behind the idyllic facade of his parties and Arcadian landscapes, however, his paintings possess some melancholy features. He ex-

pressed the isolation of the individual in *Gilles*, where the character of the hapless bumpkin from the *commedia dell'arte* is captured on canvas with an unusual monumentality.

The works of François Boucher (1703–1770) were seen as the epitome of charm and gallantry; however, psychological insight is entirely foreign to their nature. As a painter, engraver, and designer of decorations—and as inspector of the

Gobelins factory—he was highly regarded. His delicate, porcelain-like palette produced enchanting landscapes, pastoral scenes, and portraits, including that of his patron Madame de Pompadour (1759; illus. p. 228 top).

Jean Honoré Fragonard (1732–1808) was the third outstanding painter of the "Ancien Régime." He produced lively genre paintings that seem almost improvised (illus. above).

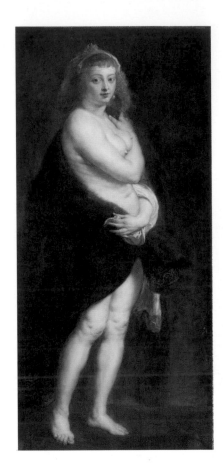

## Flanders

Three masters helped make Flemish painting famous within only a few years: Peter Paul Rubens, Jacob Jordaens, and Anthony van Dyck. Rubens is first among them, and not merely because of his age. With his studies of ancient sculpture and comprehensive knowledge of the works of Raphael, Michelangelo, and Titian, this widely traveled and cosmopolitan painter and diplomat laid the foundation for the high standards reached by Flemish Baroque painting and for the development of his own style, which expresses both vigor and enjoyment of pleasures.

### Peter Paul Rubens

Rubens was born in Siegen in 1577. In 1588 the Protestant emigrant family moved back to Antwerp, where Rubens, now converted, began an apprenticeship as painter with Tobias Verhaecht.

In 1598 he was accepted as member of the Guild of St Luke. In May 1600, he set off on an eight-year trip to Italy and Spain, where his main destinations were Mantua (where he worked as court painter for Vincenzo Gon-

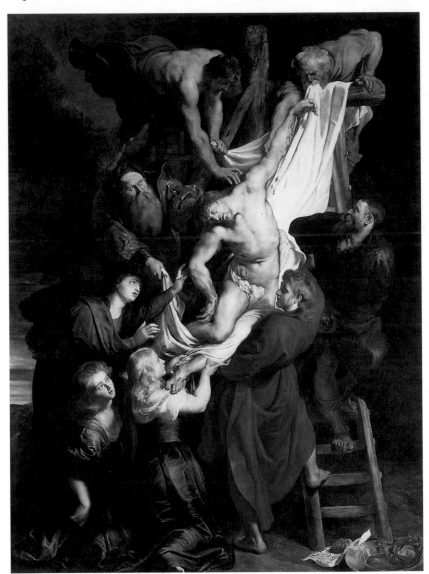

Above left: **Peter Paul Rubens,** *"The Fur" (Portrait of Hélène Fourment),* 1635/1640(?), oil on wood, 176 x 83 cm/69.5 x 32.5 in, Vienna, Kunsthistorisches Museum

Above: **Peter Paul Rubens,** *Descent from the Cross,* c. 1612, central plate of a triptych, oil on wood, 462 x 341 cm/15 ft 2 in x 11 ft 2 in, Antwerp, cathedral

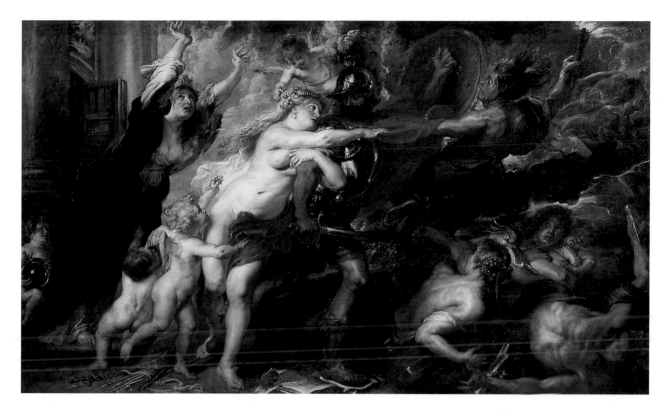

**Peter Paul Rubens,** *The Horrors of War*, 1637–1638; oil on canvas, 206 x 345 cm/6 ft 9 in x 11 ft 4 in, Florence, Pal-azzo Pitti. The work is a cry of protest stemming from the confusion of the Thirty Years' War. This theme had never been dealt with more strikingly; not until Picasso's *Guernica* would an artist create a similarly disturbing work.

zaga), Rome, and Genoa. It was during this time that he developed his high relief style using color and light as a means of modeling (*chiaroscuro*).

After returning in 1608, he was swamped by commissions from the Flemish bourgeoisie. In 1609 he was appointed court painter by the Spanish viceroy. Rubens ran a flourishing workshop, built a house, and started his first family with Isabella Brant. During these years he painted the monumental *Descent from the Cross* in Antwerp Cathedral (c. 1612; illus. p. 230 right). The bold diagonal sweep of the composition and pale skin tones

of the body in contrast with the brilliant red of St John's robe opened up sensuous new dimensions in painting.

In the 1620s, Rubens' career reached further high points: for Marie de Médicis he painted the 21 pictures of the "Medici cycle" that glorify the life of this controversial regent. Louis XIII commissioned him to design tapestry patterns, and he produced a series of paintings for the courts of Spain and England, where he stayed as a diplomat. He was knighted in 1624.

His marriage with the 16-year-old Hélène Fourment, whom Rubens immortalized in a charming

and intimate portrait, *The Fur* (1635/1640[?]; illus. p. 230 right), was also an artistic turning point. Increasingly devoted to private themes, his paintings become more picturesque, subtle, and spontaneous. *The Horrors of War* (illus. above), painted in 1637–1638 for the Grand Duke of Tuscany, is a shocking and very personal testimony from the last years of his life. This profoundly disturbing allegorical work shows the powerlessness of the goddess Venus in the face of war, plague, and hunger, and may hint at what the artist-diplomat experienced during the Thirty Years' War. Rubens died in Antwerp in 1640.

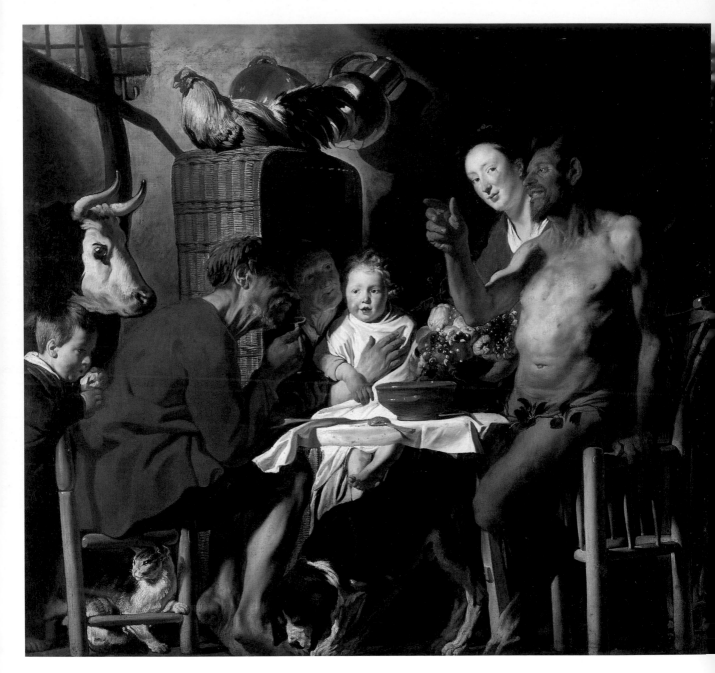

## Jordaens and Van Dyck

Antwerp also produced other painters of genius. Jacob Jordaens was born in this city on the Schelde River in 1593, and Anthony van Dyck in 1599. Jordaens, who was a colleague and occasional assistant of Rubens, used his Caravaggesque style to depict lively, popular narratives.

Van Dyck, an observant pupil of Rubens who retained his originality and objectivity, remained unsurpassed in his striking court portraits and elegant, restrained use of color. In London, where he lived and worked almost continually from 1632, he was celebrated as the court painter of Charles I, and even received a knighthood.

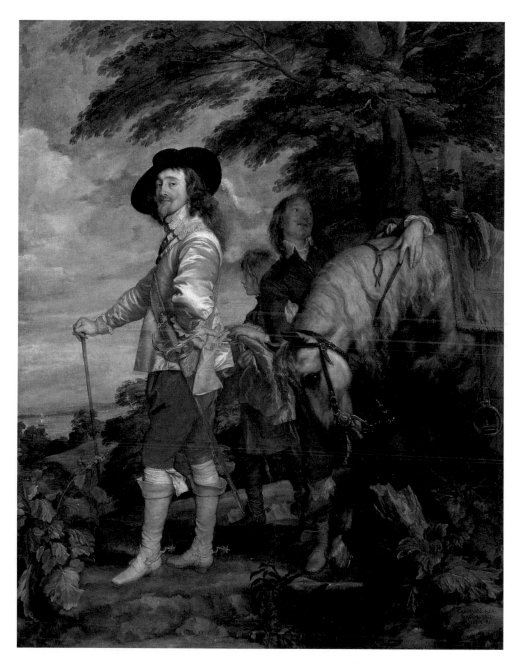

P. 232: **Jacob Jordaens,** *The Satyr at the Peasant's House*, after 1620, canvas and wood, patched at top, 194 x 205 cm/6 ft 4.5 in x 6 ft 9 in; Munich, Alte Pinakothek

In this painting Jordaens illustrates one of Aesop's fables, which tells the story of an encounter between a peasant and a satyr. The latter is amazed when he sees how the peasant first warms his hands by blowing on them, then cool his soup by the same action. The scene is linked to moral allusions.

Right: **Anthony van Dyck,** *Charles I of England*, c. 1635, oil on canvas, 272 x 212 cm/ 8 ft 11 in x 6 ft 11.5 in, Paris, Musée du Louvre

Aesop's fable *The Satyr at the Peasant's House* (illus. p. 232) is characteristic of the type of theme preferred by Jordaens. This mythological material gave him the opportunity to paint rustic, cheerful, and sometimes even crude depictions of everyday life in Flanders. His family portraits were also highly regarded.

The world of van Dyck was completely different: His mostly full-length portraits, painted in the main as commissions for the aristocracy, display a cool, intellectual objectivity. He produced his finest works as the court portraitist of the English king, and influenced English painting up to Reynolds and Gainsborough (illus. above).

# Holland

The development of Baroque painting in the United Provinces of the Netherlands, which shook off Spanish rule in 1581 and gradually took on the name of Holland, took a fundamentally different course than in Flanders, which remained under Habsburg control. One of the main reasons for this was the confessional difference between the Calvinist north and the Catholic south. This difference was strikingly expressed in artistic production. While altarpieces were still the main source of income for painters in Flanders, the market for this genre in Holland broke down completely. The Calvinist church was opposed to art and that meant the end of an important traditional source of commissions. In the secular sphere, too, requirements were changing. Instead of works representing the magnificence of the court or state, the proud citizens of the North wanted individual mythologies, representations of their independence and their economic success.

Another difference lay in the number of important centers. While art production in Flanders was concentrated mainly in Antwerp, in Holland schools representing different styles grew up in Haarlem, Utrecht, Amsterdam, Delft, and The Hague,

Below left:
**Willem van de Velde the Younger,**
*The Cannon Shot*, c. 1670, oil on canvas, 78,5 x 67 cm/31 x 26.5 in, Amsterdam, Rijksmuseum

Van de Velde's painting purports to illustrate a particular moment in history. In fact, it does much more, expressing all the pride of this seafaring nation.

Below right:
**Gerard ter Borch,**
*Woman Drinking Wine*, 1656/1657, oil on canvas, 37,5 x 28 cm/ 15 x 11 in, Frankfurt a. M., Städelsches Kunstinstitut

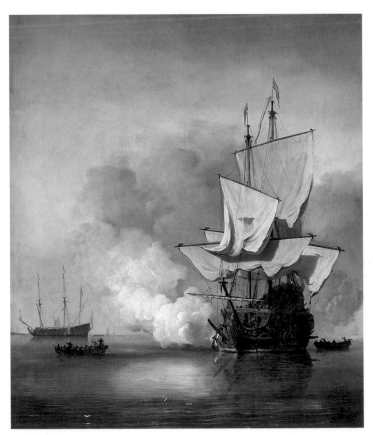

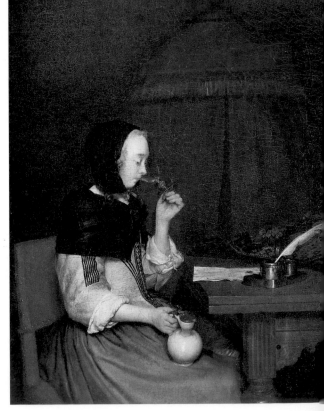

Clara Peeters, *Still Life with Flowers and Goblets*, 1612, oil on wood, 59,5 x 49 cm/23.5 x 19.5 in, Karlsruhe, Staatliche Kunsthalle

Right: **Frans Hals,** *The Laughing Cavalier,* 1624, oil on canvas, 83 x 67 cm/32.5 x 26.5 in, London, Wallace Collection

The portraits of Frans Hals are outstanding for their fresh and brilliant style of painting. He gave the traditional half-length portrait an unconventional vitality.

each of which sought an international standing.

The worldly attitude of the middle-class patrons was expressed by an artistic realism that made true-to-life reproduction of things its guiding principle. At the same time, a large number of genres arose (those that had not been highly regarded in courtly contexts), leading to a specialization of painters. Frans Hals was an outstanding portrait painter—the portrait of *The Laughing Cavalier* shown here is a self-confidently humorous example (1624; illus. above right). Jan van Goyen achieved his success with village and river landscapes dominated by wide skies (see. p. 238). Paulus Potter painted almost exclusively powerfully built cattle, while Emanuel de Witte recorded the stillness of church interiors for posterity. Willem van de Velde specialized in sea scenes (illus. p. 234 left). The reproduction of everyday life became the dominating theme.

It was in this field that Gerrit Dou, the "fine painter of Leiden," Jan Steen, Pieter de Hooch, Gerard ter Borch, and Jan Vermeer produced their unsurpassed masterpieces (see p. 240/241 and illus. p. 234 right).

The still life won itself a special niche amid this variety of genres. There seems to have been an immense demand for pictures depicting sumptuous flowers and fruits, game, and expensive vessels. It should be noted, however, that all these lavish bouquets, vases, plates, and table decorations always conveyed a moral or transcendent message as well: the fresh buds will soon wilt, the fruit rot or fall prey to pests, the pastries go stale. Worldly beauty and aesthetic pleasure is combined with the reminder of the transitory nature of existence (illus. above left and p. 242/243).

One artist, however, eludes any attempt at categorization: Rembrandt Harmenszoon van Rijn (see p. 236/237).

## Frans Hals

Frans Hals (c. 1582/1583–1666) painted portraits all his life, opening up new dimensions in this genre. The son of a cloth worker, he came to Haarlem after the Spanish takeover of Antwerp. There, he is recorded as a member of the Guild of St. Luke in 1611. He at first took his bearings from sixteenth-century portrait art, but his virtuosic technique and the unusual vitality of his portraits caused a sensation. His style is characterized by a keen gift of observation and lively use of the brush (illus. above). In addition to half-length portraits in the style of genre paintings, he chiefly executed group portraits and portraits of militiamen, for which he employed an unusually loose form of composition.

In his later years, this master's colorful palette grew darker, taking on black/gray nuances; the powerful, sketchlike character of his last works influenced the Impressionists.

## Rembrandt Harmenszoon van Rijn

Rembrandt Harmenszoon van Rijn (1606–1669), the son of a miller from Leiden, was effectively self-taught. He interrupted his study of Latin to devote himself to painting, training—for a short while only—with Jacob van Swanenburgh and Pieter Lastman in Amsterdam. Lastman's Italian-influenced history paintings and the tenebrism of the Utrecht Caravaggists both had an impact on his early style.

After some fist successes in Leiden, Rembrandt moved to Amsterdam in 1631/1632. In the same year, he painted *The Anatomy Lesson of Dr Tulp* (illus. below), which burst the bounds of its genre as a portrait to become something approaching a history painting: The members of the Amsterdam surgeons' guild are treated very individually, although not in the sense of a conventional portrait. Each

**Rembrandt Harmenszoon van Rijn,** *Self-Portrait,* c. 1668, oil on canvas, 82,5 x 65,5 cm/31.5 x 26 in, Cologne, Wallraf-Richartz-Museum

P. 237: *The Night Watch,* 1642; oil on canvas, 349 x 438 cm/11 ft 5.5 in x 14 ft 4.5 in, Amsterdam, Rijksmuseum

Below: *The Anatomy Lesson of Dr Tulp,* 1631/1632, oil on canvas, 163 x 217 cm/5 ft 4 in x 7 ft 1 in, The Hague, Mauritshuis

man is involved in the action of the lecture, and has his own way of watching how Dr. Tulp opens up the forearm of a male corpse. Some of them are comparing the practical demonstration with the theoretical explication in the form of a manual by Vesalius. Through the skillful arrangement and variety of expressions, Rembrandt is already revealed as a *pictor doctus*, a learned painter. Group portraits such as *The Anatomy Lesson of Dr Tulp* were extremely popular—and they made great demands on the painter's compositional skill.

Rembrandt's portraits assured his success in Amsterdam. He married Saskia van Uylenburgh, the daughter of a patrician, and laid the foundations for a collection of art and curiosities. In response to Rubens' works, his style took on passionate, sensuous features. These are evident in his "Baroque" cycles such as the *Samson* series or his depictions of the Passion for Frederick Henry, Prince of Orange. His etchings were dominated by ethical themes.

In 1642 he painted the famous *Night Watch* as a commission for the Amsterdam civic militia, where the militia company of Captain Frans Banning Cocq is shown setting out for duty (illus. p. 237). This painting, too, combines the group portrait with history painting: The drum calls, and the group gradually falls into line while some splendidly dressed militiamen are still busy loading their muskets. In fact, the scene takes place during the day, between

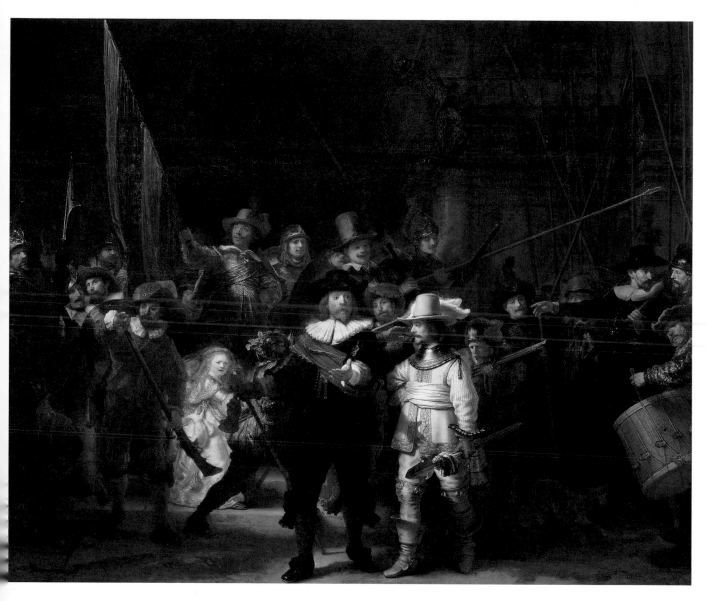

shimmering light and dark shadow—the title *Night Watch* was given to it solely because of the aging process of the varnish.

In the same year, Rembrandt's life took a dramatic turn: His wife Saskia died. The artist devoted more of his attention to religious subjects, characterizing their protagonists in a deeply personal manner. In the 1650s, the emphasis on the eternally human became even stronger; thicker impasto, dematerialized light, and an increasing concentration on the essential led to paintings of extreme intensity. His own situation was bad; he was forced to sell his house and collection. After the death of his second wife, Hendrickje Stoffels, in 1662, and that of his son, Titus, in 1668, he became increasingly isolated. He died in 1669.

Rembrandt left us numerous self-portraits. He painted himself at all stages of life, and depicted his family in splendid costumes. The self-portrait shown here is a profoundly moving work from the last months of his life (illus. p. 236 above).

**Jan van Goyen,** *Dune Landscape with Goats*, 1635, oil on wood, 39 x 63 cm/ 15.5 x 25 in, Braunschweig, Herzog-Anton-Ulrich-Museum

## The Dutch Landscape

In contrast with the ideal landscapes of the Carracci, Poussin and Claude Lorrain, or the "natural landscapes" of Albrecht Altdorfer, Dutch painters endeavored to depict nature realistically and with topological precision. The painter's local surroundings, the dunes, fields and riverbanks, the lakes, coasts, and woods were considered worthy subjects in themselves, even without providing the background for a narrative, religious, or mythological scene. Changes of light, weather, and season became subjects in their own right. Accompanying the rise in status of everyday subjects was a change in the spectator's view point: No longer were objects and scenes surveyed from above, but presented at realistic eye-level for the viewer, who could thus enter directly into the picture.

Jan van Goyen (1596–1656) was one of the first painters to adopt this new way of looking at the landscape, after starting off rather traditionally. As in *Dune Landscape with Goats* shown here (1635; illus. above), he painted apparently accidental scenes set under an endless sky. The horizon is low in the picture, while a diagonal leads deep into the interior of the picture. In the 1630s, van Goyen developed his characteristic, almost monochrome coloration: The land is dominated by brown and yellow, while water shimmers in gray and white tones.

Jacob van Ruisdael (1628/1629–1682), nephew of Salomon van Ruisdael (1600–1670), who was also a famous landscape painter, gave this genre a more dramatic note: *Windmill at Wijk, near Suurstede* is exposed to the elements; the building, seen from a low viewpoint, is still bearing up to the coming storm that plunges the scene into an oppressive gloom (illus. p. 239 above). The human figures, like the windmill, are also powerless in the face of the storms of fate. Dark visions played an increasing role in Ruisdael's landscape paintings: the *Jewish Cemetery*, which he painted around 1660 in two versions, turned into a memento mori (see p. 202/203).

Jacob van Ruisdael's pupil, Meyndert Hobbema (1638–1709), adopted the subject material and palette of his master. Until 1668 he painted many watermills and dune scenes. After this, he dedicated himself completely to his job as inspector of weights and measures. Not until 1689 did Hobbema again produce a masterpiece, *The Avenue at Middelharnis* (illus. opposite). Here, the usual diagonal composition is replaced by a central viewpoint that draws the viewer into the picture almost by force.

**Jacob van Ruisdael,** *Windmill at Wijk, near Suurstede,* c. 1670, oil on canvas, 83 x 101 cm/ 32.5 x 40 in, Amsterdam, Rijksmuseum

A windmill in a thunderstorm becomes a metaphor for human destiny. Ruisdael has given the landscape a dramatic character.

**Meyndert Hobbema,** *The Avenue at Middelharnis,* 1689, oil on canvas , 103.5 x 141 cm/41 x 55.5 in, London, National Gallery

Here, Hobbema breaks with the traditional diagonal composition of Dutch landscape painting: The structure of *The Avenue at Middelharnis* is as clear and cool as the light. This picture is considered one of the last great examples of this genre.

239

**Pieter de Hooch,** *Woman and Maid in the Courtyard*, c. 1660/1661, oil on canvas, 73.7 x 62.6 cm/ 29 x 24.5 in, London, National Gallery

**Jan Steen,** *The World Upside-Down*, 1663, oil on canvas , 105 x 145 cm/41.5 x 57 in, Vienna, Kunsthistorisches Museum

"The world upside-down" was a popular subject in art and literature, calling into question both the social and the natural order. This game with contradictory elements allowed the inclusion of satire and social criticism.

## Dutch Genre Painting

The concept of genre painting comes from French art theory of the late eighteenth century and means the depiction of scenes from everyday life. There were genre pictures before this, integrated into religious or courtly subjects, or as moral references. However, it was not until Pieter Brueghel's depictions of peasant life that genre painting came into its own. In the Baroque era, it was mostly the Dutch who took up this development. They produced a large number of different genre pictures showing social gatherings and scenes in taverns and

brothels, which sold like hot cakes in the bourgeois society. Classical art theory dismissed them as vulgar, but today we are beginning to recognize the complex meanings conveyed by these pictures: Scenes that at first glance may appear trivial, crude, or jovial in fact conceal allegorical, moral, or even obscene messages that were easily understood by, and delighted, their audience.

Jan Steen (1626–1679), a painter and brewery owner, was a master of such riddles. His detailed, ironic paintings showing parties, lovers, and drinking scenes are full of veiled hints and allusions to proverbs and emblems. In *The World Upside-Down*, also the name of a popular role game involving questions about the meaning of life and the validity of accepted values, one sees a pair of lovers drinking wine, surrounded by numerous motifs with either a clear meaning or a double one (1663; illus. p. 240 bottom).

Pieter de Hooch (1629–1684) specialized in domestic scenes set in interiors or courtyards in the city of Delft, painted in warm red and brown tones (illus. p. 240 top).

It was in the works of Jan Vermeer (1632–1675) that Dutch genre painting reached its zenith. Vermeer also concentrated on interiors, to give his calm figures the right atmospheric background (illus. below). There is almost always bright light pouring in from a window on the left side, accentuating the meticulously painted surfaces. The precision of paint application is something Vermeer has in common with Gerard Dou, the founder of Leiden "fine painting," who achieved enamel-like effects. Vermeer produced relatively few paintings (only between 40 and 60), nonetheless, they ensured him immense fame.

**Jan Vermeer,** *The Glass of Wine*, c. 1660/ 1661, oil on canvas, 65 x 77 cm/25.5 x 30.5 in, Berlin, Staatliche Museen, Gemäldegalerie

The calm atmosphere is deceptive: the viewer is witness to an attempt at seduction. The young man is about to pour the woman more wine. The motifs that have been casually slipped into the picture—the lute as a symbol of a frivolous way of life, the pane of glass with a coat of arms and the figure of Temperantia, "moderation"—elucidate the true meaning of the scene.

## The Still Life

Like the term "genre painting," the expression "still life" was not yet widely used as a description of a type of painting in the early seventeenth century. Instead, one spoke of kitchen, flower, fish or fruit scenes, or of the *banketje* (banquet picture) or *ontbijtje*, the breakfast picture. A *still-leven* is first mentioned in a Dutch inventory in 1650, which proves that the painters had depicted objects using a (motionless) model.

Even in Antiquity, the still life was accorded a special importance in art theory. The goal was to reproduce objects in such an exact manner that they were able to deceive the senses; the fable about the grapes of Zeuxis that were picked at by the birds, and the story of Parrhasios' curtain illustrate this idea.

Dutch painters and their patrons enjoyed both the games played with perception, as well as the aesthetic beauty of delicate foods and valuable objects. The hunting still lifes of Willem van Aelst (illus. left) and the sumptuous still lifes of Willem Kalf, which were painted around the middle of the seventeenth century, are among the masterpieces of this genre. *Still Life with Chinese Porcelain Bowl* presents the luxuries of an elevated lifestyle in a no less luxurious fashion: The fragility of the porcelain with its decorative figures in relief, the shimmering glass of the wine goblet, and the skillfully draped oriental carpet can completely take in the viewer (illus. p. 243).

But even in the still life, the beautiful appearance conceals a deeper, usually tragic meaning. As fragile as the porcelain in Kalf's still life, all the other luxuries depicted on his canvas are equally subject to the fleeting quality of existence: the rose wilts, the glass breaks, the food spoils or is eaten. This idea is given its clearest expression in the *vanitas* paintings of Pieter Claesz and Juan de Valdés Leal (see p. 202/203).

**Willem van Aelst,** *Hunting Still Life,* 1668, oil on canvas, 68 x 54 cm/27 x 21.5 in, Karlsruhe, Kunsthalle

**Willem Kalf,** *Still Life with Chinese Porcelain Bowl,* 1662, oil on canvas, 64 x 53 cm/25 x 21 in, Berlin, Staatliche Museen zu Berlin

Right: **Georg Flegel,** *The Cupboard. Picture with Flowers, Fruit, and Goblets,* c. 1610, oil on canvas, 92 x 62 cm/ 36 x 24.5 in, Prague, National Gallery

P. 245: **Johann Liss,** *The Inspiration of St Jerome,* 1627, oil on canvas, 225 x 175 cm/7 ft 4.5 in x 5 ft 9 in, Venice, S Niccolò dei Tolentini

Below: **Adam Elsheimer,** *The Flight into Egypt,* 1609, oil on copper plate, 31 x 41 cm/12 x 16 in, Munich, Alte Pinakothek

# German Baroque Painting

German painting of the seventeenth century presents a very uneven picture. The empire, shaken by the Thirty Years' War and its aftermath, could barely give artists paid employment; only a few cities had art-loving and wealthy patrons. For this reason, many painters tried their luck in neighboring countries, including Holland, Flanders, the court in Prague, or Rome, at least during the first half of the century.

One of these was Adam Elsheimer (1579–1610) from Frank-

furt, who went to Rome via Venice. There, he achieved success with his small cabinet pictures painted on copper plates. His exquisite landscapes combine elements of the Danube school and of the works of Titian, Tintoretto, and Veronese, with the contemporary Baroque style of Roman artists. Elsheimer's small œuvre (just over 30 paintings), in its turn, had a great influence on the following generations.

*The Flight into Egypt* was considered as unique even by his contemporaries: Elsheimer sets the biblical episode in a nocturnal landscape of woods and water, barely illuminated by the expansive starry sky and the reflected moon (1609; illus. p. 244 bottom). Only a shepherds' fire produces some warming rays of light. These fall on the Holy Family passing by under the cloak of darkness. Never before had a moving story, the poetic depiction of a landscape, and an intimate mood been blended together in such a manner.

The paintings of Johann Liss speak a more powerful language. Liss, who was born in Holstein in around 1597, died of the plague in 1629 in Venice. He spent most of his short life traveling. A period of study in Holland was followed by commissions in Antwerp, after which he stayed in Paris, Rome, and Venice. Liss received a variety of inspirations on his travels: He mastered the genre painting of Haarlem, the spirited style of Jordaens, and the tenebrism of the Caravaggists. *The Inspiration*

*of St Jerome* testifies to his experiences in Venice by taking up the colorful painting of the sixteenth century and developing it further (1609; illus. above). The pastel tones of his palette clearly anticipate the Rococo.

The genre of the still life was best represented in Germany by Georg Flegel. Flegel trained with Lucas van Valckenborch before settling in Frankfurt, where he was one of the first painters to specialize in pictures of meals

and flowers. *The Cupboard. Picture with Flowers, Fruit, and Goblets* is an example of a type of still life that strives to deceive the senses even more cunningly by having a seemingly real frame (c. 1610; illus. p. 244 top).

Finally, mention should be made of the painter and art connoisseur Joachim von Sandrart, who recorded the works of his contemporaries in his book *Teutsche Akademie*, thus laying the foundation for German art historiography.

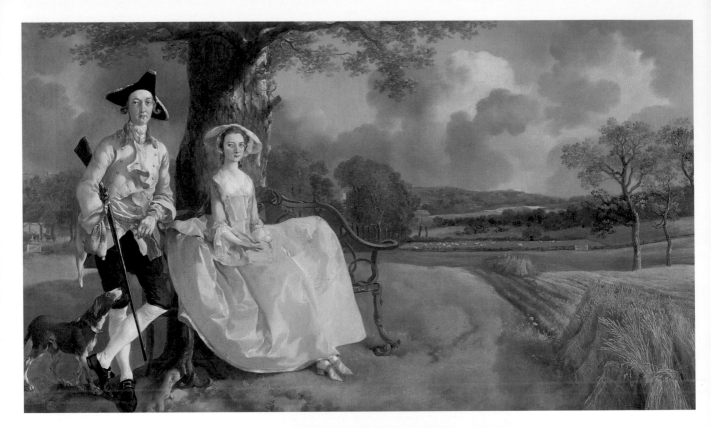

# English Rococo Painting

In the seventeenth and early eighteenth centuries, English painting was dominated by foreign artists including Anthony van Dyck from Flanders, Peter Lely from Holland, and the German Godfrey Kneller. All of them, incidentally, were knighted. However, with William Hogarth, a new form of coloristic but keenly observed art began to flourish that reached its finest expression in the portrait.

William Hogarth (1697–1764), a talented painter, copper engraver, and etcher, achieved unprecedented success with his moralizing cycles. For example, in the six part series *Marriage à la mode*, he pilloried the morals

**Thomas Gainsborough,** *Mr and Mrs Andrews*, 1748, oil on canvas, 70 x 119 cm/27.5 x 47 in, London, National Gallery

**Sir Joshua Reynolds,** *Self-Portrait*, 1775, oil on canvas, 76 x 63 cm/30 x 25 in, Florence, Uffizi

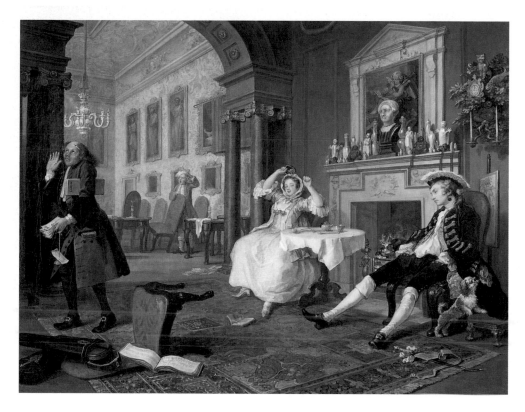

of the aristocracy (1744; illus. above). Engravings were made of his paintings, which were copied so often that the artist had to protect himself from plagiarism. Other works, like the group portrait *Hogarth's Servants* or the self portrait *The Painter and his Pug,* also show his unusual talent for social criticism and satire, which was only imaginable in this form in mercantilist England of the eighteenth century. These works put Hogarth in the vanguard of a form of art that was anti-classical and anti-academic.

The world of Sir Joshua Reynolds (1723–1792), just one generation younger, was completely different. Reynolds produced a large number of distinguished portraits of English aristocrats whom he depicted in Baroque poses, filling out the pictures with elements of history painting. His self-portrait in the Uffizi was painted in the classicizing phase of the 1770s (illus. p. 246 bottom). His idealizing, epic style, known as the "grand manner" or "grand history style," dominated the Royal Academy for decades; he was its president from the time it was founded in 1768.

Thomas Gainsborough was born in 1727 in Sudburry, Suffolk, as the son of a maker of woolen goods. His early occupation as a copyist of Dutch landscapes and his knowledge of French pastoral paintings strongly influenced his art and predestined him to become a high-society painter. Between 1759 and 1774 he lived mostly in the fashionable spa resort of Bath, where he portrayed his clientele in a casual, elegant manner. Gainsborough's full-length, *plein-air* portraits, such as *Mr and Mrs Andrews,* probably painted as a wedding picture, greatly influenced the development of landscape painting (illus. p. 246 top). The husband in hunting garb and accompanied by his dog, leans on a tree, under which his wife sits in a formal pose. Although the couple's facial expressions seem tense, the spontaneity of the expansive summer landscape is surprising. Its gentle green-yellow is in harmony with the man's shimmering white jacket and the woman's light-blue dress. Critics called this the most beautiful picture in English painting.

# Glossary

**Academies** Powerful authorizing and often teaching artistic institutions that arose in various countries in the Baroque: *Accademia di S Luca/ Academy of St Luke* in Rome (no teaching, more like a prestigious guild), *Academie Royale/The Academy* in Paris with a branch in Rome (the king held absolutist sway over acceptable style, thus careers, through the Academie), *Royal Academy* in London (also practiced strict classicism, i. e. "academic" art).

**Aedicule** A wall niche with an architectural frame, often used to display statues.

**Aisle** A longitudinal passage area in a church, separated from other areas by **piers** or **columns**.

**Apse** Semicircular or polygonal extension of a building; in churches (usually) eastern termination of the **choir**.

**Arcade** A series of arches on **piers** or **columns**.

**Architrave** Lintel resting on **columns**; in a classical **entablature** it carries the **frieze** and **cornice**.

**Archivolt** One unit in a band of moldings (archivolts) on the underside of an arched opening.

**Ashlar** Masonry made of regularly cut, squared building stones.

**Attic** A wall above the main **cornice** of a building; can take the form of a low story.

**Base** The molded foot piece of a **column** or **pillar** between the shaft and the plinth.

**Basilica** Originally, a Roman market hall or hall of justice; in Christian architecture, a church with several **aisles** and **clerestory**.

**Bay** A sub-unit of a modular building; often vaulted.

**Boscage** French term for a small artificial forest designed to look natural; sometimes surrounded by tall hedges.

**Calotte** Section of a sphere, the term used for the dome of an **apse**.

**Capital** A sculptural section at the upper end of a **column** or **pier** that mediates between the support and the load.

**Cathedral** The principal church of a diocese, in which a bishop has his throne (cathedra).

**Central-plan building** A building with a circular, polygonal or Greek Cross plan.

**Chapel** A privately owned place of worship; can be a separate building or within a church.

**Château** A palatial country seat of French nobility; typically with extensive grounds and water features (compare **Schloss**).

**Choir** In church architecture, the space behind the **crossing**.

**Choir screen** Partition inside a church between the monks' **choir** and the space for lay brothers; also a platform for singing or readings.

**Clerestory** Window story; in a church, the upper section of **nave** projecting above the **aisle** roofs.

**Cloister** An open, usually quadrangular courtyard in a **monastery** or convent, connecting the church and other buildings.

**Coffering** Decorative treatment for vault or flat ceilings developed in ancient Roman times consisting of sunken panels (coffers), often richly molded and ornamented.

**Colonnade** A series of **columns** with **architraves** or arches.

**Colossal order** An **order** of **columns** or **pilasters** that extends over two or more stories.

**Column** A slender, vertical support, usually cylindrical, consisting of a **base**, shaft with convex curvature, and **capital**.

**Communs** The outbuildings of a French château.

**Conch** Semicircular niche or **apse**.

**Console/Corbel** A support or bracket projecting from a wall.

**Cornice** Projecting horizontal molding crowning a building, especially the uppermost element of an **entablature**; can be used alone as a dividing feature on facades.

**Corps de logis** An enlarged central block; the residential section of a château and other large buildings.

**Cour d'honneur** Front courtyard, often between the wings of a Baroque **palace** or **château**, for the formal reception of honored guests.

**Crossing** The intersection of **nave** and **transept**; often emphasized architecturally.

**Crypt** Shrine room for a church's primary relics, usually (but not always) set in the foundations.

**Dormer window** An individually roofed window projecting from the main roof.

**Drum** A cylindrical or polygonal structure serving to support a dome.

**Emblem** A symbol consisting of three elements 1. the *pictura* or icon (an allegorical picture) 2. the *lemma* (motto) 3. the *subscriptio* (an epigram written below, linking the two other elements)

**Embrasure** Inwardly splayed surfaces around an opening in a thick wall.

**Entablature** Lintel system between walls and roof; in classical architecture, it consisted of **architrave**, **frieze**, and **cornice**.

**Exedra** A semicircular extension of a building.

**Fluting** Vertical grooves in the shaft of a **column** or **pilaster**.

**Frieze** A narrow strip, often decorated; in an **entablature**, the middle section.

**Frontispiece** A specially emphasized projecting section of facade, especially the main entrance

**Gallery** 1. Balcony or platform inside a church; serves to set certain groups of people apart (royalty, women) during services.
2. Originally a long covered passage, open on one or both sides; in palaces, a long hall used to house collections.

**Hall choir** A **choir** consisting of several **aisles** of equal or near-equal height.

**Hall church** A church without a **clerestory** whose **nave** and **aisles** are of equal or near-equal height.

**Hermitage** A small **garden** palace built to imitate a hermit's retreat

**Hipped roof** A roof pitched on all four sides.

**History painting** Narrative scenes, often of important historic, mythical, or religious moments.

**Hôtel** French term for nobles' city **palace**; typically designed on a **three-winged plan**.

**Impost** Plain or projecting masonry block at the top of a **pier** that appears to support the spring of an arch or vault. Often combined with a **capital**.

**Lambrequin** Cloth draped over a doorway, window or coat of arms.

**Lantern** A windowed turret that crowns a dome and functions as a light source.

**Lesene** A molded vertical strip on a wall that, unlike a **pilaster**, has no **base** or **capital**. Also called a pilaster strip.

**Loggia** An open **arcade** or **gallery**, either on the ground floor or in an upper story of a building.

**Lunette** A semicircular or crescent-shaped decorative area over a door or window; it may contain another window, a sculpture or a mural.

**Mansard roof** A type of roof, named after the French architect Jules Hardouin-Mansart, in which the pitch suddenly becomes steeper part way down.

**Mausoleum** Originally the tomb of King Mausolos of Halicarnassus (completed in 353 B.C.), now the name for all monumental tombs.

**Mezzanine** A low story between two higher ones.

**Monastery** Since early Christian times, the home of a religious community. A monastic complex includes a church, a **cloister**, the chapter house or assembly hall, the **refectory**, the dormitory, and other functional buildings.

**Monolith** A column, **pillar** or building made out of a single piece of stone.

**Narthex** The entrance hall of a church.

**Nave** The main central part of a church from the facade to the **crossing**.

**Oculus** A circular window opening.

**Orangerie** An elongated greenhouse, usually with **French windows**, developed in the Baroque period.

**Oratory** A **gallery** in the **choir** of a sacred building; also a private **chapel**.

**Order** The proportions and design of the classical **column** (**base**, shaft, **capital**) and the **entablature**; in the Baroque era, the five orders typical of classical architecture (Doric, Ionic, Corinthian, Tuscan, Composite) were extended to include new ones.

**Palace** Originally a feudal residence, later a term also used for monumental bourgeois buildings.

**Parterre** Patterned lawns or flowerbeds designed to be seen from above, and thus usually near the house.

**Pavilion** A small, separate building within a **palace** complex, or a separately roofed block in a Baroque building.

**Pediment** The usually imposing frontal feature of a trussed or gable roof, window, or **aedicule**. The **tympanum** is often decorated with sculpture.

**Pergola** An arbor; also an open **colonnade** covered with climbing plants.

**Perron** An open stairway leading to the entrance of a building.

**Pier** An upright load-bearing member of any shape; commonly embellished with **pilasters** and/or half or full **columns**.

**Pilaster** A vertical, rectangular feature with a **capital** and **base** that projects slightly from a wall; usually designed in imitation of a **column**.

**Pilaster strip** See **lesene**

**Pillar** A vertical structural member without the entasis (convex curvature) of a classical **column**. It may, however, possess a **base** and a **capital**. It usually fulfils a load-bearing or supportive function, but can also stand alone.

**Plasticity** Noticeably molded or sculptural quality, strong relief; sharply delineated.

**Portico** A structure built on **columns** that acts as a porch.

**Quadratura** Illusionistic, imitation architectural components in frescoes.

**Refectory** Dining hall of a **monastery** or convent.

**Rib** Construction element of a Gothic vault; the decorative skeleton that appears to support the masonry cladding.

**Rocaille** Shell-like decorative element of the Late Baroque and Rococo

**Rotunda** A **central-plan building** with a circular ground plan.

**Rustication** Masonry blocks with rough or strongly textured outer faces; has been used as a means of decoration for **palaces** since the Italian Renaissance.

**Sacristy** A side room in a church for robing the priest or storing liturgical vessels.

**Sanctuary** The most sacred part of a church, usually the **choir** with the high altar.

**Schloss** Palatial country seat of German nobility, typically with extensive grounds and water features. (compare **Château**)

**Summer palace** (*Lustschloss*) A small **palace** in pleasant surroundings, used for recreational pursuits.

**Tenebrism** In painting, deep pools of black shadow that throw the spotlighted subject into strong relief; strongly expressive

**Three-winged plan** Basic form of the Baroque **palace** with **corps de logis** and side wings surrounding the **cour d'honneur**.

**Transept** A part of a church, consisting of one or more **aisles**, that crosses the **nave** at a right angle. The point where the nave and transept meet, the **crossing**, is often distinctively treated.

**Transverse arch** An apparently supporting arch spanning the longitudinal axis of a vault.

**Triforium** A wall passage, open to the **nave** of a church, between the nave **arcade** and the **clerestory**.

**Triumphal arch** In classical times, a monumental arch built to commemorate an irreversible victory; in the Christian church, an arch leading from the **nave** to the **crossing** or apse, i. e. over the high altar.

**Tympanum** In a **pediment** or arched portal, the triangular or arched wall area above the lintel; usually decorated with sculpture.

**Veduta** factual, true-to-life landscape or town view paintings

**Volute** Spiral-shaped decoration on **columns** or **pediments**.

**Ward** Area between the between the walls of a castle or fort; courtyard.

# Bibliography

A selection of works that provide an overview of the art and culture of the Baroque and Rococo

The Age of Caravaggio. Exhibition Catalog, New York 1985

Alewyn, Richard: Das große Welttheater. Die Epoche der höfischen Feste, Munich 1989

Bauer, Hermann, Sedlmayr, Hans: Rokoko, Cologne 1991

Blunt, Anthony (ed): Baroque and Rococo. Architecture and Decoration, London 1978

Boucher, Bruce: Italian Baroque Sculpture, New Haven/London 1998

Brown, Jonathan: Painting in Spain 1500–1700, New Haven/London 1997

Brown, Jonathan: Velasquez, New Haven/London 1988

Brucher, Günter (ed): Die Kunst des Barock in Österreich, Salzburg, Wien 1994

Dinzelbacher, Peter (ed): Europäische Mentalitätsgeschichte, Stuttgart 1993

Elias, Norbert: Die höfische Gesellschaft, Neuwied, Berlin 1969

Elliott, J. H.: Spain and its World 1500–1700, London/New Haven 1990

França, José-Augusto et al.: Arte portuguesa (SUMMA ARTIS vol. XXX), Madrid 1986

Fuchs, Rudi: Dutch Painting, London 1984

Grimm, Claus: Stilleben. Die niederländischen und deutschen Meister, Stuttgart, Zürich 1988

Hansmann, Wilfried: Gartenkunst der Renaissance und des Barock, Cologne 1983

Hansmann, Wilfried: Barock: Deutsche Baukunst 1600–1760, Leipzig 1997

Harbison, Robert: Reflections on Baroque, Chicago 2001

Haskell, Francis: Patrons and Painters: A Study in the Relations Between Italian Art and Society in the Age of the Baroque, New Haven 1986

Held, Julius & Donald Posner: 17th and 18th Century Art: New York

Hernández Diaz, J. et al.: La escultura y la Arquitectura españolas del siglo XVII (SUMMA ARTIS Bd. XXVI, Madrid 1982

Jones, W T: The Sciences and Humanities, Conflict and Reconciliation, Berkeley, 1965

Kaufmann, Emil: Architecture in the Age of Reason, Cambridge, MA 1955

Kitson, M: The Age of Baroque, New York 1966

Kitson, M: Circle and Oval in the Square of St Peter's: New York, 1974

Krins, Hubert: Barock in Süddeutschland, Stuttgart 2001

Kruft, Hanno-Walter: Geschichte der Architekturtheorie, Munich 1991

Lavin, Irving: Bernini and the Unity of Visual Arts, 2 Vol, New York/London 1980

Lewis, W H: The Splendid Century: Life in the France of Louis XIV, Chicago 1997

Lieb, Norbert: Barockkirchen zwischen Donau und Alpen (6th ed), Munich 1992

Lieb, Norbert: Die Vorarlberger Barockbaumeister, Munich, Zurich 1976

Norberg-Schulz, Christian: Barock (Weltgeschichte der Architektur), Stuttgart 1986

Norberg-Schulz, Christian: Spätbarock und Rokoko (Weltgeschichte der Architektur), Stuttgart 1985

Pears, Iain: The Discovery of Painting—The Growth of Interest in the Arts in England 1680–1768, New Haven/London 1988

Pérouse de Montclos, Jean-Marie: Histoire de l'Architecture française de la Renaissance à la Révolution, Paris 1995

Pevsner, Nikolaus: Academies of Art, Past and Present, Cambridge 1940

Pope-Hennessy, John: Italian High Renaissance and Baroque Sculpture, New York 1985

Schama, Simon: The Embarrassment of Riches: Dutch Culture in the Golden Age, New York 1987

Schneider, Norbert: Stilleben. Realität und Symbolik der Dinge. Die Stillebenmalerei der frühen Neuzeit, Cologne 1994

Schneider-Adams, L: Key Monuments of the Baroque: New York 2000

Slive, Seymour: Dutch Painting 1600-1800, New Haven/London 1995

Stamm, R (ed), Die Kunstformen des Barockzeitalters, Munich 1956

Stechow, Wolfgang: Dutch Landscape Painting of the Seventeenth Century, Oxford 1981

Steer, John: Venetian Painting, London/New York 1986

Summerson, John: The Classical Language of Architecture, New Haven/London

Summerson, John: Architecture in Britain 1530–1800, 9th ed., New Haven 1993

Summerson, John: Architecture of the 18th Century, New Haven/London 1986

Tintelnot, Heinrich: Barocktheater und barocke Kunst, Berlin 1939

Varriano, John: Italian Baroque and Rococo Architecture, Oxford 1986

Vlieghe, Hans: Flemish Art & Architecture 1585-1700, New Haven/London 1999

Von Kalnein, Wend: Architecture in France in the 18th Century, New Haven/London 1995

Watanabe-O'Kelly, Helen: Court Culture in Dresden, London 2002

Waterhouse, Ellis: Painting in Britain 1530–1790, New Haven/London 1993

Weisbach, Werner: Der Barock als Kunst der Gegenreformation, Berlin 1921

Whinney, Margaret: Sculpture in Britain 1530–1830, New York 1988

Wittkower, Rudolf: Art and Architecture in Italy 1600–1750, Vol 1–3, 4th ed, New Haven/London 1999

Wölfflin, Heinrich: Renaissance und Barock. Eine Untersuchung über Wesen und Entstehung des Barockstils in Italien, Basel 1888

Zuffo, Stefano (Ed): Baroque Painting, New York 1999

Zürcher, R.: Rokokoschlösser, Munich 1977

# Index of Names

252

253

# Index of Places

# Picture Credits

Most of the illustrations, which are not listed individually here, were taken by the Cologne architecture photographer Achim Bednorz. The publisher thanks the museums, archives, and photographers for their permission to reproduce the images and their friendly support during the production of this book. The publisher and the editor made every effort to ascertain any additional holder of picture rights up until the time of publishing. Persons and institutions who possibly could not be reached and hold rights to images that appear in this book are kindly requested to contact the publisher.

m=middle    a=above    b=below    l=left    r=right

© 2003 Feierabend Verlag OHG
Mommsenstraße 43
D-10629 Berlin

Project management: Bettina Freeman
Translation from German: Timothy Jones
Editing: Perette E. Michelli
Coordination and typesetting: APE Intl., Richmond VA
Design management: Erill Vinzenz Fritz
Layout: Roman Bold & Black, Thomas Paffen
Picture editor: Petra Ahke

Lithography: scannerservice, Verona
Printing and Binding: Eurolitho s.p.a.; Milan

Printed in Italy
ISBN 3-936761-57-4
61 05 005 1